Third edition

OTHER FOCAL BOOKS ON IMAGE AND SOUND TECHNOLOGY

SOUND RECORDING AND REPRODUCTION
GLYN ALKIN

BASIC MOTION PICTURE TECHNOLOGY

L. BERNARD HAPPÉ

FILM LIBRARY TECHNIQUES
HELEN P. HARRISON

HISTORY OF MOTION PICTURE COLOUR TECHNOLOGY R. RYAN

> MOTION PICTURE AND TELEVISION FILM: Image Control and Processing Technique D. J. CORBETT

> > To
> > ANDREA, JOHANNE and KIRSTI

VIDEOTAPE RECORDING

Theory and Practice

Third edition

JOSEPH F. ROBINSON

Revised by
STEPHEN LOWE

London and Boston

05744276

Focal Press

is an imprint of the Butterworth Group which has principal offices in London, Sydney, Toronto, Wellington, Durban and Boston

First published 1975 Reprinted 1975, 1976 Second edition 1978 Third edition 1981 Reprinted by Butterworths 1981, 1982

© Butterworth & Co. (Publishers) Ltd. 1981

All rights reserved. No part of this publication may be reproduced or transmitted in any form or by any means, including photocopying and recording, without the written permission of the copyright holder, application for which should be addressed to the Publishers. Such written permission must also be obtained before any part of this publication is stored in a retrieval system of any nature.

This book is sold subject to the Standard Conditions of Sale of Net Books and may not be re-sold in the UK below the net price given by the Publishers in their current price list.

British Library Cataloguing in Publication Data

Robinson, Joseph Frederick, b.1942 Videotape recording. — 3rd ed. — (Library of image and sound technology). 1. Video tape recorders and recording

I. Title II. Lowe, Stephen TK6655.V5 621.388

ISBN 0 240 51083 6

American Library of Congress No: 80-041244

Printed and bound in Great Britain by A. Wheaton & Co. Ltd, Exeter

Contents

PR	REFACE	13
N	TRODUCTION	15
1	TAPE RECORDING PRINCIPLES	19
	Hysteresis	19
	Sheared hysteresis	22
	Audio recording	23
	Erase process	24
	Record process	25
	Replay process	28
	Low frequency losses	31
	High frequency losses	31
	Other losses	32
	Head alignment losses	34
	Final response	36
	Distortion	36
	DC bias	37
	AC bias	38
	Equalisation	39
	Characteristics of recording tape	41
	References	44
2	BASIC REQUIREMENTS OF VIDEOTAPE RECORDING	45
4		
	Elements of a videotape recorder	45
	Care of tape	48
	Tape checking	49
		5

	Care of the tape deck	49
	Degaussing	51
	Tip projection	51
	Care of the electronics	51
3	THE BROADCAST QUADRUPLEX FORMAT	55
	Track width and spacing	56
	Overlap	58
	The purpose of longitudinal tracks	58
	Position of field sync	61
	Format data	61
	Deck layout	63
	Vacuum chambers	63
	Super high band and pilot tone	65
	References	65
4	THE BROADCAST HELICAL FORMATS	67
	Segmented B-format	67
	Track width and spacing	69
	Overlap	69
	Longitudinal tracks	69
	Format data	70
	Operational facilities	70
	Editing	71
	Non segmented C-format	71
	Track width and spacing	73
	Overlap	74
	Longitudinal tracks	74
	Still frame and slow motion	76
	Auto scan and dynamic tracking	76
	Editing	77 78
	AST head problems	79
	Portable machines Format data	79
5	INDUSTRIAL, EDUCATIONAL AND DOMESTIC FORMATS	80
5		80
	Two-headed wraps	82
	One-headed wraps	86
	Sync line-up Stop-motion	87
	The control track	88
	Colour under recording	88
	Zero guard band recording	89
	Double limiter frequency modulation	92
	Linear video recording	92
	Conclusion	93

	References	93
6	FM THEORY	96
	Basic FM theory	96
	Frequency modulation used in video recording	99
	Deviation frequency and modulation index	102
	Distortion in FM Signals	102
	Causes of moiré patterning	106
	Choosing centre frequency to combat patterning	
	Pilot tone and chroma pilot	108
	Response requirements for the signal system	110
	Specification of pre-emphasis	111
	Conclusion	112
		113
	References	113
7	SIGNAL SYSTEMS	114
	Record electronics	114
	Frequency modulators	114
	Automatic frequency control	118
	Record driver	119
	Optimisation	120
	Playback	121
	High input impedance amplifier	122
	Low input impedance channel amplifier	123
	Equalisers	123
	The cosine equaliser	124
	Switchers	126
	Blanking switchers (quadruplex)	127
		129
	The stages of switching (quadruplex)	129
	Switch waveform generation (quadruplex)	130
	Generation of front porch switch	
	Demodulation	131
	Methods of producing twice frequency pulses	132
	Switch suppression and feedback clamping	133
	Drop-out compensation	134
	Auto-equalisation	135
8	SERVO-MECHANISMS	138
	Velocity control methods	138
	Servo elements	139
	Phase comparators	140
	The forward backward counter	140
	Discriminators	143
	Motor control	145
	Ring counter	147
	Amplitude and pulse width control of an a.c. supply	148
	implicade and pulse width control of an a.c. supply	. 140

	DC control	149
	Practical quadruplex servos	150
	Identification of frame pulse	157
	Head wheel servo	157
	Head wheel comparator	160
	Auto tracking (capstan)	161
	Practical helical servos	162
	Playback modes	163
	Instability	165
	References	165
	references	103
9	GEOMETRICAL ERRORS	166
	Adjustments to quadruplex machines	166
	Azimuth (preset)	167
	Axial displacement (preset)	168
	Quadrature displacement (preset)	168
	Guide positional errors (adjustable)	169
	Velocity errors	172
	Guide radius	172
		173
	Tape transport topology	175
	Temperature and humidity	175
	Tape tension	
	Conclusion	175
	Adjustments to helical machines	176
	Head position	176
	Tape path and interchange	177
	Compatibility coefficient	178
	Timing errors	181
	Environmental changes	181
	Tape tension	184
	Auto tension	186
	Conclusion	187
	References	187
10	TIME BASE ERROR CORRECTION	188
	Nature of timing errors	189
	Methods of monochrome correction	189
	Methods of applying delay	190
	Binary delay switching	193
	Determining the required delay	194
	Fourth power law	195
	The stable references	196
	The quantised gate	198
	Binary error detection	198
	Colour correction	200
	Sync feedback	202
	Error dumping	204
		-01

	Sync subcarrier lock Velocity error correction (quadruplex) Conclusion References	204 205 212 212
11	DIGITAL TIME BASE ERROR CORRECTION Analogue-digital conversion LF linearity Differential gain Differential phase Interpretation of results Methods of analogue to digital conversion A practical A-D convertor for video Single stage convertors Digital to analogue conversion Time-base correction of digital signals Vernier correction Coarse correction The line shift register The RAM Sync feedback Velocity error correction Reduction of bit rate Delta modulation References	213 213 216 216 217 217 218 220 221 221 222 224 225 226 227 229 230 231
12	COLOUR CORRECTION IN CCTV Tolerant systems Electronic stabilisation Pilot tone Burst locked oscillator Methods of stabilisation Bandwidth reduction Pilot chroma carrier Conclusion References	232 235 236 237 238 240 242 243 244
13	CASSETTES AND CARTRIDGES Broadcast cassettes The BCN multicassette The helical cassette References	246 246 249 250 252
14	EDITING Physical editing Electronic editing	253 253 255 9

	Erase and RF turn-on	257
	Playback and record phase	265
	Editing color sequences	266
	Electronic editing, general	268
	Cue tone programming of edits	268
	Time code addressing	269
	Recording codes SMPTE address code	270
	Format of SMPTE/EBU code	272
		274
	Functions of sync word Bit number 10 (the "drop frame flag")	277 277
	Bit number 11 (standard binary groups)	278
	Bits numbers 27, 43, 58, 59	278
	Time code controlled editing	279
	Off line editing	279
	Automatic editing	280
	References	281
15	SLOW MOTION TECHNIQUES	282
13	The state of the s	284
	Record and playback sequence Stop-motion	285
	NTSC chroma correction	286
	Half line delay logic	287
	Video disc signal path	290
	PAL chroma correction	290
	Slow and fast motion	292
	Helical slow motion	293
	Conclusion	294
	References	294
16	MOBILE VIDEO RECORDING	295
	Electronic news gathering	296
	The portable recorder	297
	Editing	299
	Remote replay	300
4	Time base correction	300
	Electronic field production	303
	Conclusion	303
17	DIGITAL VIDEO RECORDING	305
	Conclusion	308
	References	309
	APPENDIX	310
	GLOSSARY	354
	INDEX	359

The author wishes to thank the following organisations for help and permission to reproduce some of the diagrams in this book.

Ampex Corporation
Audio Engineering Society
British Broadcasting Corporation
Committee Consultative International Radio
European Broadcasting Union
International Video Corporation
Philips Electrical Ltd.
Plymouth Polytechnic
Radio Corporation of America
Society of Motion Picture and Television Engineers
3 M (United Kingdom) Ltd.
U.S. Department of Defence
Bosch Fernseh
Sony
National Panasonic

t respektaria establica di terro di ritargeno giu a colle i conti di contra di contra contra di collegio di co La collegio di collegio di collegio di contra di collegio di collegio di collegio di collegio di collegio di c

		ar .
	JA	

Preface

The object of this book is to review the practice and underlying theory of videotape recording. For the reader with a basic engineering knowledge and some experience in television, the main body of the text should be practical, readable and informative, although owing to the complexity of the subject some effort is required toward the end of each chapter. For the student or engineer requiring a more precise treatment the complex analysis is included as an appendix. This should not deter the less academic reader, who should find plenty of information in the rest of the text.

The terminology used has been, where possible, that defined by the SMPTE, although in some cases a choice between two or more common terms has had to be made. A complete glossary, which contains most of the various terms used in VTR, is included at the end of the book. Trade terms,

which have been avoided in the text, are also defined here.

The book fully explains the difference in VTR practice owing to the differing television line standards used throughout the world. This covers the 525 line 60 fields per second, NTSC colour, of the American continent and Asia, and the 625 lines 50 fields per second, PAL and SECAM colour of Europe, Russia, Africa and Australasia.

The choice of units was a difficult one, as most mechanical design work on VTR was based on the foot, pound, second (FPS) system, making dimensions in these units whole numbers or neat fractions of whole numbers. Today, however, there is an international drive to standardise on the metric system.

The metre, kilogramme, second (MKS), system of units has, therefore, been adopted, with the exception of mechanical dimensions where the FPS system is used with its metric equivalent in brackets.

The book is designed to be a useful reference work for the VTR engineer, because, where possible, the various standard formats have been described and analysed. These include the Broadcast Quadruplex 2 in wide, B and C 1 in wide, IVC alpha 1 in wide, VCR ½ in wide cassette, EIAJ ½ in wide, VHS ½ in wide, Betamax ½ in wide, VCC ½ in wide and LVR. Each chapter is well referenced and bibliographed for further reading.

그 사람들이 하다고 그렇게 되었다면 하는데 가는데 되었다.

Introduction

The achievement of magnetic recording has a long history of arduous struggle, inspiration, deep theoretical analysis and lucky breaks. Its evolution has been motivated by war and economic gain. Its progress can be followed for over 70 years in three main continents of the world, Europe, America and Asia. Sometimes the major steps were as a result of theoretical research but more often the theory followed the practical demonstration. The development did not result from international co-operation but as a result of an international engineering requirement to store or record information. The milestones in this development can be seen in Denmark, United States of America, Germany, United Kingdom, Holland and Japan.

Evidence of experiments in magnetic recording exists as early as 1880 but the first practical demonstration was given by Valdemar Poulson in 1898 when he patented, in Denmark, the Telegraphone. The device used a continuous steel wire as the recording medium and produced a noisy, distorted low output signal. This poor performance did not deter Poulson and a colleague Pederson from forming the American Telegraphone Company in 1903 and later, in 1906, they patented d.c. bias, which improved the distortion and increased the output although the signal/noise ratio was still poor.

Apart from developments in electronic amplification very little improvement was made until the late 1920's when two major advances on opposite sides of the Atlantic created the improvements which, although not fully exploited until after the war, led to high quality recording and playback as we understand it today:

1. Research work in the US Navy by Carlson and Carpenter culminated in the first patent for the use of a.c. bias.² This improved the distortion and the signal/noise ratio on existing wire recorders considerably.

2. In 1928, Pfleumer³ patented a method of coating and using paper tape

covered with magnetic powder. This idea of a tape was to overcome several problems associated with wire recorders, in particular that of the wire twisting and the difficulty of coupling the flux from the wire to the pick-up head. With improvements in tape oxide⁴ and the increased use of plastics instead of paper, magnetic tape consisting of ferric oxide on a plastic base was to provide the future magnetic recording medium exclusively for at least 40 years. In 1935 the AEG Company in Germany demonstrated the Magneto-phone⁵ at the German Annual Radio Fair. It was this recorder that laid down the basic principles that are in use up to the present day. Many improvements have been made but the layout and concept is almost identical with that of modern 1/4 in reel-to-reel recorders.

In parallel with plastic covered tape, the use of steel tape was developed in the United Kingdom by the Marconi company with the Marconi-Stille⁶ and in Germany with the Blattnerphone.⁷ Such devices were limited by the recording medium itself where large reels over 60 cm in diameter containing 3000 metres of tungsten-steel tape lasted a little over 30 minutes. During World War II Germany developed the plastic tape medium while the Allies concentrated on wire and steel tape. In 1946 it was obvious which had advanced the most.

Further improvements in tape and heads brought the tape speed on high quality audio recorders from 30 inches per second down to $7\frac{1}{2}$, $3\frac{3}{4}$, and even $1\frac{7}{8}$ i.p.s., giving satisfactory performance. Since 1947 recorders based on the Magnetophone design have been produced in almost every industrialised country of the world. Audio cassettes now provide a quality superior to any recording device known before World War II with a packing density that enables a man to store in his pocket more information than it would have been possible for him to lift using steel-tape as the recording medium.

In the early 1950's the need to record measurement signals used in medical, physical, mechanical and electronic research led to recorders of similar design to audio recorders but with a much higher frequency response, multitrack facilities and a tighter specification on tape speed. The response of such

machines can now exceed 3MHz with speeds up to 120 i.p.s.

It was thought that the answer to video recording was an extension of this stationary head and fast tape speed principle and in 1954 RCA demonstrated a longitudinal track recorder⁸ operating at a speed of 360 i.p.s. It did not have the full bandwidth capabilities and three main problems were evident:

1. The quantity of tape used and the size of the spools became intolerable

for any reasonable length of recording.

2. It was difficult to control the tape speed, in particular fluctuations in tape speed, to within the limits required for a television signal. A time-base error of \pm 1 microsecond can be severe on a television signal and this would require the tape to be in the correct position at the correct time to within one millionth of a second.

3. The bandwidth of a video signal is at least 18 octaves and the theoretical limit for any tape system is 10 octaves, irrespective of head-to-tape speed.

An attempt to solve the last point was made in 1958 by the BBC with their Vision Electronic Recording Apparatus.⁹ The video was band-split into two separate frequency bands,0–100 kHz and 100 kHz – 3 MHz. The low-frequency components frequency modulated a 750 kHz carrier which was recorded on a separate track to the unmodulated high frequency components. A third track was used for the frequency-modulated audio signal.

The development of the longitudinal track recorder for video at first proved to be a cul-de-sac and the progressive step which was to provide the basis for further development, the quadruplex transverse track recorder, was demonstrated by the Ampex Corporation¹⁰ in 1956 and was the result of two major solutions devised by Charles P. Ginsburg and Charles E. Anderson:

1. To slow down the tape and achieve the high head-to-tape speed by moving the head or heads. Two-inch-wide tape was used and the video heads were mounted on a 2 in diameter wheel and rotated at 240/250 r.p.s. to scan

the tape transversely from edge to edge.

2. To devise a wideband, low deviation, low carrier f.m. signal with frequency components within the pass-band of the tape system.

Most modern broadcast video recorders use both these principles but improvements in tape and recording heads have enabled the original concept to be redesigned for domestic, industrial and broadcast uses.

The development costs and the complexity of early videotape recorders

was so great that the obvious and only market was the broadcaster.

At over £50 000 each they were not expected to sell by the hundred. Their use as a simple record/playback device, however, soon became outmoded and their use as a production machine increased. Many thousands of broadcast VTR's are in use throughout the world and can be seen in almost every television network.

With the facility of instant playback, television producers wanted the flexibilities of film with editing, mixing and inlay techniques. Also high quality multigeneration dubs were required in colour. Alas, in the early days, even though the playback quality from Video-tape* recorders was good, at times imperceptible from the original, its stability was inadequate for monochrome mixing, never mind colour. Quality deteriorated rapidly with multigeneration dubbing. Physical editing was very tricky. Interchange between machines was also risky and it became quite common to send the record head assembly with the programme tape to ensure satisfactory playback. Some engineers likened the situation to Dr. Samuel Johnson's preaching woman. 'It is like a dog walking on its hind legs, it is not done well but you are surprised to find it done at all.'

Patents were held for several developments used in the first rotary head recorder. These obviously were not insuperable because RCA (USA), Rank-Cintel (UK) and Fernseh (W. Germany) soon developed machines to produce tapes of identical format. Rank-Cintel subsequently withdrew. Some credit must be given to bodies such as the SMPTE, EBU, CCIR and IEC for standardising tape format and general practice.

^{*} Ampex trade mark.

At about 1960 the development split along two paths to satisfy two require-

ments, broadcast and CCTV.

The broadcast machine was developed to achieve playback synchronism and improved stability. Editing was improved first by precision physical cutting of the tape and then by electronic editing. This was further improved by developing cueing arrangements with rehearse and cue shift facilities and editing to one-frame accuracy. Even animation proved no obstacle for development. The art has now reached the sophistication of fully automatic editing with unique digital frame address codes for each frame on the tape and automatic fast search and edit. A-B roll techniques are possible.

Time-base stability was also improved, electronically, to allow for multiple

generation of colour tapes.

The response of the system was increased to permit the high band standard with its improved signal performance, particularly for colour signals.

All this, coupled with automated controls to alleviate manual adjustment,

has led to an extremely complex system.

However impressive the broadcast development may seem, the closed circuit television requirement of a low cost machine giving reasonable quality was a formidable problem of equal magnitude. In the early 1960's this task was undertaken in Japan, USA and Holland.

The solution was common, helical scan, but the number of separate developments meant a whole host of differing techniques and tape formats. Standardisation was impossible. In the early 1970's the VCR cassette was developed, to be joined by the VHS and Beta formats at the end of the decade.

The object of the following chapters is to detail the theory on which the practice is based. In many instances the practical solutions to any one problem are manifold, as in the case of CCTV colour recorders. An attempt is made to explain them all with emphasis on those in common use.

References

1. POULSEN, v., The Telegraphone, *Electrician*, Nov. 30, 1900. POULSEN, v., Steel Tape as a Recording Medium, U.S. Pat. No. 661,619.

2. CARPENTER, G. W. and CARLSON, W. L., A.C. Biasing, U.S. Pat. No. 1,640,881.

3. PFLEUMER, F., Powdered Recording Media, German Pat. No. 500,900.

4. KATO AND TAKEI, Preparation of magnetic material by mixing metallic oxide powders, JIEE of Japan 1933.

5. VOLK, T., A.E.G. Magnetophone, AEG Mitteilungen, Sept. 1935.

 Rust, N. M., Marconi-Stille recording and reproducing equipment, Marconi Review, Jan-Feb. 1934.

7. HAMILTON, H. E., The Blattnerphone, Electrical Digest, Dec. 1935.

 OLSEN, H. F., A system for recording and reproducing television signals, RCA Review, March 1954.

9. AXON, P. E., The BBC VERA, EBU Review, Part A Technical 49, May 1959.

 GINSBURG, ANDERSON AND DOLBY, Video Tape Recorder Design, JSMPTE, Vol. 66, No. 4, April 1957.

 ANDERSON, DOLBY, ROIZEN, GINSBURG, BEHREM, Ampex Videotape Recorder, JSMPTE, Vol. 67, No. 11, Nov. 1958.

1 Tape Recording **Principles**

Some of the problems of video recording are an extension of those found in audio recording and the basic limitations of both techniques are very similar. Several publications deal with the basic principles and are to be recommended to the complete novice.1, 2

A summary of the fundamental processes involved would not only help the reader to understand the underlying principles of video recording but might also counteract the growing neglect of the audio performance of VTR's. It should be remembered that all video recorders have at least one audio track. Broadcast machines have between two and four, with provision for stereo on some.

Hysteresis

It is the phenomenon of hysteresis that makes tape recording or any magnetic memory device a possibility.

Figure 1.1 shows the relationship between the applied magnetic force, H(At/m), and the resultant flux density, B(wb/m²) in a magnetic material.

If no magnetic force is applied and the material is unmagnetised then:

H = 0 and B = 0 (point 1).

Increasing H causes B to increase in a non-linear manner. The reason for the non-linearity is rather complex and beyond the scope of this book. One explanation for it is the Weiss domain theory2 which, although not rigorous, does give a physical picture and produce quantitative results. An important factor is that the material saturates and any increase in H causes a minimal increase in B (point 2). If the applied force is now reduced, B does not follow

the increasing curve. When H is reduced to zero the value of B is reduced to some value greater than zero. This value of B is said to be the remanence, its dimensions being that of flux density, Webers/square metre.

This remanence can be made to fall to zero by application of a force H in a negative direction from 3 to 4. The value of H required to achieve this is said to be the coercivity and is a measure of the ability of the material to retain its magnetism. Its units are the same as those of H in ampere turns/metre.

A further increase of H in a negative direction causes the material to saturate in a negative direction (4 to 5) and a reduction of H forms a curve similar to that obtained in the upper quadrants (5 to 6 to 7).

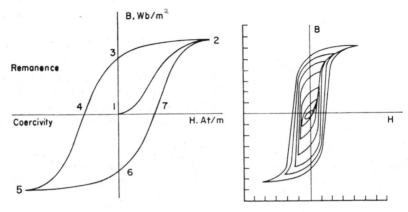

Fig. 1.1. Major hysteresis loop (left) and family of loops (right).

If the material is taken to saturation, the hysteresis loop is called a major loop and the values of remanence (sometimes called retentivity) and coercivity are the maxima obtainable and are those normally quoted by a tape manufacturer.

For different values of peak H we can obtain a family of hysteresis loops and a whole range of remanent flux densities.

These results can be transposed to form a new curve of remanent flux against applied force, Fig. 1.2. This curve is very non-linear at low and high values of H but exhibits a useful linear section between the two extremes.

A hysteresis loop is normally measured on a closed loop of that material. Its shape and dimensions give an indication of the usefulness in various applications. This can be seen if the characteristics of the tape oxide and the head material are compared as in Fig. 1.3. The desirable characteristic for the tape oxide is that it has high remanence for good signal to noise ratio and high coercivity so that the magnetic image is unaffected by stray fields. This means that a loop of large area is required. The head material should have a high $\frac{B}{H}$ ratio to provide a low reluctance path on playback. The material should also have a very low value of coercivity to reduce the possibility of the

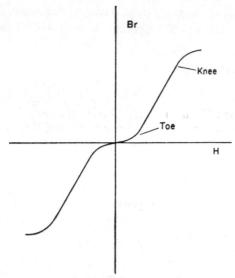

Fig. 1.2. Remanent flux against peak value of applied magnetic force.

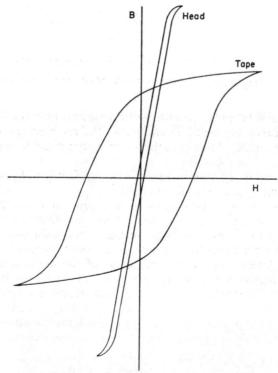

Fig. 1.3. Comparison of tape and head materials.

head becoming magnetised in a fixed direction. A small hysteresis loop area also indicates low loss which is desirable in a magnetic head.

Sheared hysteresis

It is possible to draw B-H characteristics for magnetic circuits. Figure 1.4 compares the loops obtained for two different circuits of similar material. From the curves it can be seen that the resultant remanent flux density is not

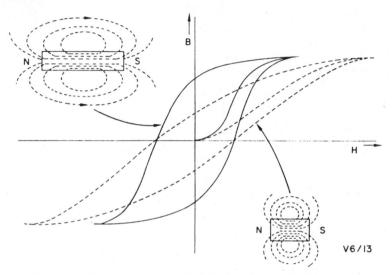

Fig. 1.4. Illustrating the sheared hysteresis loop caused by self-demagnetisation of a relatively short specimen.

only a function of the material and the applied magnetic force but also of the dimensions of the material. This is of importance in the resolution of magnetic tape. If the magnetic pattern on the tape is regarded as a series of bar magnets, then as can be seen from Fig. 1.4 the resultant magnetic flux density is higher for the longer specimen. This is due to the greater degree of self demagnetisation on the shorter magnet where the interaction between the poles is greater.

Typical values of coercivity and remanence for long wavelengths are as follows:

Coercivity

$$\begin{array}{ll} \gamma \; Fe_2O_3 & \rightarrow 20 \; - \; 40 \; \times \; 10^3 \; At/m \\ \text{(Magnetite)} \; Fe_2O_4 & \rightarrow 25 \; - \; 47 \; \times \; 10^3 \; At/m \\ \text{Nickel Cobalt} & \rightarrow 60 \; \times \; 10^3 \; At/m \\ C_nO_2 & \rightarrow 40 \; \times \; 10^3 \; At/m \\ \text{Head Alloys} & 0.5 \; \text{to } 80 \; At/m \end{array}$$

Maximum remanence (retentivity)

 $\begin{array}{ll} \gamma \; \text{Fe}_2\text{O}_3 & \longrightarrow 0.06 \; \text{to} \; 0.09 \; \text{wb/m}^2 \\ \text{Nickel Cobalt} & \longrightarrow 0.3 \; \text{to} \; 0.45 \; \text{wb/m}^2 \\ C_n\text{O}_2 & \longrightarrow 0.07 \; \text{to} \; 0.11 \; \text{wb/m}^2 \end{array}$

Audio recording

As can be seen in Fig. 1.5 the audio recorder consists of a tape transport which passes the tape across a series of heads which:

1. Erase any information existing on the tape.

2. Record new information in the form of magnetic patterns along the length of the tape.

3. By means of these magnetic patterns, induce an e.m.f. by causing a changing magnetic flux around a replay head.

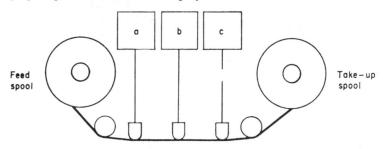

Fig. 1.5. Basic layout of an audio recorder: (a), erase. (b), record. (c), replay.

Sometimes, in cheaper equipment or where synchronisation is required, the same head is used for recording and subsequent playback. Record electronics are required to process the audio signal in a form suitable to cause linear magnetisation. Replay electronics are required to amplify very small level signal and compensate for losses in the process.

The three heads can be of similar construction but have some dimensional differences. Figure 1.6 shows a typical construction for audio heads. If a current is passed through the windings, a magnetic flux is produced proportional to this current. (Relative permeability, μr , being constant. See

Appendix 1.)

The front gap is normally shunted by the tape oxide and forms a low reluctance path for this flux. This in turn causes the oxide to take up a remanent magnetism which changes in flux density along the length of tape.

The rear gap is a consequence of the method of construction of the head. However for the record head it is spaced with a magnetically inert material such as copper, paper, silica or polymer resin and is used to stabilise the reluctance of the flux path. This will stabilise resultant flux density, for a given current, against changes in μr or changes in head dimensions due to wear.

For the replay head the front gap is made smaller and the rear gap shunted with magnetic material for higher efficiency.

For the erase head, the gap is made very much larger and consequently requires larger drive due to the increase in reluctance. To understand the reasons for this it is necessary to look at the basic functions in more detail.

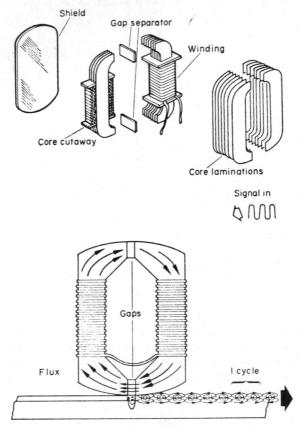

Fig. 1.6. The construction of an audio head.

Erase process

The object of erasure is to remove any remanent flux that may be on the tape. This could be done by applying a coercive force to oppose the flux. The difficulty arises in the fact that the force would have to be exactly that required to reduce B to zero.

An alternative approach is to apply a large saturating alternating flux which slowly reduces to zero. The effect can be seen in Fig. 1.7. If the rate at which alternating flux reduces allows the point to be erased to be subjected to several cycles of reducing flux, then as that point is taken around several reducing loops it subtends towards zero when the alternations reduce to zero.

The diminishing flux can be achieved with a standard head. Figure 1.10 shows the flux distribution across the pole pieces of a head. If a point on the

tape is pulled linearly across the head, it is subjected to, initially, an increasing flux taking the tape into saturation and then a decreasing flux reducing to zero. It is important that each point on tape is subjected to several cycles of reducing flux. This is achieved by increasing gap length and by using a high frequency erase current, 50 kHz – 100 kHz being typical.

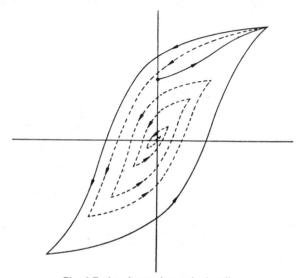

Fig. 1.7. An alternating reducing flux.

A more modern approach to erase head design can be seen in Fig. 1.8. The core is normally made of ferrite encapsulated in resin. This gives higher efficiency than metal alloys and the arrangement shown produces a smoother fall off in flux. A gaussian response is thought to be ideal.

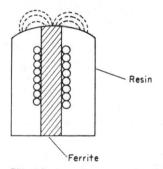

Fig. 1.8. A modern erase head.

Record process

Figure 1.9 shows the development of the magnetic record head. The simplest form is that shown in Fig. 1.9(a) where the tape is passed through a coil. The

tape is magnetised along its length according to the magnitude and direction of the current through the coil. For the instantaneous remanent flux to be proportional to the instantaneous current, the time taken for a point on tape to pass through the coil should be small compared with the periodic time of the signal frequency. At 15 i.p.s. tape speed and 15 kHz signal frequency, the coil would have to be somewhat less than 0.001 in long. Figure 1.9(b) shows the type of head used until 1950 in the Marconi-Stille steel tape recorder. Its main disadvantage is the difficulty in maintaining the tight tolerance required for the pole piece position.

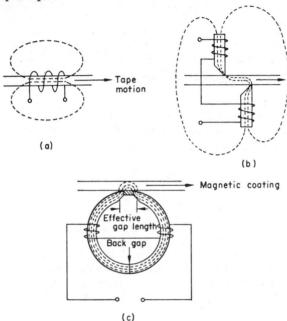

Fig. 1.9. The development of the record head.

The modern approach is that shown in Fig. 1.9(c). The face of the head is contoured to allow a smooth transition of the tape across the head. The tape is held in contact over the face either by use of pressure pads or by tensioning the tape across the head. The flux distribution across the pole pieces can be seen in Fig. 1.10. Some leakage flux occurs across the gap and through the non-ferromagnetic tape backing but most of the flux is through the oxide, the maximum flux density occurring between the pole pieces.

If the current and therefore flux, is changed sinusoidally, the remanent flux on tape varies in a similar manner. When the current is at a maximum the longitudinal flux density is also at a maximum. This can be seen in Fig. 1.11 where the resultant pattern on tape is shown diagramatically. When the current is positive, it causes a magnetic polarity from left to right from north to south. When the current reverses, the magnetic polarity also reverses. The net result can be regarded as a wavelength on tape from north to south

and back to north, or two bar magnets with like poles touching. This is somewhat over simplified and it must be remembered that Bx is changing sinusoidally.

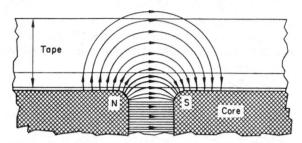

Fig. 1.10. The flux distribution across the pole tips of a conventional head.

The wavelength on tape is determined by the signal frequency and the tape speed. One wavelength is equal to the distance moved by the tape for the periodic time of the input signal.

$$\lambda = S \cdot \frac{1}{f} = \frac{S}{f}$$

 λ = wavelength in inches

S =tape speed in inches per second

f = signal frequency

The higher the frequency the shorter the wavelength. The lower the tape speed the shorter the wavelength.

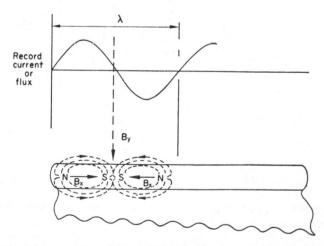

Fig. 1.11. Diagrammatic representation of resultant flux for sinusoidal current.

Replay process

Figure 1.12 gives a three dimensional picture of recorded pattern for a given wavelength. The three axes of flux density being Bx the longitudinal, Bz the lateral normally zero, and By the flux coming out of the tape. The useful

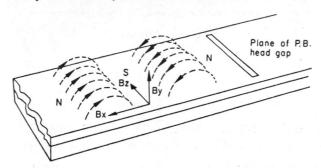

Fig. 1.12. A three-dimensional picture of magnetic pattern.

component is obviously By which is at a maximum when Bx is zero or By is

shifted by 90° to Bx.

If one considers various wavelengths recorded on tape all having the same record current as in Fig. 1.13 then ignoring all losses Bx is the same for all wavelengths. By (flux density determined by density of lines of flux) however increases as wavelength reduces, or

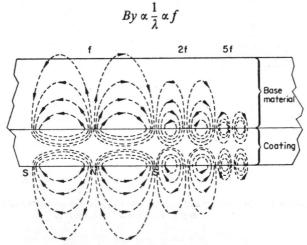

Fig. 1.13. Resultant pattern for various frequencies.

As the e.m.f. induced in the head windings is proportional to the rate of change of flux,

e.m.f. $\alpha By\alpha$ frequency

The mathematical calculations are:

During Record

$$i = I \sin \omega t$$
 2

The longitudinal remanent flux density

bxαi (For linear portion of transfer curve)

$$bx = K_1 I \sin \omega t$$

$$by\alpha \frac{dbx}{dt}$$

$$e\alpha by$$

$$\vdots$$

$$e = K_2 I \omega \cos \omega t$$
3

 K_2 depends on head efficiency, number of turns, tape material etc. Formula 4 shows that:

- 1. The output voltage is proportional to the record current.
- 2. The output voltage is proportional to the signal frequency.
- 3. The output voltage undergoes a 90° phase change as indicated by the change from a sine term to a cosine term.

If all frequencies are recorded with the same peak head current, on playback, ignoring all losses, the e.m.f. increases at 6dB/octave as shown in Fig. 1.14.

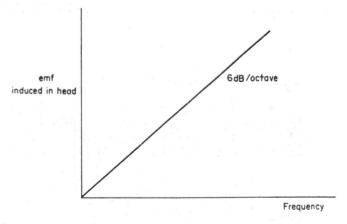

Fig. 1.14. A graph of head output against frequency ignoring all losses and assuming a constant record current for all frequencies.

Formula 4 may be written:
$$e = K_2 I \omega \cos \frac{2\pi x}{\lambda}$$
 5

where $\omega = 2\pi f, f = S/\lambda$ (from 1), $t = \frac{x}{S}$
 \therefore ft = $\frac{x}{\lambda}$ x = distance moved in time t .

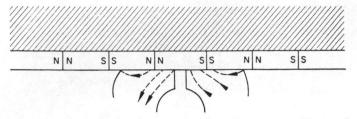

Fig. 1.15. Flux distribution, during playback, for medium frequencies

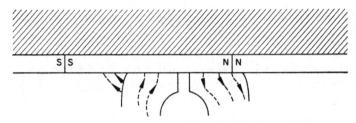

Fig. 1.16. Flux distribution for low frequencies.

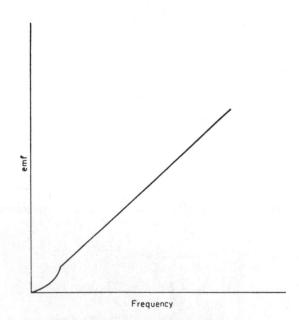

Fig. 1.17. Response modified by low frequency loss.

Low frequency losses

Figure 1.15 shows the flux distribution for the playback of medium frequencies. Medium frequencies can be defined as those that produce wavelengths greater than the gap length but smaller than the head face. The head can be regarded as providing a low reluctance path for the flux between the pole pieces and the head intercepts all the flux linkages between $\frac{1}{2}$ wavelength poles.

If the wavelength increases, as in Fig. 1.16, and becomes longer than the length of tape in contact with the head face, the head does not provide a low reluctance path for the total flux and an extra reluctance is introduced in the path of some of the flux.

High frequency losses

Increasing the frequency causes the wavelengths to become shorter. As the wavelength on tape becomes comparable to the gap length, a falling off of induced e.m.f. occurs. This can be seen in Fig. 1.18 where the gap length is equal to one wavelength. The resultant flux through the head is zero and as tape moves remains zero.

The frequency at which this occurs is called the 'extinction frequency' and depends on gap length and tape speed.

$$If \lambda = \frac{s}{f}$$

$$f = \frac{s}{\lambda}$$

$$fext = \frac{s}{\text{gap length}} \text{ where } \lambda = \text{gap length}$$

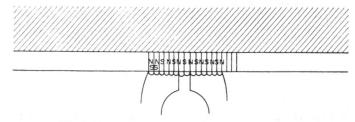

Fig. 1.18. Flux distribution where $\lambda = gap\ length$.

If the frequency is increased and wavelength reduces even further, output increases again. Except for special applications only the output below fext is used.

The response is similar to $y = \frac{\sin x}{x}$ function (Appendix 2) and is shown in Fig. 1.19(a). If this response is added to those obtained previously, a response as shown in Fig. 1.19(b) is the result. The frequency axis is normally logarithmic and a somewhat distorted view of the response may be obtained. Ignoring all other losses, the peak of the response is at $\frac{fext}{2}$, indicating equal pass band above and below the peak. The logarithmic scale tends to compress the upper response.

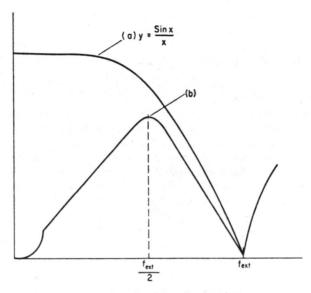

Fig. 1.19. Response modified by finite gap length.

Other losses

These are normally high frequency losses.

Spacing loss. The surface finish on tape is made as smooth as possible. However, it is not perfect and the tape tends to ride over the head on the peaks of the surface, causing an air gap between the tape and head. This high reluctance gap has a greater effect on shorter wavelengths than longer wavelengths, as can be seen in Fig. 1.20. The emergent flux spreads out farther from the surface for long wavelengths because the percentage increase in flux path is relatively small for long wavelengths as one moves out from the surface. For shorter wavelengths the same distance produces a proportionately higher percentage increase in the length of the flux path.

An empirical formula for the loss shown by R. L. Wallace4

Loss in
$$dB = \frac{55 d}{\lambda}$$

where d = distance from surface

 λ = wavelength on tape

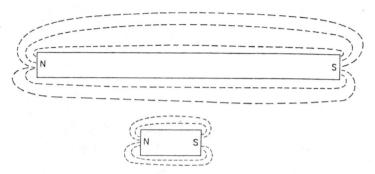

Fig. 1.20. Showing how emergent flux reduces more rapidly from the surface for short wavelengths.

Thickness loss. This follows from spacing loss. If one considers the oxide as being made up of discrete layers, the layer farthest away from the head has less effect at shorter wavelengths. At short wavelengths the surface of the tape produces most of the useful flux.

Demagnetisation. Demagnetisation can be caused by strong fields, temperature changes or physical vibrations. Shorter wavelengths tend to be affected to a greater extent owing to the self-demagnetisation effect previously mentioned. For this reason high coercivity tapes produce better high frequency response. All metal parts in the path of the tape should be degaussed at regular intervals to reduce this loss of high frequency components.

Eddy current. This is a similar problem to that experienced in transformer cores. Currents are induced in the core itself by the alternating flux. These can be minimised by forming the head in laminations insulated from each

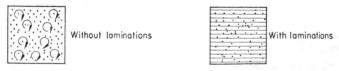

Fig. 1.21. Minimising losses in head due to eddy currents.

other, as shown in Fig. 1.21. Ferrite heads with high reluctance and low conductivity have negligible eddy current loss.

The relative effects of all these losses can be seen in Fig. 1.22.4 The absolute

33

values of each loss depends upon many factors but the order of magnitude is typical for γ ferric oxide tape and a magnetic alloy head assembly.

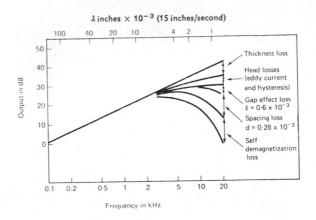

Fig. 1.22. HF losses in the tape process.

Head alignment losses

The head should be aligned to the tape correctly and losses should occur only when the head is mis-aligned. The five major positional adjustments are shown in Fig. 1.23.³

Tilt, tangent and contact. Misalignment of tilt, tangent and contact all affect the proper head to tape contact and accordingly upset the signal/noise ratio.

High frequency loss is also caused by the increased spacing loss. Dropouts—which are mainly caused by stray particles, creases or buckles lifting the tape away from the heads—also become worse. If gross mis-alignment occurs, a complete loss of signal may result.

Height. Mis-alignment of height causes mis-tracking and may result only in a loss of signal level, but if adjacent tracks are close or the adjustment too far out, cross-talk from neighbouring tracks could occur.

On videotape recorders all these adjustments of the audio heads tend to be more critical than on $\frac{1}{4}$ in audio recorders, owing to the wide tape and the several heads contacting it. The audio tracks are in general on the edges of the tape and the tape does not readily form itself around a head, particularly in the presence of buckles. If the contact of a head is too great on an audio recorder, the effect is minor but on a video recorder the deformation may affect the contact of other heads. Edge damage may also result, causing audio drop-out at a later date.

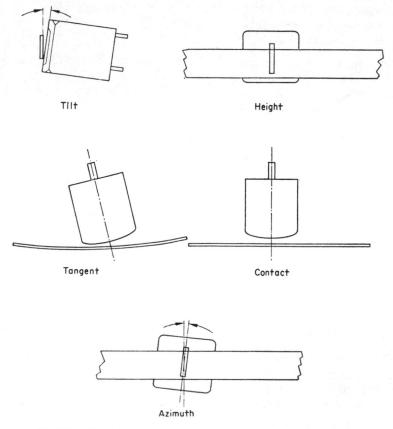

Fig. 1.23. The five major positional adjustments of an audio head.

Azimuth. The effect of azimuth can be seen in greater detail in Fig. 1.24. If a tape is recorded correctly,* but on playback the head is set at an angle θ then a phase difference occurs between the flux cut at the top of the gap and that at the bottom. θ is said to be the angle of 'azimuth' or 'static skew'. At long wavelengths the phase difference is slight and the loss negligible but as the wavelength falls the loss increases. The output would fall to zero when $\lambda = \alpha$.

At 7.5 inches per second with a $\frac{1}{4}$ in width track, an angle of 10 minutes would give an extinction frequency of approximately 10 kHz.

$$fext$$
 (due to azimuth) = $\frac{s}{z\theta}$ Appendix 3

* This is normally with the head gap at 90° to the longitudinal edge of the tape, although on some helical recorders this is not so.

z = track width

 θ = angle of azimuth in radians

s =tape speed (same units as z)

An accurate line up is required for both the record and playback heads if compatibility and interchange is required. This is normally done using an alignment tape, accurately recorded, and adjusting the azimuth for a maximum output at a nominal high frequency.

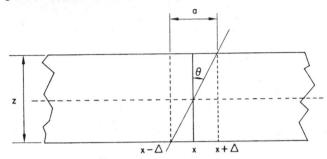

Fig. 1.24. The angle of azimuth.

Final response

The final response is shown in Fig. 1.25 and for an acceptable signal/noise ratio the system is limited to a dynamic range of about 50 dB.

This gives a bandwidth of about 10 octaves irrespective of tape speed. The upper frequency response is limited by the head to tape speed, gap width, tape resolution and tape finish.

A bandwidth from 25 Hz to 12.8 kHz is equal to 9 octaves.

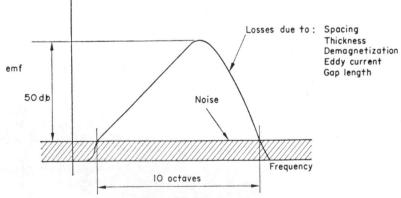

Fig. 1.25. Final response.

Distortion

It was shown that the curve of resultant remanence against applied magnetising force is very non linear, particularly at very low and high values. If a 36

sinusoidal current is the cause of the magnetising force, the resultant remanent flux density (bx) is far from sinusoidal, as can be seen in Fig. 1.26. On playback the e.m.f., which is proportional to the rate of change of flux, is rich in odd harmonics, predominantly third.

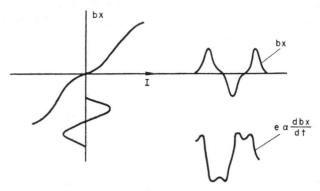

Fig. 1.26. Distortion without bias.

DC bias

If a d.c. current is added to the signal, as shown in Fig. 1.27, the signal can be shifted up on to the linear portion of the curve. This improves the linearity but has two main disadvantages:

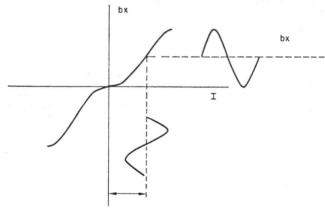

Fig. 1.27. Effect of adding d.c. bias to signal.

1. The full magnetic range of the tape characteristic is not being used; therefore the maximum signal/noise ratio cannot be realised.

2. Induction noise increases considerably. Any modulation of the surface contact causes a flux change in the head thus causing an unwanted e.m.f. The d.c. component always exists, therefore induction noise is always present.

AC bias

If a high frequency signal is added to the recorded signal during the record process, (see Fig. 1.28), it has the effect of lifting the record signal on to the linear portion of the curve. The high frequency is not amplitude modulated but consists of the simple addition of two signals.

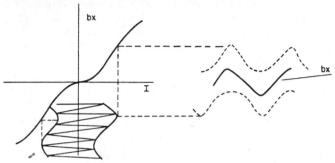

Fig. 1.28. Effect of adding a.c. bias to signal.

An element of tape crossing the gap is subjected to an h.f. signal whose average level depends on the audio signal. The effect is similar to erase except that the average level of the high frequency component is not zero but depends on the instantaneous level of the recording signal. The bias frequency is chosen to be at least three times higher than the highest record frequency to facilitate the averaging effect and to minimise any strange beat effects. It is normally the same frequency as the erase oscillator, 50–100 kHz.

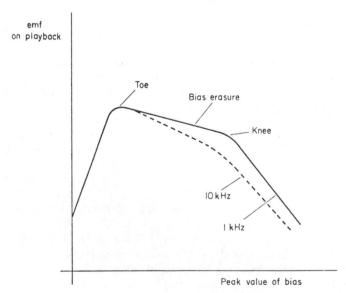

Fig. 1.29. Graph of output against amplitude of bias.

As can be seen in Fig. 1.28 non-linearity still affects the composite waveform but the average level of bias envelope, which determines the resultant

flux, is sinusoidal.

If a curve of output level of signal on playback were plotted against bias level used in record process, the result would be similar to Fig. 1.29. The output is determined by the toe and knee of the remanence curve and also by erasure caused by the bias itself. The greater the bias amplitude the greater the degree of erasure. Also, because of self demagnetisation, previously discussed, shorter wavelengths are erased to a greater degree.

If a curve of distortion against bias is also plotted, any increase in bias has

little effect once peak output is obtained.

The optimum setting for bias is about 1-2 dB over the peak; this gives the most stable results with oxide variations. Over-biasing tends to cause increased erasure of high frequencies and ultimately distortion due to the knee of the remanence curve. Under biasing tends to increase distortion.

Equalisation

Standards have been laid down by various bodies as to the record preemphasis and playback post de-emphasis for tape recorders to allow for the interchange of tapes between machines.

The important standards are:

NAB* National Association of Broadcasters

BSI British Standards Institute

CCIR Committee Consultative International Radio

IEC† International Engineering Committee

The technique is to specify high frequency boost response for record and high frequency cut response in playback. The amount required is difficult to determine but should be arranged to give the best signal/noise ratio and minimum overload distortion. It is the compromise between these factors and the desired spectrum for noise about which the various bodies disagree. CCIR, BSI, and IEC have recently agreed on a common standard for 15 i.p.s.

and 7½ i.p.s. but agree to differ on other speeds.

With reference to Fig. 1.25, the overall response without equalisation is quite complex and can be compensated for during playback or record In fact a combination of both is used. The increase in output proportional to rate of change of flux (6 dB/octave) is compensated for during playback. Tape noise, due to the random magnetisation of domains, has a flat spectrum (white noise) on tape. During playback noise e.m.f. increases at 6 dB/octave and by passing signal and noise through a circuit with a suitable response a flat spectrum for noise is obtained.

The losses due to thickness, spacing and demagnetisation etc. are compensated for before loss so that noise is not increased in obtaining a flat

response.

^{*} USA.

[†] International body of 40 countries including Europe and USA.

The record response and the playback response are *not* complementary. The combination of record equalisation, tape transfer response and playback equalisation should provide a flat response within the pass-band required.

In specifying a standard, either the record response can be defined from input to record flux or the playback response can be specified from induced e.m.f. to output. The latter is normally chosen because it is easier to measure and the record characteristic can be simply defined as that required to produce a tape which, when played back on a recorder with the specified response,

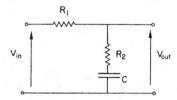

Fig. 1.30. Playback equalisation circuit.

produces an overall flat frequency response. Such a response can be produced by the simple circuit shown in Fig. 1.30 Normally R_1 is larger than R_2 . At very low frequencies X_c is large and

$$V_{\rm o} = V_{\rm in}$$

At very high frequencies X_0 is small and

$$V_{\rm o} = V_{\rm in} \, \frac{R_2}{R_1 + R_2}$$

More rigorously

$$|V_{\rm o}| = |V_{\rm in}| \frac{\sqrt{R_2^2 + X_{\rm o}^2}}{\sqrt{(R_1 + R_{\rm o})^2 + X_{\rm o}^2}}$$
 6

If
$$R_2 \ll R_1 < X_c$$

$$|V_{\rm o}| = |V_{\rm in}| \frac{X_{\rm c}}{\sqrt{(R_1 + R_2)^2 + X_{\rm c}^2}}$$

Output falls by 3 dB = $\frac{1}{\sqrt{2}}$ when

$$R_1 + R_2 = X_c = \frac{1}{2\pi fC}$$

$$\operatorname{or} f_1 = \frac{1}{2\pi C(R_1 + R_2)}$$

$$f_1 = \frac{1}{2\pi t_1}$$

where
$$t_1 = C(R_1 + R_2)$$

At frequencies above f_1 output will fall at approximately 6 dB/octave until X_c is comparable in reactance to R_2 . At very high frequencies $X_c = 0$ and

$$V_{\rm o} = \frac{V_{\rm in} \, R_2}{R_1 + R_2}$$

Output will be 3 dB up on this value at f_2 when $X_c = R_2$

From (6)

$$V_{o} = V_{in} \frac{\sqrt{2} R_{2}}{\sqrt{(R_{1} + R_{2})^{2} + X_{c}^{2}}}$$
If $R_{1} > X_{c} (R_{1} + R_{2})^{2} \gg X_{c}^{2}$

$$V_{o} = \frac{\sqrt{2} R_{2}}{R_{1} + R_{2}}$$

$$\therefore f_{2} = \frac{1}{2\pi C R_{2}}$$

$$f_{2} = \frac{1}{2\pi t_{2}}$$
9

where $t_2 = CR_2$

Also
$$\frac{t_2}{t_1} = \frac{R_2}{R_1 + R_2}$$

which equals the attenuation at high frequencies. The complete curve therefore can be specified by quoting two time constants. This specifies two turnover frequencies at the 3 dB points and the attenuation of high frequencies relative to low frequencies.

The table on page 42 compares the various international specifications in use.

Characteristics of recording tape

Magnetic tape with all its virtues is, and most probably will always be, one of the imponderables in audio and video recordings.

A recorder will almost certainly use more in value of tape than the capital cost of the equipment itself. Its quality is variable and faults are normally disastrous. When the requirements for tape are investigated it is surprising that it is possible to manufacture at all.

The tape backing, consisting of 0.001 in* thick Mylar or acetate, is coated with 0.0004 in† of a gamma ferric oxide suspended in a binder. Tapes using

† 0.0002 in coatings for extra long play.

^{*} 0.0005 in sometimes used for 'long play', 0.0015 in used for increased strength in special applications.

Speed i.p.s.	Standard	t ₂ µsec	t ₁ μsec
7	CCIR	35	∞
15 i.p.s.	IEC 94	35	00
1	BSI (1970)	35	∞
	NAB (I.E.C. U.S.A.)	50	3180
	CCIR	70	00
	IEC (GB)	70	
$7\frac{1}{2}$	BSI (1970)	70	∞
- 2	NAB (I.E.C. U.S.A.)	50	3180
	IEC (France)	50	∞
	CCIR	140	00
	BSI (1970)	90	3180
33	IEC (GB)	90	3180
34.3	IEC (EUR)	140	3180
	or	90	00
	CCIR	280	00
17	BSI (1970)	120	1590
17/8	IEC ₁ 94	120	00

 $t_1 = \infty$ signifies that $f_1 = 0$ Hz

both chromium dioxide and nickel cobalt coatings have recently been introduced. These give improved performance although video head life may be reduced.

The tape can be used in various widths depending upon applications.

- < 1/4 in domestic audio cassettes
 - 1/4 in professional or domestic audio
 - ½ in pro audio, industrial, educational and domestic video
 - 3/4 in industrial and news broadcast video
 - 1 in pro audio, broadcast, industrial or computer
 - 2 in pro audio or broadcast video

Base material. Several materials have been used as a backing material for the oxide. Cellophane, paper and PVC were used with varying success but have now been superseded by Mylar (Terylene), polyester and cellulose acetate. The ideal backing material should be:

- 1. Flexible
- 2. Inexpensive
- 3. Non-hygroscopic
- 4. Perfectly plane and flat surfaced
- 5. Non-inflammable
- 6. Resistant to fungus and mildew growth

It should also have

- 7. A tolerable temperature expansion*
- 8. A tolerable elastic elongation*
- 9. Good tensile and tear strength

The perfect backing does not exist but the two most suitable are acetate and Mylar with the following characteristics (based on 0.0015 in $\times 0.25$ in tape):

TABLE 2

	Acetate	Mylar or Polyester
Cost	Inexpensive	Expensive
Thickness uniformity	Excellent	Good
Tensile strength	5·6 lb	11 lb
Tear strength	4 grams	25 grams
Mildew resistance	Low	High
Coefficient of thermal expansion per 1°F change	30×10^{-6} in/in	15×10^{-6} in/in
Coefficient of humidity expansion per 1% change of R.H.	150×10^{-6} in/in	11×10^{-6} in/in

The worst properties of acetate are its low tear strength and its high coefficient of humidity expansion. These are just tolerable for audio but prove to be inadequate for video transports. For this reason Mylar type backing is used for videotape.

Oxide. The oxide that is used on most tapes is the acicular (needle-shaped) form of ferric oxide called the gamma form. It has a particle length of 0.2 to 0.8 microns (1 micron = 10^{-6} metres) and a width one-half to one-sixth of its length.

Binder. The binder has many functions which can be seen from its ingredients:

- 1. Adhesive—to bind the particles to the backing.
- 2. Plasticiser—to keep binder flexible.
- 3. Wetting agent—to keep the oxide particles separate.
- 4. Lubricant—to minimise head and transport friction.
- 5. Anti-fungicide.

The oxide and binder are mixed in a ball-rolling process for several days to ensure the even dispersion of the oxide particles. After several sample tests it is coated on the backing material in 26 in wide reels. Before drying, the particles are oriented along a preferred direction depending on its intended application, i.e. longitudinal for audio and transverse for 2 in video.

After drying, the surface is polished to ensure a good and consistent head-to-oxide contact when used. The tape is then checked for the following parameters:

^{*} It would be incorrect to state that these should be zero for VTR (see Chapter 8, Geometry errors).

Physical imperfections of backing material. Poor handling of the tape can cause creasing, stretching or buckling of the backing. The slitting process in particular is liable to cause edge damage.

Oxide and binder physical parameters. The oxide and binder consistency is critical. If it is too soft, oxide shedding can occur with the possibility of head clogging and oxide build-up on tape guides. If it is too hard, the tape may be abrasive, causing high head and guide wear.

Loose particles from the tape are also a major cause of drop-outs.

Consistency in width. The guiding of the tape is dependent on tight tolerances and the specification of a tape is typically nominal width +0, -0.004 in.

Ground noise. Random noise on virgin tape is caused by the slight magnetisation of oxide and their uneven dispersion. In practice ground noise is not absolutely random and does not quite produce a white noise spectrum. It is modified by the formation of agglomerates, surface finish and irregularity in coating depth.

Modulation noise. Noise in the presence of a signal is mainly due to surface imperfections causing amplitude modulation of the recorded signal. Mistracking caused by poor guiding due to deformed edges is a secondary source. Tape speed variations can also cause frequency modulation of the signal.

Output level variations. Long term variations are normally due to non-consistency of the oxide or changes in thickness. Variations are normally less than ± 0.5 dB.

Drop-outs. A drop-out can be defined as a drop in signal level in excess of a determined amount, say 35 dB. It can be caused by a surface imperfection, a stray particle of dust or oxide or a complete loss of oxide on the tape. A drop-out count is normally specified as a maximum number of drop-outs per minute modified by a weighting factor dependent on the drop-out length and the time interval between them.⁵

Because of the precarious nature of drop-outs the exact record and playback conditions are specified for measurement.

Sensitivity. The sensitivity of the tape is measured to ensure that it takes up a given remanence for a given applied field. This is important to avoid resetting of record signal and bias levels to maintain constant output, distortion and response.

References

- MCWILLIAMS, A. A., Tape Recording, Focal Press Ltd., SPRATT, H. G. M., Magnetic Tape Recording, Temple Press Ltd.
- 2. BROWN JR., W. F., Magnetostatic Principles in Ferromagnetism, North-Holland Co.
- 3. 3 M'S COMPANY, Sound Talk, Vol. II No. 3, 1969.
- WALLACE R. L., JR., The Reproduction of Magnetically Recorded Signals, Bell Systems Technical Journal, Pt. 2, 30, 1145 (1951).
- BBC RESEARCH DEPT. TECH. REPORT, No. E.L-6 1967/26. A meter for the assessment of drop-outs in video tape recording.

2 Basic Requirements of Videotape Recording

The recording of high frequencies requires high head to tape speeds and it is difficult to record a signal with a frequency range exceeding 10 octaves. The high head to tape speed, something normally in excess of 500 i.p.s. (12·7 m.p.s.), is achieved by moving the tape at a relatively slow speed, 5 i.p.s. to 15 i.p.s. (12·7 cm.p.s. to 38·1 cm.p.s.), and rotating the video record/playback head or heads, mounted on a wheel or drum at a high velocity to provide the necessary high head to tape speed. The action of the head is to scan the tape and the resultant track layout is called the record format. Formats in use are explained in detail in the following chapters but basically the tape can be held across its width and scanned transversely from edge to edge, as it is with the quadruplex format (Chapter 3) or it can be wrapped longitudinally around a drum in the form of a helix to produce an helical format (Chapter 4).

The problem of reducing the number of octaves can be solved by modulating a high frequency carrier and shifting the d.c. components up the band. If a video signal, with a bandwidth from d.c. to 5.0 MHz, modulates an 8 MHz carrier then, assuming a double side-band system, the modulated signal would have a bandwidth from 3 MHz to 13 MHz. This has a frequency span slightly greater than two octaves. Frequency modulation is nearly always used because of its tolerance to amplitude variations, which occur in tape recording.

Elements of a videotape recorder

The theory and practice of the individual elements of videotape recorders are covered later but it is worthwhile to obtain a picture of the general system shown in Fig. 2.1.

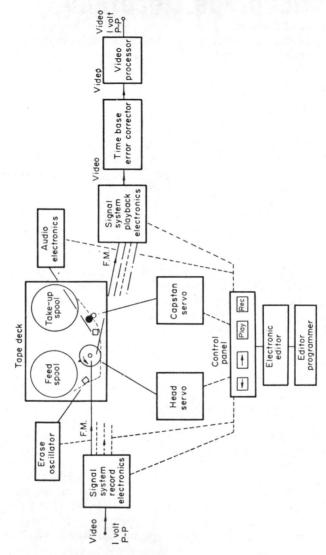

Fig. 2.1. Basic elements of a videotape recorder.

The tape deck. The configuration of the tape deck differs considerably between manufacturers and formats but the basic requirements are the same.

It must have a feed spool and take-up spool to contain the tape.

A capstan is required to control the longitudinal speed of the tape. This may have a pinch roller to provide traction or may simply depend on friction between itself and the tape.

A rotating head wheel or drum scanner with a separate motor drive is also required to provide the head speed. This assembly has some method of coupling the r.f. signal to and from the heads, either by using slip rings and carbon brushes or rotary transformers.

The audio heads are stationary and audio tracks are recorded longitudinally in the conventional manner with an audio erase head preceeding the record/playback head.

Erasure for the video tracks is achieved by a stationary head on transverse scan machines and helical machines not intended for editing. Broadcast and industrial helical machines have a flying erase head fixed to the rotating head drum in advance of the record head.

Head servo. The rotational speed and phase of the video head(s) are electronically controlled by means of a servo mechanism on the head motor. The playback timing stability is a function of the velocity stability of the head.

Capstan servo. The tape speed and phase is controlled by means of an electronic servo on the capstan motor, although on some cheaper helical recorders the servo is eliminated. During record the servo determines the video track spacing whilst during playback it ensures accurate alignment of the video head with a recorded track.

Signal system record electronics. The record electronics produces the frequency modulated r.f. signal, from the input video signal, at a level high enough to saturate the tape. Individual adjustment of the drive to each head is normally provided which is set to the onset of saturation. This adjustment, called 'optimization', is important to obtain the best signal noise ratio.

Signal system playback electronics. The playback electronics amplifies the very low level induced e.m.f., equalises for playback losses, switches between heads and finally demodulates the f.m. signal back to video. Playback equalisation is normally adjusted for a flat video frequency response. Some sophisticated systems also provide automatic equalisation on colour signals and compensate for tape drop-outs.

Time base error correction. The video on the output of the signal system has timing instability owing to the mechanics of the head scanning process. These can be removed by further electronics, either using switchable analogue delays to progressively reduce the errors or by converting the signal to digital form and adjusting the clock timing.

The colour correction is a further reduction to improve the stability for

colour signals.

Velocity error correction reduces the remaining error, after the above two processes. This error occurs during the line period if the rate of change of error is fast, i.e. it has a high velocity.

Video processing. This unit re-blanks and adds fresh synchronising pulses and colour bursts to the output video. It is only used in broadcast systems or in the more expensive CCTV installations.

Audio electronics. The audio electronics is similar to conventional audio recording with high frequency bias, pre-emphasis and de-emphasis. The audio quality is very often inferior to audio recorders of a similar standard owing to the proximity of stray fields, grain orientation being on the wrong axis, poor tape contact on edges of tape and reduced track width.

It is quite common to have more than one audio track.

Control panel. The control panel provides the normal control functions required by any recorder, fast spooling, forward or reverse, playback and record. The control logic needs interconnection to most of the elements described in order to switch individual circuits on or to switch their mode of operation.

Electronic editor. An electronic edit is a controlled switch from the playback of a previously recorded scene to the recording of a new scene. The edit should be synchronous so that a disturbance is not noticeable at the splice point. The editor logic therefore also needs interconnection to the individual elements via the normal controls.

Editor programmer. Once an electronic edit is made, some of the original scene is over recorded and destroyed, which can be disastrous if an error is made. An editor programmer enables edits to be rehearsed and edit points changed until the final result is achieved. The recorded edit can then be made as programmed.

Repeatable results can be achieved by recording cue tones or a digital address code on a separate audio track. Some modern helical machines use a code recorded during the vertical synchronising period. These signals are then used to switch the outputs of the editing machines during rehearsal and to initiate the record mode when the edit is made (see Chapter 14).

Care of tape

The limitation of any recorder is normally the tape itself and meticulous care of the tape pays dividends in the final playback quality. The following are the more important points in handling videotape:

1. Tape should be stored away from stray magnetic fields under moderate ambient conditions: 55–75°F (12–24°C) and 40–80% relative humidity.

2. If tape has been allowed to go outside these limits, i.e: during transport, it must be allowed to normalise to moderate conditions for at least 24 hours before use.

3. Tape should be rewound under constant tension to avoid uneven

wind and slippage. After rewinding, the tape pack should be examined for

windows or cinching.

4. All physical contact with the oxide side of the tape should be avoided and, unless absolutely necessary, the tape should not be removed from the transport in the middle of a reel.

5. Physical splicing of the tape should be avoided whenever possible.

6. A reel of video tape should be handled and lifted from the centre hub, not the flanges, and storage boxes should always have a hub support.

7. Videotape boxes should be stored upright.

- 8. The wrinkled and damaged end of any tape should be cut off. Rapid wear results from its contact with the head.
- 9. Drop-out is caused by stray particles of dust or oxide on the surface of the tape. Contamination should be avoided, wherever possible, by keeping the recorder and the surrounding area clean.

Tape checking

Tape is expensive and the careful checking and selection of tapes also results in improved playback performance. The procedure however is time consuming, tedious and also costly so that the economic factors must be weighed against the final improvement. Several electronic devices with a tabulated readout have been marketed to check tapes although in practice the most reliable way is to view a tape from end to end.

Careful logging by the operator of the performance of each tape is the most efficient way of checking tape condition. This is easily done by recording a test signal, such as colour bars, at the start of the recording. A test like this is also necessary for the alignment of the playback machine.

- 1. Average drop-out count with an indication of areas and severity of excessive bursts of drop-out.
 - 2. Noise.
 - 3. Banding due to noise or response changes.

4. Tendency to clog heads or shed oxide.

5. Audio quality, with particular emphasis on level variations and dropout caused by edge damage on the tape.

Care of the tape deck

Loose dirt on the videotape transport can eventually deposit itself on the tape surface and cause drop-out and increased head wear.

Fixed dirt, in particular tape oxide and binder, can cause tape scratch and

misguiding of the tape path.

Cleaning solvents marketed for use on videotape recorders fall into two categories.

- 1. Tape oxide binder solvents such as xylene or MEK (methyl ethyl ketone) and
- 2. Non binder solvents such as freon, alcohol, petrol and carbon tetrachloride.

Group 2 form the most widely used as they are relatively harmless and little damage can be done with careless use, although they are all toxic to some degree and should not be used in confined spaces. Their main disadvantage is that they are not very efficient at removing deposits of oxide, particularly in the corners of the guides.

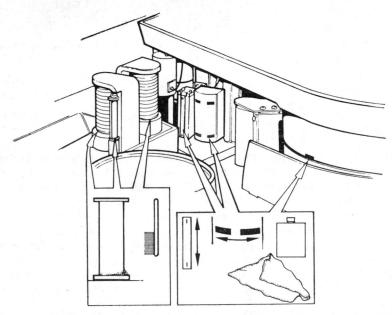

Fig. 2.2 Cleaning the recorder. A lint-free cloth should be used to apply solvent. An eyelash brush is useful for inaccessible corners.

Group 1 are better in this respect, although care must be used because these solvents *must not* come into contact with rubber, paintwork, plastic or Perspex. They must be used sparingly and allowed to evaporate before the tape is placed on the transport. The solvent removes oxide just as efficiently from the tape, causing deposits on guides and giving a high probability of a head clog.

A lint-free cloth provides the best general applicator for the solvent and all areas should be rubbed vigorously. A ladies eye lash brush is very useful for corners of guides and inaccessable niches. Cotton buds and conventional paper tissues should be avoided because they release fluff which can block

vacuum guides and add to the general debris.

A tape deck should be cleaned after every recording or playback and it should be remembered that it is much easier to clean a transport just after a tape has been used rather than twelve hours later after the oxide and binder have had time to harden.

Degaussing

If the tape passes over any magnetic metallic parts of the transport including the heads, partial erasure of the short wavelengths can occur. A deterioration in the signal/noise ratio can also result, owing to modulation noise. It is good practice to demagnetise the transport at least daily and strictly every time the machine is switched on because surges can leave components magnetised.

The procedure is simple. A hand held degausser, producing an a.c. field from the mains supply, is brought near any metallic part. The field strength can be slowly reduced by physically moving the device away causing a cyclic reduction to zero.

Tip projection

To ensure adequate contact with the oxide surface the video head is made to press into the tape which it deforms as it passes. The amount of penetration, about 0.002 in on quadruplex machines, is critical. Over penetration can cause rapid head wear and tape damage while under penetration would give a poor signal/noise ratio and increased drop-out.

Gauges are provided for checking particular machines, but in general adjustment is not possible and they are used to determine head wear.

Measurements should be taken over a period of time. Typically a head wear rate may be 5 micro inches per hour, therefore over 20 hours the head would wear 100 micro inches or 0.1 of a mil. If the maximum useful portion of a new head is 2 mil (from pole tip to the heel of the gap) then the expected life of that head, at the same rate of wear is 400 hours. The wear however may not be linear. If a lower projection is used, which may occur as the head wears, the rate of wear is less. It is a fact that a video head is at its peak performance during its last hours of life, owing to the leakage flux across the gap being at a minimum when the gap depth is zero.

On quadruplex machines the tip projection is fixed, although the tip penetration is adjustable by moving the tape vacuum guide. Because timing errors are caused by maladjustment of the guide (Chapter 9) the tip penetration

reduces with the life of the head

Care of the electronics

It is not good practice to make continual adjustments to the preset components of any electronic device. This causes unreliability as the component

progressively becomes worn.

It is better practice to monitor and check performace continually. When any parameter falls outside the tolerable limit, the required adjustment should be made. These adjustments are dealt with in the following chapters but at this point the principle operational adjustments affecting performance are discussed:

1. Input video gain

2. Record optimisation

3. Playback tracking

4. Playback frequency response

On all but the cheapest recorders these are operational adjustments and ones that even the least technically minded must be conversant with if he hopes to obtain the best performance.

Input video gain. Most recorders are calibrated to accept a 1 volt peak-peak video signal. If the video amplitude is too low, the modulator is not fully deviated and the playback signal/noise ratio is poor. If the video amplitude is too high, the modulator is over deviated and sidebands, which cannot be reproduced, are lost, resulting in a video playback signal suffering from line tearing with a tendency to break-up.

The input video gain is either set on a meter to 100% or an oscilloscope to

a set level.

Record optimisation. This adjustment sets the amplitude of the RF drive to a video head. If the RF amplitude is too low, the playback is noisy and if it is too high, self erasure occurs, particularly of the short wavelengths, giving noise in the high frequencies. As a video head wears, the RF drive required to saturate the tape becomes less and re-optimisation is continually required.

The basic technique is simple, although for broadcast colour the tech-

nique is refined and described later in Chapter 7.

A recording is made with the RF gain initially turned to zero and then increased in discrete steps. During the recording the RF level is monitored on an oscilloscope or on a meter if provided, and a commentary is recorded on the audio track indicating the RF level at each step. If the recording is now played back and the e.m.f. is monitored, for each increase in RF record drive, the playback e.m.f. should increase up to a point where no further increase is noted, followed by a slight decrease. The RF record level giving the onset of saturation is optimum and a new recording should be made with the RF level adjustment set to this value. This should be repeated for all heads and the playback checked for noise. This adjustment is easier on broadcast helical machines because an extra head mounted on the scanner enables simultaneous replay. The record drive can then be set by observing the off tape RF level directly.

Playback tracking. During playback the video head should be aligned exactly to the track it is scanning. Failure to do this results in the partial scanning of the guard band or eventually the scanning of two tracks with a beat pattern between the two signals. A tracking control is provided which should be adjusted for the maximum RF on playback, which is normally indicated on a meter.

This adjustment should be made at the start of every playback and checked

periodically throughout the reel.

Playback equalisation. The setting of the playback equaliser determines the high frequency response of the output signal and therefore effects the fine detail of the displayed signal. On NTSC and PAL colour signals it also

effects the saturation of the displayed colours. Equalisation should be set at the start of every playback tape because its setting depends on the type of tape used, the head condition and its penetration and the record optimise settings when the programme was recorded. It is convenient to record a leader lasting at least a minute with test signals suitable for making this adjustment. For monochrome recordings the most useful signal is the line multiburst consisting of four or more discrete bursts of frequency up to the maximum response of the recorder.

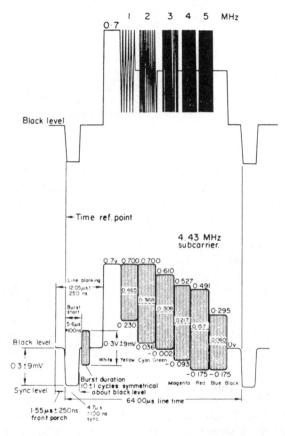

Fig. 2.3. (Top) The multiburst signal. (Bottom): 75% amplitude 100% saturated colour bars (EBU). Note: on 525/60 Hz standard, the line time is $63.5~\mu s$ and the colour subcarrier is 3.58~MHz.

The setting of the equalisers also effects the signal noise ratio and a recording of black level provides a useful signal to assess the amount of noise in the picture, particularly for the quadruplex format where noise banding can occur. For monochrome playback a compromise is sometimes reached

between the setting which gives the best response and that which produces the minimum noise.

For colour signals it is better to assess playback response on a recorded video signal of colour bars. This is particularly useful if a large area of one colour is also displayed to highlight banding between heads and beat moiré components produced in the FM system.

The adjustments described are normally operational ones, except on the very cheapest of machines where they are at least pre-set under cover. It is important that they are familiar to even the casual operator if the best is

desired from a recorder.

3 The Broadcast Quadruplex Format

The first format, or record track layout, used for broadcast video tape recording was the quadruplex (fourheaded) format, Quad 1. Although still in common use it is being replaced by helical formats using single or doubleheaded machines. Standards have been adapted for the various line standards in use, specifications tightened up here and there and recommendations for the particular use of tracks altered, but basically the format is the same. This standardisation has been the result of considerable effort throughout the world and has enabled the world wide interchange of tapes (see Appendix 20, Standards).

The broadcast concept is to mount 4 record/playback heads at 90° with respect to each other on a head wheel which has a nominal diameter of 2.06405 in, see Fig. 3.1. This wheel is rotated at 250 r.p.s. (5 × field frequency)

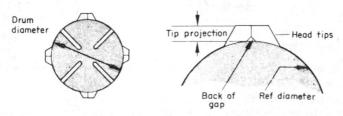

Fig. 3.1. The quadruplex head wheel.

on $625/50~\mathrm{Hz}$ standards or 240 r.p.s. (4 × field frequency) on $525/60~\mathrm{Hz}$ standards.

$$S = \pi DN$$

where D = Nominal diameter

N =Rotational speed

S = peripheral speed

On 625/50 Hz systems

$$S = \pi \times 2.06405 \times 250 = 1620 \text{ i.p.s.*}$$

On 525/60 Hz systems

$$S = \pi \times 2.06405 \times 240 = 1556 \text{ i.p.s.*}$$

Two-inch wide tape is held across its width, by means of a vacuum, in a guide to form it into an arc of nominal radius 1.03315 in (see Fig. 3.2). During

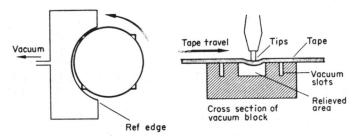

Fig. 3.2. The vacuum guide.

record or playback the guide presents the tape to the rotating heads causing the heads to penetrate up to 0.003 in into the tape as it scans the tape from edge to edge. The tape is also pulled longitudinally past the heads by means of a capstan. Its nominal speed is 15.625† i.p.s. on 625/50 Hz standards or 15.0 i.p.s on 525/60 Hz standards.

The net result can be seen in Fig. 3.3 where a series of transverse tracks, at almost 90° to the tape edge are formed.

Track width and spacing

The track width (K) is simply determined by the video head width and with a nominal width of 0.010 in a 10-mil wide track is produced.

The centre-centre track spacing (L) is a function of the longitudinal tape speed and the head rotational speed. Both of these differ between line standards but this does not produce a different track spacing dimension between standards.

* These speeds can vary by 0.1% with head wear.

† There is also a half-speed standard of about 7.5 i.p.s. although it is seldom used.

L

A new track is formed for each 90° rotation of the head wheel. The centrecentre track spacing is determined by the distance moved by the tape for 90° rotation of the head:

On 625/50 Hz

$$360^{\circ}$$
 rotation takes $\frac{1}{250}$ sec = 4 msec

90° rotation takes 1 msec

The longitudinal speed = 15.625 i.p.s.

Dimension $L = 15.625 \times 10^{-3} = 15.625$ mil

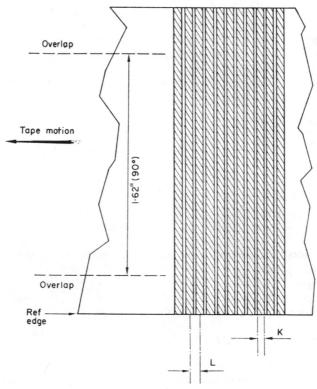

Fig. 3.3. The video tracks.

On 525/60 Hz

$$360^{\circ}$$
 rotation takes $\frac{1}{240} = 4.167$ msec

90° rotation takes
$$\frac{1}{960} = 1.04167$$
 msec

The longitudinal speed = 15 i.p.s.

Dimension
$$L = \frac{15}{960} = 15.625 \text{ mil}$$

This similarity is not surprising when the mechanism of pulling the tape is understood. The rotation of the capstan, the device that pulls the tape, has a locked relationship with the rotation of the head wheel. This means that for every revolution of the head the tape moves the same amount irrespective of the head speed.

Overlap

During record, the frequency-modulated video is coupled, via slip-rings or rotary transformers, to all four heads simultaneously. The two-inch wide tape forms an arc well in excess of 90° wrap around the wheel. This means that at certain positions of the head wheel two heads are in contact and are recording the same information on the tape. Some of this overlap is erased to accommodate three longitudinal tracks giving the tape the format shown in Fig. 3.4.6 It is important that video tracks representing at least 90° head rotation are left on the tape.

The track length representing 90° is:

$$\frac{\pi D}{4} = 1.62 \text{ in}$$

It is practice to allow an excess of this to permit the occasional use of a scan greater than 90° on subsequent playback. During playback a switch is made from a head leaving the bottom of the tape to a head starting at the top of the tape. A switching transient during the picture period can be avoided by delaying the switching action until the line blanking period. For this reason the length of the video tracks is nominally 1.82 in (46.1 mm). From Fig. 3.4, length of video track = G - E.

The purpose of longitudinal tracks

Main audio. This track is placed at the top of the tape and is used

to record the main programme audio.

The audio record/playback head is placed downstream from the video heads by 9.25 in (235 mm). This means that the audio is physically in advance of the video and this distance, which represents about 0.6 sec, creates some problems when physically editing.

A typical specification for the track is:

Frequency response 50 Hz to 15 kHz ± 2 dB

Signal: noise ratio = 55 dB w.r.t. 3% harmonic distortion point.

Cue. This is a second audio track of narrow width and inferior quality which can be used for commentary, production information or second language sound. It is placed just below the video tracks and the head is positioned in

vertical alignment with the audio head, 9.25 in downstream. The track can also be used for cue marks in the form of 1 kHz and 4 kHz bursts of tone for initiating electronic edit functions or remote start of external operations.

Its third use is to record an 80 bit per frame digital address code; 28 bits are used to detail the frame address in the hour, minute, second and frame

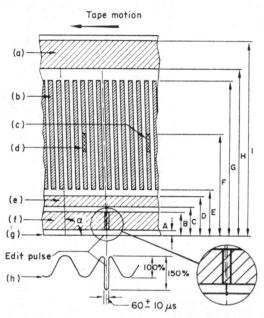

Fig. 3.4. The record track. Format for quadruplex from C.C.I.R. recommendation 469. The dimensions are as shown in Table 3. (a), Audio track. (b), video tracks. (c), start of field synchronising signal, 625 lines—50 fields. (d), start of field synchronising signal, 525 lines—60 fields. (e), cue track. (f), control track. (g), reference edge of tape. (h), wave form of the record current in the control track head.

Notes: 1. The magnetic coating of the tape faces the observer.

2. Audio and cue records lead corresponding video record by 235 mm ± 2.5 mm.

3. Periodic time of control track signal:

525/60 Hz-4-167 ms

625/50 Hz-4 ms

4. Position of edit pulse is indicated for 625/50 Hz standard for position on 525/60 Hz (see Appendix 5).

of the twenty four hour day: 32 spare bits can be used for production idents and the remaining bits are used for synchronising information.

The facility of having unique frame addresses for every frame on the tape enables automatic search, cue, synchronisation and edit functions. A typical analogue specification for the track is:

Frequency response 60 Hz to 8 kHz \pm 3 dB.

Signal/noise ratio 45 dB w.r.t. 5% harmonic distortion point.

Table 3

Dimensions	Millimetres	Inches
A	0.00 min.	0·000 min.
	0·10 max.	0.004 max.
B	1.02 min.	0.040 min.
	1.24 max.	0.049 max.
C	1.47 min.	0.058 min.
	1.57 max.	0.062 max.
D	1.98 min.	0.078 min.
	2·16 max.	0.085 max.
E	2·21 min.	0.087 min.
	2·39 max.	0.094 max.
F	29.2 ± 1.3	1.15 ± 0.05
G	48·31 min.	1.902 min.
	48.62 max.	1.914 max.
H	48·79 min.	1.921 min.
	49.02 max.	1.930 max.
I	50·50 min.	1.988 min.
	50.70 max.	1.996 max.
K	0.240 min.	0.0095 min.
	0.265 max.	0.0105 max.

Control track. The control track is required as a synchronising signal by the VTR itself. During the record process a 250 Hz sine wave (240 Hz on 525/60 Hz systems) is recorded longitudinally on this track, one periodic cycle representing four video tracks. On playback the control track signal is used to control the tape position and ensure that the video heads re-scan the existing tracks exactly. Its full use is discussed in the section dealing with the capstan servo. The phasing of the video tracks relative to the control track is critical and the control track record/playback head is therefore placed as close to the video heads as possible to minimise the effect of longitudinal tape stretch.

A frame or edit pulse is added to the control track sine-wave signal, the purpose of which is twofold:

1. It acts as a reference mark indicating a position from which the video tracks containing the vertical blanking can be found. The frequency of this pulse depends on the standard:

Line standard	Frequency standard	Frequency of frame pulse
525/60 Hz	Low band and high band	30 Hz
625/50 Hz	Low band	25 Hz
625/50 Hz	High band	$12\frac{1}{2}$ Hz

The reason for the difference between 625 low band and high band is that the high band standard is normally used for PAL or SECAM colour signals which both have a four field sequence and a pulse identifying one field in four is required.

Figure 3.4, Note 4, shows that the pulse is in different positions, with respect to the track with the vertical sync, on the European standard and the USA standard. The reason for this is that the control track head cannot be placed directly underneath the video heads. On the USA standard it is placed almost three fields downstream. Because of the different field time this does not correspond to an integral number of fields on the European standard. Its exact position is as calculated in Appendix 5.

2. It phases up the VTR signal on playback. The control track pulse is used as a reference of the tape position and the capstan speed adjusted

accordingly.

Position of field sync

The field synchronising period of the recorded video is positioned in the centre of a given track. This central position is chosen to avoid any switching transient occurring during the field sync period. This would be difficult to remove. Its position is also defined to within close limits to enable physical splices to be made between separate recordings. It is thought that the tolerances indicated are a little wide in this respect. The tolerance allowed depends on the required stability over the splice.

If a stability to within 5 μ sec is required, each recording must be held to

within $2.5 \mu sec$ therefore:

2.5
$$\mu$$
secs at 1620 i.p.s displacement (ΔI) 1620 \times 2.5 \times 10⁻⁶ = 0.004 in (0.1 mm)

This does not allow for physical errors when joining the splice.

The exact mechanism for aligning the vertical sync on a track is shown in Appendix 4.

Format data²

General transverse tracks

Tape width = 2 inArc of contact $= \frac{2}{1 \cdot 03315}$ radian $= 111^{\circ}$ Overlap $= 111^{\circ} - 90^{\circ}$ $= 21^{\circ}$ Track spacing $= 15 \cdot 625 \times 10^{-3}$ in $= 0 \cdot 397$ mm

Tracks per longitudinal inch = 64

25.2

General longitudinal

Tracks per longitudinal cm

Programme audio
Erased track width
Recorded track width
Guard band $90 \times 10^{-3} \text{ in}
70 \times 10^{-3} \text{ in}
20 \times 10^{-3} \text{ in}$

Cue Audio	
Erased track width	40×10^{-3} in
Recorded track width	20×10^{-3} in
Guard band	10×10^{-3} in
Control track width	50×10^{-3} in
Total width of longitudinal tracks =	$180 \times 10^{-3} \text{ in}$
625/50 Hz Transverse	
Angular velocity = $360^{\circ} \times 250$	= 90° per msec
Angle per T.V. line = $90^{\circ} \times 64 \times 10^{-3}$	$= 5.76^{\circ}$
TV lines per 90°	= 15.625
15.605 103	— 13 023
TV lines per lateral inch = $\frac{15.023 \times 10^{9}}{1620}$	= 9.7
TV lines per lateral cm	= 3.8
Tracks per field	= 20
Tracks per second	= 1000
525/60 H- T-	
525/60 Hz Transverse	
Angular velocity = $360^{\circ} \times 240$	$= 86.4^{\circ}$ per msec
Angle per TV line = $864 \times 63.5 \times 10^{-3}$	$= 5.49^{\circ}$
TV lines per 90°	= 16.4

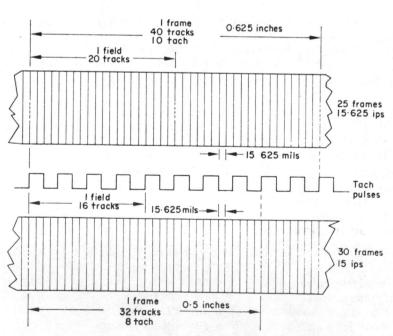

Fig. 3.5. Comparison of 25 and 30 frame rate television standards.

TV lines man lateral inch	15.75×10^3	10.1
TV lines per lateral inch =	1556	= 10.1
TV lines per lateral cm		= 3.98
Tracks per field		= 16
Tracks per second		= 960

Fig. 3.5 compares the track spacing for both standards. One cycle of tach is produced for every revolution of the head.

Deck layout

The transport of two-inch wide tape past the various head assemblies requires an accurate, though simple, deck layout as can be seen in Fig. 3.6. The technique is very similar to that used on audio recorders where the longitudinal tape traction is provided by a capstan rotating at a constant speed. A pinch roller is used to hold the tape against the capstan spindle during play or record.

The supply spool provides a slight holdback torque to tension the tape as it is pulled past the erase head assembly (A). This head erases only the portion of the tape assigned for the video and control track areas with the provision for the control track section to be separately inhibited during some electronic edit functions. By not erasing the full width of the tape, video-only recordings can be made over existing audio or cue material. The tape is next formed into a canoe by the vacuum guide around the rotating video head wheel (C). On the bottom edge of the tape, just after the video heads, is the control track head. There is no erasure between the video heads and the control track head. For this reason and because bias is not used, the playback signal is distorted with a large amount of interference. The 250/240 Hz fundamental component is selectively filtered on playback.

The next head assembly provides the erasure of the audio and cue tracks followed by the record/playback heads, sometimes followed by a monitoring head. After the capstan the tape is passed around a linear measuring device calibrated in time.

The compliance arms after the supply spool and before the take-up spool operate brakes to act as buffers on the high inertia tape spools and prevent any rapid accelerations and tape snatch which might cause tape damage.

Vacuum chambers

Another modern approach⁵ in tape transport design is to isolate the two reels even further by means of two vacuum chambers as shown in Fig. 3.7.

The pinch roller can be eliminated and the contact force against the capstan provided by vacuum suction holes around the capstan roller. With the reduction in inertia, extremely fast lock-up times can be achieved without the danger of tape stretch because it is possible to accelerate the tape rapidly for short periods by using up the reservoir of tape stored in the chambers.

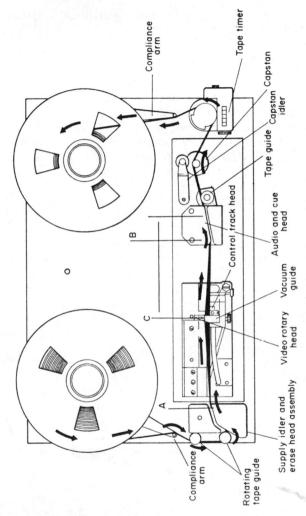

Fig. 3.6. The deck layout.

In the chapter on geometry errors the importance of tape tension is discussed and with the reels completely isolated it is easier to keep this tension constant as the reel diameters change.

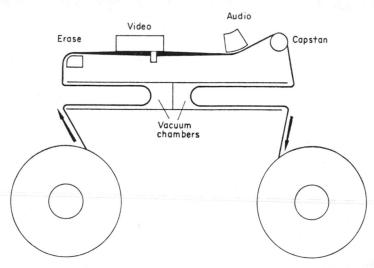

Fig. 3.7. Deck layout with vacuum chambers.

The control of the reel motors is more complex because each spool motor must be activated to keep the quantity of tape in the chambers to within the required limits. This can normally be done by monitoring the maximum and minimum limits of the tape with a light and PEC sensor which is blocked by the tape. The reel motor can be activated in either direction to add or remove tape and keep it within the limits.

Super high band and pilot tone

The existing quadruplex standard has a number of deficiencies which became more apparent as multigeneration use increased. These included edge of track banding, moiré and timing errors. In an effort to overcome these problems a new standard was proposed using higher modulation frequencies and a pilot tone. It was found possible to reduce the video track width by half without loss of picture quality, which implied a considerable saving of tape.

The higher modulation frequencies, centred on 11·35 MHz for 625/50 Hz and 9·9 MHz for 525/60 Hz, were chosen to reduce the moiré and to accommodate the pilot tone.

The pilot tone, at one and a half times subcarrier, is used to effect continuous timing and chrominance correction. The reduction in head banding and the subjective 'quietness' of the pictures makes the video tape recorder an essentially transparent device.

The tape format is identical to the existing quadruplex standard except for the reduction in track width and spacing and tape speed. This makes it possible for a single machine to be used on either standard by simply changing the heads. Tapes currently in libraries could then be used without the need to transfer them to a new standard.

Format data

Video modulation frequencies

	EBU	SMPTE
Sync tips	9 MHz	9.58 MHz
Blanking	9.9 MHz	9.9 MHz
Peak white	12 MHz	10.7 MHz
Pilot tone	6.65 MHz	5.37 MHz
Track width	7 mils	7 mils

All other features to match quad 1.

References

- 1. ROIZEN, J., Television tape techniques today, Broadcast Engineering, Nov. 63 April 64.
- 2. BBC, Technical Instruction V. 6, Video-tape Recording, BBC Engineering Division.
 3. GINSBURG, C. P., ANDERSON, C. E., DOLBY, R. M., Video tape Recorder Design, SMPTE,
- Vol. 66, April 1957. 4. EBU, EBU Standards for television tape recordings, EBU Tech 3084-E, April 1967.
- WHITEHEAD, S., Design consideration of tape transports for quadruplex Videotape Recorders, Ampex Corp., Redwood City, California.
- 6. CCIR, Standards for the international exchange of television programmes on magnetic tape. CCIR Recommendation 469.

4 The Broadcast Helical Formats

The quadruplex format (see Chapter 3) was the standard broadcast system for twenty years before rising capital and running costs made manufacturers look for cheaper methods. This took the form of increasing the packing density of the recording to reduce the tape consumption. Attempts were made to achieve this by reducing the width and longitudinal speed of the existing system. This offered two advantages in that a dual standard machine could be made enabling the expensive libraries already compiled to be retained for use and that much of the necessary technology was understood. In the event all but one manufacturer offered machines using one-inch wide tape with much longer video tracks almost parallel to the tape edge. The tape was wrapped in a half or a complete turn around the head drum in the form of a helix, hence the term 'helical scan'.

One of the advantages of the standardisation of the quadruplex system, apart from library usage, was the possibility of an international interchange of programmes. It was apparent that this would be lost unless a similar standard was set for the new systems and in 1977 the American SMPTE and the European Broadcasting Union, EBU, both began to consider the possible formats. The two systems which have been accepted and are now being used by broadcasters are described below.

Segmented B-format

Because the tape is only in contact with the head drum, scanner, for half its circumference, a single head could only record part of the waveform. There are therefore two record/replay heads mounted at 180° in relation to each other on a scanner which has a nominal diameter of $50 \cdot 33 \text{ mm}$ ($1 \cdot 9815$

in), see Fig. 4.1. The scanner rotates at 150 r.p.m. which gives six successive video tracks on 625/50 Hz systems and five on 525/60 Hz systems. The peripheral speed, which in effect, is the head to tape speed, is given by:

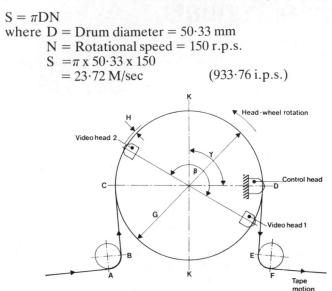

Fig. 4.1. B format head drum.

The one-inch wide tape is held in position by two guide posts, one each at entrance and exit point, which form a helix at an angle of $14\cdot434^{\circ}$. The tape's longitudinal movement at $24\cdot3$ cm/sec causes the video tracks to be laid at an angle of $14\cdot289^{\circ}$ (see Appendix 6). The heads project from the scanner by $0\cdot06$ mm $(0\cdot0025$ in) and penetrate the tape which is held at a tension of $0\cdot2$ N at the input and $0\cdot230$ N at the output guide.

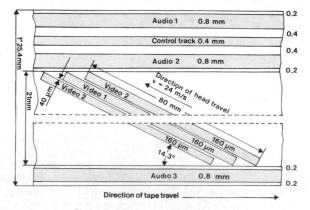

Fig. 4.2. B format tape layout.

There are three audio tracks each 0.8 mm (0.031 in) wide in addition to the control track which is 0.4 mm (0.016 in) wide. The video tracks which are approximately 80 mm (3.150 in) long are 160 μ m wide with a guard band of 40 μ m between them. The net result can be seen in Fig. 4.2.

Track width and spacing

The video track width is governed by the head width and the spacing by the longitudinal tape speed and the scanner rotational speed. These are chosen to line up the synchronising pulses on successive tracks.

360° rotation takes 1/150 sec 180° rotation takes 1/300 sec

The longitudinal speed = 24.3 cm/secTape movement per video track = $\frac{1}{300} \times 24.3 \text{ cm}$ = 0.81 mm

The track angle is 14.434° so the track pitch is $0.81 \times \sin 14.434^{\circ}$ = 0.2 mm (.0079 in)

Overlap

The tape is wrapped 190° around the scanner which means that for a time both heads are in contact with the tape and so record the same information. This enables the switch between heads during replay to be adjusted to occur during line blanking, so avoiding a picture disturbance. The recorded video track length is therefore longer than the active track length.

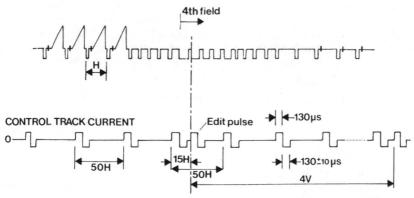

Fig. 4.3. B format control track waveform.

Longitudinal tracks

There are four longitudinal tracks, three audio and one control track. All the audio channels have the same specification, are recorded using a.c. bias and positioned so that they lead the video by 23·25 cm. Channels 1 and 2

can be used in parallel, for stereo or for dual language recordings. If only one channel is used the main programme sound will be on channel 1, which will be used for the left hand channel in stereo applications. When time code is used it will be recorded on channel 3 which is otherwise undedicated.

The control track waveform is shown in Fig. 4.3. The field synchronising signal is recorded five lines ahead of the head switch point at the end of the video track.

Format Data

Video tracks

Track length = 80 mm 52 television lines Track angle = 14.434° Arc of contact = 180° Overlap = 10° Track pitch = 0.2 mmTrack width = $160 \mu \text{m}$ Scanner rotation = Anticlockwise opposing tape motion

Video modulation

The video is recorded as a frequency modulated signal. It is passed through a pre-emphasis network before being applied to a linear modulator. The frequencies are:

Sync tip 6.76 MHz Blanking 7.40 MHz Peak white 8.90 MHz

Audio tracks

Track width = 0.8 mmFrequency response (typical) 80 Hz to 15 kHz \pm ldB Playback equalisation 15 μ S

Operational facilities

The main features of the B-format are the result of the small diameter low mass scanner and the use of two video heads. This enables rapid lock up from rest to play, typically two seconds, and a high degree of immunity to mechanical shock, especially important to a portable machine. The two heads enable the whole of the video signal to be recorded. The half circumference wrap lessens the tension difference between the input and output guides. The short video tracks are less prone to straightness variations and interchange compatibility is eased. It is reasonably simple to provide a self-lacing or cassette machine.

The main operational disadvantages are the need to provide a separate frame store for still frame and the violent tape movements in slow motion.

These are necessary in order to read into the store all the segments of each new field which must be done more rapidly as the tape speed approaches normal play.

Because the recording is segmented there are banding problems although these are much reduced by the lower head to tape approach angle and impact shock. The small size of the scanner makes it difficult to provide monitoring replay heads.

Editing

The audio editing system is no different from normal video tape practice.

Because the video tracks are at such a shallow angle it is impossible to cut and join the tape mechanically. If a join is made perpendicularly to the tape edge the replay will show a vertical wipe between the old and new material (see Chapter 14). To overcome this it is necessary to mount erase heads on the scanner so that they can erase the video track just in front of the record head. It is possible to use a single double width flying crase head since on both the 625/50 Hz and 525/60 Hz formats the start of each frame of two fields is recorded by the same head. This means only one extra head is required.

Non segmented C-format

The tape is in contact with almost the whole of the circumference of the scanner. There is a single record/play head mounted on the rotating upper half of the scanner which has a nominal diameter of 134·620 mm (5·30 in) (see Fig. 4.4). The drum rotates at field rate and so each field of the video is recorded on a single track, arranged so that the start of the field is recorded at the beginning of the track. The points at which the head loses and gains contact with the tape are about 14° apart and cause a loss of signal, vertical interval gap, for a period of 12 lines on the EBU 625/50 Hz and 10 lines on the SMPTE 525/60 Hz. These missing lines can either be replaced by the time base corrector or recorded by an extra head spaced at an angle of 30° ahead of the main head. This sync head records 18·75 lines on EBU and 15·75 lines on SMPTE and the overlap in the recordings allows for variations in the gap size resulting from tape tension changes and, more importantly, slow motion and still frame.

The peripheral speed is:

$$S = \pi DN$$
EBU = $\pi \times 134.62 \times 50$
= 21.146 m/sec (832.56 i.p.s.)

SMPTE = $\pi \times 134.62 \times 60$
= 25.375 m/sec (999.06 i.p.s.)

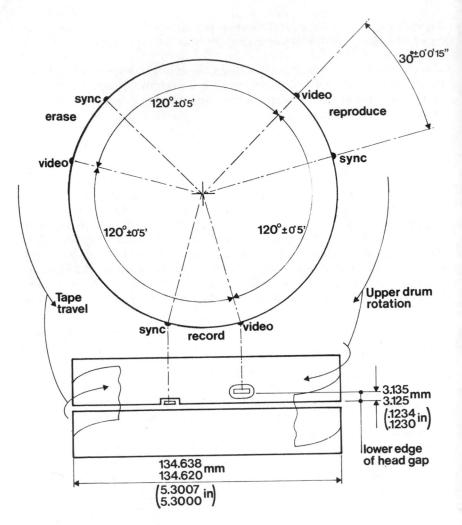

Fig. 4.4. Video head drum for C format.

The one-inch video tape is held in place by entrance and exit guide posts and a bottom edge guide which extends around the scanner from the one to the other. The helix angle is 2.591° which, combined with the tape's longitudinal movement against the head movement at 23.98 cm/sec (9.441 i.p.s.) for EBU and 24.40 cm/sec (9.606 i.p.s.) for SMPTE, gives tracks at 2.562° and 2.567° respectively.

The video heads are 0.160 mm (0.006 in) wide and project 0.06 mm (0.0024 in) from the surface of the scanner. The upper half of the scanner rotates, causing an air film to form between the tape and the drum. This reduces the friction between them and so lessens the tension in the tape. It

also increases the effective drum diameter which makes the video tracks slightly longer than calculations based on static dimensions would suggest. There are three 0.8 mm (0.03 in) audio tracks in addition to a 0.6 mm (0.024 in) control track. The video tracks which are 41.146 cm (16.2 in) long are 160 μm (0.006 in) wide and have a guard band of 54 μm (0.02 in) between them. The EBU format offers the choice of using an extra head to record the vertical interval or of having an extra, high quality audio track. If the latter format is chosen dummy heads are placed on the scanner to ensure mechanical compatibility. The result can be seen in Fig. 4.5.

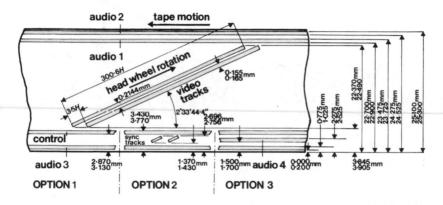

Fig. 4.5. Positions of recorded tracks in the three options of C format.

Track width and spacing

The track width is set by the video head which is chosen to give the widest possible track allowing space for a guard band. The distance between tracks is set by the rotational scanner speed and the tape speed. These are chosen so that the line synchronising pulses on each field are recorded in register. This ensures that if the head crosses from one track to the next there will be minimum picture disturbance. This enables a still frame to be displayed on a suitable picture monitor. Each track must be spaced by a distance equal to a whole number of recorded lines plus a half line to account for the field interlace, see Fig.4.6. The spacing is $2\frac{1}{2}$ lines for EBU and $3\frac{1}{2}$ for SMPTE.

EBU systems

36° rotation takes $\frac{1}{50}$ sec

Tape speed = 23.98 cm/sec

Tape movement per video track = $\frac{1}{50}$ x 23.98 cm

= 4.796 mm (0.189 in)

The track angle is 2.562° so the track pitch

= 4.796 x sin 2.562° = 0.2144 mm (0.0084 in)

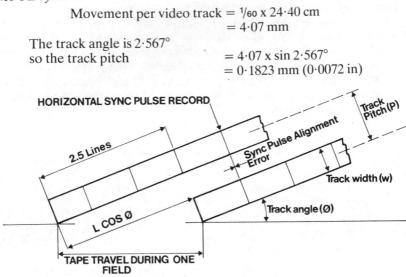

Fig. 4.6. Sync pulse line-up.

Overlap

When the vertical interval record head is in use it is necessary to ensure that there is some overlap, or duplication, of the recorded video at the points where the switch from sync to main video head occurs on replay. On EBU the overlap is 6.75 lines and on SMPTE it is 5.75 lines. This allows some freedom in the choice of switch timing to accommodate geometrical and tensional differences between machines.

Clearly there can be no overlap on machines using the fourth audio channel format.

Longitudinal tracks

There are up to five longitudinal tracks, one control track and three or four audio tracks.

The main audio is placed second from the top of the tape to protect it against edge damage. The SMPTE format specifies that for stereo operations this channel will carry the sum signal and the audio 2 track the difference signal. The EBU format places the left hand channel on audio 1 and the right hand on audio 2. In each case where the same signal is recorded on both tracks the phase will be arranged so that when played by a single wide head the signals will be additive.

Audio 3 is an independent track intended for use as a cue channel or for time code recording which is recorded with a.c. bias. EBU audio 4 is also

an independent track which is intended for use as a dubbing facility during editing.

On the EBU format the audio record reference level is 9 dB below the recorded peaks, on the SMPTE format it is 8 dB below the 3 per cent distortion level. In each case this should result in a recorded flux of 100 nWb/m. Predistortion is not used when setting record levels but is allowed on both formats.

The control track record head is mounted on the same stack as the audio heads. They are all positioned 102 mm (4·016 in) downstream of the start of video reference. The positional tolerance of \pm 0·4 mm (0·016 in) means that the worst case interchange timing error will be 3·3 mS. This is roughly half the quadruplex figure.

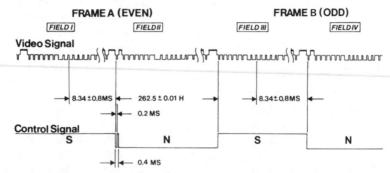

Fig. 4.7. SMPTE C format control track.

The SMPTE control track signal is a series of saturated flux levels alternating in polarity, Fig. 4.7. There is an extra pair of transitions on every other frame to aid colour frame identification. The transitions occur at the middle of each field to reduce the sensitivity to timing errors.

The EBU control track signal, Fig. 4.8, is recorded using a.c. bias at the same level as a 1 Hz sine wave set to the audio reference level. The start of an even field is marked by a positive pulse, odd fields by a negative pulse. There is an additional pair of pulses during the middle of every eighth field. This identifies the PAL sequence if required, but a four-field signal may be derived within the recorder where two frame edits are acceptable.

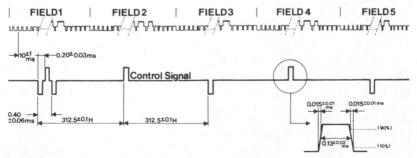

Fig. 4.8. EBU C format control track.

Still frame and slow motion

The major advantage of the non-segmented helical format is that if the longitudinal movement of the tape is stopped a still frame is replayed. By moving the tape at a reduced speed so that each track is replayed several times, slow motion is achieved. The head drum is kept rotating at field rate.

When the tape is slowed or stopped the angle that the video head scans across it changes and some of the lines of the field cannot be replayed because they are placed in the vertical interval gap. In addition the duration of each line increases since fewer are reproduced in a given time.

The missing lines ($3\frac{1}{2}$ per field for EBU, $2\frac{1}{2}$ for SMPTE) and the change of length are compensated by the time base corrector (see Chapter 11). In stop the scan angle is the same as the helix angle. If the video head is to be kept on the track along its whole length some means of moving it must be devised. If it can be moved along the axis of the drum as it rotates it can be made to track exactly down the video r.f.

Auto scan or dynamic tracking

On machines where a broadcast quality still frame or slow motion is required an extra head spaced 120° after the record/replay head is provided. This head is mounted on a piezo-electric bi-morph element which will bend in response to an applied voltage in the region of 400 volts. The element is made to bend in an S-shape in order to keep the video head perpendicular to the tape, as shown in Fig. 4.9. A sense element down the edge of the bi-morph provides deflection feedback to the drive circuit.

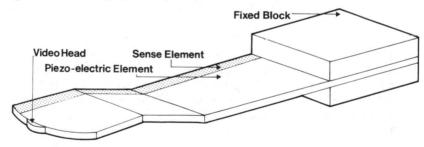

Fig. 4.9. Auto scan video head.

During replay the head is caused to oscillate at 150 Hz across the video track. The variations in the amplitude of the replayed r.f. are then detected and used to move the head to the centre of the track.

When the head is on track the frequency of the amplitude changes which result from the dither is twice the frequency produced when the head is to one side. This is because it passes through a peak each time it moves from one end of its travel to the other. When it is off track the maximum signal is obtained at one end of the sweep. The polarity of the error depends upon which side of the track the head is positioned and so the appropriate

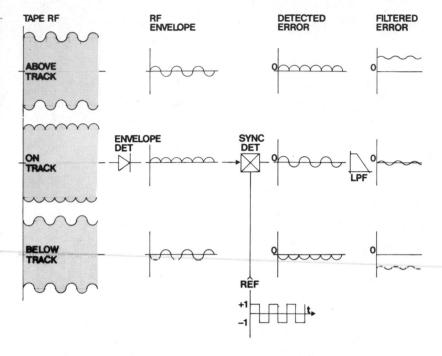

Fig. 4.10 Auto scan head track position detector.

correction can be applied. This alters the capstan servo to bring the video tracks into the correct phase with the scanner as in Fig. 4.10.

The drive voltage applied to the head in still frame is a field rate sawtooth. The a.c. component represents the scan angle error and the d.c. component the capstan/drum phase error. If the tape is moved the deflection of the head increases. When the tape has moved by a distance equal to the track pitch the d.c. error will equal the a.c. error. At this point the head will be switched to a new track. In slow forward movement this is done by allowing the deflection to continue in the same direction. In slow reverse the head has to jump by an amount equal to two scan angle errors, see Fig. 4.11.

Editing

The shallow track angle precludes the possibility of cutting and splicing the tape. It is therefore necessary to provide an erase head which leads the video record head and can erase the tracks just ahead of it. A video erase head is placed on the drum at an angle of 120° ahead of the video head and a second one is placed ahead of that to erase the sync tracks (see Chapter 13).

If the machine is not fitted with sync heads then three dummy heads are provided. This is to reduce the velocity errors should the tape be played on

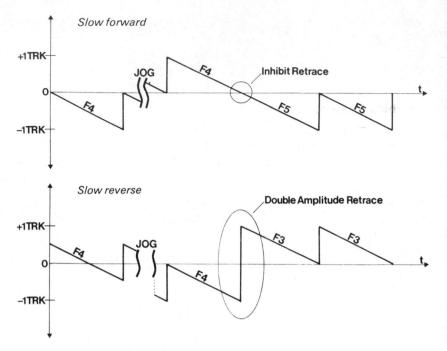

Fig. 4.11. Auto scan deflection voltages.

a sync head machine. The percussion effect of the heads on the tape affect the audio quality and the extra dummy heads ensure minimum interchange degradation.

AST head problems

Although great advantages may be gained by using the moving play head, there are inevitably some new problems.

1. The movement of the play head must be exactly in line with the gap. If it is not the azimuth angle will change as the head moves and the varying loss of high frequencies will affect the replayed chrominance. This will be especially visible on large high saturated areas.

2. The dither action of the head which is required to enable the centre of the track to be found will vary the offtape r.f. level. This can also be seen on large highly saturated areas but the variations will be more uniform and frequent than for 1 above.

3. In stop and slow motion the PAL sequence has to be reconstructed from a signal field. This is done by a decode/recode process which causes a loss of picture quality. If a transition is made from one mode to the other it is necessary to arrange a change of replay processing after normal play speed has been reached.

4. When an edit is made the scanner has to be phased to make the record head match the existing video tracks. This means that it has to be repositioned by the 120° between the play and record heads which takes several seconds because of the mechanical inertia of the head drum.

Portable machines

Portable C format machines are available, but as yet no cassette loading version has been produced. The entrance and exit guides need very accurate positioning and do not lend themselves to being moved to facilitate tape lacing.

The large scanner is susceptible to gyroscopic errors introduced when the machine is moved and although these can be reduced by increasing the power of the drum servo the errors can still exceed the range of the replay time base corrector.

Format Data

Video tracks

	EBU	SMPTE				
Track length	411·46 mm	411·46 mm				
Track angle	2.562°	2·567°				
Track pitch	0.2144 mm	0·1823 mm				
Track width	0·160 mm	0·130 mm				
Arc of contact	346·18°	346·18°				
Drop-out angle	13·82°	13·82°				
Drop-out lines	12.00	10.00				
Length of recorded line	1.3688 mm	1.630 mm				
Scanner rotation	Clockwise opposing tape motion					

Video modulation

The video is recorded as a frequency modulated signal. It is passed through a pre-emphasis network before being applied to a linear modulation.

Sync tip	7·16 MHz	7.06 MHz
Blanking	7.68 MHz	7.90 MHz
Peak white	8.90 MHz	10.00 MHz

Audio

Track width	0.8 mm	0.8 mm
Playback equalisation	$15 \mu S$	15 μS
Linear tape speed	23.98 cm/s	24.4 cm/s

5 Industrial, Educational and Domestic Formats

The object of designing a specific format for CCTV purposes is to make an economic saving on the amount of tape used and the number of heads, with associated electronics, required to scan the tracks. A saving in tape can be made by reducing the head to tape speed and the track width. Reductions in bandwidth and signal/noise ratio inevitably result but are considered tolerable for most closed circuit applications.

The number of rotating heads can be reduced only if the tape is wrapped further around the periphery of the head assembly. A 180° wrap would allow a minimum of two heads while a full 360° wrap would allow a single head.

Timing errors due to geometry changes occur on any recorder at track scanning frequency and the perceptibility of these fixed errors becomes less if they repeat themselves at a field rate and not multiples or sub-multiples of field rate. For this reason it is an advantage to make one track contain one television field.

The simplest method of wrapping the tape around the head wheel is to form the tape into a helix around a drum assembly causing the tape to rise as it moves around the head or heads. The method gives rise to the term helical scan or wrap and can be adapted for any number of heads although normally only one or two heads are used.

Two-headed wrap^{1,2,3}

This is the simplest arrangement and can be seen in Fig. 5.1. The angle of wrap is made slightly greater than 180° to allow a slight overlap of information. The distance the tape moves up the drum, over the 180°, must always be less than the width of the tape to allow a space along the edges of the tape for

longitudinal tracks. The video heads, which can either move in the same or opposite direction to the tape, traverse almost from edge to edge producing a track length nearly equal to the peripheral distance between the heads. If the tape and head motion oppose each other, the resultant track length is increased. Similarly it is reduced if the tape and head move in the same direction.

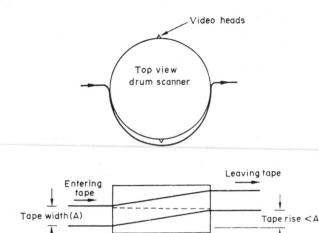

Fig. 5.1. Two headed wrap.

The track angle is determined by the rise and is slightly modified by the tape motion (see Appendices 4.1 to 4.4).

The rotational speed of the head must be half that of the field rate so that one video track contains one field.

The diameter of the head drum scanner determines the head to tape speed:

For a 50 Hz field rate

Rotational speed = 25 r.p.s. Circumference of the drum = πD

where D = drum diameter

Head speed = $25\pi D$ i.p.s.

If the required head speed is 600 i.p.s.:

$$D = \frac{600}{25\pi} = 7.64 \text{ in}$$

The angle of the track is very small so that to a first approximation the final head to tape speed = head speed + tape speed.

V.R.- F

When the tape and head motion oppose:

If the tape speed = 7 i.p.s.,

Track length =
$$\frac{607}{50}$$
 = 12·14 in

For a 60 Hz field rate

For same diameter drum,

Head speed =
$$30 \times \pi \times 7.64 = 720$$
 i.p.s.

Track length =
$$\frac{727}{60}$$
 = 12·1 in

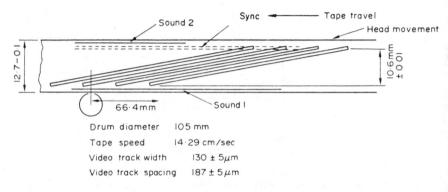

Fig. 5.2. Phillips VCR format.

One-headed wraps⁵

On one-headed wraps the head rotates 360° for one field period which allows, for the same head to tape speed, the drum diameter to be reduced to half that required for two-headed configurations. The problem of aligning the heads with respect to each other is eliminated, although the problem of a long drop-out is created by the loss of information after ending one track and starting the next. The difficulty is in trying to get tape contact around the full 360° of the drum.

There are three basic methods of forming the tape around the drum: omega wrap, alpha wrap and conical wrap. Of these only the first two are in common use.

Omega wrap. If this wrap is viewed from the top of the drum scanner it forms the Greek letter Ω as shown in Fig. 5.3. Because of its shape it permits the 82

lower edge of the tape leaving the drum to be below the upper edge of the tape entering the drum. This produces the overlap, dimension 'd', which allows room for the longitudinal tracks. In a similar way to the two headed format the space left unrecorded is determined by the tape rise over 360° and is equal to the difference between the tape rise and the tape width. The overlap should be large enough to allow sufficient width for at least one

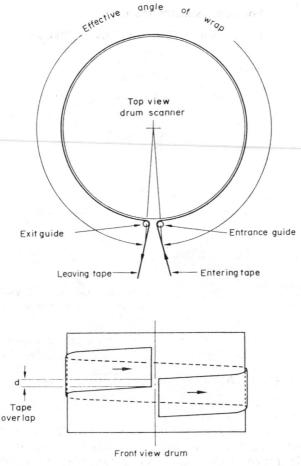

Fig. 5.3. Omega wrap.

audio and one control track and some formats leave room for a second audio track.

It is not possible to achieve tape contact over the full 360° because a small exit and entrance clearance is necessary for the tape.

This gap seldom exceeds 10° drum angle although even this creates a large drop-out.

On 625/50 Hz

1 revolution (360°) records 312.5 TV lines

$$10^{\circ} = \frac{1}{36}$$
 revolution contains $\frac{312.5}{36} = 9$ TV lines.

On 525/60 Hz

360° records 262.5 TV lines.

$$10^{\circ}$$
 contains $\frac{262 \cdot 5}{36} \neq 7$ TV lines

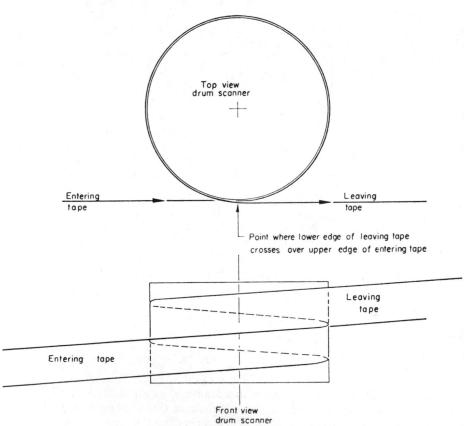

Fig. 5.4. Alpha wrap.

Alpha wrap. This wrap, as the name implies, forms the Greek letter α when viewed from the top and is shown in Fig. 5.4. It is a simpler form than the omega and is somewhat easier to produce operationally. Because the lower edge of the tape leaving the drum must be slightly higher than the upper

edge of the tape entering the drum the tape rise must be at least equal to the tape width. With no overlap the tape is scanned from edge to edge with the minimum of drop-out from the end of one track and the start of the next. A deterioration of the signal at the edges of the tape can easily result if the tape is in any way damaged. With the full width of the tape used up there is no room for the audio. If a portion of the tape width is erased, a second drop-out is created which, for a reasonably wide audio track, is quite large.

This is equal to 12.5 TV lines on 625/60 Hz systems and 10.0 TV lines on 525/60 Hz systems. If a second audio track and control track are required,

third and fourth drop-outs are created.

A compromise can be made if a poorer audio performance can be tolerated. Either a reduction in track width can be made or the audio signals can be recorded up-stream prior to the video. The action of the overscanning video head is to cause an amplitude modulation of the audio signal at the track or field frequency.

The effect of this distortion can be minimised by low frequency rejection filtering on playback and by placing the audio gap at an angle. The distortion of the audio on the video signal is minimal. Although beat components can

be produced, the order of magnitude is low.

The distinctive feature of the omega format is the positioning of the audio tracks on the extreme edges with the video tracks stopping short of the edge. The alpha format has video tracks extending to the edges of the tape with overlapping audio. If a new audio track is recorded over existing video then obviously the additional drop-out will be produced.

on the extreme edges with the video tracks stopping short of the edge. The alpha format has video tracks extending to the edges of the tape with overlapping audio. If a new audio track is recorded over existing video then

obviously the additional drop-out will be produced.

Conical wrap. The conical wrap is a form of alpha wrap which is not of practical use but it is of interest to see why a wrap with such apparent advantages cannot be used.

The form of the wrap can be seen in Fig. 5.5. where the entering angle of the tape is slightly greater than the leaving angle thus allowing an overlap where the entering tape is underneath the leaving tape. To achieve this the drum assembly needs to be slightly conical. The method seems to have the simplicity of alpha with the unrecorded section of the omega. Unfortunately the technique suffers from one major disadvantage. Because of the cone angle, as the tape moves up the drum its angle changes, thus causing the video track angle to change. The cone angle is determined by the required space for the audio tracks and the permissible angle of overlap. If the angular overlap is limited to 65° and the required width for the audio tracks is one tenth of the tape width, the track angle doubles over its length (see Appendix 7).

The recorded tracks are now no longer straight lines but form arcs with a centre–centre track spacing that varies. As this is a function of track angle,

sync line-up is impossible on this format.

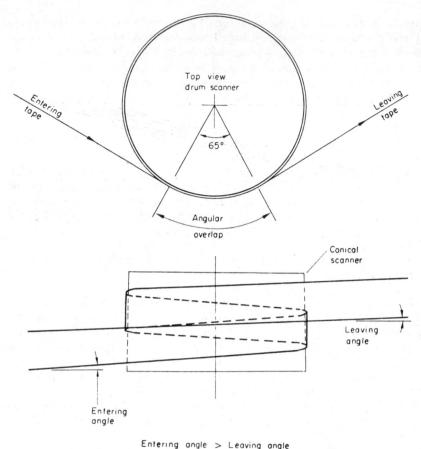

Fig. 5.5. Conical wrap.

Sync line-up

On all the formats described, one important design feature is that the distance the tape moves during one field time is such that the horizontal syncs on adjacent tracks 'line-up'. For this to occur the distance moved should be a whole number of lines plus half a line to take into account the horizontal sync phase at the start of a new field (see Fig. 5.6). This precise distance depends on the length of a horizontal line on a video track and the track angle. The exact number of lines moved depends on the format, but in general it is between $2\frac{1}{2}$ to $4\frac{1}{2}$ TV lines depending on the head/tape speed and line standard used (see Appendix 6). This feature very often results in rather odd values of linear tape speed which alter slightly between standards.

The advantage of sync line-up is apparent if the scanning of adjacent tracks is considered. This occurs during still frame, slow motion or simple mistracking during playback when the head crosses the guard band on to another

track. If sync line-up was not designed into the format, a horizontal sync phase change would occur, causing the monitor picture to break-up and relock. Sync line-up ensures sync continuity over such disturbances.

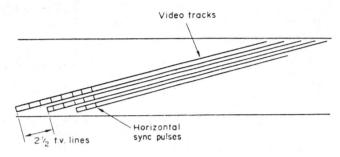

Fig. 5.6. Sync line-up.

Stop-motion

One advantage of helical scan is that stop motion playback is possible by stopping the tape and keeping the head rotating at field rate. The scan angle is now slightly different owing to the lack of tape motion. If the scan starts on the centre of a track, it ends on the centre of an adjacent track, a longitudinal distance equal to the distance the tape has moved. In crossing the guard band a noise bar is produced in the centre of the picture. A slight adjustment of the track position moves the bar to the top or bottom of the picture, thus starting the scan in a guard band and ending, in an adjacent guard band (see Fig. 5.7). The same recorded field is repeated on playback giving the effect of still frame.

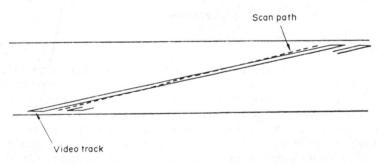

Fig. 5.7. Scan path of head when tape stationary.

A field by field inspection, sometimes misquoted as slow-motion, can be achieved by slowly moving the tape, but a noise bar drifts through the picture until the track presentation rate matches the scanning rate of the head at normal speed.

The control track

The object of the control track is to provide an identification mark for the start of each track. This can be used in playback to synchronise track and scanning rate. It is normally derived from field sync and can be a single or multiple pulse placed on the tape by a separate head upstream or downstream from the video drum scanner.

Colour under recording

The bandwidth of non broadcast machines is not sufficient to record the high frequency subcarrier used in colour signals. It is also necessary to eliminate the timing errors introduced by the tape transport. There are several methods of overcoming these problems (see Chapter 12), but the colour under or heterodyne system is most generally used.

In this system the chrominance is separated from the composite video and its carrier frequency changed by mixing, or heterodyning, with a suitable local oscillator. The luminance is used to frequency modulate a carrier which varies between about three and a half and six megahertz with its lower sideband cut off below about one and half megahertz. This allows the new amplitude modulated colour subcarrier to be added below the luminance which acts as the bias during recording. The spectrum of the signal is shown in Fig. 5.8.

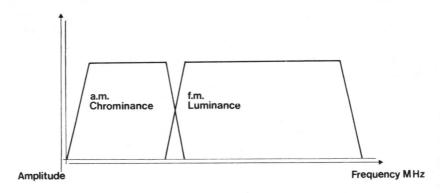

Fig. 5.8. Colour under spectrum.

During replay the subcarrier is reconverted to its original frequency by an oscillator which has the line sync pulse timing error added. This ensures that the final chrominance has a stable frequency that can be decoded by a receiver. However, the fixed relationship that existed between subcarrier and line syncs has now been destroyed, and the resulting non phased video signal cannot be mixed with others. Where this is necessary or where the output is to be used in a broadcast chain, for example, in Electronic News Gathering, a suitable time base corrector must be used.

Zero guard band recording

To prevent the video head from replaying the wrong track a small space is left between each one and its neighbour. This is called the guard band and is usually about one third of the track width which represents a waste of about one quarter of the tape. An alternative method of preventing crosstalk is to angle the video heads. This is possible on formats which use a two-headed drum because adjacent tracks can then be recorded and replayed by their own heads.

An alternative method of preventing crosstalk is to arrange for the azimuth of the heads to slanted in opposite directions on adjacent tracks, as shown in Fig. 5.9. This is simply arranged on two-headed scanners where one head can be made to record and replay odd fields and the other even fields. If a head overlaps the wrong track the adverse azimuth will attenuate the high frequencies used to record the luminance to such a degree that it will not be visible. The heads are angled between 6° and 15° on systems in current use.

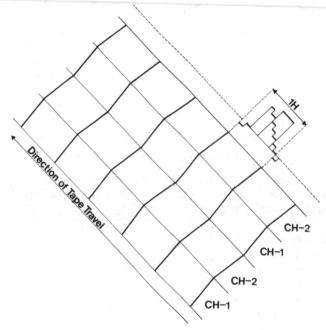

Fig. 5.9. Zero guard band slant azimuth tracks.

The use of an f.m. signal for the chrominance in the SECAM signal makes it nearly immune to interference but the a.m. PAL and NTSC subcarriers are readily affected by crosstalk. During record the phase of the subcarrier on one field is advanced by 90° in addition to the phase change inherent in the signal. The other field is not altered. On replay the signal is divided, one path going through a two line delay and the other

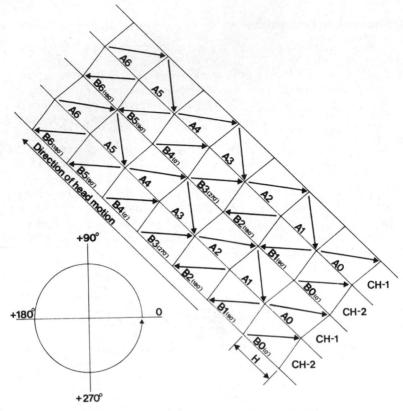

Fig. 5.10. Chrominance crosstalk cancellation.

directly to an adder. The phase of the signal passing through the delay will be changed by 180° with respect to a direct signal (see Fig. 5.10). The output can be found as follows:

Main signal Ao Crosstalk signal Bo Two line delayed main signal A180 Two line delayed crosstalk Bo But the delayed signals are phase reversed delayed main $= A180 + 180^{\circ}$ $= Bo + 180^{\circ}$ delayed crosstalk = B180= (Ao + Ao) + (Bo + B180)adding these gives = 2Ao + o=2Ao

Each line can be treated in this manner and it can be seen that in all cases the crosstalk signals will cancel. The penalty for this form of crosstalk

elimination is a reduction in vertical resolution, but this system is used successfully on the VHS and Betamax systems.

The Phillips VCC system has a replay head capable of moving vertically, as on broadcast C-format machines, and relies on accurate tracking to eliminate crosstalk.

On record one of the heads is fixed in nominal centre position, the other is deflected to compensate for spacing errors. At the start of each track a 96 μ s tone burst is recorded, the frequency of which is different for each of four fields, see Fig. 5.11. Immediately after recording the tone burst the head is switched to play and senses the tone burst of the previous track. An error signal is thus generated which enables the movable head to be set to a predetermined crosstalk level.

Replay tracking control signals are derived by beating the tone burst frequencies together. Table 4 below shows all possible combinations and it can be seen that only two frequencies, 15 kHz and 47 kHz occur.

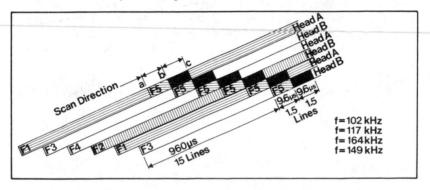

Fig. 5.11. VCC track position tone bursts.

TABLE 4

Replay head	A	В	В	A	
Replay track	F ₁ 102	F,117	$F_{3}149$	F ₄ 164	
Adjacent up track	F,117	F ₄ 164	F ₁ 102	F,149	
Error tone	15	47	47	15	
Adjacent down track	F ₃ 149	F ₁ 102	F ₄ 164	F,117	
Error tone	47	15	15	47	
	110-02		2000	3973	

For head A 15 kHz would produce a deflect down signal, for head B deflect up. The 47 kHz tone would produce the reverse effect but in both cases correct tracking will result. If both heads produce a deflection error in the same direction there must be a speed error and the capstan can be controlled accordingly.

Double limiter frequency modulation

The video tracks on the half-inch helical recorders have been reduced in width as far as possible to accommodate the slower tape for a long recording time. Decreasing the track width is known to cause deterioration in the signal/noise ratio and steps have to be taken to improve it.

The higher frequencies are most affected and so to compensate the signal is pre-emphasised during recording. However, high contrast transitions in the picture, such as chimneys against the sky, produce large rapid changes in the video signal which, after pre-emphasis, cause over modulation of the f.m. The use of a double limiter overcomes this problem and

allows the use of a high degree of pre-emphasis.

Fig. 5.12 shows the action of the circuit. The overloading of the modulator causes a decrease in carrier at the point where the transition would be demodulated as a negative signal component. To restore the carrier to its correct amplitude it is separated from the playback f.m. by a high pass filter, phase corrected, amplified and limited. This signal is then added to the low frequency component of the wave form and the result passed to the conventional demodulator.

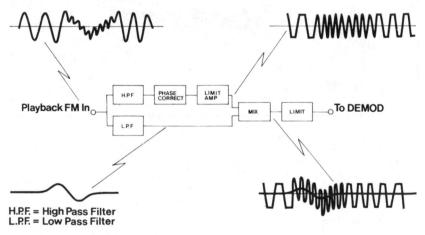

Fig. 5.12. Action of double limiter frequency modulation.

Linear video recording

The first video recorders were developed from audio machines and used a longitudinal track, as in the BBC Vision Electronic Recording Apparatus (VERA) of 1958. It has only recently become possible to reduce the speed of the tape to one that can be obtained easily and safely.

Two systems, one on 12.5 mm tape and the other on 6.25 mm tape, have been produced but are not in widespread use. The Linear Video Recording, LVR, system uses several tracks parallel to the edge of the tape, 28 on the 6.25 mm system, which runs at 3 m/s. At the end of each track the

tape motion is reversed and the head moved to the next track, all in the field interval. This is made possible by using a large diameter capstan which contacts the supply and take up spools directly as Fig. 5.13 shows. The tape is self threading and tensioning so the cassette contains only a single reel.

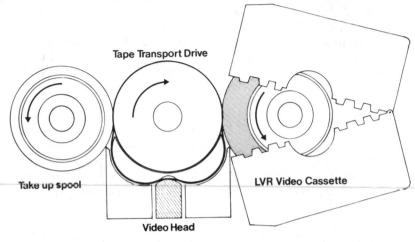

Fig. 5.13. LVR drive.

Conclusion

There are several competing industrial and domestic systems but, with the exception of the LVR, they are all fundementally similar in that they use moving video record and replay heads. As tape and head technology improve the performance increases at the same time as the size decreases. It is now possible to include a Betamax type recorder in a camera the size and weight of a Super 8 film camera. The 8mm wide high quality metal tape is contained in a 56 x 13mm cassette and provides a recording time of 20 min. This can later be replayed and edited on a companion machine or transferred to another format.

It is to be expected that other methods of storing the video will emerge, perhaps solid state once the origination is digital, and that electronic means will be as flexible as film currently is.

The major format features are summarised in Table 5 while Fig. 5.14 shows the tape lacing and head patterns for the more common machines.

References

- SAWAJI YOSHIO, EIAJ Standards for half-inch videotape recorders, JSMPTE, Vol. 79, Dec. 1970.
- EBU, Different Types of non-standard television tape-recorders. Technical Information Sheet No, 2, July 1967.

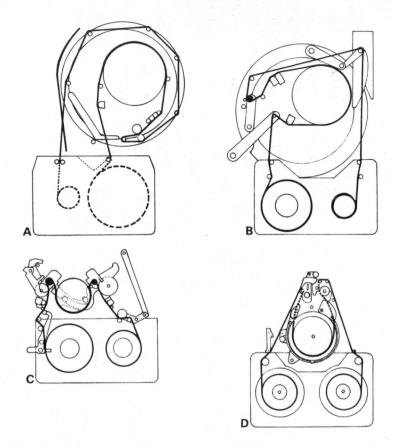

(b) Betamax (c) VHS (d) VCC Fig. 5.14. Cassette tape paths. (a) U-matic

- 3. FOERSTE, G., Technical Aspects of the Phillips VCR System, Montreux TV Symposium
- 4. EBU, Video player and recorder systems for home use. Tech. 3093, March 1971.
 5. JOHNSON, D., Video record format of helical scan recorders, Ampex Educational Division, Illinois.
- 6. BBC SPECIFICATION TU250, Outline specification for a Colour Helical Scan Video Tape Recorder.

TABLE 5 Comparison of industrial/domestic systems

	12.5 12.5 or 8 12.5 or 6.25	3.95 600 or 300 2.44	820 600 or 300 508	51 100 22.6	3-1-5-1 3-6-5 3-3-4-8		
VCR-LP	12.5 12.5	95.9	810	85		±15	
VCR	12.5	14.29	810	130	3-4-4	0	
VHS	12.5	2.339	483	49	3.8-4.8	97	
Betamax VHS	12.5	1.873	583	32.8	3.8-5.2	+7	
U-matic	19	9.5	854	85	3.8-5.4	0	
Format	Tape width (mm)	Tape speed cm/s	Writing speed cm/s	Video track width μ m	FM Deviation MHz	Video head angle degrees	

6 FM Theory

The frequency response of a television signal is

0 to 5.5 MHz for System I 625 line system 0 to 5.0 MHz for System II 625 line system 0 to 4.2 MHz for 525 line system

Assuming that the d.c. component could be restored and that the minimum frequency required to be transferred through the tape recorder is 10 Hz, a pass band of up to 20 octaves would be required for the full bandwidth recording of the above standard signals.

To produce a record signal of less than 10 octaves some form of modulation

of the video is required.

Frequency modulation is the most suitable, owing to its relative simplicity and ease of production compared with the more complex pulse code modulation techniques, and owing to its tolerance of amplitude variations compared with amplitude modulation.

Frequency modulation as used in VTR differs in two respects from most

other systems in common use:

- 1. The centre frequency is very close to the highest modulating frequency.
- 2. The modulation index $\left(\frac{fd}{fm}\right)$ is lower than in most other systems.

Basic FM theory

A simple FM modulator system is shown in Fig. 6.1. where the input signal, called the modulating frequency (fm), controls the reactance circuit of an oscillator tuned to a centre frequency (fc). The system is assumed to be a

linear one, whereby the oscillator frequency deviation is proportional to the amplitude of the input signal.

The output of the modulator therefore would be of the form

$$f = (fc + fd\cos 2\pi fmt)$$

or $w = wc + wd\cos wmt$

where fd = maximum deviation of instantaneous frequency from centre frequency

fm = frequency of the modulating signal

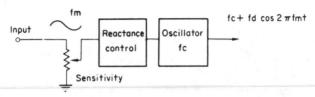

Fig. 6.1. The FM modulator.

The resulting waveform is shown in Fig. 6.2, with the modulated signal advancing and retarding in phase with respect to an unmodulated centre frequency.

If a phasor diagram is constructed as in Fig. 6.3(a), the modulated signal can be seen to advance and retard to a maximum angle θ . The magnitude of this angle is a function of the maximum deviation and the rate of deviation and is equal to

$$\theta = \frac{wd}{wm} = \frac{fd}{fm}$$

See Appendix 8.

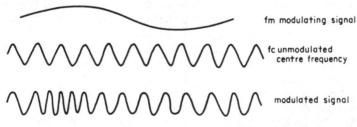

Fig. 6.2. The modulated signal.

This is not unreasonable to expect because it shows that, if the deviation is increased, θ will increase. Also if the rate at which the centre frequency is deviated is reduced, by reducing the modulating frequency, the resulting angle increases.

This is analogous to the phase difference between two cars on a circular race track, both averaging the same speed. If car A remains at a consistent speed of, say, 60 m.p.h. and car B accelerates to a speed of 70 m.p.h. and then decelerates to 50 m.p.h., the deviation can be said to be ± 10 m.p.h. Increasing the deviation increases the angle between the two cars. Increasing the rate of deviation reduces the angle.

The analysis of the spectral or sideband distribution is complex and is

shown in Appendix 9.

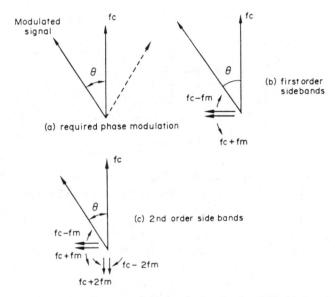

Fig. 6.3. Phasor diagrams showing the synthesis of FM side-bands.

From the phasor diagram in Fig. 6.3(b) it can be seen that, as a first order approximation, two sidebands at fc + fm and fc - fm would produce the required phase modulation assuming that the angle θ is small, i.e. <45°. The presence of only two, first order, sidebands do not quite produce the classical picture of an FM wave. Amplitude modulation exists because the resultant vector is larger in amplitude when the sidebands add in quadrature to the centre frequency. However if θ is small the effect is minimal and higher order sidebands can be ignored. To reduce the effect of AM, two extra sidebands can be postulated as shown in Fig. 6.3(c). These subtract from fc when fc + fm and fc - fm add to fc in quadrature. To achieve this, the second order sidebands must rotate through 360° for 180° rotation of the first order sidebands. In other words twice as fast or equal to fc + 2fm, fc - 2fm. It can be shown that third, fourth indeed an infinite number of SB's are present in an FM wave. The amplitude of these sidebands initially increases as θ increases. A graphical representation of the sideband amplitudes against θ are shown in the Bessel functions in Fig. 6.4. From the graph it can be see that if θ is less than 1 radian (57°), most of the energy is in the first order sidebands.

The sideband distribution can also be shown as a spectral distribution as in Fig. 6.5 and it is interesting to note that as the modulating frequency reduces, θ increases, causing greater energy in the higher order sidebands. The bandwidth however remains substantially the same.

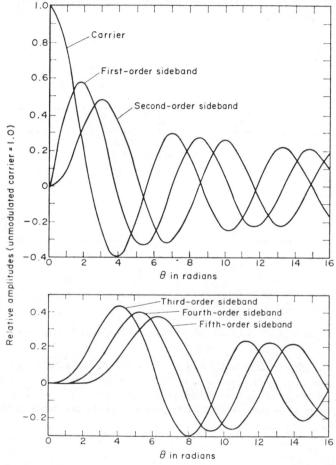

Fig. 6.4. Bessel functions showing the relative amplitudes of FM side-bands.

Frequency modulation used in video recording

Centre frequency. The term centre frequency, when referred to video signals, is not easy to define. As the limits of the system response are reached by the high frequencies of the modulating signals, it is convenient to regard the centre frequency as the modulator frequency at the mean level of these components, i.e. the low frequency luminance level.

Figure 6.6 shows the range over which the centre frequency can change for the various systems in use with peak white giving the highest frequency and sync tip the lowest. The choice of upper and lower frequency limit is set by the response of the *FM* path, the highest sideband being created by a high frequency component at peak-white and the lowest sideband by a high frequency component at black level.

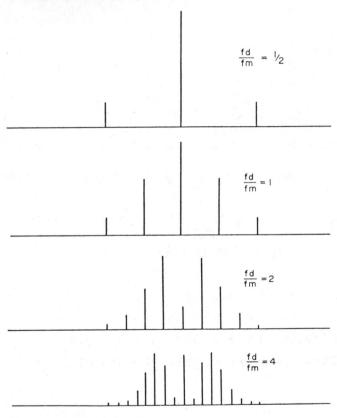

Fig. 6.5. The spectral distribution of an FM wave.

In VTR the maximum permissible centre frequency is limited by the upper frequency response of the tape transfer process and the highest video frequency. The response must be high enough to pass the highest first order upper sideband. In general this is limited by the head and the resolution of the tape. The maximum resolution of the gamma-ferric oxide tape is about 80–100 micro inches (2 microns). High energy tapes are improving this figure with possibilities of three to four times the resolution of gamma-ferric oxide. The lowest permissible centre frequency is limited by the low frequency response because it is required that the first order lower sideband is passed

by the system. The lowest centre frequency therefore must be higher than the highest video frequency plus the low frequency limit.

Table 6

T.V. Sustania		Video Level		
T.V. System	A Sync Tip	B Black Level	C Peak White	
625/50 Low Band	4·95 MHz	5·50 MHz	6·80 MHz	
625/50 High Band	7·16 MHz	7.80 MHz	9-30 MHz	
525/60 Low Band	4.28 MHz	5.00 MHz	6.80 MHz	
525/60 Colour Low Band	5.50 MHz	5.79 MHz	6.50 MHz	
525/60 High Band	7.06 MHz	7.90 MHz	10.0 MHz	
Typical 1" Format (Video -3.0 MHz)	3.5 MHz		5.5 MHz	
Typical ½" Cassette (Video −2.7 MHz)	3.0 MHz		4.2 MHz	
625/50 Super High Band (9000)	9.0 MHz	9.9 MHz	12 MHz	

Quadruplex. With a head to tape speed of 1570 i.p.s. and a resolution of $100-80 \mu in$.

$$f \max = \frac{1570 \times 10^6}{100}$$
 to $\frac{1570 \times 10^6}{80} = 15.7$ MHz to 19.5 MHz

fc + fm must be less than 15.7 MHz

or
$$fc < 15.7 \text{ MHz} - fm$$

where fc is the centre frequency

and fm is the highest modulating frequency

for
$$625/50$$
 Hz with $fm = 5.5$ MHz $fc < 10.7$ MHz

for 525/60 Hz with
$$fm = 4.5$$
 MHz $fc < 11.2$ MHz

Fig. 6.6. The deviation standards of the FM signal. See Table 6.

With a low frequency limit at about 200 kHz

$$fc > 5.0 + 0.2 = 5.2$$
 MHz for system II 625/50 Hz $fc > 4.2 + 0.2 = 4.4$ MHz for 525/60 Hz

For Helical. Typically the bandwidth of the video signal is limited to 3 MHz, and the tape speed is of the order of 800 i.p.s.

$$f \max = \frac{800 \times 10^6}{100}$$
 to $\frac{800 \times 10^6}{80} = 8.0$ MHz to 10.0 MHz

(With high energy tape, the head to tape speed can be reduced, owing to the higher resolution. Typically 320 i.p.s. would give the same maximum frequency of 8.0 MHz with cobalt doped or chromium dioxide compound tapes.)

$$fc < 8.0 - 3.0 = 5.0 \text{ MHz}$$

 $fc > 3.0 + 0.2 = 3.02 \text{ MHz}$

The centre frequency of a video modulated FM signal is difficult to define but if a peak-white signal or a black-level signal has a high frequency component on it, it would be required that both the first order upper and the first order lower sidebands produced are passed by the system. The frequency produced by the average level of the video signal can therefore be defined as the instantaneous value of the centre frequency and this is a variable quantity between peak white and black level. The output frequency of the modulator therefore should not go beyond the limits calculated for an input video signal excursion from black level to peak white.

Broadcast standard frequencies have been internationally agreed but CCTV practice is as varied as the number of manufacturers. Table 6 shows the main standards in use.

Deviation frequency and modulation index

The maximum sinusoidal deviation that can occur would be for a video signal with an average mid-grey level and a frequency component with a peak value from peak-white to black level. In monochrome signals such a situation is rare although black to white transitions contain large amplitudes of high frequency components. In colour signals where the chrominance information is transmitted on a high frequency sub-carrier large amplitudes of high frequency are more common.

Assuming the worst case of 100% amplitude, 100% saturated bars, the maximum peak-peak sub-carrier amplitude is always less than 0.9 of the peak-peak excursion from sync tip to peak-white. On this basis the maximum peak-peak deviation and the resultant modulation index due to colour sub-carrier can be calculated from the frequency standards given in Fig. 5.6.

Where

peak-peak
$$fd=(C-A)\times 0.9$$
 (Without pre-emphasis)
$${\rm peak}\, fd=\frac{C-A}{2}\times 0.9$$

This is modified by the amount of high frequency boost applied to the video signal prior to modulation and this is determined by the pre-emphasis characteristic which is discussed later.

However from Fig. 6.15

After pre-emphasis

$$fd = \frac{C - A}{2} \times 0.9 \times \frac{\tau_1}{\tau_2}$$

The modulation index $(\theta) = \frac{fd}{fm}$

where fm is the colour sub-carrier frequency.

For 625/50 high band (colour sub-carrier = 4.43 MHz)

$$fd = \frac{9 \cdot 3 - 7 \cdot 16}{2} \times 0.9 \times \frac{600}{240} = 2.4 \text{ MHz}$$

$$\theta = \frac{2 \cdot 4}{4 \cdot 43} = 0.54 \text{ radians} = 31^{\circ}$$

For 525/60 Hz high band (colour sub-carrier 3.58 MHz)

$$fd = 10 - \frac{7.06}{2} \times 0.9 \times \frac{600}{240} = 2.06 \text{ MHz}$$

$$\theta = \frac{3.35}{3.58} = 0.935 \text{ radians} = 53^{\circ}$$

These are maximum values and show, with reference to the Bessel functions (Fig. 6.4), that most of the energy is in the first order sidebands. With smaller amplitudes of colour sub-carrier the small second order sidebands become proportionally smaller. In all instances they can be ignored and their loss causes negligible distortion.

Distortion in FM signals

An FM signal is tolerant of amplitude variations but it is important that the modulation index (θ) is preserved.

Several distortions can cause θ to deviate from its correct value, the most important being:

- 1. Non-flat frequency response
- 2. Non-linear phase response
- 3. Random noise
- 4. Moire (unwanted sideband components produced by harmonic distortion and folded sidebands).

Non-flat frequency response. If a modulated signal is passed through a network with a frequency response as shown in Fig. 6.7, the upper sideband (fc + fm)

is attenuated with respect to the centre frequency (fc) and the lower sideband (fc-fm). One result of such distortion is to cause amplitude modulation, although this is of little consequence because it can be removed by limiting. A more important factor is that θ has been reduced which will result in a reduced amplitude demodulated signal. Low modulation frequencies would

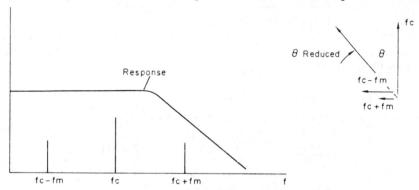

Fig. 6.7. The effect of a non-flat frequency response.

be less affected due to a greater proportion of the energy being in the sidebands close to the centre frequencies. The result is that of high frequency loss on the demodulated signal.

For colour signals differential gain occurs due to the higher luminance levels producing an increased shift of fc, fc - fm and fc + fm thus causing the upper sideband to be attenuated still further. A similar effect occurs if the lower sideband is attenuated.

Some differential gain correctors produce a slope in the upper sideband region to compensate for differential gain distortion.

Initially it would seem that it is important to have a flat response. It has been found however that some improvement in signal/noise ratio and unwanted beat interference can be made by having a linear fall off in response. If the response is linear, as shown in Fig. 6.8, fc + fm is reduced relative to

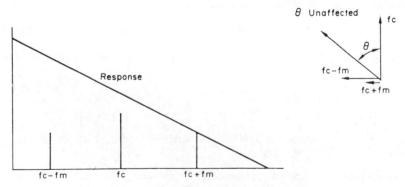

Fig. 6.8. The effect of a linear fall-off in response.

fc, and fc-fm is proportionately increased. The net result is that although amplitude modulation occurs, θ remains constant. The advantage gained in using such a response is that less of the upper sidebands are used and as these tend to be noisier, owing to compensation of high frequency loss and the presence of unwanted beat components (harmonic distortion), an improvement in overall signal/noise ratio and moire is made.

The process is sometimes called 'vestigial sideband' 2FM , but both sidebands are used even though the lower sideband is used to a greater extent than the upper sideband. No saving in bandwidth is made and the term is a

misleading one.

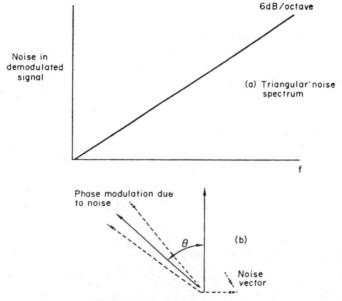

Fig. 6.9. Noise in an F.M. signal.

Non-linear phase response. In order to preserve θ , a linear phase response or constant group delay is required by the system. This involves complex equalisation to compensate for some playback losses.

Random noise. If random noise with a uniform spectrum is added to an FM signal, the frequency spectrum of the noise has a triangular distribution as shown in Fig. 6.9(a). This shows that the higher frequencies are noisier than the lower frequencies, which arises from the fact that in a simple FM modulation system:

$$\theta \propto \frac{l}{wm}$$

i.e. the greater the modulation frequency, the smaller the value of θ . If a noise component is added to the spectral components of an FM wave,

its effect as an added phase modulation to θ depends on the magnitude of θ itself. From Fig. 6.9(b) it can be seen that if a given amplitude of noise component modulates a signal with a modulation index (θ) of 20° by \pm 2°, the noise modulation is \pm 10% of the signal modulation. If θ is increased to 100°, the same noise modulation is only \pm 2% of the signal modulation. As θ reduces for higher modulating frequencies the effect of the noise increases, causing a triangular noise spectrum increasing at 6dB/octave.

The problem can be minimised by pre-emphasis of the higher video frequencies before modulation and an HF boost of 6dB/octave would cause θ to remain constant. If the modulating frequency were doubled in amplitude,

fd would double, thus causing $\frac{fd}{fm}$ to remain constant. This is sometimes

referred to as phase modulation.

In VTR practice, phase modulation would cause too high a value of θ for high video frequencies, thus producing energy in the higher order sidebands. A compromise is reached and about 8dB of boost is applied above 1 MHz before modulation. An equal and opposite de-emphasis is applied after demodulation.

Moiré. The presence of large amplitudes of high frequencies, particularly sub-carrier, on the video signal cause beat components in the FM system. These appear on the demodulated video as objectionable patterning. On colour signals they amplitude and phase modulate the colour subcarrier causing saturation and hue errors. The subjective effect is similar to a beat or moire between two gratings and the unwanted components are called moire components.

Causes of moiré patterning

The unwanted components described in the previous paragraph are created in two ways:

1. Folded sidebands. Energy in second order sidebands due to colour subcarrier is low and the loss does not cause a noticeable distortion. The

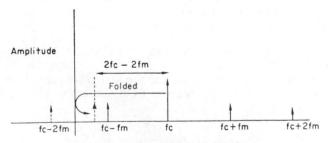

Fig. 6.10. The folded sideband.

second order lower sideband however is not lost and can be folded back into the pass-band (see Fig. 6.10).

```
fm = 4.43 \text{ MHz}
    fc = 5.5 \text{ MHz} \text{ (Black level)}
   2nd order lower sideband
    fc - 2fm = -3.36 \text{ MHz}
   After demodulation 5.5 - 3.36 = 2.14 MHz
For 525 Low Band
    fm = 3.58 \text{ MHz}
    fc = 5.0 \text{ MHz} \text{ (Black level)}
  2nd order lower sideband
     fc - 2fm = -2.16 \text{ MHz}
  After demodulation 5.0 - 2.16 = 2.84 \text{ MHz}
For 625 High Band
    fm = 4.43 \text{ MHz}
    fc = 7.8 \text{ MHz}
  2nd order lower sideband fc - 2fm = -1.06 \text{ MHz}
  After demodulation = 7.8 - 1.06 = 6.74 MHz (Out of Band)
  3rd order lower sideband fc - 3fm = -5.49
  After demodulation = 7.8 - 5.49 = 2.31 \text{ MHz}
For 525 High Band
    fm = 3.58 \text{ MHz}
    fc = 7.8 \text{ MHz}
  2nd order lower fc - 2fm = +0.64 \text{ MHz}
  3rd order lower fc - 3fm = -2.94 \text{ MHz}
  After demodulation 7.8 - 2.84 = 4.86 MHz (Out of Band)
  4th order lower fc - 4fm = -6.52 \text{ MHz} = 1.28 \text{ MHz}
```

For 625 Low Band

The negative sign has little meaning in terms of frequency and the sideband appears as a positive frequency, which after demodulation appears as a spurious frequency equal to the difference between the unwanted sideband position and the centre frequency.

2. Harmonic distortion. If an FM signal is passed through a non-linear device, harmonics of the fundamental are produced. Even harmonic distortion can be minimised by good design but odd harmonic distortion, predominantly 3rd, is inherent in the saturation record process, lack of HF bias and the limiting action of the demodulator.

If the centre frequency is 6 MHz, the 3rd harmonic would be at 18 MHz. If the centre frequency is deviated, the harmonic would also deviate. The harmonic therefore appears as a separate FM signal with its own sidebands. Although the harmonic is outside the fundamental passband, the lower sidebands of the harmonic can appear within the passband of the system and became a moiré component.

The problem is further aggravated by the fact that the modulation index increases by the order of the harmonic. If a 6 MHz carrier is deviated by 1 MHz to 7 MHz, the third harmonic deviates from 18 MHz to 21 MHz—a deviation of 3 MHz.

$$\theta = \frac{fd}{fm}$$
 for the fundamental $\theta_3 = \frac{3fd}{fm}$ for the third harmonic $\theta_3 = 3\theta$

This higher modulation index increases the energy in the higher order sidebands of the harmonics and appear in the pass band as shown in Fig. 6.11.

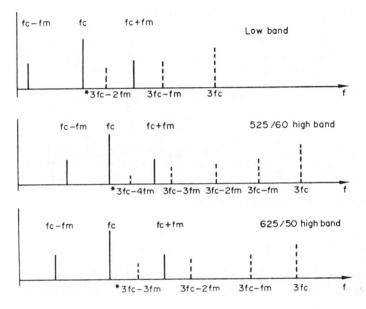

* Worst in band component

Fig. 6.11. Moiré components due to third harmonic distortion.

Choosing centre frequency to combat patterning

High band. A reduction in the energy of unwanted components, within the pass-band, can be made by increasing the centre frequency thus causing the folded sideband to reduce in frequency and the sidebands of the harmonics to increase in frequency out of the passband.

The advent of colour, with its large amplitudes of high frequencies, and the improvements in the upper frequency limit of tape systems, led to the development of the highband standard where the centre frequency was chosen as high as possible within the limits of the system.

It has been seen from calculations that for the lowband standard the worst interfering folded sideband is the second lower sideband of the fundamental while for the highband it is the third lower on 625/50 with a 4.43 MHz subcarrier and the fourth lower on 525/60 with a 3.58 MHz subcarrier.

The energy decreases with the order of the sideband (see Appendix 10).

It can also be seen from Fig. 6.11 and the following calculation that for the lowband standard the worst interfering sideband (due to the third) harmonic) is the second lower sideband of the third harmonic. On highband the worst sideband is the third lower of the third harmonic on 625/50 systems and the fourth lower of the third harmonic on 525/60 systems.

```
625/50 Hz Colour subcarrier 4.43 MHz
   Low Band
      fm = 4.43 \text{ MHz}
     fc = 5.5 \text{ MHz} \text{ (Typical)}
      3f = 16.5 \text{ MHz} (3\text{rd Harmonic})
 1st lower SB of 3fc = 16.5 - 4.43 = 12.07 \text{ MHz} (6.57 \text{ MHz}^{\dagger})
 2nd lower SB of 3fc = 16.5 - 8.86 = 7.64 \text{ MHz} (2.14 \text{ MHz}^*)
   High Band
     fm = 4.43 \text{ MHz}
     fc = 7.8 \text{ MHz}
      3fc = 23.4 \text{ MHz}
 1st lower SB of 3fc = 23.4 - 4.43 = 18.97 \text{ MHz} (11.17 \text{ MHz}^{\dagger})
2nd lower SB of 3fc = 23.4 - 8.86 = 14.54 \text{ MHz} (6.74 \text{ MHz}^{\dagger})
3rd lower SB of 3fc = 23.4 - 13.29 = 10.11 \text{ MHz} (2.31 \text{ MHz}^*)
525/50 Hz Colour subcarrier 3.58 MHz
   Low Band
     fm = 3.58 \text{ MHz}
     fc = 5.0 \text{ MHz}
     3fc = 15.0 \text{ MHz}
1st lower SB of 3fc = 15.0 - 3.58 = 11.42 \text{ MHz} (6.42 \text{ MHz}^{\dagger})
2nd lower SB of 3fc = 15.0 - 7.16 = 7.84 \text{ MHz} (2.84 \text{ MHz}^*)
   High Band
     fm = 3.58 \text{ MHz}
     fc = 7.9 \text{ MHz}
     3fc = 23.7 \text{ MHz}
1st lower SB of 3fc = 23.7 - 3.58 = 20.12 \text{ MHz} (12.22 \text{ MHz}^{\dagger})
2nd lower SB of 3fc = 23.7 - 7.16 = 16.54 \text{ MHz} (8.64 MHz†)
3rd lower SB of 3fc = 23.7 - 10.74 = 12.96 \text{ MHz} (5.06 MHz†)
4th lower SB of 3fc = 23.7 - 14.32 = 9.38 \text{ MHz} (1.48 \text{ MHz}^*)
```

Frequencies on demodulated signals in brackets.

Shelf working. It was shown by Felix in 1965 that there is an optimum value for the centre frequency. This can be seen in Fig. 6.12. If fc is increased, the

3rd Harmonic component

[†] Out of video pass-band.

^{*} Worst in-band interference component.

moire due to the third harmonic has a descending step function, reducing as each lower sideband falls outside the pass-band, thus causing the next lower sideband to be the worst interference. Before an unwanted component drops out of the passband its effect becomes greater due to the triangulation noise spectrum, thus causing an increase in moiré prior to a rapid decrease. The net result is that fc should be chosen as high as possible and then reduced to

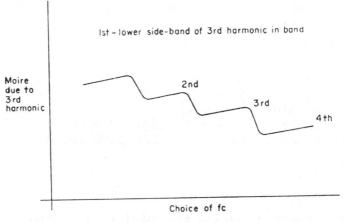

Fig. 6.12. Shelf working.

a minimum trough. This is called 'shelf working' and the 625 High Band standard operates on the third shelf with moiré components about 32dB down on the peak-peak subcarrier. From previous calculations it can be seen that, owing to the lower frequency subcarrier of 3.58 MHz the 525/60 Hz standard operates on the fourth shelf with moiré components about 40dB down.

Pilot tone and chroma pilot

An additional requirement in video recording, and in particular in colour video helical recording, is to record a colour subcarrier reference as a pilot tone or chrominance information on a pilot carrier with the FM signal. So that the pilot tone does not interfere with the FM signal, it must either be placed above the FM band or below it. It has already been shown that it is important to place the FM band as high as possible, so it is expedient to place the pilot below the FM signal. If a pilot is added to the FM signal, it must be ensured that cross-talk between the two signals is minimal. A typical example is shown in Fig. 6.13 where the chrominance signal modulates a $562.5 \, \text{kHz}$ pilot and is added to the FM signal. To keep the two signals separate, the chrominance signal is bandwidth restricted to $0.5 \, \text{MHz}$ allowing the upper sideband to extend to about $1.1 \, \text{MHz}$. The black-level centre frequency is $3.36 \, \text{MHz}$ allowing space for a luminance frequency up to $2.26 \, \text{MHz}$. In practice, owing to the low energy in the luminance signal above

2 MHz, the bands can overlap slightly allowing a luminance bandwidth up to 2.7 MHz. The chrominance information can be an AM signal and distortion is minimised by the presence of the FM signal which acts as an HF bias.

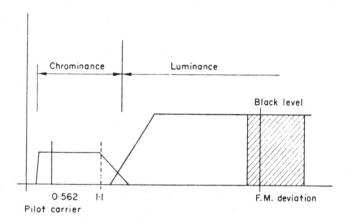

Fig. 6.13. Addition of pilot frequencies.

Response requirements for the signal system

The EBU define the ideal recording chain as:

- 1. A modulator having a flat frequency response with respect to the modulating video frequencies.
- 2. An RF section having a transfer characteristic such as to produce constant amplitude alternating flux emanating from the video head pole tips when driven by an alternating signal from the modulator having constant amplitude.
 - 3. A video pre-emphasis network inserted before the modulation stage.

The playback chain should contain:

- 1. A compensator for phaseless high frequency losses due to resolution of the tape, spacing loss, thickness loss, self-demagnetisation and gap effect.
- 2. A compensator for losses due to head and pre-amplifier reactive components.
- 3. A low pass filter with a linear fall-off in frequency response (noise reduction).
- 4. A demodulator with a linear response, producing an output amplitude proportional to frequency deviation.
 - 5. A video low pass filter to remove out of band components.
 - 6. A de-emphasis circuit following the demodulator.

The ideal signal path is shown in Fig. 6.14 and the frequency response from the output of the modulator to the input of the linear filter should be flat. The phase response should also be linear.

Specification of pre-emphasis

Equalisation has already been covered in the section on fundamentals and the requirements for pre-emphasis are very similar. The circuits should be simple, passive and easy to specify.

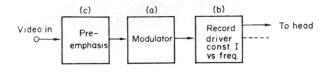

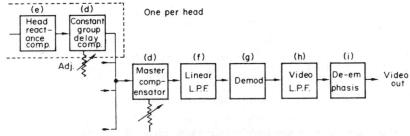

Fig. 6.14. The ideal signal path for a VTR.

The pre-emphasis is defined by the frequency and phase characteristics of a network such as that shown in Fig. 6.15, fed from a low-impedance source and feeding a high impedance load. The components can be specified by

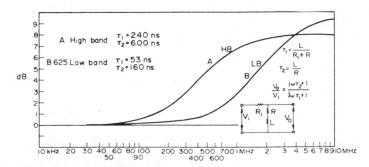

Fig. 6.15. Pre-emphasis curves.

two time constants and the attenuation can be calculated from the following relationship:

$$v_i = v_0 \frac{R + j\omega L}{R_1 + R + j\omega L}$$

$$\frac{v_0}{v_4} = \frac{j\frac{\omega L}{R} + 1}{\frac{j\omega L}{R + R_1} + 1} \times \frac{R + RI}{R}$$

$$v_0 \quad j\omega T_2 + 1 \dots T_1$$

$$\frac{v_0}{v_i} = \frac{j\omega T_2 + 1}{j\omega T_1 + 1} \times \frac{T_1}{T_2}$$

For low frequencies $\omega \to 0$

$$\frac{v_0}{v_i} = 1 \times \frac{T_1}{T_2} = \frac{R}{R_1 + R}$$

For high frequencies $\omega \to \infty$

$$\frac{v_0}{v_4} = \frac{j\omega T_2}{j\omega T_1} \times \frac{T_1}{T_2} = \frac{T_2}{T_1} \times \frac{T_1}{T_2} = 1$$

The high frequencies therefore are boosted by a factor of $\frac{T_2}{T_1}$.

If the output is specified referenced to the low frequency attenuation then

$$\frac{v_0}{v_i} = \frac{j\omega T_2 + 1}{j\omega T_1 + 1}$$

Conclusion

The technique of FM in recording has evolved to a stage where most of the limitations are in the choice of deviation, centre frequency, modulating frequency and pre-emphasis. These have been chosen to provide the minimum distortion. Further improvements can be gained only by a further change in standards when the system limits will allow. A pulse code modulation may provide the answer or possibly a super high band. An improvement in heads and tape will allow either an increase in centre frequency with its moire improvements or a reduction in head speed for the same response capabilities. The market has accommodation for both improved quality for the broadcaster and greater simplicity, packing density and economy for the educational/domestic user.

References

- FELIX, M. O., WALSH, H., FM systems of exceptional bandwidth. Proc IEE, Vol. 112, No. 9, Sept. 1965.
- CHERRY, E. C., The transmission characteristics of asymmetric-sideband communication networks. *JIEE*, 1942, 89, Pt. III, p. 19.
- TOOMS, M. S., Moire effects in the reproduction of TV signals by VTR machines. RTS Journal, vol. 13, No. 1, Jan. 1970.
- 4. FAGOT AND MAGNE, Frequency Modulation Theory. Pergamon Press.
- 5. VAN DER POL, B., The Fundamental Principles of FM. Proc IEE, 1946, 93, Pt. III.

7 Signal Systems

The signal system of a VTR is the section of electronics which modulates the video signal and provides enough drive current for the video head(s). During playback it amplifies the small e.m.f. induced in the head, compensates for losses or deficiencies in the signal and demodulates the RF signal back to video. It does not constitute the complete signal path but just the part that is the minimum requirement in any recorder.

The system has three modes of operation: Record, Playback and Standby,

sometimes referred to as Electronic-Electronics (E-E).

During standby and record, the playback electronics are switched to the output of the modulator. This is useful as a visual check on the major portion of the record electronics and can also be used in alignment of the modulator and demodulator. During playback the input to the demodulator is switched to the output from the playback head(s).

Record electronics

The main elements of a record section are shown in Fig. 7.1. The AFC is optional and is a requirement only for colour signals. An adjustment of input video level determines the frequency deviation whilst the clamp potential, changing the d.c. level of the video signal, sets the black level frequency. The pre-emphasis circuit is a simple CR network composed of high tolerance passive components.

Frequency modulators

The centre frequency of the modulator is chosen to suit the line standard and the response of the record-playback process. It normally, however, lies

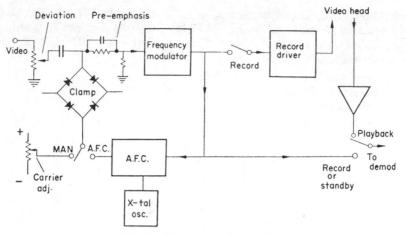

Fig. 7.1. The record electronics.

somewhere between 3.5 MHz and 8.5 MHz. The deviation from centre frequency is also a design variable which is of the order of 1 MHz. The problem therefore is to design an oscillator which can be deviated by at least 12%. The deviation frequency should have a linear relationship with input voltage up to the highest input frequency. Conventional 'reactance oscillator'

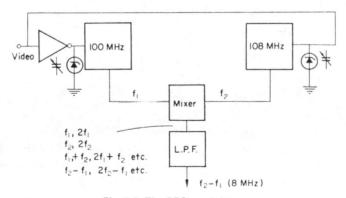

Fig. 7.2. The BFO modulator.

circuits produce a linear deviation only when the change in oscillator frequency is less than 0.5%. Two methods of modulation are most commonly used: the beat frequency reactance oscillator and the A-stable multivibrator.

Beat frequency reactance oscillator. The arrangement of two reactance oscillators shown in Fig. 7.2, can be used to produce the required deviation linearly.

The two modulators are off-set by the required centre frequency and deviated in opposite directions. When the input voltage is zero volts the

wanted intermodulation product, $f_2 - f_1$, would be 108 MHz - 100 MHz = 8 MHz, in the example shown. An increase in voltage causes f_1 to reduce and f_2 to increase. If the sensitivity of each oscillator is 1 MHz/volt then an increase of 0.5 volts causes

 $f_2 - f_1 = 108.5 - 99.5 = 9$ MHz. a deviation of 1 MHz. For a decrease of 0.5 V. $_2 - f_1 = 107.5 = 7$ MHz.

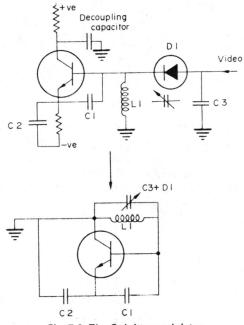

Fig. 7.3. The Colpitts modulator.

Linearity is good, owing to the low deviation, only 0.5% of the oscillator frequency. It is also improved by the cancellation of square law non-linearities. The output of each oscillator can be represented by

$$f_1 = K - \alpha v + \beta v^2$$

$$f_2 = K' + \alpha v + \beta v^2$$
where $K = 100 \text{ MHz}$

$$K = 108 \text{ MHz}$$

$$\alpha = 0.5 \text{ MHz/volt}$$

$$\beta = \text{square law coefficient.}$$

$$f_2 - f_1 = K' - K + 2\alpha v$$
cubic and odd law coefficient add square and even law coefficient cancel

A Colpitts oscillator with a varactor diode as a reactance control, Fig. 7.3, forms an excellent modulator for one of the two required. The second modu-

lator can be made to operate in the opposite direction by reversing the varactor diode. It is important that the two modulators are identical in all other respects so that the magnitude of **th**e square law coefficients are equal. The a.c. equivalent diagram shows the varactor diode shunting the inductive element that is connected between the collector and base.

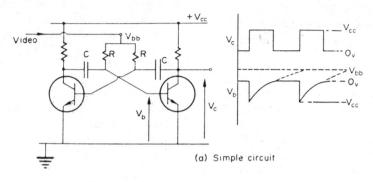

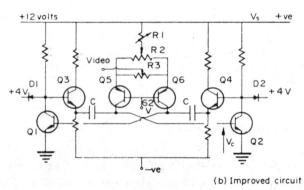

Fig. 7.4. The A-stable modulator.

A-stable multivibrator. This form of modulator provides an extremely popular method of producing FM, particularly in CCTV applications, as it has a small number of components compared to the BFO.

The multivibrator shown in Fig. 7.4(a) has a frequency of oscillation dependent on the time constants CR and the aiming potential Vbb. If the modulating signal is Vbb, the instantaneous frequency of oscillation is a function of the amplitude of the modulating signal. The simple circuit however has two main drawbacks. First, the frequency deviation is not proportional to the voltage Vbb but has an exponential relationship, as seen in the waveform on the base of either transistor. Secondly it is difficult to produce the ideal fast rise times on the collector waveforms owing to the integrating effect of the coupling C, discharge resistor and the base input

impedance of the opposite stage. This also is a limiting factor on the highest

frequency of oscillation.

The problems are solved by modifying the simple circuit to that shown in Fig. 7.4(b) involving 6 transistors. Q1 and Q2 are the multivibrator transistors. The coupling however is via the emitter followers Q3 and Q4, which provide a high input impedance to the collectors of each transistor and a low output impedance to the base circuits. This greatly improves rise times. The rise times are further improved by limiting the collector excursion to +4 volts by means of diodes D_1 and D_2 . Linearity is improved by providing constant current sources to discharge the coupling capacitors. The value of this current determines the rate of discharge and hence the frequency (see Appendix 13). The standing current is determined by adjustment of R₁ (frequency). To compensate for differences in transistor and component values R2 (static balance), is adjusted for an equal mark space ratio at the centre frequency. This ensures minimum second harmonic in the resulting waveform. R₃ (dynamic balance) ensures that symmetry is maintained at extremes of frequency deviation. R4 adjusts the sensitivity of the modulator in terms of the frequency deviation caused for an input voltage change. The output is taken as a push-pull signal from the two emitter followers thus ensuring a symmetrical loading. To align the symmetry of a multivibrator as accurately as mentioned creates a condition where, on switch on, the device will not commutate. Both transistors come on and stay on. Safety circuits are sometimes added to momentarily unbalance the device should this occur. A second method of achieving symmetry is to design the modulator to operate at twice the centre frequency and dividing down by two to produce the correct frequency.

Automatic frequency control

Automatic frequency control of the modulator can be used to control the black level frequency to within very close limits. The AFC control voltage can be used to adjust the clamp reference and alter the d.c. level of the video before modulation.

The control voltage can be derived by comparing the frequency of the modulator, produced during the back porch time of the input video, with a reference crystal oscillator tuned to the correct black level frequency. One method of comparison is shown in Fig. 7.5. The black level crystal oscillator output is passed except at back porch time when the modulator output is gated through. This signal is then demodulated. If the crystal frequency and back porch frequency are the same, the demodulator output would be a fixed d.c. level. If the back porch frequency is high, the demodulator output would be a pulse whose amplitude would be a measure of frequency difference. The polarity of this pulse is arranged to be negative and is applied as a clamp reference potential reducing the d.c. level of the video and thus the back porch frequency. A positive pulse would result from a low back porch frequency.

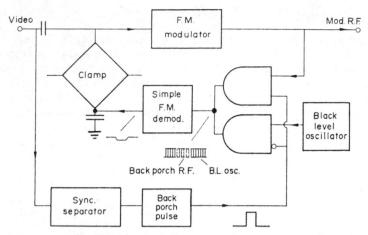

Fig. 7.5. Automatic frequency compensation.

Record driver

The record driver is required to switch on the *RF* to the video heads when required, pre-equalise to compensate for the head inductance and losses, provide for individual adjustment of the *RF* to each head (if there is more than one), and provide enough head current to saturate the tape. During normal record the same *RF* is applied to all heads simultaneously and no attempt is made to switch the *RF* to individual heads. The arrangement shown in Fig. 7.6 illustrates how the major portion of the record driver can be common to all outputs. The optimisation controls and all circuitry following are separated to allow for individual adjustment of record level. This will vary with the efficiency of each head. Adjustment is normally made to just saturate the tape. Full advantage of the tape remanence would not be made if a level below this optimum were used and any level above it would tend to demagnetise short wavelengths on tape.

The record equalisation is quite complex and is designed to produce a constant current over the complete frequency spectrum. The video head is basically inductive which means that if the final output stage has a low output impedance (a constant voltage source) the current through the head will tend to fall off at high frequencies. A simple equivalent circuit is that shown in Fig. 7.6. The shunt capacity has been ignored which is permissible if the source impedance is low compared with Xc (see Appendix 11).

The series resistance *Rh* represents the winding resistance and losses due to hysteresis and eddy currents. Its value is complicated by the fact that it increases with frequency. The high frequency fall off is compensated for by an equivalent high frequency boost. It is achieved in the circuit shown by selective feedback in the form of an emitter impedance. The adjustments are normally pre-set. The gain approximates to:

Gain =
$$\frac{Rc}{Ze}$$
 where Ze reduces with frequency

Optimisation

The record current can be set to optimum most simply by increasing the level during record and noting the level on the audio track. On playback the e.m.f. from the head can be monitored and the point where any increase in record current fails to cause an increase in playback e.m.f. must be the onset of saturation which is optimum. The technique is simple but time consuming particularly if more than one head needs adjustment. The current also needs regular adjustment as the head wears.

Multiheaded machines can be arranged to make the process easier by allowing a combination of record and playback as in Fig. 7.7.

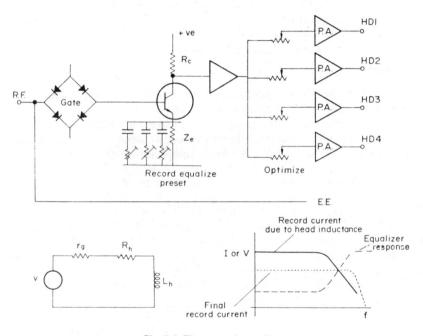

Fig. 7.6. The record equaliser.

If the record is only gated on when one head is in contact with the tape, the following head can be allowed to play back that track. This permits continuous monitoring of a record current and saves time in rewinding and replaying. Record current can then be adjusted until the e.m.f. induced in the following head reaches optimum. The capstan speed obviously needs reducing to allow the playback head to scan the recorded track. For a quadruplex machine the speed is reduced to $\frac{1}{4}$ while for a two-headed machine it is reduced to $\frac{1}{2}$ speed.

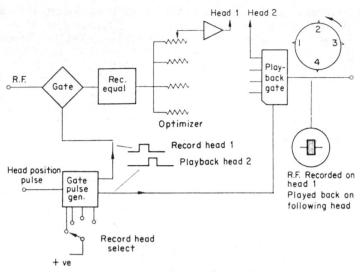

Fig. 7.7. The record current optimise mode on multi-headed VTRs.

Colour optimisation. On colour recordings optimisation is more critical owing to the importance of the frequency response on differential gain. A vernier adjustment is sometimes made in the following way.

- 1. A standard recording is made to which all other recordings are made to match.
- 2. The playback adjustments are made on the playback of the standard recording to obtain the best frequency response and differential gain.
- 3. A recording is made on the blank tape and the frequency response and differential gain are checked.
- 4. Record current is then adjusted (*note*: playback settings must not be readjusted) to obtain the best response and DG.

If this is done and checked regularly all recordings should be consistent.

Playback

The equivalent circuit for a head during playback can be seen in Fig. 7.8. By good design Lh and Ch are made low enough to produce a resonance well above the frequency limit of the system. Resonance between Lh and Cin, the input capacity to the pre-amp, however will occur between 8–12 MHz. If Rin, the input impedance to the pre-amp, is high, this series resonance

produces a peak within the passband. If Rin is low compared with $\frac{1}{jwCin}$ then the effect of Cin can be ignored and the circuit will have a fall off at high frequencies due to Lh.

In the resonant case *Lh* varies from head to head and also on the same head as it wears so that if high impedance pre-amps are used the resonance must be compensated for and operational controls must be provided for alignment.

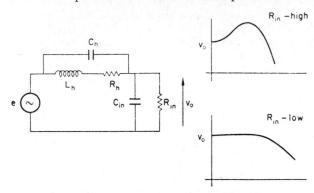

Fig. 7.8. Head equivalent circuit in payback.

High input impedance amplifier

Compensation for the head constants is achieved in two separate circuits (see Fig. 7.9). The high frequency fall off is first improved with a simple *CR* differentiating network. The resonant peak is then cancelled using a tuned circuit in the emitter of an amplifier. At resonance the gain of the stage is

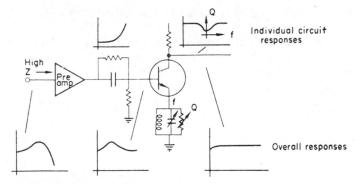

Fig. 7.9. Compensation of head constants with high input impedance.

sharply reduced as the emitter impedance increases. The f and Q are operational adjustments to exactly cancel the resonance in amplitude and frequency. As the video head wears then a re-adjustment is required. The method of adjustment involves sweeping the head and playback electronics by inducing RF into the head windings using a small coupling loop and adjusting the f and Q controls. The Q is sometimes later adjusted for best differential gain. The advantage of the high impedance pre-amp is this ability of differential gain compensation. Its disadvantage is the extra sweep alignment.

Low input impedance channel amplifier

The low input impedance channel amplifier has the advantage of being less dependant on the head constants. A single differentiating circuit is all that is required to compensate for high frequency fall off (see Fig. 7.10). This can be constructed of fixed passive components, with no requirement for operational adjustment. Such a simple arrangement does not allow for slight

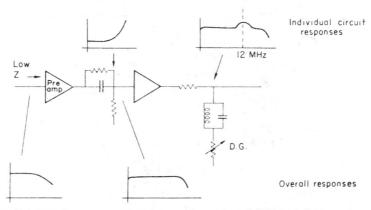

Fig. 7.10. Compensation of head constants with low input impedance.

corrections that may be required for differential gain matching. For colour operation therefore a peaking circuit tuned to resonate at around the upper sideband due to colour subcarrier at black level is used to create a slope at higher luminance levels. The amplitude of the peak is used operationally to provide the best differential gain.

Equalisers

The object of the playback equaliser is to compensate for high frequency losses due to finite gap length, tape resolution, spacing loss and tape thickness loss. These losses are different from head constant compensation because the frequency response does not have an accompanying non-linear phase response. High frequency boost therefore must have a linear phase response or constant 'group delay' for frequencies within the pass band. For optimum performance it is desirable to have control of the amount of equalisation to allow for variations from tape and also an individual control for each head. The simplest arrangement, for a quadruplex recorder, is that shown in Fig. 7.11(a) where five equalisers are used. One is used for each head and one as an overall adjustment affecting all four outputs which is adjusted to obtain a flat response. For a two headed machine such an arrangement would require three separate equalisers. A more economical method is that shown in Fig. 7.11(b) where advantage can be taken of the fact that only one head output is being used at any time. The first equaliser affects all outputs similarly, but the second equaliser has its adjustments switched as each head is selected in turn. Only two equalisers are therefore required irrespective of the number of heads. Such systems are in use but suffer from increased switching transients due to the additional switching of the equaliser control voltage.

For quadruplex recorders a third alternative, using three equalisers as shown in Fig. 7.11(c) overcomes the switching transient problem. The first

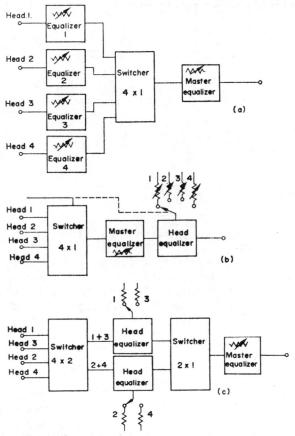

Fig. 7.11. Multi-head equaliser arrangements.

switcher combines opposite heads in a 4×2 operation. Two equalisers can now be used with an arrangement to switch the control between two adjustments for each equaliser. The final switcher combines the signal in a 2×1 operation. The third equaliser operates on all head outputs to adjust overall frequency response.

The cosine equaliser

The circuit shown in Fig. 7.12 has all the parameters required to equalise for losses in the tape transfer process. It has a constant group delay which is 124

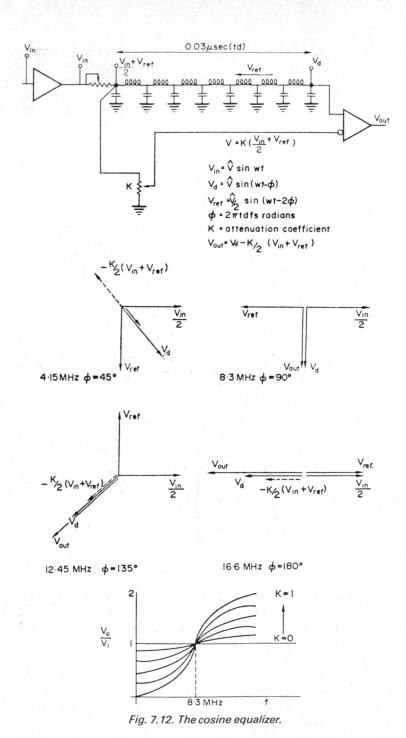

constant for all settings of the potential divider K. It operates about a turnover frequency, determined by the length of the delay line. Frequencies above the turnover frequency are amplified by an amount determined by the setting of K while those below the turnover frequency are attenuated. The delay line is unterminated at its output and correctly terminated at its

input.

The output of the delay line is the input signal delayed by the line (V_D) . This is applied to one input of the differential amplifier, the other input being a fraction of the combined input and reflected signal. The length of the delay line depends on the frequency characteristic required but typically for a high band standard it would be $0.03~\mu$ secs giving a turnover frequency of 8.3~MHz. The delay line being a $\frac{1}{4}$ wavelength or 90° at this frequency. The phasor diagrams at various spot frequencies are shown in Fig. 7.12(b). At 8.3~MHz, the turnover frequency, the reflected signal is in anti-phase with Vin causing complete cancellation at the input of the delay line. The output of the equaliser at this frequency equals Vin delayed by the line with the potentiometer having no effect.

Examination of the phasor diagrams at other frequencies shows that above the turnover frequency the output is greater than Vin, increasing with K and below the turnover frequencies the output is smaller decreasing with K. Further examination will show that the group delay is constant and equal to the delay of the line, irrespective of the setting of the potentiometer. This is important to avoid mis-timing similar to quadrature error. The final response is that shown in Fig. 7.12(c) which gives a cosine shaped response. Appendix 12 shows the full analysis. The adjustment of the potentiometer (K) becomes the operational control for individual equalisers and is adjusted for best response on the demodulated signal when playing back. The variable resistance on the input to the delay line is set to remove further reflections up

and down the line.

Switchers

On multiheaded video recorders, the outputs from the heads can simply be added. If this is done, however, a deterioration in signal/noise ratio results because only one head contributes a useful signal and all heads contribute noise. Also if two FM signals are mixed during the overlap period, any phase differences result in a beat pattern between the two signals. A hard switch therefore is preferable allowing only one output to pass at any instant in time.

The action of switching inevitably produces a transient which can be objectionable if allowed to occur during the picture period. It is normally arranged to switch during the blanking period to avoid this. On two headed machines the vertical blanking period of 25 lines (625) or 20 lines (525) allows more than enough time for switching between heads. For quadruplex machines several switches per field are required, which means the use of the horizontal blanking period with increased complexity.

Blanking switchers (quadruplex)

If, on a four headed machine, switching is made every 90° rotation of the head wheel, a transient every 15.625 lines (625) or 16.4 lines (525) would result. This means that a switch must occur during the active line period. This can be avoided by making use of the small available overlap and delaying the switching action until the horizontal blanking period. The time for a particular head playing back is therefore always a whole number of lines. It must however average the number of lines for 90° rotation of the head, as in Table 7.

Table 7

	Head number								
Line Standard	1	2	3	4	1	2	3	4	Average
625	15	16	16	15	16	15	16	16-	15-625
625 525	17	16	16	17	16			_	16.4

For 625 lines with a required average of $15\frac{5}{8}$

 $15\frac{5}{8}$ lines per head pass = 125 lines per 8 head passes.

For 525 line system with a required average of $16\frac{2}{5}$ lines

 $16\frac{2}{5}$ lines per head pass = 82 lines per 5 head passes.

The sequence therefore repeats itself every 8 head passes for 625 line/50 field systems and every 5 head passes for 525 line/50 field system.

The next problem is where to switch during the horizontal blanking period. Figure 7.13 shows the blanking period for the two main standards. It would initially seem feasible to switch at the bottom of sync. This would be away from the colour burst with an interval greater than 4 μ sec to position the switch time. This part of the waveform however cannot be used if electronic correction of the signal is to be used later on in the system.

Electronic correctors measure the timing error by comparing the leading edge of sync on the tape signal with a stable reference. This necessitates the sync edge being a timing reference for the following line. If a switch is made at the bottom of sync then the leading edge of sync is from the head preceding the following video. The trailing edge of sync could be used as a reference but this is somewhat unprofessional and can cause residual timing errors on signals from some sync pulse generators. Two solutions are possible:

- 1. Separate sync demodulation.
- 2. Front porch switching.

Separate sync demodulation. Figure 7.14 shows an arrangement with two switchers and two demodulators. One switcher for the video path switches in the bottom of sync and the other for the sync path switches in the middle of the active line period, during the previous line. After demodulation two signals are available, one with an unwanted transient in the sync and the

other with an unwanted transient in the picture period. The wanted sections of each signal are separated and combined to form a composite, transient free signal.

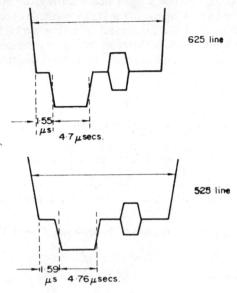

Fig. 7.13. Horizontal blanking.

Front porch switching. A more economical method, although one requiring more precision in timing, is to switch during the front porch period which can be as short as $1\cdot 2$ μ secs. Care must be taken in order to avoid distortion of the leading edge of sync, and front porch switching is normally followed by transient suppression clamping on the demodulated video.

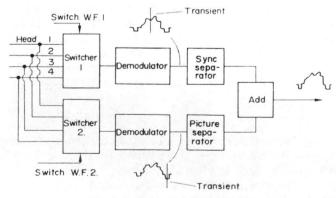

Fig. 7.14. A transient free switcher.

The stages of switching (quadruplex)

The operation of switching can either be achieved in one stage or made in two attempts to provide the required continuous RF. A switching stage is generally described in terms of the number of inputs and outputs, a 4 by 2 switch having 4 inputs with 2 outputs. Figures 7.11a and c show two methods of achieving the same result with b having a single 4×1 switch and c having two separate switches of a 4×2 followed by a 2×1 . The switching waveforms required by both methods are very similar and are derived from the head position pulse and a front porch clock pulse.

Switch waveform generation (quadruplex)

Basically three waveforms are required to perform the switching between four heads. Combinations of the three waveforms are sometimes derived for the various switching configurations and inverted versions of the waveforms maybe used. The head position pulse is formed into a 250 Hz (240 Hz on 60 Hz systems) square wave with transitions when heads number 1 and 3 are in the centre of the tape. This waveform can be used in a slow switch to combine heads 2 and 4. The second waveform is a delayed version of waveform 1 and is used to combine heads 1 and 3.

The slow switch requirements are quite modest because the switching action takes place during the 1 msec space between the opposite head outputs. The final switch waveform is the fast switching action which must occur during the front porch period with the minimum possible transient. The mean frequency of this switching waveform will be 500 Hz (480 Hz on 60 Hz systems) with the fast edges clocked to the front porch time of the demodulated video.

The timing of this fast switch waveform must be locked to the head position and then timed to the following front porch. The most convenient method of achieving this is to use a 1kHz (960 Hz on 60 Hz) AFC locked oscillator, locked to the head position pulse, as seen in Fig. 7.15. The output frequency is then re-timed to the front porch switch time by means of a

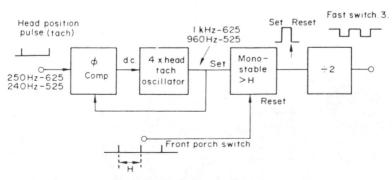

Fig. 7.15. The fast switch generator.

mono-stable which is triggered in both directions. It is set by the AFC

oscillator output and re-set by the FP switch.

The circuit does not operate as a mono-stable unless a reset pulse is missing. By setting the relax time to an amount slightly greater than 64 μ secs a switcher 'lock-out' can be avoided. Without this safety factor a situation might arise where a front porch pulse, which is derived from the video, cannot occur until a switch is made and a switch cannot be made until a front porch switch occurs. The mono-stable relaxing enables the switch to occur and start the correct sequence.

Generation of front porch switch

The front porch switch must be derived from the tape video and the switching action must take place on the FM signal before demodulation. The circuit delay between these two points would be in the order of 3 μ sec, the greatest delay being in the integration filter following the demodulator. A pulse therefore must be derived from the leading edge of sync to place the switch about 0.75 μ sec on the front porch of a signal in advance by 3 μ sec. The timing of this pulse therefore has to be 3.75 μ sec in advance of the leading edge of sync and variable to allow for changes in integrating filters when standards are altered. One method of producing this would be to delay the preceding sync pulse by 60.25 μ sec (59.75 μ sec on 525/60). Such an arrangement would create large errors for small changes in the 60.25 μ sec delay or input line time.

A more accurate method, which compensates for slight timing changes, is to introduce a delay into a line frequency AFC oscillator loop Fig. 7.16. The

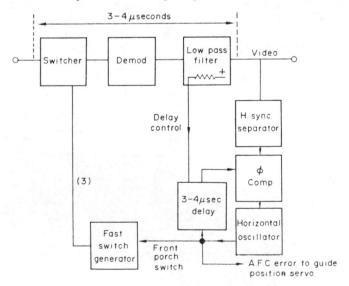

Fig. 7.16. The front porch pulse generator.

oscillator phase settles down to a stable condition where the two inputs to the phase comparator are synchronous to within close limits. The signal at the input to the 3 to 4 μ sec delay therefore must be in advance of the tape reference input. This is substantially true for all input line times, once the oscillator has locked in. The circuit lends itself to changing the advance in timing and preset resistor can be incorporated in the demodulator integrating filter which will set the timing correctly for the delay of that filter.

The elements of the circuit also provide a convenient measure of timing error caused by vacuum guide positional errors and a d.c. correction voltage

for a guide position servo can be derived.

Demodulation

The disadvantage with using more conventional frequency discriminators, such as the Foster Seeley or Ratio detector on VTR FM signals is the problem of linearity over such a wide deviation. Such circuits provide excellent performance at centre frequencies of 10.7 MHz, deviations of ± 75 KHz and audio modulating frequencies. With deviations of ± 1 MHz it is difficult to provide the linearity, and at modulating frequencies comparable to the centre frequency it is difficult to separate the RF from the video.

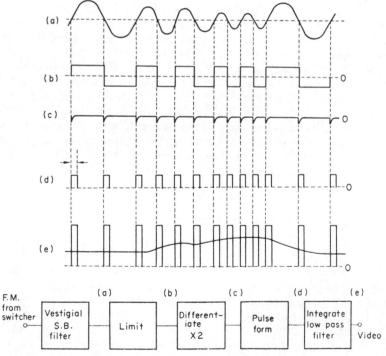

Fig. 7.17. The pulse counter demodulator.

The discriminator which is most suitable and is used almost to the exclusion of all others is the 'pulse counter' type. The technique is to detect the zero cross over points of the modulated signal and determine the pulse repetition rate of the resulting pulse chain. The signal path of the complete demodulator can be seen in Fig. 7.17. Amplitude modulation is removed by limiting and several stages may be necessary to achieve this. At least 50 dB of limiting is required to provide an output square wave signal whose edges are unaffected by input amplitude changes. The edges are detected by differentiating the square wave. Simple differentiation would result in negative and positive spikes. If the negative spikes were removed by clipping the resultant pulse chain would have the fundamental frequency of the FM signal.

The pulse repetition frequency is determined by integrating, by means of a filter, to produce a signal whose amplitude is proportional to the input frequency. The response of the filter should be such as to pass all frequencies up to the highest video frequencies and stop all frequencies down to the lowest *FM* centre frequency (i.e: sync tip). For the low-band standards this would place an intolerable design constriction on the low pass filter, because for 625 low-band the sync tip frequency is 5·16 MHz with the highest video frequency being 5·00 MHz. Such a sharp cut-off is obviously impractical. One solution is to frequency double the pulse repetition frequency by inverting the negative spikes and adding them back to the positive spikes.

The lowest *PRF* is now twice that of the lowest carrier frequency.

The spikes are sometimes shaped to provide greater energy, but the maximum pulse width is limited to less than half the periodic time of the highest carrier frequency. Care must be taken to ensure that the pulse amplitude of the inverted pulses match those of the non-inverted. Failure to do this would result in a residual carrier component. An adjustment is normally available called 'demodulator balance' which is set for minimum carrier on the bottom of sync. The symmetry of the pulses is also important and is normally determined by the operating point of the limiter. If this is not about the zero axis of the input sine-wave, an unequal mark-space ratio would also cause a resultant carrier at the bottom of sync. An adjustment of 'limiter balance' is also very often provided.

Methods of producing twice frequency pulses

Figure 7.18 shows three methods of producing twice frequency pulses and ensuring equal amplitude pulses. In circuit (b) the differentiated pulses are phase split, using a centre tapped transformer. The pulses are clipped by means of a transistor which is biased to turn off during the most positive excursions of its base signal. The emitter capacitor charges to a positive value holding the transistor off until the next positive excursion. The differential capacitor is adjusted for equal amplitude pulses on the output.

An alternative approach is that shown in (a) and (c) where the square wave is split into two phases prior to differentiation. In (a) the simple differentia-

tion circuits are balanced by altering the capacitive element of one circuit. In (c) differentiation is achieved by means of a short circuit delay cable to provide well defined pulses, and the balance is effected by adjusting differentially negative bias on the push–pull pulses before the diode clipping circuit.

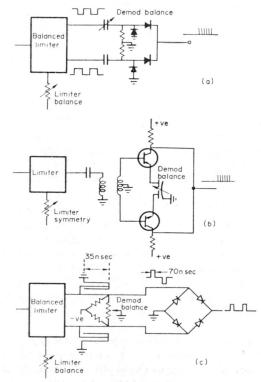

Fig. 7.18. Methods of frequency doubling.

Switch suppression and feedback clamping

The output circuit of the signal system is required to reduce the d.c. level of the video, suppress the unwanted front porch transient and apply deemphasis. Figure 7.19 shows how this may be done. The transient is suppressed by switching on Q1 and applying a ground potential to the video signal during the front porch period. To avoid a transition, either positive or negative, in the signal when this occurs the signal d.c. level is arranged to place the blanking level at zero volts. The feedback clamp ensures this for all input d.c. levels and the d.c. level changes in the input amplifier. The d.c. level of the signal from the integrating filter depends on the average centre frequency of the *FM* signal, this being higher for high band standards. The back-porch voltage is sampled and held for the line period. This d.c. voltage

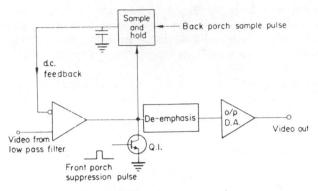

Fig. 7.19. Transient suppression.

is inverted and added to the video signal to provide d.c. negative feedback and restore the d.c. level of the signal.

Drop-out compensation

The reasons for random drop-out are manifold but in general they result from the head and tape parting company and causing a loss in RF. The loss in RF causes a burst of noise or impaired video signal which at best produces a subjective annoyance and at worst can cause a false sync or elimination of a sync edge or colour burst. One definition of a 'drop-out' is: loss of RF level of more than 20 dB for at least 3 μ sec. The compensation for drop-out requires two separate functions: the detection of a drop-out and the sub-

stitution of an alternative signal.

Figure 7.20 shows a drop-out compensator operating on the RF of a playback signal; it is inserted between the switcher and demodulator. The delay line is a quartz one line delay. The principle is that two consecutive lines of a video signal have very similar information and when a drop-out is detected the output of the delay line is switched to the input of the demodulator, this repeating the RF from the previous line for the duration of the drop-out. The drop-out is sensed by amplitude detection of the RF envelope and the sensitivity of the device is set by the input level. Some form of hysteresis is necessary to avoid marginal signals switching the one line delay in and out and causing a worse impairment of the signal with the switching transients.

Once the signal has fallen below the threshold and has been classified a drop-out, the signal must increase by an amount, equal to the hysteresis, before being redeemed. This can be done by attenuating the input signal

during 'drop-out' time. Typically 9 dB of hysteresis is used.

The advantage of connecting the input of the delay to a position after the drop-out switch is that for drop-outs greater than one line the RF is re-circulated and the last good line repeated. The advantage of inserting the compensator in the existing RF section is mainly economic because the frequency

band is quite suitable for quartz delay and it saves separate modulation and demodulation. The disadvantage is that switching transients, as the delayed signal is inserted and removed, are larger than if the switching was done on the video signal. A second disadvantage is that it is difficult to separate the luminance and chrominance information. This is desirable for the correction of PAL colour signals where the chrominance information from one line

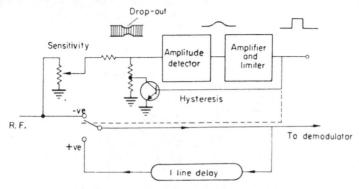

Fig. 7.20. The drop-out compensator.

would not be suitable for the following line, owing to the reversal of the V axis. For correct PAL compensation two lines of delay for the chrominance are required while one line for the luminance is satisfactory. Figure 7.21 shows a compensator inserted after the demodulator. A second modulator/

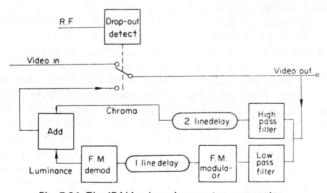

Fig. 7.21. The 'PAL' colour drop-out compensator.

demodulator is required for the luminance channel to obviate the problem of poor *LF* response in the quartz delay. With switching transients of less than 20 nsecs on the video signal resulting transients can be imperceptible.

Auto-equalisation

The frequency response on playback is obviously more critical for colour signals than for monochrome. A colour signal however has a reference

chrominance amplitude in the form of 10 cycles of subcarrier, on the back porch, of known amplitude. The equalisation on playback could be adjusted to set this burst to its specified level and could also be done automatically. With four heads, obviously a separate adjustment for each would be required, and a head auto-equalisation can be seen in Fig. 7.22. The burst on the output of the demodulator is amplitude detected and its voltage level stored on one of four capacitors, one for each head. If the stored voltage is low, owing to a

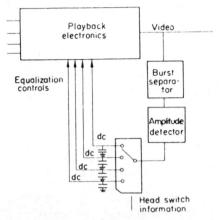

Fig. 7.22. Head by head automatic equalisation.

low amplitude burst, it causes that channel equaliser to correct the response until the output burst level is correct. It should be noted that the burst is normally at blanking level and therefore the auto-correction only maintains correct chrominance level at black. If differential gain is present in the system,

a chrominance error can still exist at higher luminance levels.

The charge on an individual capacitor is the average value of several head passes, which gives good noise immunity although a sluggish response. One disadvantage is that such a system cannot compensate for response changes as the head scans across its track. These response changes can be caused by thickness variations in tape oxide or a maladjusted vacuum guide causing head penetration errors. Another system is to have a line-by-line adjustment of equalisation with a capacitor store for every line from each of the four heads or 64 stores (68 on 525 line systems). The store indexing is more complex, although most of the computing electronics is already available in the velocity error compensator. The disadvantage is in determining the integration time constant which is a compromise between noise immunity and speed of operation. The amplitude of an individual burst cannot be guaranteed accurate, owing to noise, moire and drop-out. The larger the number of bursts over which the correction voltage is made the more accurate is the result. If 150 bursts are thought to give a good compromise, it would take the capacitor ten head passes on a head by head or 40 msec (41.6 msec on 525/60). On a line by line it would take 150 passes or

600 msec to integrate the required amount. A head by head therefore has a faster reaction time for the same noise reduction while a line by line has the ability to effect changes as the head sweeps across the tape although being unable to follow other fast changes such as mistracking.

Like all good engineering solutions the best system is a compromise be-

tween the two with a head by head operating as a coarse adjustment followed

by a line by line as a vernier.

8 Servo-mechanisms

Most modern electro-mechanical devices involve servo-mechanisms and video tape recorders are no exception.

The two main control systems in a recorder are the head servo for the rotating head-wheel and the capstan servo for the linear transport of the tape. Several other smaller control loops may be used to control the vacuum guide and tape spools on quadruplex machines or the tape tension on helical

machines.

The object of the servo is to position an output shaft to the same angle as an input reference. If the input reference is set to a new potential, it is amplified to produce sufficient power in the field winding of a motor. The motor rotates and adjusts the output shaft via a reduction gear. On the output shaft is connected a feedback reference potentiometer, the output of which is fed back to a comparator, in this case a simple resistive matrix, and compared to the input reference. When the potentials of the input and feedback voltages are equal and opposite, drive to the motor ceases.

The elements described form the phase loop of the system and would suffice if the field current could be changed instantaneously and the mechanical system had zero inertia. Because of the winding inductance and the rotational inertia of the system, the output shaft would tend to overshoot its correct position. A correction voltage would cause it to return but if the loop gain is high it could overshoot again and continuously hunt about a mean position. Some form of damping is required to control the velocity or rate

of change of the output shaft.

Velocity control methods

A frictional force on the output shaft has the undesirable characteristics of stiction at small error angles and a better method is to apply a force proportional to the velocity of the output.

Velocity control can be achieved in three separate ways and the application of any one can eliminate hunting.

Viscous damping. This can be applied with an eddy current brake applying a retarding force which increases with the velocity of the disc. The power dissipated in the disc must be provided by the motor drive amplifier which can make the technique uneconomic.

Tachometer derived velocity loop. A voltage proportional to the velocity of the shaft can be derived from a tachometer and subtracted from the phase error, causing the input to the drive amplifier to be reduced when the rate of change is fast.

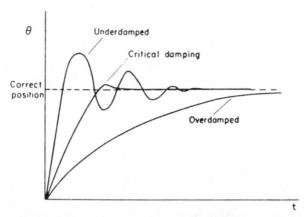

Fig. 8.1. Response with velocity damping.

Derivative of phase error. If the phase error voltage is differentiated, using reactive components, a signal proportional to $\frac{d\theta}{dt}$ or velocity can be derived without the additional tachometer. This method provides an economical way of providing a well damped servo. If several time constants are present in the system, extra loops with differing time constants may be introduced to compensate. Adjustment of the velocity gain can be made to provide critical damping of a step impulse as shown in Fig. 8.1.

If the velocity gain is too low, the underdamped condition can occur with several oscillations before settling down. A velocity gain that is too high can cause a slow reacting over damped situation. A setting of gain that gives a slight overshoot provides the fastest correction to an input command.

Servo elements

All the elements of any servo can be seen in the previous example: an input reference, a power amplifier, a motor or equivalent electro-mechanical device to provide movement, a feedback reference of output position, a comparator to determine the difference between output required and output

achieved and finally velocity feedback to control the rate of change of output position.

Rotational servos. The video head and capstan control sections of a VTR are rotational servos where there is an extra requirement for the output to be in the correct position at the correct time. The control elements are similar to the positional servo as can be seen in Fig. 8.2. The form of the reference is

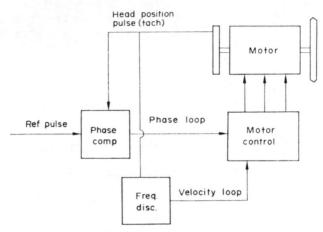

Fig. 8.2. Rotational servo.

more conveniently a timed pulse to which the motor phase and/or frequency is locked. The feedback reference can also be a pulse which is initiated from the motor shaft at a particular phase sometimes referred to as a tachometer. The motor phase can be adjusted until the reference and feedback pulse coincide. A second (velocity) loop is used to control the rate of phase change of the motor and thus avoid hunting.

Phase comparators

The object of the phase comparator is to produce a voltage proportional to the timing difference between two signals. The sample and hold circuit, operating on a trapezoid waveform, is the most common method used but can take several forms. Figure 8.3 shows three types of sample gate. The requirements of any sample gate are that when open it should allow current to flow in or out of the store capacitor with a minimum of impedance to allow the capacitor to rapidly charge up to the instantaneous voltage of the ramp and when closed provide a high impedance to avoid the discharge of the capacitor. Also a high degree of isolation from the sample pulse is required to avoid current flow due to switching. The trapezoid waveform can be derived by using one input pulse to trigger a mono-stable and applying the resultant square wave to a switching transistor. With the transistor in the saturated (ON) condition the ramp capacitor rapidly discharges. When the transistor

switches OFF the capacitor charges from a constant current source to form a ramp. The phase difference between the ramp and the sample pulse timing determines the hold capacitor voltage.

A characteristic of phase locked loops is that lock-up can be achieved when the sample pulse frequency is a sub-multiple or multiple of the ramp frequency. In such a condition a sample may only be made on every second

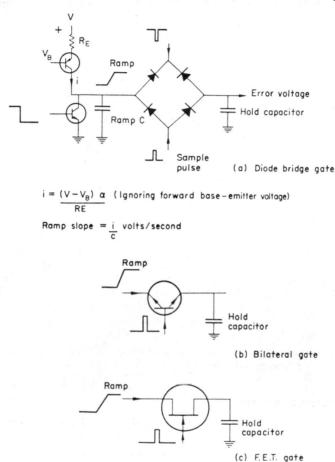

Fig. 8.3. Types of sample gate.

or third ramp. This can be an advantage if rotational speeds that are multiples of the input frequency are required although it can also cause unpredictable results. Another characteristic of phase locked loops is that they work well when the reference and feedback pulses are approximately phased. During the acceleration of the motor the sampling is random, causing a random control voltage and intermittent drive to the motor. A circuit which inhibits lock-up at odd multiples and ensures full power to the motor until the correct

velocity is achieved is the forward backward counter which can be included into the phase loop as shown in Fig. 8.4.

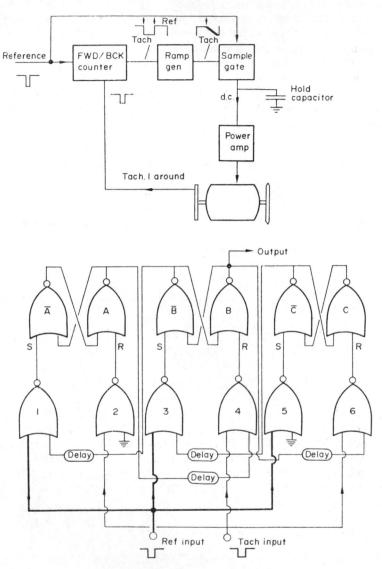

Fig. 8.4. The forward/backward counter.

The forward/backward counter

The object of the counter output is to provide a low output if the motor is overspeed, a high output if the motor is underspeed and a square-wave when 142

correct. Once the speed is approximately correct, the analogue sample and

hold circuit adjust the final phase of the motor.

Inspection of the circuit shows that it consists of three R-S flip-flops and six trigger gates. A positive pulse on the set input of the flip flop causes the true output to go high. A, B and C are the true outputs. Once set it remains set until a positive re-set pulse causes the true output to go low. \bar{A} is the inverse of A. A high output only occurs on the output of a gate (-ve AND) when both inputs go low.

If the starting condition is assumed where all the counters are re-set and the motor is not rotating, A, B and C are low and only reference pulses are

present.

Table 8: TRUTH TABLE

A	В	C REF
0	0	0
0	0	1
0	1	1
1	1	1 TACH

The flip-flops can be set by only a +ve pulse. Gates 1 and 3 are inhibited by

high outputs.

Only gate 5 will give a high output when the reference input goes low causing C to go high. This now enables gate 3 after a short delay allowing B to go high on the next reference pulse. This in turn allows A to go high on the third reference pulse. Once all set the reference pulses have no further effect until tach pulses are present. Only 4 states for the combination can now exist as shown by the truth table.

If the motor is now allowed to start, the first tach pulse will reset A, gates number 4 and 6 being inhibited. The next reference pulse sets A and the counter will keep transferring from state 111 to 011 (see truth table). The counter cannot progress to state 001 until two tach pulses occur after a single reference pulse, i.e.: the motor is just overspeed. The next reference pulse drops the counter to 011 and the counter switches between 011 and 001.

Examination of the B output reveals an alternating change of state with a transistor from high to low at tach time. This edge is formed into a ramp which

is sampled by a reference pulse.

Discriminators

The object of the discriminator is to produce a voltage proportional to the velocity or rate of change of phase of the motor.

The three most common methods of deriving this voltage are shown in Fig. 8.5, i.e:

- a. Derivative of the phase error.
- b. Pulse integrator.
- c. Comparison with timing reference.

Derivative of phase error. This provides the simplest and most economical method of deriving a velocity error, a simple CR differentiating circuit being sufficient. The only requirement for its use is that the phase comparator has locked on and is sampling correctly on the ramp. This does place a requirement on the phase loop being stable enough without the velocity loop to enable the velocity error to be derived. Such simple methods are therefore only used on systems that are stabilised.

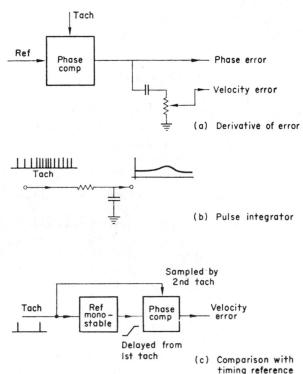

Fig. 8.5. Methods of deriving velocity error.

Pulse integrator. If the tachometer pulses are shaped to provide pulses of equal width, independent of the pulse repetition frequency, the average d.c. level of the pulse chain increases with frequency. The integration of the shaped pulses therefore provides the required measurement of velocity.

Comparison with a timing reference. If the tachometer pulse is used to trigger an accurately timed reference mono-stable, the following tachometer pulse could be phase compared with the delayed edge of the monostable. If the time between tach pulses equals the monostable period, the two inputs to the phase comparator are coincident. If the time between tach pulses is greater, lower in frequency, the tach input to the phase comparator lags the delayed input. The phase comparator output is therefore a measure of tach frequency or motor velocity.

Motor control

Several methods of motor control are available in servo design, the most common being:

- 1. Control of a d.c. supply to an eddy current brake, the motor being supplied with constant power.
 - 2. Frequency control of the a.c. supply to a synchronous motor.
- 3. Amplitude control of the a.c. supply to a motor running below synchronous speed.
- 4. Pulse width control of the a.c. supply to a motor running below synchronous speed.
 - 5. Control of the d.c. supply to a d.c. motor.

Of these, methods 1, 2 and 5 are common in CCTV helical machines while methods 2, 3, 4 and 5 can be found in broadcast quadruplex machines.

Eddy current brake. The advantage of this method is that it is inexpensive and some velocity damping is inherent in the system. Its full economic advantage can be gained if the motor is driven directly from the mains; otherwise the system is wasteful of amplifier power. Its control range is also restricted by the amount of power it is possible to dissipate.

Frequency control. A typical system using a three-phase motor can be seen in Fig. 8.6. Two phase systems or single phase systems split to provide two or three phases can also be used.

It is convenient to drive the motor with two state waveforms rather than sine-waves as this allows a high efficiency output stage, where the output drive transistors are either saturated on or off, with the minimum of power dissipation.

The three phase drive voltages are square waves but it is interesting to note that if the windings are star connected the phase currents approximate a sine-wave.

From Fig. 8.6 taking the loop currents:

$$i_{a} = \frac{V_{1} - V_{2}}{2Z}$$

$$i_{b} = \frac{V_{3} - V_{1}}{2Z}$$

$$i_{c} = \frac{V_{2} - V_{3}}{2Z}$$

$$i_{1} = i_{a} - i_{b}$$

$$= \frac{(V_{1} - V_{2})}{2Z} - \frac{(V_{3} - V_{1})}{2Z}$$

$$i_{1} = \frac{2V_{1} - V_{2} - V_{3}}{2Z}$$

V.R.-K

1

where $Z_1 = Z_2 = Z_3 = Z$ are the winding impedances

similarly
$$i_2 = \frac{2V_2 - V_1 - V_3}{2Z}$$

$$i_3 = \frac{2V_3 - V_1 - V_2}{2Z}$$

 i_1 , i_2 , i_3 therefore are stepped waveforms as shown in Fig. 8.6.

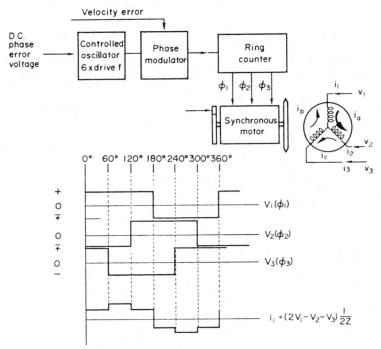

Fig. 8.6. Frequency control of a synchronous motor.

The d.c. error voltage can be used to control the frequency of an oscillator the output of which is divided down by a ring counter to provide the three phase signal. The rate of change of phase can be controlled by means of a phase modulator on the output of the oscillator which is controlled by the velocity error. The oscillator must be at least six times the frequency of the final drive waveforms as an examination of the three phase drive waveforms shows that each phase changes, 1-2-3, with a positive change every 120° and a negative change 180° later. A change therefore occurs every 60° with only one phase changing at any time. The sequence is also such that at any instant two phases are high with one low or two phases are low with one high. A circuit able to provide the three output waveforms for an input pulse at each transition is shown in Fig. 8.7 and is called a ring counter.

Ring counter

Assume the three counters are in the correct state for the start (0°) of the voltage waveforms shown in Fig. 8.6. Then the truth table from that point would be as follows:

	Ta	able 9		
Angle	ϕ_1	ϕ_2	ϕ_3	Input pulse
0°	1	0	1	
60°	1	0	0	1
120°	1	1	0	2
180°	0	1	0	3
240°	0	1	1	4
300°	0	0	1	5
360°	1	0	1	6
	0° 60° 120° 180° 240° 300°	Angle φ ₁ 0° 1 60° 1 120° 1 180° 0 240° 0 300° 0	Angle ϕ_1 ϕ_2 0° 1 0 60° 1 0 120° 1 1 180° 0 1 240° 0 1 300° 0 0	Angle ϕ_1 ϕ_2 ϕ_3 $\begin{array}{ccccccccccccccccccccccccccccccccccc$

The trigger pulse is applied to all gates and can either reset or set an R-S flip-flop. At angle 0° gates 6, 4 and 1 are enabled but only 6 is effective, as

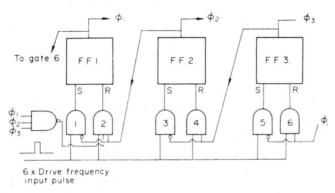

Fig. 8.7. The ring counter.

FF1 is already set and FF2 reset. This allows FF3 to be reset and ϕ_3 to go low on the first input pulse. For the second input pulse only gate 3 is effective and ϕ_2 goes high. The truth table shows that the required waveforms are produced. When the device is initially switched on the outputs can come up in any one of eight possible combinations. If it is any one of the six shown in the truth table, the sequence will progress from that point. The remaining two combinations are 111 and 000 and if all the outputs are low, gates 1, 3 and 5 are enabled allowing all the flip-flops to be set to 111 on the first input pulse. Similarly all flip-flops are reset on the next input pulse. This obviously incorrect sequence can be prohibited by an extra 'AND' function on the input to gate 2. When all outputs are high gate 2 is inhibited causing ϕ_2 to remain high when ϕ_2 and ϕ_3 go low on the next input pulse. The counter is now in the 60° position and will sequence correctly.

One disadvantage of a synchronous motor is that the control torque at synchronous speed is very low and better stability would be provided by a control system providing a large torque range at the nominal running speed.

Amplitude and pulse width control of an a.c. supply

In amplitude and pulse width control the frequency of the supply is not critical although the motor is normally arranged to run at approximately

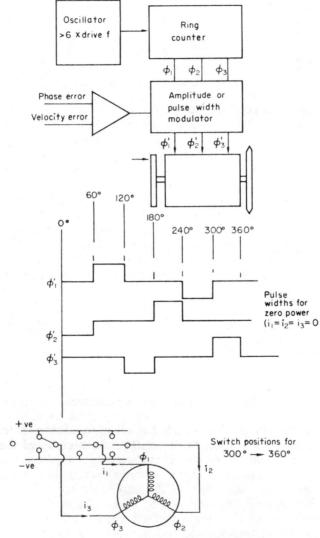

Fig. 8.8. Amplitude or pulse width control.

half its synchronous speed. In this induction mode the motor speed can be controlled by adjusting the power input to the three phase windings. This can be done either by adjusting the amplitude of the input signal or the duty cycle.

The disadvantage of amplitude modulation is that the final output stage cannot be a simple two state device but must be an analogue drive amplifier

with all the problems of efficiency and power dissipation.

With pulse width modulation the output can still be digital but with three output conditions of positive, negative or zero, the zero condition being open circuit. It can be readily seen by comparing the waveforms in Fig. 8.6 with those in Fig. 8.8 that if the pulse width is reduced from the 100% duty cycle to 30%, the power input is reduced from 100% to zero. Pulse width control gives excellent stability with efficient drive conditions.

DC control

DC motors provide excellent torque characteristics at all operating speeds and although stable high gain d.c. amplifiers are difficult to design the motor performance in terms of power to weight ratio and resultant stability make the extra circuit complexity worthwhile. The worst characteristic of a d.c. motor is brush noise, particularly if it is used as a head motor. Any commutator sparking radiates high frequency energy which will soon deteriorate the signal/noise ratio of the playback signal.

One solution is the brushless d.c. motor which uses electronic commutation. A simplified concept of the d.c. motor is shown in Fig. 8.9. The stator consists of permanent magnets to provide the field and the motor consists of windings connected via the brushes and commutator to the d.c. supply.

Fig. 8.9. A simplified concept of a d.c. motor.

The polarity of the winding field is such that it is attracted towards the stator field to cause a clockwise rotation. When the fields are aligned the motor would stop were it not for the fact that the polarity to the windings are reversed causing the motor to continue towards the next pole. A d.c. motor cannot operate without this commutation. As far as the windings are concerned they do not see a d.c. voltage but an alternating one.

An electronic equivalent of the commutator can be seen in Fig. 8.10. An indication of the motor position can be determined from the tach wheel and, for a 6-pole motor, six reference pulses are required. The pulses trigger a ring

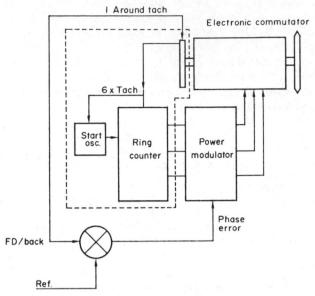

Fig. 8.10. A brushless d.c. motor.

counter, the output of which is very similar to the three phase output already described. There is one important difference and that is that the transitions are precisely locked to the head position at all rotational speeds. The ring counter and tach wheel only provide the same function as the commutator, but without brush noise.

The motor can be designed with a permanent magnet rotor and a wound stator which will exclude the use of slip-rings.

One undesirable characteristic of the electronic commutator described is that the motor can align itself into a fixed position requiring a polarity change to move. This cannot occur until a tach pulse is generated which in turn cannot occur until the motor rotates. To start events a starting oscillator provides an output in the absence of tach pulses and initiates commutating.

A more sophisticated method is to use Hall effect sensors around the motor to detect the field position and switch polarities accordingly.

Practical quadruplex servos

The head wheel and capstan operate in different modes during record and playback. Also during playback one of several different modes can be selected dependant on the accuracy of synchronism and stability required.

Record mode. The first object of the head wheel servo in record is to rotate the headwheel at 250 r.p.s.—five times field frequency, on the 625/50 Hz line standard or 240 r.p.s., four times field frequency, on the 525/60 Hz line standard.

The second object is to position the head-wheel so that the vertical sync is recorded in its correct position in the centre of the tape. The phase loop of the servo can achieve this by knowing the relationship between the head

position and the tachometer pulse (see Fig. 8.11).

Conveniently the head position pulse can be produced when the head is in the desired position, and if the servo reference is derived from the field sync of the video signal, coincidence between signals would position the video correctly on tape.

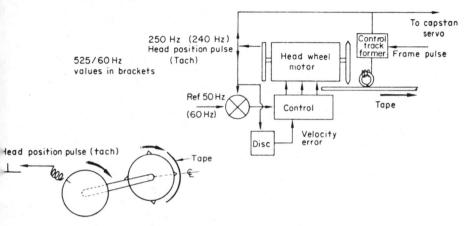

Fig. 8.11. Quadruplex head wheel servo record mode.

A control track signal is recorded to assist the re-scanning of the video tracks on playback and this can be derived from the head position pulse (tach). It is shaped to form a 250 Hz or 240 Hz sine wave giving one complete cycle for every revolution of the head or one cycle per four video tracks. Added to the sine wave is the edit or frame pulse which is positioned on the peak of the sine-wave. The frequency of the edit pulse is 25 Hz on 625 low band or 30 Hz on 525 standards, identifying one field in two and 12-5 Hz on 625 high band standard to identify one field in four for PAL and SECAM signals.

Capstan record mode. The object of the capstan during record is to pull the tape at the correct linear speed in order to obtain the correct track spacing. In some recorders the capstan, being a 60 Hz synchronous motor, is simply driven from a constant frequency a.c. supply.

The linear tape speed is determined by the rotational speed and the diameter of the capstan shaft. A convenient drive signal can be derived by dividing the head position pulse by four.

On $625/50 \text{ Hz} : 250 \text{ Hz} \div 4 = 62.5 \text{ Hz}$ On $525/60 \text{ Hz} : 240 \text{ Hz} \div 4 = 60 \text{ Hz}$

On the 525/60 Hz standard the capstan diameter is chosen to pull the tape at 15 inches per second. On 652/50 Hz standards the rotational speed is

slightly faster and with the same diameter capstan the resultant tape speed is $15\frac{5}{8}$ inches/second. This simple arrangement is shown in Fig. 8.12 and does not involve a servo loop.

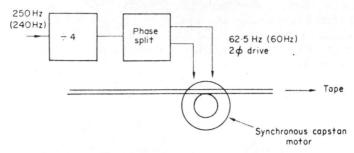

Fig. 8.12. Simple capstan drive for record mode.

If a d.c. motor is used, some form of velocity control is required and this can be seen in Fig. 8.13. The velocity of the capstan shaft can be monitored by means of two optical transparent glass discs on which equally spaced, radial, opaque lines are photographically printed. One disc is held stationary while

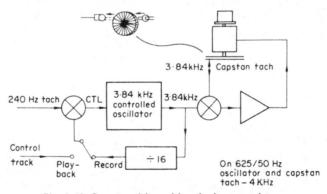

Fig. 8.13. Capstan drive with velocity servo loop.

the other is mounted on the capstan shaft and rotates. A shutter action between the two can be monitored with a light source and photo-cell and the resulting frequency would be a measure of the capstan speed.

It is convenient to make the number of lines on the disc such that when the capstan is running at the correct speed the resulting frequency is a binary multiple of the head position pulse frequency. Example 1: Ampex AVRI.

On 525/60 Hz

The required frequency = 16×240 Hz = 3.84 kHz (Fig. 8.13) and the capstan circumference = 6 in (Typical for a non pinch-roller version). Then for a tape speed of 15 i.p.s. the capstan rotates at $2\frac{1}{2}$ times a second.

$$\therefore$$
 Number of radial lines = $\frac{3840}{2.5}$ = 1536 lines

On 625/50 Hz

required frequency =
$$16 \times 250 \text{ Hz} = 4 \text{ KHz}$$

 \therefore Tape speed = $\frac{4000}{1536} \times 6 = 15.625 \text{ i.p.s.}$

Example 2: RCA TR70C

On 525/60 Hz

required frequency = $240 \times 64 = 15.36 \text{ KHz}$

capstan diameter = 0.62 in

capstan

circumference = $0.62 \times \pi = 1.95$ in

For 15 i.p.s. capstan rotates $\frac{15}{1.95} = 7.68 \text{ r.p s.}$

$$\therefore$$
 Number of radial lines = $\frac{15\ 360}{7.68}$ = 2000 lines

The head wheel tack pulse is multiplied by an a.p.c. oscillator loop, as shown in Fig. 8.13 to produce the required frequency which in turn is phase compared to the tach frequency to provide the control voltage to the motor.

Drum and capstan simple playback mode (TACH). The simplest playback mode is that shown in Fig. 8.14(a). The control of the head wheel is similar to the record mode although the 50 Hz (60 Hz) reference would be derived from station sync.

The capstan control however has the more complex task of ensuring that the tracks are presented to the video heads in synchronism or in other words for every revolution of the head, four tracks are pulled past the heads. If the phase comparison of the 250 Hz (240 Hz) control track signal to the 250 Hz (240 Hz) head wheel tachometer signal is used to control the capstan, the servoloop will settle down to a condition where the control track is phase and frequency locked to the head. One cycle of control track, denoting four video tracks, is matched to one cycle of head revolution or four head scans. To ensure that the video head is aligned to the video track as it scans, a phasing or tracking control in the form of a delay on the control track signal adjusts the dynamic tape position and is adjusted for maximum RF from the video heads on playback. The loop will always settle down to the same phase conditions between the two signals on the input to the phase comparator. A delay in the control track signal will therefore cause an error until the capstan speeds up to advance the control track signal and hence the tape position by the delayed amount. Reference to Fig. 8.13 shows how the same comparator as that used by the a.p.c. loop can be used during playback to control the same oscillator.

The simple playback mode (Tach mode) has the advantage that the only tape signal used is the 250 Hz (240 Hz) control track. It therefore is not vulnerable to tape or video quality. Its two disadvantages are the video

timing stability, a function of the head wheel stability, and the lack of phase synchronism with station sync.

Vertical synchronism (or place your bets please). To achieve vertical synchronism on playback the vertical synchronising pulse on the tape must be played back at the same time as the occurrence of the station vertical sync.

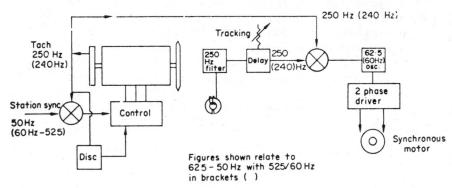

Fig. 8.14(a). Drum and capstan simple playback mode.

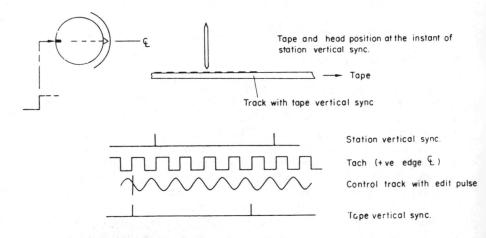

N.B. For 625/50 5 tach cycles per vertical sync. - 250 Hz

For 525/60 4 tach cycles per vertical sync. - 240 Hz

Fig. 8.14(b). A typical 250/240 Hz locked situation out of vertical sync.

In the tach mode a chosen head is aligned to the centre of the tape when station vertical sync occurs (Appendix 4).

The track with the tape video vertical sync however may not be underneath the head at that instant. It is the capstan that adjusts the tape position and Fig. 8.14(b) shows a typical locked situation when the 250 Hz comparator is used.

The positive edge of tach coincides with station vertical sync, this being determined by the head wheel servo in playback. If the tape vertical sync is in the centre of the tape (determined by the head wheel servo in record) then this will also coincide with a positive edge of tach.

On the 625/50 Hz standards there are five tach positive edges per vertical sync, therefore there is a one in five chance that the tape and station vertical sync are on the same edge. On the 525/60 Hz standard the chance is 1 in 4. The vertical alignment made may of course be one of opposite fields making the odds for correct field alignment 1 in 10 on 625/50, 1 in 8 on 525/60 and 1 in 20 on PAL and SECAM signals, owing to the four field sequence.

If the exact chroma phasing is taken into account, the 525 NTSC signal has a four field sequence, 625 PAL has an 8 field sequence and SECAM has a 12 field sequence, making the odds 1 in 16, 1 in 40 and 1 in 60 respectively. In practice for a synchronised playback the correct two field alignment is obtained for monochrome and NTSC, and the correct four field alignment for PAL.

The higher order alignments are difficult to define and are only a problem in editing.

Capstan servo vertical mode. To achieve vertical alignment the capstan speed must be controlled to place the correct track under the correct head at the right time.

One method of achieving this is to use a second analogue comparator, to control the capstan oscillator for framing, which compares the station frame pulse with the tape frame pulse. This arrangement can be seen in Fig. 8.15. Once alignment is achieved the control of the oscillator can revert to

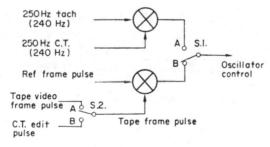

Fig. 8.15. The analogue framing control.

the normal 250/240 Hz comparator which has a better stability, owing to its higher sample rate.

The sample rate of the framing comparator depend on the TV line standard and would be:

30 Hz - 525/60 Hz All standards

25 Hz - 625/50 Hz Low band

12.5 Hz - 625/50 Hz High band.

A second approach, shown in Fig. 8.16, is to speed up or slow down the capstan, whichever is the nearest route, until synchronism is achieved and

then revert to normal speed.

The amount of speed change permissible depends on the inertia of the system, but with isolated reels and a low inertia capstan a speed change of $\pm 33\%$ or ± 5 inches per second is permissible. The time taken to achieve lock with this second method is very fast although it still depends on the distance the tape must be moved to the nearest frame pulse.

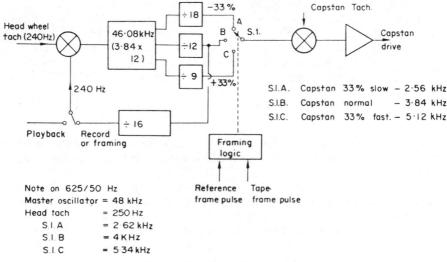

Fig. 8.16. The digital framing control.

On 525/60 Hz

one frame occupies
$$\frac{15}{30} = 0.5$$
 in

... nearest frame pulse is less than 0.25 in At 5 i.p.s. 0.25 in of travel takes

$$\frac{0.25}{5} = 50 \text{ msec}$$

On 625/50 Hz

one monochrome frame occupies
$$\frac{15.625}{25} = 0.625$$
 in

one PAL or SECAM frame occupies 1.25 in

At 5.2 i.p.s. (33%)

for monochrome 0.3125 in of travel takes
$$\frac{0.3125}{5.2} = 62.5$$
 msec

for PAL or SECAM 0.625 in of travel takes 125 msec

In practice these framing times are about trebled after acceleration, de-

celeration and decoding time is taken into account.

With a higher inertia system the permissible speed change is less and typically for a pinch roller system a 10% change is used. The time taken to frame is proportionally longer.

Identification of frame pulse

A frame pulse must uniquely identify one field in two (one in four on PAL and SECAM) and therefore a circuit able to identify the odd or even field is required. Figure 8.17 compares the odd and even field synchronising periods for both 525/60 Hz and 625/50 Hz.

The field syncs contain twice line frequency pulses for the equalising and broad sync pulse period. The line sync pulses can easily be separated over this period by a monostable with a period greater than a 1-line period. It should be noted that the line sync is coincident with the first vertical serration in the broads on only one field in two. On 525/60 Hz this coincidence is the start of the even field while for 625/50 Hz the coincidence is on the start of the odd, due to an odd multiple of equalising pulses. An 'AND' gate with one input timed to the first serration of both fields and another input of line sync would produce a pulse output every two fields, i.e. 30 Hz on 525, 25 Hz on 625.

On PAL signals a particular line is different from the corresponding line two fields later owing to the phase alternation of the V signal and an odd number of lines per frame. Similarly on SECAM signals an R-Y chrominance signal on line 1 of field 2 would be a B-Y signal on line 1 of field 4. The signal which identifies the phase of the V signal on PAL or the R-Y line on SECAM is the 7.8 KHz and if this is gated with the two monochrome signals a 12.5 Hz pulse identifying one field in four is produced.

The position of the control track is downstream to the video heads and the field identified may not be the nearest field on tape (Appendix 5). The

nearest field on tape is indicated in Fig. 8.17.

Head wheel servo

Vertical mode. If the track with the vertical sync is aligned with the correct head at the correct time and the vertical sync is recorded in the centre of the tape, vertical synchronism will be obtained using the tach comparator. The tolerance on the vertical sync positioning in record is about $\pm \frac{1}{2}$ a line (Appendix 4). To allow for this and for non-standard recordings the head wheel phase is controlled by a second comparator, shown in Fig. 7.18, which compares the vertical sync off tape with a reference station vertical sync. This adjustment need only be $\pm 45^{\circ}$ from the tach mode position if the capstan is phased correctly. The stability of the playback video, which is directly related to the stability of the head wheel, is not improved in this mode because the sample rate is the same as the tach mode. The reliability

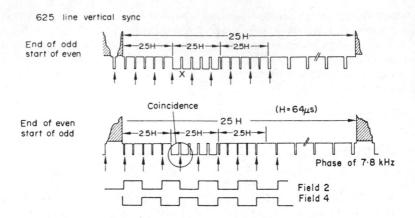

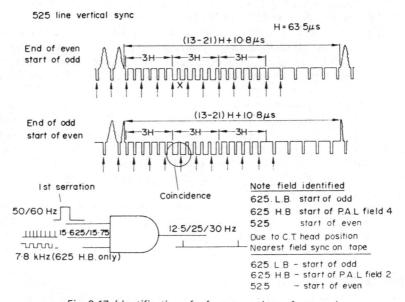

Fig. 8.17. Identification of reference and tape frame pulse.

of the vertical mode is somewhat less owing to the dependence on tape vertical sync which is prone to drop-out.

Horizontal mode. The video stability on playback can be improved and full synchronism with station sync can be achieved with the addition of a third comparator, shown in Fig. 8.18, which compares tape horizontal sync with reference horizontal sync. In this mode the sample rate is over 300 times greater than used in the tach and vertical modes.

For full synchronism or 'automatic lock' the vertical mode must achieve

synchronism to within $\pm \frac{1}{2}$ a line before switching to the horizontal comparator. If the stability of the horizontal mode is required but synchronism is not, the vertical framing of the capstan and head wheel can be missed.

Four separate modes of operation are available and can be selected depending on the requirements. Table 10 lists some of the more important requirements.

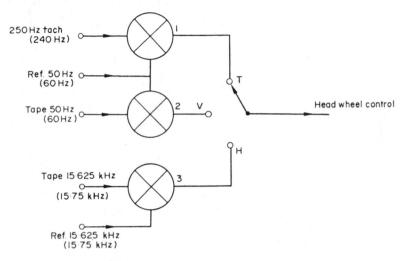

Fig. 8.18. The head-wheel comparators.

Table 10

Requirement Mode (stability)	Mono- chrome	Cut without Frame Roll	Fast Lock-up	Mixing	Colour playback with an analogue delay corrector
Tach (±10 μsec) Vertical	Yes	No	Yes	No	No
(±10 μsec) Horizontal non vertical	Yes	Yes	No*	No	Not
(±75 ηsec) Horizontal and	Yes	No	Yes	No	Yes
vertical. auto. $(\pm 75 \ \eta \text{sec})$	Yes	Yes	No*	Yes	Yes

^{*} Except with isolated reels and low inertia capstan.

[†] A digital corrector with \pm 32 μ sec range allows vertical mode to be used.

Head wheel comparator

A logic system is required to determine the comparator to be used, which depends on the mode selected and the condition of synchronism. On all modes selected the initial lock-up is achieved on the tach comparator. If a higher mode has been selected and other conditions in the machine are correct, such as the guide being in and tape syncs being available on the output of the

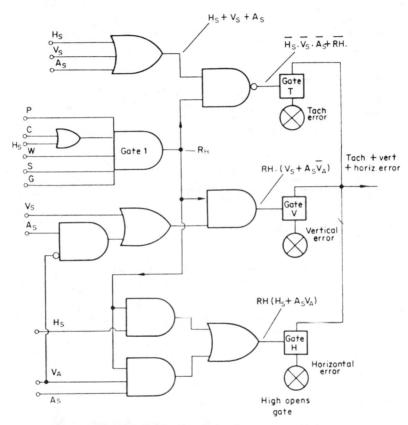

Fig. 8.19. Typical headwheel comparator logic.

signal system, the tach comparator can be switched off and another on. Only one comparator is normally used at any instant. If the vertical or horizontal mode is selected, the vertical or horizontal comparator would be used.

All the conditions can be expressed more clearly with logic equations and illustrated with logic symbols as shown in Fig. 8.19.

$$R_{H} = P.W.S.G. (C + H_{S})$$

$$T = (H_{S} + V_{S} + A_{S}) R_{H}$$

2

 $= H_s \cdot V_s \cdot A_s + R_H$

$$V = R_{\rm H} \cdot (V_{\rm S} + A_{\rm S} V_{\rm A})$$

4...

$$H = R_H \cdot (H_S + A_S V_A)$$

 H_s = horizontal synchronism selected

V_s = vertical synchronism selected

 $A_s = Auto or full synchronism selected$

V_H = vertical synchronism achieved

P = VTR in play mode

C = capstan framed

W = head-wheel error stable

S = sync pulses on output of signal system

G = vacuum guide in

 $R_{\rm H}$ = recorder function happy (1)

The pre-conditions to switching off the tach comparator and progressing to a comparator dependent on tape sync are provided by gate 1. The output of gate 1 will only go high when certain states in the recorder exist to make the recorder functions happy $(R_{\rm H})$, these being:

Play button pressed and Head wheel stable and vacuum guide in and tape syncs present and capstan framed, except if the horizontal mode has been

selected, when it does not matter.

The tach comparator is used if none of the higher modes are selected or if

the output of gate 1 is low.

The vertical comparator is used if the recorder functions are happy and vertical mode is selected or until vertical synchronisation has been achieved if auto has been selected.

The horizontal comparator is used if the recorder functions are happy and the horizontal mode has been selected or after vertical synchronism if auto has been selected.

Auto tracking (capstan)

The phase of the tape with respect to the video head is adjusted on playback to a condition where the video head scans exactly down the centre of an existing track. Tolerance variations on control track head position and record phase means that a manual adjustment of control track phase for a maximum amplitude *RF* envelope is required for each tape played back.

An automatic method has been devised which is shown in Fig. 8.20. Adjustment for a peak is difficult because until the output falls a maximum point cannot be sensed. One method is to add a small 10 Hz oscillation to the capstan error which causes the tape to advance and retard in phase. The amplitude of this dither is kept small and produces less than 0.1% flutter on

161

the audio. If the video heads are centred on the track then a reduction in *RF* is caused as the tape is advanced and retarded or in other words a 20 Hz amplitude modulation of the tape *RF*. If the tape's nominal position is advanced, an increasing advance reduces the *RF* while an increase occurs for the retard half cycle. This gives a 10 Hz amplitude modulation reaching a minimum at maximum advance.

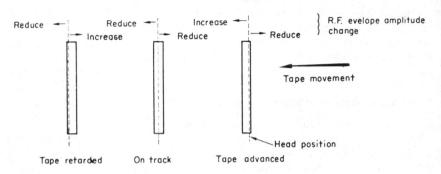

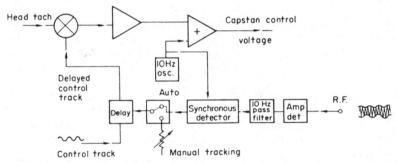

Fig. 8.20. Auto tracking.

If the tape is retarded, a 10 Hz amplitude modulation would result with a minimum at maximum retard.

By detecting the 10 Hz modulation and phase comparing it with the original dither signal in a synchronous detector, a voltage proportional to the average track position can be derived. This error voltage can be used to adjust the capstan speed either by adjusting the tracking delay, as shown in Fig. 8.20, or, in the absence of a control track, by directly controlling the capstan speed.

Practical helical servos

In helical recorders the principles of operation of the capstan and drum scanner is very similar to those in quadruplex recorders. The techniques however do differ slightly.

In helical recorders the head rotation rate is either $\frac{1}{2}$ field rate for two headed machines or field rate for single headed machines.

Drum scanner, record mode. Apart from locking the head rotation to field rate, or a division of field rate, it is important during record to adjust the phase of the head to ensure that the drop out or switching transient occurs

either at the bottom of the picture or in field blanking.

The position of the drop-out is known to be at the exit/entrance point of the tape. A tachometer pulse is sensed prior to this point and compared with the vertical sync to produce a control voltage for the motor. For the drop-out to be positioned at the bottom of the picture the vertical sync should occur after the exit point at the start of a new track. For the drop-out to occur in field blanking the vertical sync should be recorded at the end of a track before the exit point. A monostable delay can be adjusted during record as in Fig. 8.21 and 8.22 to position the drop-out accordingly.

Capstan record mode. The object of the capstan in record is to pull the tape at the correct nominal speed to provide the correct track spacing. The accuracy depends upon the requirement for sync 'line-up' and a 1% variation in tape speed would cause about a $0.64~\mu sec$ error in sync line up.

Some cheaper recorders drive the capstan motor with local a.c. mains supply thus obviating the requirements for a drive amplifier and control electronics (see Fig. 8.21). This provides an adequate method while the mains is the correct frequency, but changes up to $\pm 4\%$ are not uncommon.

A better system, though more expensive is that shown in Fig. 8.22, where the capstan speed is controlled from a comparison of an input reference to a

feedback reference from a capstan tachometer.

On both systems a control track pulse is recorded which is generally derived from the vertical sync of the recorded video. The pulse repetition frequency would be 50 Hz on 625 line systems or 60 Hz on 525 line systems, recording one pulse per video track. On some more complex machines with playback framed to the correct field sequence a 25 Hz or 30 Hz pulse is recorded, giving one pulse per two tracks.

Playback modes

During playback the prime objective is to re-scan the video tracks exactly at a 50 Hz or 60 Hz rate. Basically there are two methods of achieving this:

1. Control of the drum scanner only (Fig. 8.21).

2. Control of both the drum scanner and the capstan (Fig. 8.22).

Drum scanner control. In this arrangement the capstan is driven from the a.c. mains, and the track presentation rate, or field rate, depends on the mains frequency. The rotational rate of the head must now be controlled so that it revolves 360° (180° on two headed machines) for each track or control track pulse. This can be done by comparing the head position pulse with the control track pulse, ensuring a head rotational rate locked to the track rate. The delay used for adjusting the drop-out position in record can now be used in

playback as a tracking control to synchronise the track and head for a maxi-

mum RF off tape.

The technique provides an economical and simple method of control requiring only one controlled motor. Its disadvantage is that the playback video is not locked to any external reference. Owing to changes in capstan

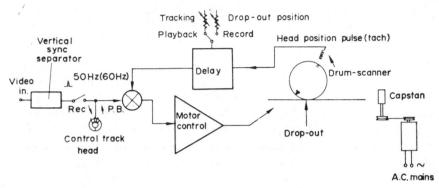

Fig. 8.21. Helical motor control with a non-servo capstan.

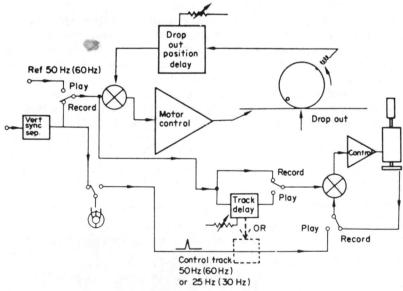

Fig. 8.22. Helical motor control with capstan servo.

diameter and slight tape slippage it is not even locked to mains. Another disadvantage is that the drum input reference is a control track pulse which is prone to phase modulation caused by tape longitudinal speed variations. The phase loop gain of the system must be low to avoid hunting giving a rather loose control of the head position.

Control of both drum scanner and capstan. In this system both the drum and the capstan use an external reference which can be either station vertical sync or a.c. mains. The drum scanner is locked to this in an identical manner to record and the reference being stable allows a higher phase gain and stability than with the previous method. This determines the playback field rate.

It is now left to the capstan to synchronize the track rate to the head. This is done by controlling the capstan from a comparison of reference 50 Hz (60 Hz) and control track. Both the track rate and the head rotational rate are now locked to the same reference. Tracking can be adjusted by altering the head phase by delaying the head position pulse or the track phase by delaying either input to the capstan comparator.

Not only is the stability improved by using a capstan servo but vertical synchronism to station sync can be readily achieved. If a greater stability is required with horizontal synchronism, an extra horizontal comparator can be used to control the drum scanner. Because of the extra complexity this is

only done on the higher priced helical recorders.

Instability

Unlike quadruplex machines playback instability is not only a function of variations in head speed but is also caused by variations in tape or capstan speed. It is worth determining the rotational speed of the capstan for a recorder which can be anything from 8 Hz to 60 Hz depending on the tape speed and capstan diameter. Knowing this, it is sometimes easier to isolate the causes of instability by knowing its frequency. Typically the causes for fluctuations are as in Table 11.

Table 11

Frequency	Probable cause
field rate	Drum scanner imbalance.
> field rate	Drum scanner bearings worn or servo fault.
< field rate $>$ 5 Hz	Capstan eccentric or pulley wheel.
< 5 Hz	Torque variations on take-up or supply spool.

References

- SADACHIGE, Quadruplex recorder servo systems, new performance criteria JSMPTE, Vol. 80, July 1971, 552–557.
- CLARKE, H. V., An improved servo system for quadruplex videotape recorders, Ampex Corporation, Redwood City.
- ROIZEN, J., Television tape techniques today, Broadcast Engineering, Nov. 1963 and April 1964.
- CRUM, C., Design considerations for a new generation quadruplex videotape recorder. Ampex Corporation, Redwood City.

9 Geometrical Errors

In any videotape recorder it is extremely important that the recorded tracks are scanned exactly and that the information from the tape is read at a consistent rate. Any difference in tape path, tape dimensions or head to tape geometry between recording and playback will give rise to tracking or timing errors or both. All errors due to these factors are called geometry errors and are additive to servo stability errors.

There is only one correct tape geometry for a given format and errors on playback can be caused by incorrect geometry in record or playback. During record all controls must be adjusted to produce a tape within the tolerances specified for that format. Alignment tapes are normally provided for this although on most helical machines the controls are preset and the geometry

can only be checked.

It is considerably easier to minimise errors by recording and playing back on the same transport because most errors are repeated in playback. However, if it is required to interchange tapes, transports which are similar to within very close tolerances are required. The problem is one of compatibility and it is this requirement that adds to the cost of any VTR. Quadruplex machines are compatible irrespective of manufacturer. Most helical machines are only compatible with similar models from the same manufacturer and some cheaper models do not even claim this. The problems in minimising errors are obviously different for helical and quadruplex machines and it is worth treating them separately.

Adjustments to quadruplex machines

Several of the geometry adjustments to a quadruplex head assembly are preset and the problem of adjustments is a manufacturing one. The tolerances

however are extremely small and a check on the parameters affected ensures good interchange.

Azimuth (preset)

The head gap should be perpendicular to the transverse track and, as in audio recorders, a loss in induced e.m.f. results at short wavelengths if an error occurs between record and playback.

The shortest wavelength recorded

$$\lambda = \frac{\text{head/tape speed}}{f \max}$$

where $f \max = \text{highest record frequency (15 MHz on High Band)}$

$$\lambda s = \frac{1560}{15 \times 10^6} \simeq 100 \,\mu\text{in}$$

The tolerance on azimuth would seem intolerable for such short wavelengths were it not for the fact that the gap width is only 0.01 in.

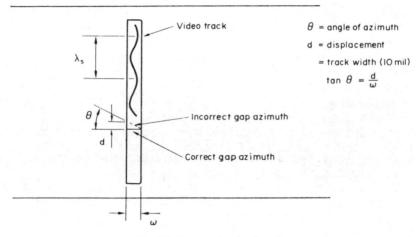

Fig. 9.1. The angle of azimuth.

From Fig. 9.1 it can be seen that if the displacement (d) is small compared with the shortest wavelength (λs) say 1/10, then the loss is negligible.

$$\tan \theta = \frac{d}{\omega} = \frac{10 \times 10^{-6}}{10 \times 10^{-3}} = 10^{-3}$$
$$\theta = 3'$$

or the gap should be at $90^{\circ} \pm 1.5'$ to the video track for good interchange. Azimuth problems can readily be detected by comparing the frequency

response of a video head playing back its own recorded track with the response of that same head playing back other recorded tracks. The response should be within 2dB at 15 MHz w.r.t. 8 MHz.

Axial displacement (preset)

The transverse tracks should be equally spaced and this can be achieved only if the longitudinal speed is constant and the heads are accurately positioned axially. Figure 9.2(a) shows the effect of an axial error. The tolerance on track

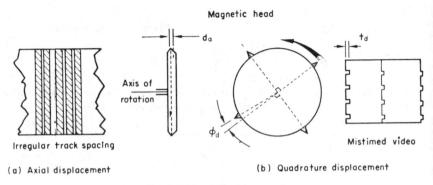

Fig. 9.2. Head displacement.

to track spacing is ± 0.00625 mm (± 2.36 thou), but variations in capstan speed also contribute to this tolerance so that an axial displacement of less than ± 0.001 in is required. Axial displacement only causes tracking errors which will tend to reduce the *RF* signal level and thus deteriorate the signal/noise ratio for that head or track. Timing errors, which constitute a larger problem, are a function of radial displacement.

Quadrature displacement (preset)

With four heads equally spaced around the periphery of the head wheel, each head should be at 90° to its adjacent heads. If this is not so, as in Fig 9.2(b), the result is that when the displaced head plays back a recording made on a correctly aligned head the information will be delayed from the rest of the video. The servo action on the head wheel motor would be unable to correct such a rapid change owing to the inertia of the head assembly and the subjective effect on the picture is for sections to be displaced horizontally causing a discontinuity on all verticals in the picture. On the European 625 line/50 Hz field standards the displacement would occur for 15 or 16 lines in five positions per field whilst on the USA 525 line/60 Hz field standard it would be 16 or 17 lines in four positions per field.

The timing error for a given displacement can be calculated knowing the angular velocity. On the 625 line/50 Hz the rotational speed of the head

$$N_{\rm H}=250~{\rm r.p.s}$$

1 revolution = $\frac{1}{250}=4~{\rm msec}=360^{\circ}$

For a displacement $\phi d = 1$ min of arc

$$td = \frac{4 \times 10^{-3}}{360 \times 60} = 0.18 \,\mu\text{sec}$$

With a circumference of 6.48 in 1 min of arc represents

$$\frac{6.48}{360 \times 60} = 0.0003$$
 in

In order to keep this timing error to within 150 η sec peak-peak the deviation must be better than ± 0.5 min of arc, assuming the worst case of build up of tolerances.

To obtain this accuracy a head assembly is normally adjusted on a standard tape to bring the heads into approximate position. A vernier adjustment can then be made by recording and playing back, adjusting the head positions to achieve a peak-peak error of less than 150 η sec on all positions of the track selector.

Although the adjustment is a manufacturer's preset, corrections can be made by the user if extreme care is taken. In the author's experience the adjustment should be made only if a spare head assembly is available. The adjustment of a head is normally achieved by means of tapered screws which are mounted either side of each head. By releasing one and tightening the other the head can be made to move radially. It must be appreciated that, owing to the tolerances involved, it is extremely difficult to adjust one head without affecting another.

Guide positional errors (adjustable)

The vacuum guide should have a fixed position between record and playback. It does however have operational controls on its position in order to compensate for variations in recordings.

Being a three dimensional device it can be moved along three axes as shown in Fig. 9.3. The longitudinal position of the guide is normally fixed, inhibiting movement along the z axis while adjustments on the other two axes are permitted. Movement along the x axis increases or decreases the tip penetration into the tape and movement on the y axis affects the guide height with respect to the head wheel. The adjustment of either of these can cause the guide to lose concentricity with the head wheel which in turn causes a timing displacement.

The correct position for the guide is shown in Fig. 9.4(a) where the effective radius of curvature for the guide is concentric with the radius of the head wheel. If a tape is recorded with the guide in the correct setting, but during playback the guide is moved out so that its position, relative to the head, is as shown in Fig. 9.4(b), a timing error will result. At the start of a head scan the video head is in advance of its correct position while at the end of

Fig. 9.3. Movements of the tape guide.

its scan the head is late, being correct at the centre. The subjective effect on the displayed picture, sometimes referred to as 'venetian blinding' appears on all verticals.

The displacement error dx

 $dx = x \sin \theta \dots$ (See Appendix 14)

and a 0.001 in movement of the guide would give a peak-peak timing error of 0.916 μ sec.

The adjustment can be made manually or, by means of a guide servo and timing sensor, automatically. It is interesting to note that there is only one correct setting for the guide position and this is true irrespective of the tip projection from the wheel. No further adjustment is required as the pole tips wear, although it should be checked frequently to allow for temperature changes and guide wear.

The effect of incorrect guide height setting is more complex, but examination of Fig. 9.4(c) shows that if the guide is set too low the effect is that of the

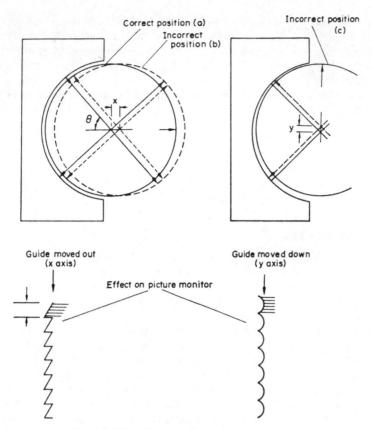

Fig. 9.4. The effect of incorrect guide position.

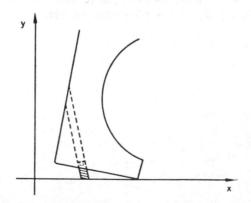

Fig. 9.5. Wrap around or tilt adjustment.

guide being too close at the top and too remote at the bottom. The subjective effect is that of 'scalloping' where the error starts off as if the guide is too far in and ends as if the guide is too far out. A 0.001 in error in guide height would give a peak-peak error of 0.194 μ secs (see Appendix 15), with a displacement error $dy = y \cos \theta$.

This result shows that the height adjustment is not as critical as the tip penetration, but because of its non-linear nature it can be more difficult to

correct for electronically.

There is one other guide adjustment and that is the wrap-around or tilt adjustment. This control simply ensures that the guide height and penetration adjustments operate on their correct axes. If the guide is not square on to the relative movement of the guide as in Fig. 9.5, the adjustment of guide penetration will have a component affecting guide height and vice versa.

Velocity errors

The time-base stability required for monochrome signals is considerably less than that for colour. With care and adjustment on every playback, geometrical errors should be contained to within 150 nsec which is just tolerable on

monochrome although an improvement would be desirable.

For colour systems however a stability of ± 3 nsec is required and this can be achieved only by correcting these residual errors electronically with variable delays. The exact method of correcting these errors will be covered in the following chapter but basically the error is corrected at the start of each line and it is important that the error does not change significantly between corrections. The important figure therefore is not the absolute timing error of the signal but the rate of change or velocity of the error.

With the advent of colour and the critical nature of the signal, a considerable amount of research investigating other causes of velocity error was made. Most of the causes are manufacturer problems, but they do illustrate areas that affect the interchange of colour videotape recordings. It was shown by Nikolai Laserev in 1969 that, in addition to those errors already mentioned,

interchangeability is affected by the following factors.

1. Vacuum guide radius tolerances.

2. Tape transport topology.

3. Erase head temperature change.

4. Tape tension.

5. Ambient temperature and humidity.

Apart from the errors in the guide radius, the errors caused by these factors are in general of a low order. With the demand for multiple generation tapes, however, these errors tend to accumulate.

Guide radius

From our previous arguments it can be appreciated that if the guide radius is increased between record and playback, an angle of 90° on the record

radius would be less than 90° on the playback radius. With a constant angular velocity for the head wheel this causes an effective increase in pole tip velocity on playback. The relationship is a linear one, i.e.

velocity =
$$2\pi r \times N_{\rm H}$$

 \therefore velocity αr

The tolerance on the guide radius is $\pm 250 \,\mu \text{in}$ with a nominal radius of 1.03315 in. If the difference in radius between record and playback guides is 500 μin , an error of 500 ηS would result over a 90° rotation of the head (Appendix 16).

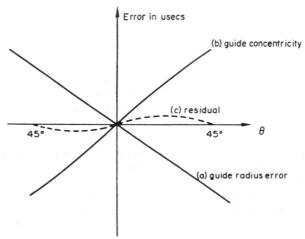

Fig. 9.6. Graph showing residual error after off-setting concentricity to compensate for guide radius error.

This can be compensated for by off-setting concentricity, but as this is a sinusoidal function the error cannot be completely eliminated. Fig. 9.6 shows the relationship between the two errors with the residual error shown in C. The theoretical reduction in timing error is about 23:1 reducing a 500 η sec peak-peak error to about 22 η sec.

Tape transport topology

The velocity errors caused by the distortion of the tape is complex and is the result of forming the tape, an elastic medium, into its canoe. Reference to Fig. 3.6 shows that the tape is formed from a flat plane into an arc and back to a flat plane. The tape between the two guides A and B is called a canoe and its shape should be the same in record as it is in playback.

To analyse the distortion on the tape the position of the tape is referred to the 'neutral-plane'. The neutral plane is defined as the path taken by the tape between guides A and B when the video head and vacuum guide is

removed. The deformation from the neutral plane when the head assembly is inserted can now be seen in Fig. 9.7.

By means of a simple experiment Laserev showed the importance of spacing the two guides A and B symmetrically about the video head. In this experiment, shown in Fig. 9.8, the tape was simulated by a rubber band clamped at A and B representing the two guides. The head, represented by a frictionless roller

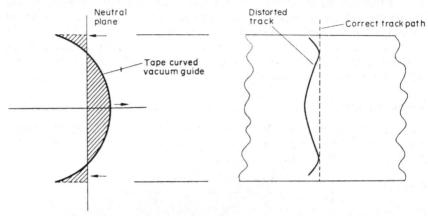

Fig. 9.7. Deformation from the neutral plane causing track distortion when A and B (Fig. 3.6.) are asymmetric.

Axis of head rotation

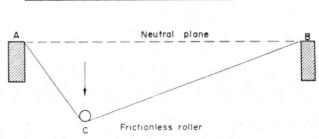

Fig. 9.8. Laserev's experiment to demonstrate track deflection due to tape topology.

C, was moved out to deflect the band from its neutral plane to form ACB. As the component of force along AC is larger than along CB, the band moves toward A until equilibrium is reached. If a mark is made at C and the roller is moved back to the neutral plane, the mark will move toward B. In the case of the tape canoe the recorded track, which is analogous to the mark on the rubber band, will form an M shape where it is deflected in three places.

In practice an assymetry of 1.0 in would cause a deflection of 0.001 in, which in turn would cause a velocity error of 0.5 η sec per TV line.

The second parameter of importance on canoe shape is the error in parallelism between the neutral plane and the axis of rotation of the head wheel.

An error here would cause a C-shaped video track. For a similar error of $0.5 \, n \text{sec}$ per TV line the permissible deviation from parallelism would be $0.0035 \, \text{in/in}$.

Temperature and humidity

The expansion of the tape relative to the guide is also a cause of timing error and in this respect the action of the erase head increasing in temperature during the recording must be taken into account. In general however an error of 1 nsec per TV line should not be exceeded.

The coefficient of hygroscopic expansion for Mylar is 11 μ in per inch per cent of relative humidity which would cause about 2.5 nsec per TV line per 10% change in relative humidity.

Tape tension

Variations in tape tension due to holdback torque cause errors somewhat less than might be expected and a theoretical value of 1.25 nsec per TV line per 5 oz variation is quoted.

Conclusion

In all the cases quoted the timing error per horizontal line is given which means that if a line is corrected at the start of a line and that correction is held, the uncorrected error at the end of the line will be the figure quoted. This is sometimes loosely referred to as the velocity of the error although strictly the velocity is the first derivative of the phase error and can be a complex function with respect to time.

To place the results in perspective it is worth comparing the phase distortion on the colour sub-carrier resulting from each parameter.

For 625 PAL 360° of subcarrier = 226 nsec For 525 NTSC 360° of subcarrier = 279 nsec

therefore 1 η sec of error causes 1.6° phase error on 625 systems and 1.3° on 525 systems.

For an interchange playback without velocity compensation the resulting phase error should not exceed that shown in Table 10 on modern high-band VTRs.

Table 12

Cause of Error	Phase error	Phase error per TV line		
	525 NTSC	625 PAL		
Guide position	20°	24°		
Guide radius	10°	12·5°		
Transport topology	3°	3.5°		
Transport topology Erase head temperature	1°	1.25°		
Tape tension	2°	2.5°		
10% humidity	3°	3.5°		

Mylar has a very slow rate of moisture absorption and it is therefore only necessary to control humidity when storing tape.

Adjustments to helical machines

The timing stability requirements, for many applications of helical VTRs, are not as critical as for broadcasting. Despite this the problems of head and tape geometry and subsequent compatibility are more exacting, requiring more ingenuity from the designer, a greater allowance for ambient variables and a greater degree of alertness on behalf of the operator.

The magnitude of the problem can be seen from Fig. 4.5, helical scan

C-format.

In general, each track carries one television field of information. The length of each track depends on the particular design, but for a single headed machine, with a drum diameter of 5 in, the track length would be over $15\frac{1}{2}$ in. The problem then is to scan the narrow video track, which is of the order of 0.006 in wide, without a deviation of more than 0.001 in over its total length of over $15\frac{1}{2}$ in. An additional problem is to avoid distortion of the tape longitudinally, causing a change in head velocity which would accumulate a large timing error over the scan.

If compatibility is not required, the problem is not a difficult one because any deflections of the tape caused by mis-alignment in the transport are

present in record and playback, which avoids mistracking.

With all other parameters being equal the higher bandwidth machines have a more difficult problem, because the higher head to tape speed results in a larger diameter drum and longer video tracks. Advances in high energy tapes, with higher resolution of recorded wavelengths, coupled with the higher efficiency ferrite heads has resulted in designs of helical VTRs with lower diameter drums, making compatibility less of a problem.

Head position

Double headed and single headed machines have very similar problems although two headed machines have the added complexity of aligning the

heads with respect to each other.

For a one headed machine the only two important positional parameters are head azimuth, the angle of the gap to the direction of the track, and tip projection, the amount the pole tip projects from the drum into the tape. The tolerance on either of these is not exceptionally difficult for the same reasons given for the quadruplex format. The fact that the gap width is even less relaxes the tolerance even further on azimuth.

For a two headed machine the two extra positional parameters are more critical. Firstly the two heads should rotate in the same plane i.e. no axial displacement. This ensures a minimisation of tracking error and an equal spacing of tracks.

With a guard band of the order of 0.003 in a tracking error of 0.001 in is the maximum permissible due to head axial displacement. This allows for additional tracking errors due to capstan instability. Assuming a worst build up of tolerances this places an error tolerance between the two planes of rotation to be no greater than 0.0005 in.

Secondly the two heads should be positioned at 180° with respect to each other. The tolerance of this adjustment, called dihedral, depends on the permissible time base error. This in turn depends upon the application, but

the error should not exceed $\pm 1 \mu sec.$

On a 50 Hz standard

$$20 \text{ msecs} = 180^{\circ}$$

1
$$\mu sec = \frac{180 \times 10^{-3}}{20} = \pm 16$$
 seconds of arc

Tape path and interchange

To ensure that the track is recorded in the correct position or that an existing track is scanned correctly, the tape has to be guided around the head with an accuracy of 0.0005 in over its entire length. The tape is guided on entering and on leaving the scanner and by a bottom edge guide around the drum.

The difference in height between the entrance guide and the exit guide determines the amount the tape climbs as it wraps around the scanner and thus determines the resultant track angle. The bottom edge guide ensures that the tape does not distort from a linear angle. A further requirement for an omega wrap machine is to set the guide arms as close and as parallel to the scanner assembly as possible to ensure a small and well defined drop-out as the head and the tape part company.

Figure 9.9. shows the mechanical arrangement used on an omega format. The guides are nominally set to the dimensions shown, leaving the vernier adjustments to be made dynamically on a 'standard interchange alignment tape'. An interchange tape is one manufactured on a very accurately aligned tape deck under very closely controlled temperature and humidity

conditions.

The technique of vernier adjustment is to adjust the tape guides during the playback of the interchange tape, until a flat *RF* envelope is obtained with well defined leading and trailing edges. If the video head scans into the

guard band, a reduction in RF amplitude would result.

The timing position of this reduction of the envelope is an indication of the physical position of the deviation. The ideal envelope is shown in Fig. 9.10(a) with the effect of an incorrect adjustment of the edge guide in Fig. 9.10(b). If the adjustments are even further out then the head will start to read adjacent tracks with a null as it passes through the guard band, giving RF envelope shapes as shown in Fig. 9.10(c), (d), (e).

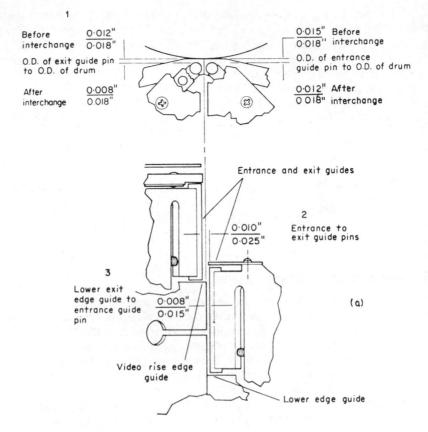

Fig. 9.9. The position of the tape guides on an omega wrap: Nominal position of the tape guides.

Compatibility coefficient

A measurement of how accurately the adjustments have been made can be done by adjusting the tracking control and noting that the RF envelope reduces evenly over its length for a given range of the tracking control.

The range over which the tracking control should give a satisfactory picture depends on the format and in particular the video track width and guard band dimensions.

On a 50 Hz standard an adjustment of 20 m sec on the tracking control would move the tape phase from the centre of one track to the centre of the adjacent track. For a format with 0.006 in video track width and 0.003 in guard band, this would result in a 0.009 in movement of the tape with respect to the video head. If a track is being scanned exactly down the centre, an adjustment of tracking control causing a movement of ± 0.003 in would

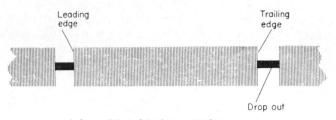

(a) Ideal interchange envelope

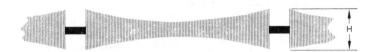

(b) Interchange envelope when tape guide on rear of drum is at its lowest position

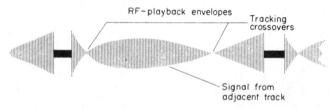

Envelope with most severe amplitude (c) fluctuations near leading edge

Envelope improved from that of (d) illustration c

(e) Envelope with greater guiding error

Fig. 9.10. R.F. envelopes showing various degrees of compatibility.

only result in scanning in the guard band with a reduction in RF level of 6 dB or one-half at the extremes of the adjustment. A satisfactory picture therefore would result for 0.006 in of the total 0.009 in. Further adjustment would cause the scanning of two tracks with a resultant beat or moire between the two RF signals, causing a very objectional disturbance on the picture.

The time delay of the tracking control over which a satisfactory picture is obtained is called the 'good time' and for the format discussed should be

$$tg = 20 \times 10^{-3} \times \frac{0.006}{0.009} = 13.3 \text{ msec}$$

the remaining time is called the 'bad time'

$$tb = 20 \times 10^{-3} \times \frac{0.003}{0.009} = 6.67 \text{ msec}$$

If for any reason the video head does not scan the video track exactly in the

first place, there would be a reduction of the 'good time'.

An excellent method of expressing compatibility between two machines is to measure the range of tracking delay giving a satisfactory picture on an exchange recording and playback basis and expressing it as a percentage of the known theoretical time for the format used.

Compatibility coefficient

$$C = \frac{tg^1}{tg} \times 100\%$$

 tg^1 = measured good time in msec

tg = maximum possible good time

For formats where the guard band dimension is less than the track width and one track represents one field (all known formats to date) tg can be calculated as follows.

For 50 Hz standards.

$$tg = \frac{20 \times 2 \times \text{guard band width}}{\text{centre track spacing}} \text{ msec}$$

For 60Hz standards.

$$tg = \frac{16.67 \times 2 \times \text{guard band width}}{\text{centre track spacing}} \text{ msec}$$

Timing errors

In a similar manner to the quadruplex format, it is important that the same length of tape is around the drum scanner assembly in playback as in record. Failure to do this results in a phase discrepancy during playback in horizontal sync timing between the end of one field and the start of the next, i.e. over the drop-out.

The effect of this is to cause a 'hook', just after the drop-out or head switch time, as the flywheel oscillator in the picture monitor tries to adjust itself to the new sync phase (see Fig. 9.11.). Shorter time constants in the line

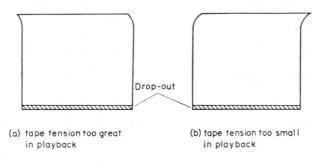

Fig. 9.11. The subjective effect of 'hooking' with incorrect tape tension.

time base circuits will shorten the recovery time but very often this parameter is not available to the VTR operator. A reduction in the time constant also makes sync circuits more vulnerable to noise.

The effect of the problem can be minimised by arranging the drop-out, or head switch time on two headed machines, to occur at the bottom of the picture just before the vertical synchronising interval. This allows 25 lines of vertical blanking before the active picture period for recovery.

The three main variables to affect tape length are temperature, humidity and tape tension. The first two are normally inconvenient and expensive to control. The third however can be used to compensate for the environmental changes.

Environmental changes

If the tape and the drum scanning assembly expand simultaneously by the same amount, the angle of wrap, for a given length of tape, would be the same before and after expansion. If the angular velocity of the head remains constant, no timing error will result.

The most common material for drum scanner assemblies is aluminium and unfortunately this has a different temperature coefficient of expansion from Mylar, the tape material.

Assuming a temperature rise of 30°F between record and play, the net

effect can be calculated as follows.

Temperature coefficient of expansion for Mylar

 $= +1.5 \times 10^{-5} \text{ in/in}^{\circ}\text{F}$

Temperature coefficient of expansion for aluminium

 $= +1.07 \times 10^{-5} \text{ in/in}^{\circ}\text{F}$

Net temperature coefficient

 $= +0.43 \times 10^{-5} \text{ in/in}^{\circ}\text{F}$

For a 30°F change the % change in length

$$lt = 0.43 \times 10^{-5} \times 30 \times 100 = 0.0129\%$$

This small amount however is quite significant.

Each track represents one TV field of 312.5 lines (on 625 line systems)

This expansion therefore represents

$$0.0129 \times 312.5 = 4\%$$
 of a TV line
= $2.56 \,\mu\text{sec}$

This result is independent of the type of wrap, drum diameter or the number of heads.

Changes in relative humidity have a greater effect on timing errors, owing to the wide variation in ambient conditions and the non compensating effect of the drum scanner assembly.

For a 40% change in relative humidity

Humidity coefficient of expansion for Mylar = 1.1×10^{-5} in/in % R.H.

% change in length for 40% change in R.H.

$$= 1.1 \times 10^{-5} \times 40 = 0.044\%$$

% of a 625 standard line

$$= 0.044\% \times 312.5 = 13.7\%$$
 of a TV line

 $= 8.8 \mu sec$

For an increase in temperature and humidity this would result in a total of $11.32 \mu sec$ of error.

For one-inch wide, one-mil tape a decrease in tension of $4\frac{1}{4}$ oz would be required to compensate for such an increase. As tape stretch is proportional to tension, a graph of tension change required to compensate for environmental changes is a linear one as can be seen in Fig. 9.12 (a and b).

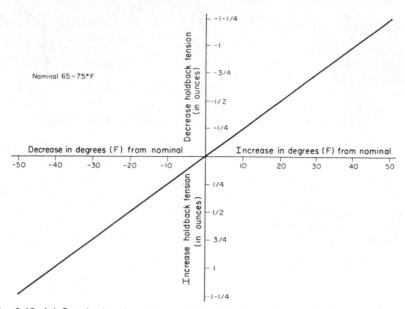

Fig. 9.12. (a) Graph showing changes in holdback tension required to compensate for temperature changes.

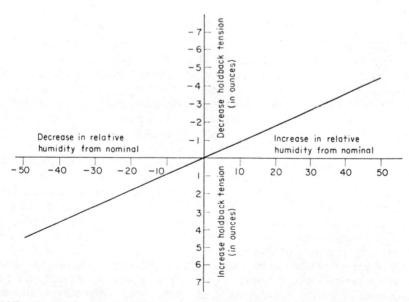

(b) Graph showing tension change required to compensate for environmental changes.

Tape tension

In most helical recorders a nominal tension of 6 to 8 oz is maintained in record. This can then be varied by ± 5 oz during playback to minimise

'hooking' at the top of the picture.

The tape tension can be controlled by affecting the holdback torque of the supply spool or by affecting the take-up torque. The former is normally a braking action on the supply hub while the latter is a power control on the take-up motor.

The design of the transport must ensure that the tension on the tape is constant over its entire length. Failure to achieve this results in a differential

stretch which is very difficult to compensate for.

Theoretically the tension on the tape as it enters the drum scanner can only be the same as the tension on leaving the drum scanner, if the drum has a frictionless surface. In practice this is impossible but surfaces with coefficients of friction as low as 0.02 have been achieved which give a ratio of tensions

$$\frac{To}{Ti} = 1.13$$
 for a 360° wrap

where To =Tape tension at output of scanner

Ti = Tape tension at input of scanner

The problem is that this surface must be kept very clean and all stray tape oxide must be removed. A build-up of oxide could easily deteriorate the coefficient of friction to say 0.2 giving a tension ratio of $\frac{To}{Ti} = 3.5$ (Appendix

17). If the input tension is 5 oz then the output tension would be 17.5 ozs causing gross timing errors due to differential stretch. Meticulous cleaning after every recording or playback results in consistent and controllable results.

A further problem, which is a design one, is to avoid changes in torque as the tape pack increases and decreases in diameter on the spools. This can be done by monitoring the tape tension by means of a sprung tension arm, the deflection of the arm being a measure of the tape tension. By controlling the tension variable to maintain a chosen deflection, any fluctuations in tension can be sensed and corrected for.

This servo action can be seen in Fig. 9.13 which shows the method used on the IVC one-inch format recorders. Here the tension is monitored after the scanner and the tension is controlled by the take-up spool. The pivoted tension arm is loaded against a clock spring so that the correct tension of 8 oz deflects the arm to a central position.

A photocell attached to the tension arm views a lamp and varies its resistance as its position to the lamp changes. This variable resistance forms part of a triac firing circuit and controls the duty cycle of the take-up motor's

a.c. supply.

The servo action functions in the following way. If the tape tension in-

creases for reasons such as increased scanner friction, holdback torque or mains variation, the tension arm would be further deflected against the spring. The photocell moving away from the light would increase in resistance and in turn reduce the duty cycle of the triac circuit. This in turn would reduce the power to the take-up motor and cause a reduction in torque and tension, allowing the arm to move back to its central position.

During record this would keep the tension constant over the full range in diameter of the tape pack. During playback however, for reasons previously mentioned, it is required to vary the tension to compensate for environmental changes. This can only be done in the servo loop by changing its reference. In the case of servo described this can conveniently be done by changing the

spring tension.

Manual adjustment can be made during playback for minimum 'hooking'

by means of a second servo loop.

The second servo loop is a conventional positional servo. The output of the differential amplifier is zero when its two inputs are equal. If the input

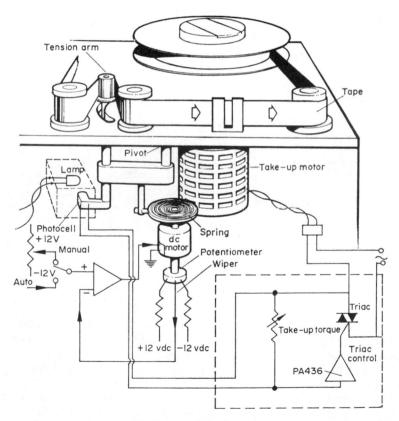

Fig. 9.13. The tension servo.

potentiometer is adjusted to a new potential, the output of the amplifier causes the d.c. motor to rotate until the output from the potentiometer on the motor shaft produces an equal voltage. When the two inputs are equal, drive to the motor ceases. The shaft of the motor will therefore take up an angular position determined by the input potentiometer setting.

Some form of tension servo is required in any helical recorder offering compatibility, but it is normally necessary for the operator to adjust the

tension on playback for minimum timing error.

A refinement on the more expensive helical recorders is automatic tension control on playback.

Auto tension

If the tension on playback is to be automatically controlled for minimum timing errors, some form of electronic circuitry is required to detect the timing error and produce a correction voltage. Use can be made of the automatic phase controlled oscillator (a.p.c.) locked to tape horizontal sync pulses. A block diagram of an a.p.c. oscillator can be seen in Fig. 9.14 which shows a complete diagram of an auto-tension error detector.

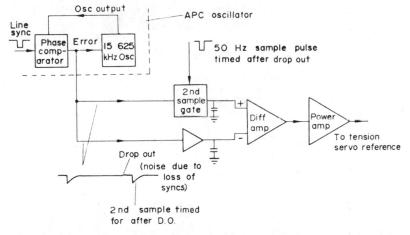

Fig. 9.14. Auto tension error detector.

The oscillator, which is nominally set to the line rate of the playback standard, can be locked in phase and frequency to the playback line sync by controlling the oscillator frequency from a phase comparator. The phase comparator compares the phase between tape sync and the oscillator output and produces an error voltage which increases or decreases the oscillator frequency until coincidence is achieved and the phase error voltage is zero. This phase error voltage is now a measure of playback sync phase.

If the VTR has a horizontal comparator in its servo system, the error can

be derived from this. Machines without horizontal servo control require the

a.p.c. loop.

The maximum phase change occurs from the end of one track to the start of the next. If the error voltage is examined over this period, a rapid change in voltage should be noticed after the switch. The polarity of the change indicates whether the tension is too large or too small while the magnitude of the change is a measure of the tension error.

A second sample gate comparator is used to sample the error voltage just after the drop out or head switch. The sample pulse can be derived from vertical sync, tach pulse or the drop-out sensor. Its important parameter is its timing which should be timed to occur at the start of a track scan. To determine the change in error the a.p.c. error is integrated and subtracted from the output from the second sample gate in a differential amplifier. This d.c. error is then amplified and used to alter the tape tension. In the servo illustrated in Fig. 9.14 it supplies a d.c. motor which alters the spring tension on the tension arm. On some recorders it supplies the d.c. current in a brake solenoid.

The phase comparators are very similar to those discussed in Chapter 8.

Conclusion

The simplicity of the helical format make it more vulnerable to geometry errors. Slight environmental changes considerably affect timing errors and slight dimensional changes affect tracking. The rapid changes of tape motion required for the additional facilities such as variable speed replay can induce such high local tensions and tape to guide pressures that the recorded signal is reduced. This pressure demagnetisation causes a picture disturbance on replay.

Solutions to most of the problems have been found but not all models incorporate them for economic reasons. It is the user who has to decide his own requirements and the necessity for the refinements. Care in cleaning, checking wear with interchange measurements and regular servo and electronic line up go a long way to maintain standards.

References

1. SMPTE R.P. 11, Tape vacuum guide radius and position for recording standard video records on two-inch magnetic tape.

SMPTE, R.P. 36, Specification for positioning tape neutral plane and adjacent tape guides for quadruplex video magnetic tape recorders operating on 7.5 i.p.s and 15 i.p.s.
 HARRIS, A., Time-base errors and their correction in magnetic television recorders.

JSMPTE, Vol. 70, July 1961.

 LASEREV, N., Causes and effects of velocity errors in the interchange of colour video tape recordings. JSMPTE, Vol. 78, No. 7, July 1969.

5. JOHNSON, D., Helical formats, Ampex Educational Industrial Products.

10 Time Base Error Correction

It has been seen that the unprocessed demodulated video can be mistimed owing to head servo instability, capstan servo instability, and tape path geometry. For monochrome signals the effect of these errors can be minimised by reducing the time constant of the flywheel synchronisation circuit in the picture monitor. If however it is required to mix two video signals, the synchronisation of the signals to within $100~\eta \rm sec$ is necessary. With the sophistication of complex servo functions and automatic geometry compensation, timing errors can be reduced to this order. Without them errors in excess of 100 times that required can accumulate.

A possible method of circumventing the problem and mixing between a studio source and a VTR signal, with gross timing errors, is shown in Fig. 10.1.

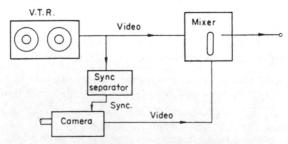

Fig. 10.1. A method for mixing VTR signals with studio source.

In this arrangement the studio camera or telecine is supplied with synchronising pulses derived from the VTR playback signal and not, as is normal, from

a stable sync pulse generator. The resultant studio signal then has the same timing error as the VTR signal and the two sources are synchronous to within very close limits. The disadvantage of the system is that the studio relies on the uninterrupted VTR signal for the complete period of time that the studio source is used. Care must be taken to ensure an adequate length of recorded signal before and after the VTR insert. A refinement to the system is to use some form of flywheel sync generator, locked to tape syncs, to provide syncs during periods of missing pulses caused by tape drop out. The main advantage of the arrangement is in its low cost, which makes it very popular in CCTV installations.

The video timing stability has not been improved and a better system is one where the error is electronically corrected.

Nature of timing errors

The important factors of a timing error are:

- 1. Static error.
- 2. Fluctuating error.
- Velocity error.

Static error. Static error is the fixed timing error between the average timing of the playback signal and a stable reference. This is normally measured as the time between the average timing of the leading edge of sync on the VTR signal and the leading edge of station-sync. If the magnitude of the error is small a comparison between station colour sub-carrier and tape chrominance information can be made.

Fluctuating error. Fluctuating timing error is a measure of the peak deviations of error from the average timing.

Velocity error. Velocity errors are produced when the replay head's relative speed changes as it travels down the video track. This occurs when there is a difference in effective drum diameter between record and replay machines. Early time base correctors were limited to assessing the error at the start of each line and applying the appropriate correction to the whole line. The velocity error is changing continuously down the line and so is uncorrected, showing as a hue change across the picture.

Methods of monochrome correction

The correction of timing errors can be achieved in a variety of ways and several techniques have been developed, each with their own limitations and cost effectiveness. All systems operate in a similar manner of adjusting the delay of the video signal to cancel out any timing discrepancy between the tape video and a stable reference.

The operation of the corrector can be separated into two distinct functions, that of determining the required delay, and that of applying the delay. The two operations can be connected in an open loop or closed loop configura-

tion. Simplified diagrams of both systems can be seen in Fig. 10.2. In both arrangements the delay is nominally set to the middle of its range. If the tape video is retarded, the appropriate amount of delay is removed while if it is advanced, delay is added.

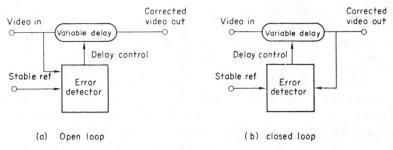

Fig. 10.2. Methods of correcting timing errors.

In the open loop system the timing of the input video is compared to a stable reference and a correction voltage (or digital signal) derived, the magnitude of this voltage being a function of the timing difference between the two signals. Care must be taken to ensure that the calibration of the detector in terms of volts per μ sec error exactly matches that of the delay line in μ sec delay per volt of correction. Failure to do this results in under or over correction.

A better system is the closed loop one where the delay is adjusted until the output is correctly timed. Unfortunately most delay arrangements cannot use such a system because only one timing comparison is made per line. If the output is in error then it is too late to do anything about it.

Methods of applying delay

The analogue delay. A lumped constant delay as shown in Fig. 10.3 has a delay time

$$td = \sqrt{LC}$$
 seconds per section

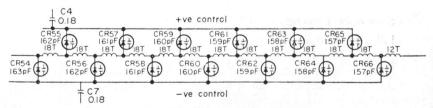

Fig. 10.3. The analogue delay.

A variable delay can be made if the capacitive elements are composed of back biased varactor diodes. By changing the bias a change in capacitance 190

will cause a change in delay. The delay can be continuously variable although large delays require a large number of delay sections. In practice anything up to 90 sections have been used with a nominal delay of 3 μ sec and a range of about $\pm 1~\mu$ sec.

The frequency response of the delay line must be satisfactory to 5.5 Mhz and distortions on the video signal kept to a minimum. For these reasons

longer delays or ones with a greater range are not practicable.

An added problem to compensating for any high frequency loss is that the frequency response will change as the delay is adjusted. Each section acts as a low pass filter with a cut-off frequency dependent on the value of capacitance. Tracking equalisation is therefore necessary with changes in response depending on the amount of delay. These can either follow or precede the delay line and are controlled by the delay bias voltages. Two control bias voltages are normally used which operate in push-pull. All diodes are backbiased and increase or decrease their capacitance simultaneously. If the delay is reduced (a reduction in the value of capacitance), the bias must be increased. The -ve control goes more -ve and the +ve control more +ve. The use of push-pull control overcomes the problem of transients appearing on the output video. If the required delay needs to be suddenly changed, the control bias will make an abrupt change in value. This change can capacitively couple itself across the diodes and superimpose itself on the video causing a transient at the time of change. With the push-pull arrangement and the careful matching of the diodes a +ve and a -ve transient occurs which cancel each other out.

The amplitude of the video itself will cause the bias of the diodes to alter and in this respect cause an amplitude/phase response or differential phase on the colour signals. This can be minimised by reducing the amplitude of the video to about 125 mV while the control voltages are in excess of 1·0 volt. The problem is further alleviated by the push-pull arrangement of the control bias. The diodes connected to the —ve control will alter in the opposite manner to those connected to the +ve control for all changes in video level. The two effects tend to cancel each other out, but not exactly, owing to the non linearity of the system, i.e.:

The capacitance of a varactor diode

$$C_v \propto \sqrt{\frac{1}{v}} \propto v^{-\frac{1}{N}}$$

where v = bias voltageand N is between 2 and 3.

The delay of the line $td \propto \sqrt{C_v} \propto C_v^{\frac{1}{2}}$

$$td \propto \left(v^{-\frac{1}{\mathrm{N}}}\right)^{+\frac{1}{2}} \propto v^{-\frac{1}{2}\mathrm{N}}$$

If N=2

$$td \propto v^{-\frac{1}{2}} \propto 4\sqrt{\bar{v}}$$

The delay of the delay line is proportional to the reciprocal of the fourth root of the voltage. This is not a very linear relationship and it must be ensured that the correction voltage follows this law.

The quantised delay line. A lumped constant delay line could be constructed with fixed components and with output tappings along the line at discrete intervals. The video which is applied at the input, could be delayed by any quantised amount, selecting the appropriate output. The delay is not continuously variable and therefore may not be exactly the correct amount. If the output that is nearest to the correct timing is chosen the maximum error will be half the timing difference between tappings. The number of outputs depends on the required correction range and the tolerance on the residual timing error of the video output. For a range of 2 $\mu \rm sec$ and a video signal timed to within 20 $\eta \rm secs$.

Number of outputs =
$$\frac{2 \times 10^{-6}}{40 \times 10^{-9}}$$
 = 50 outputs.

Each output requires a gate and a buffer amplifier with equalisation compensation for a high frequency loss caused by the delay line. The amount of electronics for a quantised delay is considerably greater than for the analogue system, although for the former there is a considerable repetition of circuitry.

The binary quantised delay line. For very long delays the number of outputs required on a simple tapped delay line becomes prohibitive. It is also difficult to design a lumped constant delay line which does not cause group delay problems. The longer the delay the greater the problem. The engineering answer to both these problems is the use of quartz delay lines made in lengths which have a binary relationship to each other (see Fig. 10.4). The appropriate delay can be selected by arranging the relevant delays in series with the video path. By using nine delays from $\frac{1}{8}$ μ sec to $63\frac{7}{8}$ μ sec can be formed. Fewer switches are needed than in the tapped delay line system, but the logic involved in deciding the switching arrangement is complicated.

Quartz delay lines have a very poor low frequency response, making them unsuitable for video signals without some form of modulation. In practice FM modulation is used, which alleviates the problem of gain stability. There are 512 different combinations of delay which must not cause differing phase or frequency response. Because of the extra cost of peripheral logic, modulation and demodulation the binary delay configuration is used only for delays in excess of 32 μ sec.

If a timing corrector has a range of 32 μ sec, a further economic advantage can be made in the servo system. The horizontal comparator would no longer be required because the horizontal information of the tape signal can never be more than 32 μ sec displaced from the reference.

Binary delay switching

The problems of delay switching can be seen in Fig. 10. 4 where the electronic switches are shown as simple toggle switches. Method (a) would seem an obvious method of connecting the delays where each delay is preceded and followed by a single-throw double-pole switch. The video could either be routed through the delay or by-passed. The method suffers from two very serious disadvantages. Imagine that the $16~\mu sec$ delay needs to be switched

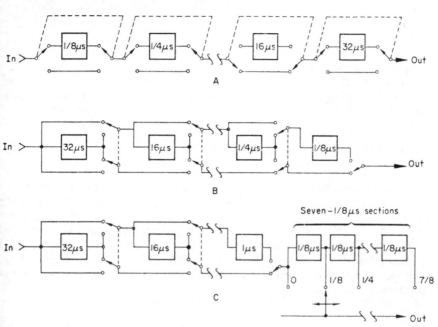

Fig. 10.4. The binary quantised delay line.

in and the delays of lower value switched out. A typical situation where an increase in delay of $\frac{1}{8}$ μ sec is required. The presence of the 32 μ sec delay means that nothing can happen to the output until 32 μ sec after the switching action. Secondly the output of the 16 μ sec delay will be zero until 16 μ sec after an input has been applied. This means that if at the start of a line the delay was changed, nothing would happen for 32 μ sec after which 16 μ sec of no signal, followed by corrected video.

The problem can be solved, with one restriction, by connecting the delay lines as shown in method (b), where each delay is followed by a double-pole, double-throw switch. The restriction is that the total delay can be adjusted only in increments of the smallest delay, in this case $\frac{1}{8}$ μ sec. With the switches in the position shown the delay is $\frac{1}{8}$ μ sec. To subtract $\frac{1}{8}$ μ sec the output switch ($S\frac{1}{8}$) should move to its upper position, thus producing a delay of:

$$8 + 4 + 2 + 1 + \frac{1}{2} + \frac{1}{4} + \frac{1}{8} = 15\frac{5}{8} \mu \text{sec}$$

To add $\frac{1}{8}$ μ sec the 16 μ sec and $\frac{1}{8}$ μ sec delays must be connected in series and this can be done by moving all switches following the 16 μ sec delay to their opposite positions. The correctly phased output will not appear until $\frac{1}{8}$ μ sec after the upper set of switches have been actuated. To maintain continuity

the action of the lower set of switches are delayed by $\frac{1}{8}$ μ sec.

The final question is whether the restrictions of being able to change the delay only in $\frac{1}{8}$ μ sec increments is any limitation. The delay is normally changed only at the start of each line and the question is whether or not the timing error will change by more than $\frac{1}{8}$ μ sec in 64 μ sec. This equals a velocity of error greater than 1 μ sec per 0.512 msec or 1 μ sec per 45° revolution of the head on a quadruplex recorder. In general, velocity errors will seldom exceed this. However in the case of a guide penetration error the timing error difference between the last line of a head and the first line of a following head can approach 1 μ sec. For this reason the arrangement is modified so that the final binary delay is 1 μ sec and the following $\frac{7}{8}$ μ sec is made up of a tapped delay line with outputs at $\frac{1}{8}$ μ sec intervals.

Determining the required delay

The analogue error detector. Phase comparators producing an error voltage proportional to the phase difference between two pulses have already been described in the chapter on servo mechanisms. Such circuits are also used in timing correctors where tape horizontal sync is compared in phase to a reference horizontal sync. The error developed however cannot be directly applied to the analogue delay line. Push-pull signals have to be derived and amplified to produce quite a large charging current. Also the error voltage, which is proportional to the timing error, must be modified to produce a fourth power law.

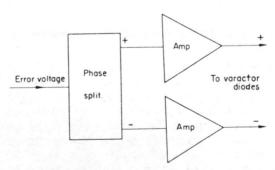

Fig. 10.5. Method to provide push-pull signals.

The arrangement to produce push-pull signals can be seen in Fig. 10.5. The circuits must be accurately matched and be capable of providing a low output impedance to rapidly charge the delay line capacitance. The control input of a 3 μ sec delay would typically have an input capacitance of about 0.5 μ F and it would be required to charge this in as short a time as possible.

The time required to charge a capacitance is approximately $5 \times CR$, where CR is the time constant of the charging circuit.

For charging time of 1 µsec:

$$CR = \frac{1}{5} \mu \text{sec}$$

$$R = \frac{10^{-6}}{5C} \text{ ohms}$$

$$= \frac{1}{2.5} = 0.4 \text{ ohms}$$

For a 1 volt change in error voltage, the initial charging current would be

$$I = \frac{1}{0.4} = 2.5 \text{ amps}$$

Fourth power law

An electronic device with the characteristic of a fourth power law $(y = x^4)$ is not easy to produce (see Fig.10.6). A compromise can be reached by approximating to the characteristics with a series of linear functions as in Fig. 10.7. The device operates as a simple divider where:

$$vo = vi \frac{R2}{R1 + R2}$$
$$\frac{vo}{vi} = \frac{R2}{R1 + R2}$$

The value of R2 depends on the number of diodes conducting. The bias potential on each diode is set by its position on the ladder network which produces reference potential from zero volts to the peak value of the control voltage. For low values of control voltage all the diodes will be conducting,

Fig. 10.6. A fourth power law.

causing R2 to be low in value. The slope of the transfer characteristic $\frac{\delta vo}{\delta vi}$ would be small. As the signal level goes more positive, the diodes turn off as their reference bias is exceeded. R2 increases in value causing $\frac{\delta vo}{\delta vi}$ to increase.

By choosing the values of resistors in series with the diodes and the bias potentials carefully a reasonable approximation to a fourth power law can be made.

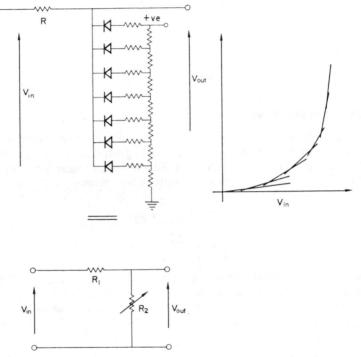

Fig. 10.7. A method of producing a transfer function with a fourth power law.

The stable references

The obvious stable reference for phase comparison is station sync and this can be used where the servo instability error combined with the geometry error does not exceed the range of the delay line corrector. In general, for analogue correction, this necessitates the use of the horizontal comparator in the head-wheel servo for complete correction of the errors. The use of a less stable servo mode however does not preclude the use of the corrector, even though the magnitude of the errors on the input video is well beyond the range of the corrector.

When playing back a signal in a non horizontal locked servo mode the

magnitude of the servo error may exceed 10 μ sec. The geometry error however seldom exceeds 1 μ sec. The inability of the monitor sync circuit to follow fast changes makes the geometry error the most objectionable. A definite advantage therefore is gained by removing those errors with a high velocity, and a corrector working in such a manner is sometimes referred to as being in the 'picture straighten mode'. A complete block diagram of an analogue corrector can be seen in Fig. 10.8.

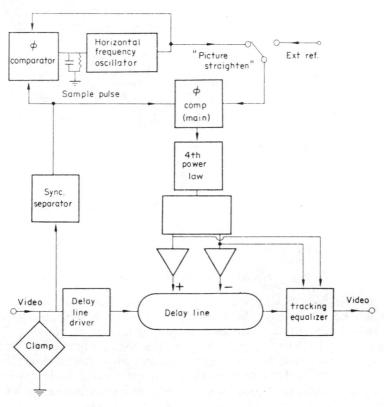

Fig. 10.8. A monochrome analogue corrector.

The object of the reference therefore is to follow the large slow-changing phase errors of the tape signal but not the fast-changing errors. The time constant of the a.p.c. loop can be made such that the oscillator will track the slow errors but integrate the rapid changes. The main phase comparator therefore compares the timing of a tape signal with slow and fast changes in phase with the timing of a reference signal with only slow changes. The error voltage therefore, and the subsequent delay correction, is proportional to the rapid changes in timing error. The corrector working in this mode does not radically improve the timing stability but just removes those errors which are subjectively annoying. For the stable mixing of video signals and all

colour applications the corrector must work in the reference mode. The input stability of the signal therefore must not exceed the range of the corrector for full correction of the errors.

The quantised gate

It is possible to produce a closed loop system when all the outputs of a quantised delay are available. The technique is to gate all outputs from the delay and select the appropriate output. The action of detection and selection can be seen in Fig. 10.9. A phase comparison is made for each output, although

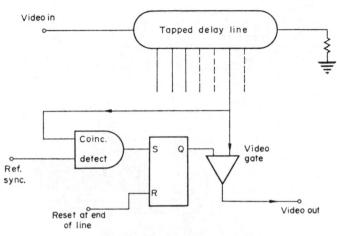

Fig. 10.9. The quantised gate.

only one output circuit is shown, and the coincidence between tape sync and the reference is detected. The coincidence detector is a simple 'AND' function with an output when the two sync inputs are synchronous. This sets a bi-stable latch which opens the gate. The bi-stable remains set maintaining the selected output until the end of the line, when another coincidence comparison is made. The circuit has the advantage of being stable with little requirement for accurately controlled non-linear functions. The cost of the detection of error increases with the number of outputs from the delay line.

Binary error detection

If lumped delay lines with a binary relationship are used, the most convenient form for the error signal to take is a binary number. For nine delays from $32 \mu \sec to \frac{1}{8} \mu \sec a$ nine bit binary number would be required.

Bit No.	9	8	7	6	5	4	3	2	1
Count	256	128	64	32	16	8	4	2	1
Delay µsec	32	16	8	4	2	1	$\frac{1}{2}$	1	18
Binary No.	for 19	μsec					٠.		and the same of the
= 152	0	1	0	0	1	1	0	0	0
Delay =		16		+	2 +	- 1			$= 19 \mu \text{sec}$

A method of producing this number is to count the number of clock pulses, which are timed at $\frac{1}{8}$ μ sec intervals, between a tape signal pulse and a reference pulse. This count would represent the number of $\frac{1}{8}$ μ sec delays required to make the two signals coincident. For example assume that the difference between the two signals was 19 μ sec.

The total count of $\frac{1}{8}$ μ sec pulses = 19 × 8 = 152

in binary = 010011000

A 0 denotes the removal of a delay while a 1 denotes the insertion. For the binary number calculated the total delay would be $16 + 2 + 1 = 19 \mu sec$. The time measurement made can only be in terms of an integral number of

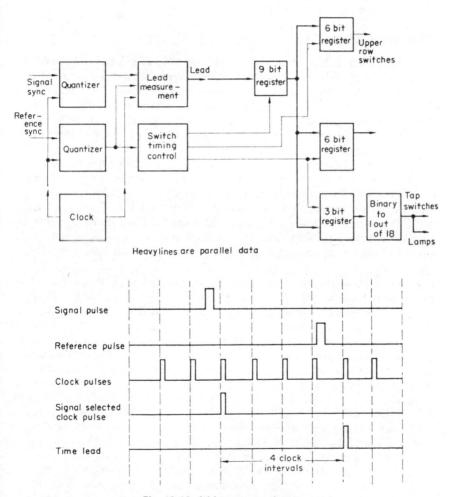

Fig. 10.10. A binary error detector.

clock pulses. In this respect the measurement is 'quantised'. The action of quantisation can be seen in Fig. 10.10 where both the signal and the reference pulses are modified in timing to the nearest following clock pulse time. The difference between the two quantised pulses must now be a whole number of clock pulses which makes the digital processing easier. The nine bit word can be temporarily stored in a register before the two final operations.

First, the final section of the delay is not binary but a $\frac{7}{8}$ μ sec long, $\frac{1}{8}$ μ sec tapped, delay line and the last three bits of the word is converted to a 'one out of eight' form. Secondly the upper row of switches and the lower set of switches actuate at differing times so that the six most significant bits of the word are transferred into two separate registers whose outputs operate the

RF switches when required.

Colour correction

The three main colour standards in use are 525 NTSC, 625 PAL and 625 SECAM. Of these NTSC and PAL systems use phase modulation of a colour subcarrier which make them very sensitive to spurious phase modulation introduced by the VTR. SECAM on the other hand uses a line sequential frequency modulated system which is more tolerant of the VTR timing instability. Stability requirements for the latter are no more stringent than for monochrome systems.

One method of overcoming the problems of recording colour signals is to convert the incoming standard into one that is more tolerant to the distortions incurred. Such systems are used but are to be avoided if the maximum performance specification is required. This limits the use of such systems to CCTV applications. Most broadcast and some CCTV systems improve, yet again, the timing stability from the monochrome corrector and reduce the error to limits small enough to cause imperceptible distortion on the colour signal.

For a PAL signal the error should be limited to ±5° and for a NTSC signal an error better than $\pm 4^{\circ}$ is required. This allows for additional errors in the transmission path and the recording of multiple generation tapes.

The tolerance on timing from the above angular displacements would be better than ±3 nsec for both systems. The colour corrector, which follows the coarse monochrome corrector, acts as a vernier adjustment of phase bringing the phase of the video to within the tolerance mentioned. Because of the small range required from such a corrector and the small limits of error the most suitable method is the analogue delay. The range of such delay lines need be no larger than $\pm 180^{\circ}$ of subcarrier because this is the maximum phase error possible between two sine waves. The longest delay required therefore would be for an NTSC signal with 3.58 MHz colour subcarrier, requiring a delay range of $\pm 140 \eta$ sec.

The error detector is very similar to the open loop analogue detector previously described with the exception of the reference used. In a colour corrector, shown in Fig. 10.11, the 10 cycles of burst on the back porch of the tape signal is compared in phase to the reference station subcarrier. Allowance has to be made in PAL signals for the burst swinging $\pm 45^{\circ}$ on consecutive lines. This is done by swinging the reference subcarrier in sympathy with the burst. The swing of the tape burst is detected to produce a $7.8 \, \text{kHz}$ switching

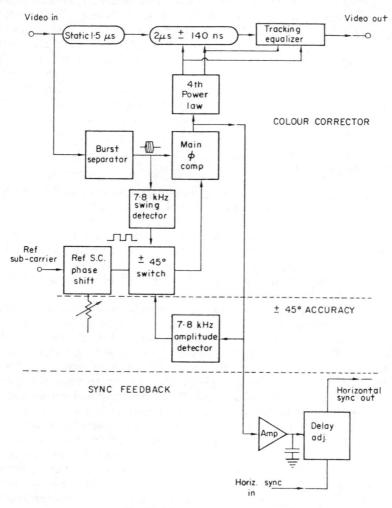

Fig. 10.11. A colour corrector.

signal which is used to switch the phase of the reference subcarrier. An operational adjustment of the reference phase can also be made in order to produce the required output video phase. The video is also delayed by a static delay of about $1.5~\mu$ sec to allow for the delay in determining the error voltage and charging the delay line. This was not required in the monochrome corrector as the time available from the leading edge of sync to the start of

the active line time is about 10 μ sec. For colour correction the time from the last cycle of the burst to the start of the active line is less than 3 μ sec. The extra static delay ensures that the variable delay is set correct before the

start of the active line period.

A problem is created by the swinging burst in PAL if either the burst swing or the reference swing is not exactly $\pm 45^\circ$. It is quite feasible that the recorded colour signal has a tolerance of $\pm 2^\circ$ from its nominal. If the reference swings $\pm 45^\circ$ while the burst swings $\pm 43^\circ$ then the 2° error would result in a false correction. This could be avoided if the reference is adjusted to $\pm 43^\circ$ to match the recorded signal. This can be done automatically by monitoring the error voltage. Any error between burst and reference due to alternate line swing would result in a 7.8 kHz component in the error waveform. The angle of the reference therefore is adjusted until a zero 7.8 kHz component occurs.

Sync feedback

It is important that the delay line operates in the centre of its delay range to enable the corrector to operate on the peak positive and negative excursions of the error. It would be wasteful to use the device to remove static errors. Without the use of sync feedback the corrector would have no method of adjusting its input phase to achieve this. The input phase to the colour corrector is determined by the head servo and the monochrome detector, and by adjusting the timing of the sync reference to either unit the input

video phase can be altered.

The delay line is at the centre of its range when the output of the phase comparator is zero volts. A positive or negative excursion would reduce or increase the delay. The sync feedback loop operates in the following way. The sync reference to the servo is delayed by a nominal 3 μ sec. The correction voltage is amplified and integrated to produce a voltage proportional to the average error of the incoming signal. If this is not zero volts, the delay of the sync reference to the servo is adjusted from its nominal timing until the input phase to the corrector causes the average error voltage to be zero. The delay line must now be operating about the centre of its range. Figure 10.12 shows two methods of applying sync feedback. In Figure 10.12 (a) the colour corrector error volts adjusts the reference to the monochrome corrector which in turn controls its output video phase. It is of course a requirement of the monochrome corrector to operate about its own centre delay and this can be done with a second feedback loop to the head servo reference. The requirement to manually adjust the monochrome timing cannot now be incorporated in the servo reference. To do this would result in a self cancelling effect. If the servo reference were manually delayed, the resulting change in head position would result in a change in video timing to the monochrome corrector, which in turn would be corrected. The change in error volts via sync feedback would adjust the servo reference reducing its delay to offset the manual adjustment.

Adjustment of the monochrome corrector reference is therefore used,

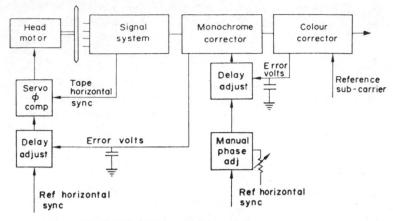

Fig 9.12 (a) The application of sync feedback.

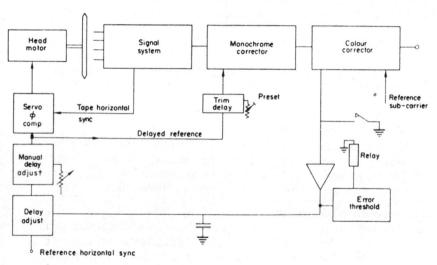

Fig. 10.12. (b) Single loop.

which in turn, via sync feedback, affects the servo reference. With two feedback loops care must be taken with the choice of time constants to avoid the two loops interacting and causing a hunting action. This problem can be solved and the saving of one adjustable delay can be made, by using the arrangement shown in Fig. 10.12(b).

The reference for the monochrome corrector and the servo are made the same by providing two outputs of the manual delay adjustment. A trim adjustment of the corrector reference is made to bring the monochrome delay to its centre. Once this is done the input video timing and the corrector reference will track, keeping the average delay central. If the manual delay is adjusted, the head wheel, and thus the video, will alter phase by the same

amount as the reference to the corrector. The only sync feedback loop is from the colour corrector error to adjust its input timing.

Error dumping

It can be seen in both circuits that the colour corrector has the final decision on the output phase. This obviously is a requirement for the mixing of colour signals. As there is no specification for sync/subcarrier phasing the monochrome phasing can be in error by an amount equivalent to ±180° of subcarrier. Adjustment of horizontal phase therefore can only be made in quantised steps of 360° of subcarrier, if the desired chroma phase is maintained. This is automatic in both sync feedback circuits. If a manual adjustment of line sync is made, it is cancelled with the feedback, maintaining correct chroma phasing. This is correct until the sync feedback exceeds 180° of subcarrier, i.e.: 226 nsec PAL 270 nsec NTSC. When this happens the monochrome phasing is not to within the nearest cycle of subcarrier. An error dumping circuit is used to sense when the control volts to the sync delay circuit exceeds a given threshold, equivalent to a delay of ±180° of subcarrier. When this occurs the error volts are forced to ground potential returning the sync delay to its nominal value. The colour corrector then rephases to its nearest cycle of subcarrier and the relay is de-energised to allow sync feedback to continue. This action is referred to as 'dumping'.

Sync/subcarrier lock

For NTSC signals the sync pulses and the subcarrier have a locked frequency relationship. It is sometimes said that the subcarrier is 'an odd multiple of half-line frequency'. This is required to interleave the chrominance and luminance spectra and thus avoid interaction between the two.

More precisely for 525 NTSC

$$f_{\rm sc} = \frac{455 \times fl}{2} = 3.579545 \text{ MHz}$$

fl = line frequency = 15.734264 kHz.

For 625 PAL the relationship is more complex.

$$f_{sc} = fl(284 - \frac{1}{4}) + \frac{1}{2}ff = 4.43361875 \text{ MHz}$$

 $ff = 50 \text{ Hz}$
 $fl = 15.625 \text{ kHz}$

This locked relationship is extremely important if the correctors described are to function correctly. It is imperative that the same frequency relationship between subcarrier and sync exists on the recorded composite signal as between station sync and subcarrier during playback. If this is not so then the monochrome corrector would present the colour corrector with a signal in

which the tape chrominance and reference subcarrier are continuously changing in phase with respect to each other. The effect is for the signal to be corrected by the colour corrector until the drift between sync and subcarrier accumulates to 180°, when the circuit dumps and skips one cycle.

The effect of an off-locked subcarrier on a live picture is not very noticeable and it is an easy matter to record such a signal. Playback can be achieved only by arranging exactly the same off-locked relationship, which is extremely difficult. Lock detectors therefore are a useful addition to any colour VTR installation.

Velocity error correction (quadruplex)

The monochrome and colour correctors sample the error and apply correction at the start of each line. This correction is then held throughout the line until the next sample, $64~\mu sec$ later. If the error changes between samples, correction is not made until the following sync pulse and colour burst. A problem exists in the correction of errors with a large velocity. Servo errors are random and although the disturbances can be large the head motor does not move from or to its correct position at a very fast rate. This is due to the inertia of the head assembly and partly the intentional damping in the servo electronics.

Head to tape geometry, however, causes relatively large velocity errors. This can be seen in Fig. 10.13 which shows a typical error due to the maladjustment of the guide height. If the peak error of the waveform is 400 nsec and the error goes from a minimum value to a positive value in half a head sweep (eight lines), the average change per line is

$$\frac{400 \times 10^{-9}}{8} = 50 \text{ nsec}$$

This will be larger for some lines where the rate of change is greater. For a given corrected line the error may be corrected to within 3 nsec, but at the end of the line, 64 μ sec later, the error could be 50 η sec. The subjective effect is colour banding which increases toward the right hand side of the displayed picture. If standard, 75% colour bars are played back, the yellow bar which is on the left hand side of the screen is substantially unaffected, but the blue bar which is on the right hand side of the screen has errors in excess of $\pm 45^{\circ}$ as can normally be seen in a vector display. The difficulty in correcting for these errors is that a tape reference timing does not exist. Three solutions have been engineered to minimise the problem:

- 1. Pilot tone.
- 2. Memory store.
- 3. Line delay.

Pilot tone (velocity compensation). If during the recording process a pilot tone is added to the FM signal, the stability or phase of this tone in subsequent playback is a measure of the timing error of the played back video. The frequency of the pilot tone has to be high enough to enable several samples

throughout a line but low enough to avoid interference with the FM signal. A division of colour subcarrier is convenient and divisions from 4 to 9 are used.

For PAL $4.43 \div 7 = 0.673$ MHz. This pilot tone frequency gives about

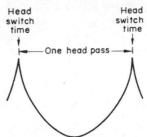

Detail A. Actual time-base error waveform (error caused by misadjustment of vacuum guide height)

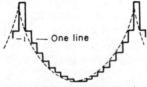

Detail B. Corrector error waveform showing line-by-line correction

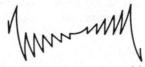

Detail C. Velocity error component remaining (A-B)

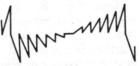

Detail D. Simulated velocity error signal generated by velocity compensator

Detail E. Output of velocity compensator (D+B)

Fig. 10.13. The derivation of linear interpolation.

45 cycles per 64 μ sec enabling 45 samples per line. On playback this tape reference can then be phase compared to a stable $4.43 \div 7$ to produce a correction signal.

For NTSC $3.58 \div 5 = 0.716$ MHz. This pilot tone also gives about 45

cycles per 63.5 µsec line.

The main disadvantage of this system is that special recordings are required and that the pilot tone, whatever its frequency, adds some extra beat components or moire to the video. For these reasons the memory system is preferred.

Memory store. The object of the memory system is to correct for the velocity errors due to geometry changes only, which constitute the larger proportion of velocity error.

The magnitude of the problem can be seen in Fig. 10.13(b) which shows a comparison of actual error in μ sec against the delay in μ sec of the delay line. The divergence between the two is a measure of the uncorrected timing error. A sample is made every 64 μ sec and the correction held constant between samples. The corrector error voltage therefore is a stepped function with 16 discrete levels, one for each line, which is used to correct the smooth cosine curve. An improvement can be made if the error voltage is interpolated between the discrete levels, changing linearly between samples. This would

not follow the curve exactly but would be a good approximation.

The interpolation voltage that needs to be added to the corrector error voltage would be a series of sawtooth ramps whose amplitude and polarity would be determined by the difference in error between the line playing back and the next line. The fundamental problem is to determine what the error is on the following line, this being impossible until that sample is made, by which time it is too late. The solution is found by using a memory, one for each line, which remembers the error between line 1 and 2, line 2 and 3 . . line 15 and 16, the previous times the head played back. Geometry errors are repetitive, which implies that if the last time the head played back, the error between the two successive lines was $x\mu sc}$ then, unless the guide moves between scans, the same error will occur on future scans. The error thus stored can now be read one line earlier to determine the sawtooth ramp magnitude and direction. One store is required per line or 16 stores per head; with four heads the total number of stores is 64.

The velocity error compensator is basically a small memory and a computing device which modifies the stepped corrector error to approximate the smooth error function. The interpolated error is then applied to the delay

line as a correction voltage in the conventional manner.

A block diagram of a velocity error compensator showing how the stepped error is interpolated is shown in Fig. 10.14. The corrector error is amplified and passed through a subtractor clamp, the object of which is to produce a voltage equal to the difference between the error on two lines. This can be done by applying a positive pulse to Q5 at the end of each line and grounding the error signal. The capacitor passes only changes in error and the input to the write gate is a series of pulses whose amplitude represent the differences in error. The store is selected by applying a ground to one side of the selected capacitor. When the write gate is opened the capacitor charges towards the voltage determined by the error pulse amplitude with a time constant CR.

With typical values of $R = 100\Omega$ $C = 1 \mu F$.

Time constant = $1 \times 100 \times 10^{-6} = 100 \,\mu\text{sec.}$

The time to charge exponentially, in a simple charging circuit, to an aiming potential is $5 \times CR$. Therefore with chosen values, charge time is 500 μ sec. This long charging time is deliberate because the charge accumulated in the store is integrated over many head passes. If the pulse width, P4, is 6 μ sec, it would take $\frac{500}{6} = 83$ write cycles to load the store, or 83 revolutions of the

head which is about one-third of a second. The advantage of doing this is to reduce the effect of false sample errors due to tape dropout and noise, the false sample contributing only one part in 83 of the stored voltage. The only penalty is the speed of operation which takes fractions of a second to settle down after the guide has been moved.

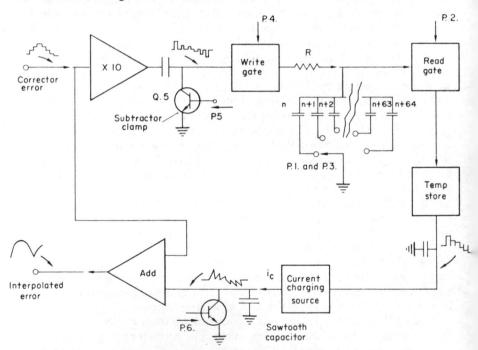

Fig. 10.14. A memory velocity compensator.

The read action is non-destructive, i.e.: the input impedance to the read gate is very high (>1M Ω). For any given line the first operation of the store is to read the accumulated error, which is the estimate for the charge expected at the end of the line. This needs to be done first because the formation of the ramp, which represents the linear interpolation, must start at the beginning of the line. The charge on the selected store is read and stored on a second

capacitor which acts as a temporary store. Once this capacitor is charged to the same potential as the read store the read gate can be closed, allowing the write function to operate during the remaining line time.

If the capacitor selected for write is n, during that line n+1 is read. The sequence therefore is Read n+1, Write n, Read n+2. Write n+1...etc. The pulse timings showing the sequence are shown in Fig. 10.15. The voltage on temporary store acts as a reference potential to a constant current

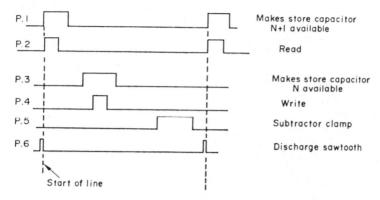

Fig. 10.15. Pulse timing diagram.

charging source for a sawtooth generator, the current (i_c) being proportional to the input voltage. At the end of each line P6 turns on Q6 and discharges the capacitor. Charging continues at a new rate determined by a new voltage on the temporary store.

The sawtooth ramp, whose peak amplitude should equal the amplitude difference on each step, is now added to the stepped error forming a better approximation to the smooth error curve. Figure 10.13(e).

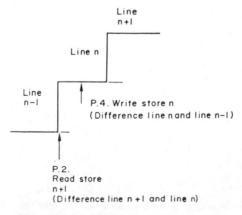

Fig. 10.16. Store read and write sequence.

Two further modifications to the sequence are now necessary and apply to the start and end of a head sweep. For line number one of any head sweep the difference in error from the previous line is of little use because the previous line was from a different head and interpolation between the two errors is meaningless. The write for line 1 therefore, is inhibited. This can most conveniently be done by turning Q5 on for all of line 1. This missing error is of no consequence until the end of the head sweep because during line 1 the difference between line 2 and 1 is read, during line 2—line 3 is read. . . etc. during line 15—line 16 is read, during line 16—line 17 read, during line 17 . . . line 18 read. Unfortunately on 625/50 Hz signals line 17 is non-existent and on 525/60 Hz signals line 18 is non existent, this being the line missed

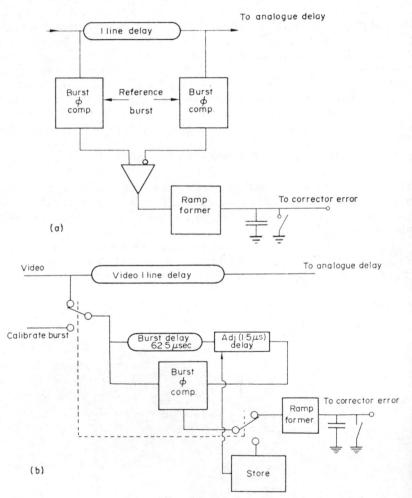

Fig. 10.17. (a) Determination of velocity error using a line delay. (b) A self calibrating system.

by switching to line 1 of the following head. A compromise is reached during the last line (16 or 17) by re-reading store 16 on 625 and 17 on 525. For the

last lines of a head sweep on a 625/50 Hz signal the sequence is:

Read 15, write 14, read 16, write 15, read 16, inhibit write 1, i.e.: store 16 read twice. The main advantage of the memory store method is that it can work on all recordings, with no special record process. Moreover, the video is not subjected to any further processing or delay which might add noise or distortion. Its disadvantage is that it can handle only repetitive errors. To remove non-repetitive errors a line delay system is needed.

Line delay. It takes a period of one line to determine the error difference between any two lines. If the video can also be delayed by one line a linear interpolation throughout the line is possible. Two methods are shown in Fig. 10.17 of producing an error difference voltage for the ramp former. In Fig. 10. 17(a) use is made of a difference amplifier where the difference in two error samples is formed. A second circuit, shown in Fig. 10. 17(b), operates on two colour bursts from two separate lines and uses a burst one line delay, the output of which is the burst from the previous line. Response requirements of the burst delay line are not critical but its timing is very critical, requiring an accuracy better than 1° of subcarrier. This accuracy can be achieved by calibrating the delay once every field during the field blanking interval when velocity compensation is not required. By passing in bursts derived from local subcarrier and known zero velocity any phase error can be measured, stored and used to adjust the delay until correct. During the active field time, the phase differences between tape bursts are made to derive the velocity of the error. A high quality one line delay is of course required for the video

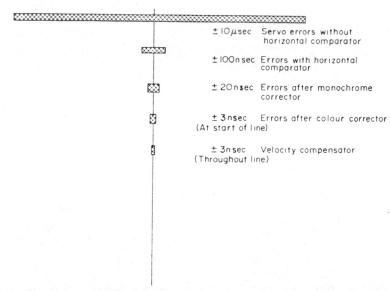

Fig. 10.18. A comparison of timing errors through a VTR.

path, which is the main disadvantage of the system. The measurement of velocity, however, is a more accurate one and theoretically most errors are reduced by a factor of 100 by straight line interpolation (see Appendix 18).

Conclusion

For colour operation the timing errors resulting from the record replay process have to be reduced to less than ± 3 n sec, the equivalent of $\pm 3^{\circ}$ of chroma shift. This cannot be achieved in one stage with analogue systems and so a series of reducing range steps is used as Fig. 10.18 demonstrates.

Helical machines generate larger errors than quadruplex machines and these cannot be corrected by analogue systems except on the B format.

References

- COLEMAN, C. H., Techniques for multiple generation colour videotapes. Ampex Corporation, Redwood City, U.S.A.
- 2. COLEMAN, C. H., A new technique for time-base stabilization of video recorders. Ampex Corporation, Redwood City, U.S.A.

11 Digital Time Base Error Correction

The range of lumped constant delay lines, with varactor diodes as the capacitive elements, are limited to about 2 to 3 μ sec. Larger delays create insuperable problems of phase and frequency response, with the difficulty of tracking equalisation as the delay is adjusted.

Differential phase, caused by the luminance changes of the video affecting the capacitance of the varactor diodes and transients on the output video, coupled across the diodes, cannot be completely eliminated by

balanced positive and negative control lines.

Switchable ultrasonic delay lines can produce a 'control range' or 'window' of $\pm 32~\mu \rm sec$. Such devices however require extremely precise equalisation for each delay path if frequency, amplitude and group delay response changes are to be avoided as the delay is altered. Accordingly they are expensive, particularly when it is considered that it must be

followed by an analogue delay for fine and velocity errors.

Storage, therefore delay, of digital information has made tremendous advances with the advent of integrated circuit computer technology. If a video signal is converted into a digital form the binary bits could be delayed without distortion, until required and then reconverted back into its analogue form. The conversion introduces some distortion but unlike other forms of delay extra distortion will not result from further delay. Care should therefore be taken to minimise the distortion introduced by analogue to digital (A–D) and digital to analogue (D–A) conversion.

Analogue-digital conversion

Two important decisions have to be made concerning the conversion:

- 1. The rate at which the level of the video waveform is sampled.
- 2. The number of bits required to represent each sample.

The sample rate. This is determined by the highest video frequency. Two samples being the minimum required to describe one cycle of a sine wave.

Fig. 11.1. Sampling at twice video frequencies.

From Fig. 11.1 it can be seen that more than two samples are desirable as the sample could take place at the zero crossover points.

In practice there are advantages in sampling at a multiple of colour subcarrier. This ensures that amplitude errors in large areas of one colour (discussed later) are at least fixed and therefore less noticeable. The minimum sampling rate which satisfies both conditions of at least twice the highest frequency and being a multiple of subcarrier is:

$$3 \times \text{fsc}$$
 or $3 \times 3.579545 \times 10^6 = 10.738635$ MHz for 525/60 Hz NTSC or $3 \times 4.43361875 \times 10^6 = 13.30085625$ MHz for 625/50 Hz PAL

where fsc = subcarrier frequency.

The number of bits required to describe the instantaneous level of a video signal is determined by the quantisation of the signal. In other words 'What is the minimum number of discrete levels that can be used before the individual steps become perceptible?'

The impairment of quantisation is most noticeable on a gradual transition, such as a line sawtooth, which is converted into a series of steps.

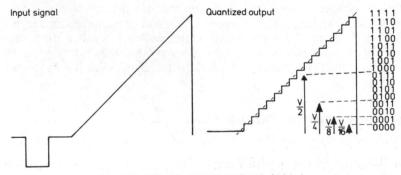

Fig. 11.2. Quantisation to 16 levels (4 bits).

This can be seen in Fig. 10.2 where:

Step amplitude =
$$\frac{1}{2^n}$$

where n = number of bits

For 4 bits:

$$\frac{1}{2^4} = \frac{1}{16}$$
th of the video level

The distortion caused by these steps is sometimes referred to as 'quantisation noise' or 'quantisation distortion'.

As a comparison with a signal with the same peak-peak random noise we obtain:

Signal/noise ratio =
$$6n + 18 \, dB$$

(see Appendix 23)

For a true RMS value of the unwanted component when the video signal from black level to peak white (0.7 V) is coded we obtain:

Signal/noise ratio =
$$6n + 10.79 \text{ dB}$$

(see Appendix 24)

If 100% colour bars are coded from tip of sync to peak chroma excursion we obtain:

Signal/noise ratio =
$$6n + 5.87 \, dB$$

(see Appendix 25)

Table 13 compares the various assessments of quantisation noise.

Table 13

No. of bits	No. of levels	S/N ratio of same peak to peak random noise in dBs (monochrome only) (3)	Actual signal RMS noise in dBs (monochrome only) (4)	Actual signal RMS noise in dBs (colour) (5)
1	2	24	16.79	11.87
2	4	30	22.79	17.87
3	8	36	28.79	23.87
4	16	42	34.79	29.87
5	32	48	40.79	35.87
6	64	54	46.79	41.87
7	128	60	53.79	47.87
8	256	66	58.79	53.87
n	2 ⁿ	6n + 18	6n + 10.79	6n + 5.87

It should be noted that this distortion cannot be correctly considered as noise. It is only present in a changing signal. A fixed grey level which

is coded and decoded does not contain this noise.

In broadcast practice 8 bits are used which gives a Signal/noise ratio of about 54 dB. It is normal to keep these 8 bits in a parallel form of 13.3 Mbits/s per channel (10.7 Mbits/s on 525/60).

Some systems however reclock to produce 24 parallel channels at the subcarrier frequency of 4·43 MHz or 3·58 MHz. This places less demand on the speed of operation of the pulse stores and processing. As the speed of high speed logic increases then the number of parallel channels can be reduced with a greater serial bit rate.

Other forms of distortion. These are normally a result of quantisation errors and the distortions, real or apparent, are indicated when the standard methods of measurement are used.

LF linearity

A five or ten step staircase is normally used for this measurement and non-linearity is indicated by variations in step levels as the luminance increases. After an encode—decode process the steps will take up the nearest quantised level to their original value. The greater the number of levels or bits the smaller will be the error.

Using the standard CCIR Rec 451 method of measurement we get the following worst possible values of LF linearity as shown in Table 14 (see also Appendix 26)

Table 14

No. of steps in test	No. of bits					
signal	5	6	7	8		
5	43.4%	24.4%	13%	6.7%		
10	71.4%	43.4%	24.4%	13%		

Differential gain

The normal method of measuring DG is to superimpose a colour subcarrier on to a step staircase. After passing the signal through a network the subcarrier can be filtered off and its variation in amplitude expressed as a percentage of its blanking value. The quantisation error in subcarrier amplitude that can occur is complicated by the sample rate. For a system which samples three times per cycle a maximum error of $\frac{4}{3}$ of the least significant bit can occur (see Appendix 27).

Table 15 gives the theoretical worst values of gain error for differing amplitudes of subcarrier and numbers of bits.

Assuming the worst possible case of maximum positive and negative errors occurring on the same waveform then the measured differential gain will be twice these values.

Table 15

Peak to peak amplitude				
of subcarrier	No. of bits			
(% of luminance)	5	6	7	8
140 mV (20%)	36.73%	18.36%	9.18%	4.59%
200 mV (29%)	25.71%	12.85%	6.53%	3.21%
350 mV (50%)	14.69%	7.35%	3.67%	1.84%

If the sampling is non-synchronous, i.e. it is not being locked to subcarrier, then an envelope of $\pm \frac{4}{3}$ lsb modulates the DG waveform. Synchronous sampling would give a fixed error which would change with the sample phase.

Differential phase

An amplitude error on the positive half cycle of a sine waveform to its negative cycle would also give a distortion which results in a phase error. The amount of phase error is again dependent on the amplitude of the subcarrier, the sample rate and the phase (see Appendix 27). Table 14 gives the theoretical worst values of phase error for differing amplitudes of subcarriers and number of bits.

Table 16

Peak to peak amplitude of subcarrier	No. of bits				
(% of luminance)	5	6	7	8	
140 mV (20%)	21·55°	10·58°	5·27°	2·63°	
200 mV (29%)	14.9°	7·38°	3.74°	1.84°	
350 mV (50%)	8·45°	4.22°	2·10°	1.05°	

Assuming the worst possible case of maximum positive and negative errors occurring on the same waveform then the measured differential phase will be twice these values.

Interpretation of results

Care must be taken when drawing conclusions from measurements made on a digital encode—decode process. Although an 8-bit three sample per subcarrier system could possibly give a differential phase of 5° and a differential gain of 9% on a CCIR 5-step staircase with 140 mV of subcarrier, it is not probable that these maximum values will occur and they certainly cannot occur simultaneously.

It should also be noted that the larger the amplitude of colour subcarrier used on the test waveform the lower the measured distortion becomes. The errors on highly saturated colours therefore are minimal. This accounts for the excellent subjective results obtained with an 8-bit system.

The errors are real but dependent on the amplitudes of the test signals. Therefore they cannot strictly be given the same emphasis as if the results truly represented the distortions for which the test signals were designed.

Methods of analogue to digital conversion

Most modern methods of A—D use feed back. One method can be seen in Fig. 11.3. where a serial count is made until the binary output gives a value which is equal to its analogue input. Unfortunately this requires a PRF input to the counter equal to the number of levels during one sample time. For an 8-bit system sampling at 13.3 MHz this would mean the counter is working at a frequency in excess of 3 GHz; this is not possible with present technology.

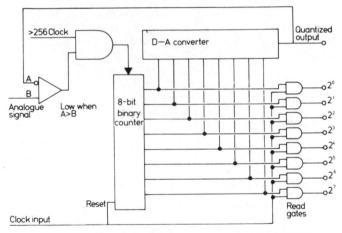

Fig. 11.3. An analogue—digital converter with feedback.

A second method would be to have $(2^n - 1)$ level comparators to determine which is the nearest level and then recode the output to its n bit form. This can be seen in Fig. 11.4 for a 4-bit-15-level convertor.

Each level comparator has a voltage reference, the output being a binary 1 when the analogue input exceeds this reference level. The 4-bit output is logically coded, as illustrated in Fig. 11.5 Boolean equations, with conventional logic gates.

Unfortunately the number of comparators required increases geometrically for the number of bits required. An 8-bit system requiring 255 comparators.

A third method can be seen by examination of Fig. 11.2. This shows 218

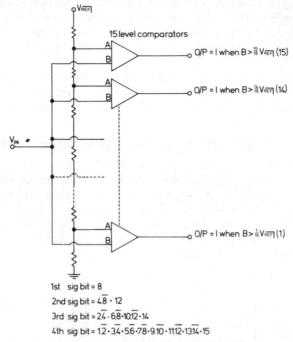

Fig. 11.4. A parallel 16-level (4-bit) comparator.

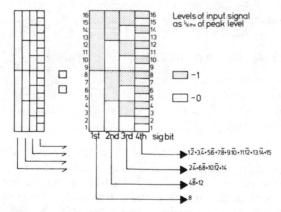

Fig. 11.5. Outputs of A-D for 4-bit conversion.

that the most significant bit indicates if the input signal is greater than half its peak level (V/2) while the second MSB indicates the $\frac{1}{4}$, $\frac{1}{2}$, and $\frac{3}{4}$ transitions. The following bits indicating the $\frac{1}{8}$, $\frac{1}{16}$, $\frac{1}{32}$, etc.

An A—D convertor could be constructed which makes successive voltage comparisons as shown in Fig. 11.6. The first sensing the half

level point, the second the quarter and so on. The input to the second comparator must obviously have the V/2 component removed if the first sig bit is binary 1. In this way it will sense if the input exceeds 3V/4. This is done in the subtractor.

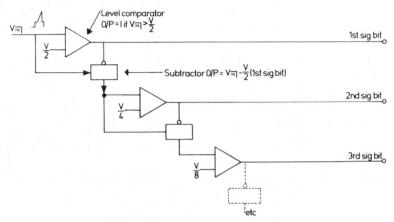

Fig. 11.6. A serial set of comparators for A—D conversion.

The main difficulty in this configuration is in the stability and accuracy of the subtractor circuit. Any errors accumulating over the whole series of comparisons and subtractions should not exceed half of the least significant bit level.

For an 8-bit system this would entail an error of less than 2 mV over 8 comparisons and 7 subtractions. Methods have been evolved for automatic error correction but involve extra circuitry for the computation.

A practical A-D convertor for video

A practical compromise solution between having either $(2^n - 1)$ comparators in parallel or n comparators in series can be seen in Fig. 11.7 where the first section consists of a 15-level-4-bit conversion and the four most significant bits are determined.

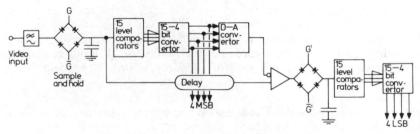

Fig. 11.7. A practical A—D for video signals.

The four least significant bits are determined in a second stage after 220

a subtractor which subtracts from the original video input the value of the first four bits. The subtractor circuit still requires to be accurate however an accumulation or convolution of errors has been avoided.

Once the four MSB have been determined they are stored for later addition to the four LSB. They are also fed to a D—A convertor which generates the analogue signal to be subtracted from the remaining video. The gain of this circuit has to be very accurately set if the difference signal passed to the second set of level detectors is to be correct.

The gain has to be such that the maximum value of the remaining signal exactly equals the value of level 15 + 1, see Fig. 11.7. This is impossible to

achieve and so error feed back system is used.

The second stage has 20 levels, 2 above and 2 below the 16 actually required. If the subtractor leaves a signal too large then the extra level detectors are triggered. A correction signal subtracting 1 from the LSB of the first convertor is generated and the appropriate adjustment made to the second stage.

The other circuitry necessary is a sample gate to hold the instantaneous value of the video while it is sampled and a filter to remove the sampling

frequencies.

Signal stage convertors

Demand for accurate A—D convertors has resulted in the large scale integrated device providing 256 level detectors in one package. These devices are far more accurate and stable than discrete component convertors. They are also very much smaller and so are becoming the most commonly used system.

Digital to analogue conversion

The conversion from digital back to an analogue form is relativly simple and can be achieved by allowing each digital bit to contribute a voltage level dependent on its significance. A simple resistive matrix has the disadvantage of poor isolation between inputs. The current in the summing resistors being affected by the other inputs.

However, advantage can be taken of the characteristics of an operational amplifier with its virtual earth. This can be seen in Fig. 10.8. If the gain of the amplifier is very high then the junction of the four summing resistors can be regarded as zero volts for all input conditions. The currents in each input resistor therefore is only dependent on its

own input.

An alternative approach is to use a resistive ladder which acts as a current splitting network. Each constant current generator contributing a current in the bottom resistor dependent on the significance of the bit. This can be confirmed by application of Kirchoff's Law. The switches shown for each bit can be either transistor or diode types.

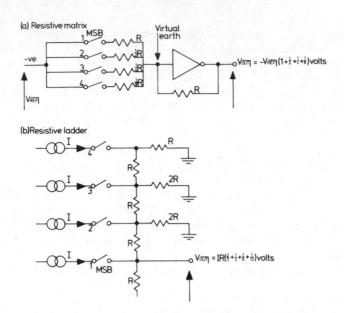

Fig. 11.8. D—A converters. Each switch is closed for a binary 'I' and open for 'O'.

Time-base correction of digital signals

The processes of error correction in a digital corrector are similar to its analogue counterpart, although the order in which they are achieved may differ.

The base processes are:

- 1. Vernier correction—for errors less than the digital sample period.
- Coarse correction—for errors in excess of the sample period but normally less than one line period.
- 3. Velocity correction—for errors which change during the line period.

Vernier correction

The fine timing error of video signal is usually measured by comparing the timing of the off-tape burst with station subcarrier. This is quite convenient for the digital corrector as the information is clocked at a multiple of subcarrier.

The vernier correction can be achieved by simply clocking the information into a store with a reference which follows the off-tape instability and then clocking the information out of the store with a stable reference locked to the station sync pulses.

This can be seen in Fig. 11.9 where the store can be of any form such as a bi-stable or capacitor. Sometimes this operation is combined with other parts of the corrector as shown in Fig. 11.9 (b) and (c).

The store can consist of a shift register which holds a complete line of information for the coarse correction. Alternatively some correctors

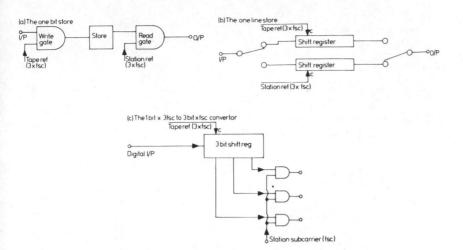

Fig. 11.9. Method of fine error correction of digital signals.

prefer to operate on a larger number of bits at a slower rate and convert the 8 bit \times 3 fsc to a 24 bit \times fsc system.

In all cases the technique is the same—to read in at the incoming or tape rate and read out at the stable station rate.

The most stable way of tripling station subcarrier frequency is to limit the signal and select the 3rd harmonic by filtering. If pilot tone is not used then the only tape reference of subcarrier phase for an individual line is the colour burst. A chroma-lock decoder technique can be used on PAL signals. This is not suitable for quadruplex or segmented helical as at head switch time a large error can exist between successive lines. The simplest way of producing a continuous tape reference is to use a burst locked oscillator. This circuit however has the disadvantage of being analogue (a cardinal sin to some designers) and of drifting between samples if the oscillator is not adjusted correctly. The choice of value for the hold capacitor is a compromise as it must be large enough to hold a charge over a line period, and small enough to be charged to its new line value during burst time.

A digital method of achieving the same result is to store the digital information representing the burst and to recycle it during the line until the following burst. The timing error between burst and station subcarrier is preserved throughout the line. This can be seen in Fig. 11.10. The normal clock reference for the A–D circuit is the tape $3 \times$ fsc except at burst time when the burst is coded from reference $3 \times$ fsc and stored in either a shift register or random access memory. All eight or ten cycles need not be stored as the rising and trailing edges are prone to unwanted phase distortion. The centre five cycles are therefore chosen, requiring a store capacity of 15×8 bits.

During the rest of the line period the burst information is recycled giving a continuous stream of digital bits, which when converted back

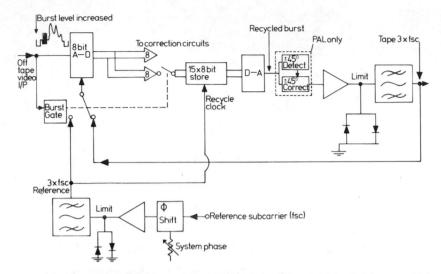

Fig.11.10. A digital method of producing a continuous tape feed reference from burst.

to its analogue form is a continuous subcarrier maintaining the phase difference between tape burst and station subcarrier. For PAL signals the $\pm 45^{\circ}$ swing must be removed prior to limiting and 3rd harmonic selection. It should be understood that the phase of the continuous tape reference does not contain the phase changes between the bursts caused by velocity errors. The tape and reference $3 \times$ fsc developed are those used in Fig. 11.9 and in other parts of the corrector. An overall adjustment of the output phase can be made by adjustment of the reference input.

To minimise quantisation errors of burst phase the burst is amplified

before conversion.

Coarse correction

The maximum delay range normally required by a corrector is $\pm \frac{1}{2}$ a line or 64 μ sec. This enables any phase of playback video to be adjusted until it is line synchronous.

The corrector therefore must have a storage capacity of at least one line of information. This information must be stored or written as it comes off tape and it must be read when determined by station sync.

One-line digital store capacity. The number of cycles of subcarrier per line period is well established and fixed in any colour system.

For 525 NTSC 1 line period = 227.5 cycles For 625 PAL 1 line period = 283.75 cycles

If 3 samples per cycle are made and 8 bits per sample produced then 224

the total number of bits per line are:

$$8 \times 3 \times 227.5 = 5460$$
 bits for 525 NTSC
 $8 \times 3 \times 283.75 = 6810$ bits for 625 PAL

A store with a capacity in excess of these amounts is therefore required in the corrector. This of course includes sync and blanking periods. A saving of about 18% can be made if only the active line period is considered.

Two basic storage techniques are in common use:

- 1. The line shift register.
- 2. The random access memory (RAM).

The line shift register

VR -P

If at the start of every off-tape line the digital information is stored in a shift register, then the information can remain there until required, when it can then be clocked out.

The writing and reading process however cannot occur simultaneously and a minimum of 3 one-line stores are required. This ensures that one shift register is available for each process irrespective of the phase condition between tape and station lines. This can be seen in Fig. 11.11.

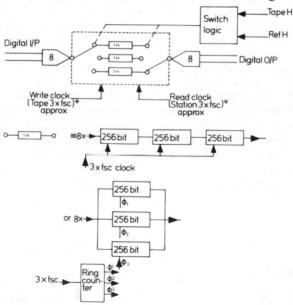

Fig. 11.11. The line shift register coarse corrector. $3 \times$ fsc modified to $3 \times$ 284 fl (625 PAL) $3 \times$ 228 fl (525 NTSC). fl = line frequency.

Although the action is simple it is wasteful of storage capacity as 3×1 H stores are required. Even if advantage is taken of only storing the active line time the storage capacity is well in excess of the minimum

previously mentioned. Most shift registers are available in binary multiples so that the 256 bit capacity is the nearest convenient size:

For 625 PAL the active line contains

$$\frac{52}{64} \times 283.75 \times 3 = 692 \text{ samples}$$

(while $3 \times 256 = 768$ bits)

The total capacity therefore for 8 parallel bits and 3×1 H stores is: $8 \times 3 \times 3 \times 256 = 18,432$ bits

This amounts to about 330% more than theoretically required for 625 PAL correction to the nearest horizontal line. Where many lines of correction are needed, as in Helical recorders, where still frame is used, shift registers become less wasteful.

The 256 bit shift registers can be connected in series and clocked at sample rate or in parallel and clocked with 3 phases of $\frac{1}{3}$ sample rate.

The subcarrier frequency of PAL and NTSC is normally chosen to

have a $\frac{1}{4}$ line + 25 Hz and $\frac{1}{2}$ line off set respectively.

If each store holds an integral number of samples then drift can occur between the picture information and the stages of the shift register. This can be avoided either by skipping a whole cycle of clock frequency as the error accumulates, or to use a clock frequency for the A-D and all following processes, which is an exact multiple of line frequency. The multiple nearest the correct subcarrier frequency is normally chosen so that visible beat patterns are avoided.

The RAM

The random access memory allows the line of information to be stored in such a way that the location of each sample is known. The time delay can be achieved by selecting the correct phase relationship between the write address and the read address. One read and write sequence must occur for each sample which requires a very fast access time for a 3×6 fsc bit rate.

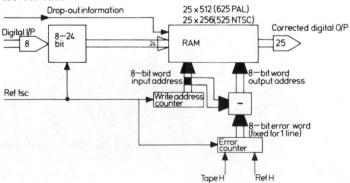

Fig. 11.12. The random access memory coarse corrector. For PAL input, output address and error word are 9 bits each.

A reduction in the access time can be permitted by conversion of the 8 bit signal to a 24 bit one as shown in Fig. 11.12. This permits a clock rate of subcarrier frequency (fsc). If the corrector is to be followed by a drop-out compensator then, as the delay of the corrector is variable, it is convenient to delay the drop-out information by the same amount and an extra bit may be added to make 25 parallel bits.

The input information is sequentially addressed into the memory by

counting clock pulses at subcarrier rate.

The output address is determined by measuring the error digitally, by counting clock pulses and subtracting the error word from the write address. This can best be seen by examination of Fig. 11.13. The write address is updated by one at every clock time with no attempt at phasing the input line to any particular address. As the store can hold about 1.13 lines of information on 525 NTSC the phasing of line sync will advance by about 28 stores per revolution.

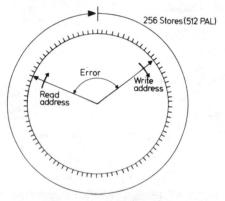

Fig. 11.13. Input and output address phasing for a RAM corrector.

The error or delay in cycles of subcarrier is represented by the phase between the read and write addresses. Theoretically the store need only have enough capacity for one line of information however as the RAM's are available in binary multiples, which also makes the counting and addressing simple, the nearest greater multiple is chosen.

Unfortunately for 625 PAL which requires 284 store the nearest binary is 512 giving an excess capacity of about 80%. A reduction in capacity could be achieved by stopping the addressing during blanking and only

storing the active line time.

Sync feedback

A further complication arises from the fact that the phase of colour subcarrier to sync pulses is not defined and can vary between sources and recordings. The coarse corrector using a phase comparison between station and tape sync to measure error, may differ by up to 180° with a vernier corrector which uses tape burst and station subcarrier.

It is normal to accept the colour comparison as the final arbiter of output phase to allow mixing with other colour signals. This means that the horizontal phasing with station sync and other sources can be out

by 113 nsec on 625 PAL and 135 nsec on 525 NTSC signals.

When the phase difference is exactly 180° the coarse corrector has to make a decision as to which way to go. Furthermore it has to stick to this decision even though phase modulation between sync and subcarrier may occur; this is a common problem with some sync pulse generators and uni-pulse distribution systems. It cannot keep hopping \pm 180° of subcarrier to maintain colour phasing because the physical movement of the picture is disturbing. The sync feedback circuitry, described in chapter 10, achieves this and the digital corrector could duplicate the same action with a combination of phase comparisons and delays as shown in Fig. 11.14.

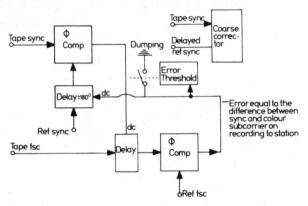

Fig. 11.14. Analogue method of sync feedback.

The d.c. error from the phase comparison of tape and reference sync is used to delay the off-tape subcarrier reference. This could simply be a colour burst, a pilot tone or any continuous tape subcarrier reference. This process is the equivalent to the monochrome time base correction in a non-digital corrector, although in this case the delay need only be a controlled monostable. The delayed tape subcarrier is next compared to station subcarrier. The d.c. error from this comparison is a measure of the difference between sync and subcarrier phasing, on the recording, to the station signals. Without phase modulation between sync and subcarrier this voltage would be fixed, being zero volts when the recording and station phasing are similar. This process is the same as the colour time base comparator in a non-digital corrector. This error is now fed back to control the timing of reference sync until the resultant colour error is zero.

There is now no ambiguity over which cycle to correct to, as any 180° error will be fed-back and cancelled.

Any error in excess of $\pm 180^\circ$ means that the wrong cycle has been chosen and this is resolved by limiting the sync delay to $\pm 180^\circ$ of sub-

carrier. Should the feedback voltage demand more delay, then the threshold circuit will sense this and momentarily ground the feedback voltage and centre the delay. The circuit would then continue to operate on the next cycle of subcarrier. An off-lock subcarrier on the recording or on station pulses would, of course, give a continuous phase change with a dumping of the error everytime there was a cycle difference.

The same process can be achieved digitally as shown in Fig. 11.15. The phase comparators consist of counters which measure the number of clock pulses that occur for the time period between its two inputs. In the example shown a 3 bit counter is used which is clocked at $8 \times \text{fsc}$. The binary output therefore gives the magnitude of the error as the number of 45° increments. Counter A gives the phase error between tape burst and station subcarrier. Counter B inputs are tape and reference horizontal sync pulses which can be up to $\frac{1}{2}$ a line period in error. This counter therefore may be cycled back to zero many times, but the resultant count will be a measure of the error in excess of a whole number of cycles.

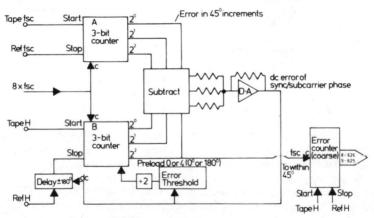

Fig. 11.15. Digital sync feedback for RAM corrector.

The output of the subtractor should be a constant for any video signal without sync/subcarrier phase modulation. This can now be converted back to an analogue signal and fed back as a dc voltage to adjust the delay of the reference input to counter B. When this delay reaches the end of its 180° range the threshold detector changes the most significant bit of counter B, causing a change in its output equivalent to $4 \times 45^{\circ}$ or 180° . This centres the delay again.

Velocity error correction

For velocity compensation the error at the start and end of a line must be known and a straight line correction interpolation made as the line progresses. This can be done by progressively advancing or retarding the phase of the clock pulses during the final digital readout and D-A

process.

If a pilot tone is not available and a geometry error store is to be avoided, then at least one line of delay must be available in the corrector. This is normal in the shift register type which has an average delay of $1\frac{1}{2}$ ($\pm\frac{1}{2}$) lines. The RAM type however has an average delay of $\frac{1}{2}$ ($\pm\frac{1}{2}$) line and extra delay of 1 line is needed. However, use can be made of the drop-out compensator one line delay if it is connected as in Fig. 10.16. In the absence of drop-out all bits are delayed by one line, and in the presence of drop-out the bits are recirculated back to the input to be delayed a further line period. This action should not cause any extra distortion.

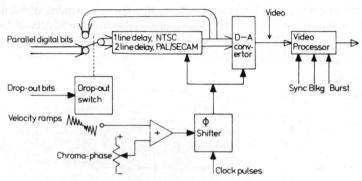

Fig. 11.16. Velocity compensation with drop-out delay.

The derivation of the ramp waveform has been discussed in the previous chapter. However, it should be noted that the video signal is in a digital form and to avoid multiple D-A conversions it is preferable to either use a separate analogue delay for the colour burst or to store the burst errors for the line period.

Reduction of bit rate

For some applications a reduction in bit rate provides a useful economy. CCTV application could either accept a reduced number of bits with the described quantisation distortion or a reduced sample rate with a reduced band width. The latter would require the transposition of the chrominance information from the upper frequency part of the video band.

Delta modulation

Another useful technique is to use an updating technique where each binary number gives the difference in level between the present level and the previous sample. For slow changes a reduction in the number of bits can be readily realised. This is because the difference between 230

samples is small and fewer bits can describe the difference. Fast changes, of course, would require larger numbers. These can be caused by large transitions in the luminance level or large amplitudes of the colour subcarrier.

A further difficulty with delta modulation is that any bit errors affect not only that particular bit period but many periods that follow.

What is required is a system which utilises the fact that for areas of great change many samples are needed but fewer levels, whilst for areas of little change more levels and fewer samples.

Many systems such as Hadamard transforms are under investigation with further techniques such as sub-Nyquist sampling and chroma prediction.

The difficulties with all these methods are the assessment of subjective distortions, the increase in complexity of codecs and the effects of cascading several A–D and D–A processes.

References

- THOMPSON J. E. Methods of digital coding for television transmission J. Royal Television Society Vol. 15 No. 11 1975.
- THOMPSON J. E. Differential encoding of composite colour television signals using chrominance-corrected prediction. Trans IEEE COM-22 August 1974.
- KITSON D. J. M., FLETCHER R. E. and SPENCER R. H. Digital time base correction. IBC 74, page 119.
- 4. FLETCHER R. E. A Video Analogue to Digital Converter IBC, 74, page 47.
- DEVEREUX V. G. Pulse code modulation of video signals: 8 bit coder and decoder BBC Research Dept. Report, EL-42, 1970/25.
- 6. LEMOINE M. The design of a DTBC for professional VTR's. Montreux, May 1975.
- 7. FELIX M. O. Differential phase and gain measurements in digitized video signals.
- ACKER D. E. and MCLEAN R. H. Digital Time-base Correction for Video Signal Processing. SMPTE, 85, 146-150, March, 1976.
- STALLEY A. D. and COFFEY J. A. Digital Time-base Correction for Helical VTR's J. Royal Television Society Vol. 15 No. 12 1975.
- GINSBERG C. P. Report of the SMPTE Digital Television Study Group SMPTE, 85, 150-151 March 1976.

12 Colour Correction in CCTV

NTSC colour signals, and PAL signals to a lesser extent, are vulnerable to the phase modulation of the colour sub-carrier caused by time-base instability of the playback signal. It is not possible to completely correct the errors cheaply and some method of reducing the effect of the instability on the chrominance information is required. Numerous methods have been devised each with their own subjective impairment and economic saving. The methods can be grouped into two major categories:

- 1. Modulation to a more tolerant system.
- 2. Electronic stabilisation of chrominance errors on playback.

Tolerant systems

SECAM.¹ This is the broadcast colour system of France and the USSR, based on the principle of line sequential transmission of the R-Y and B-Y signals and the use of a line delay or memory in the decoder—'sequential a memoire.'

The chrominance signals are used to frequency-modulate a subcarrier, as shown in Fig. 12.1, which is in turn added to the luminance signal.

The subcarrier frequency is chosen to occupy the upper part of the video spectrum and differs slightly for the two chrominance signals.

On 625

$$F_{R-Y} = 282 fl = 4.40625 \text{ MHz}$$

 $F_{B-Y} = 272 fl = 4.250 \text{ MHz}$

where fl = line frequency = 15.625 kHz.

The deviation of the subcarrier is limited for

the R-Y signal to +350 kHz and -500 kHz

and for the B-Y signal to +500 kHz and -350 kHz

Even though the frequency deviation is low, SECAM signals are very tolerant towards the phase and frequency modulation experienced in VTR. A 0.15% variation in head speed would cause approximately 6.6 kHz frequency change on a 4.4 MHz carrier. This represents about 0.78% of the

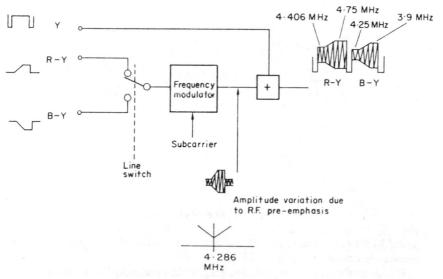

Fig. 12.1. The SECAM coder.

peak-peak deviation of the SECAM signal (850 kHz) or an amplitude variation of 0.78% of the peak value on the demodulated R-Y or B-Y signal.

SECAM signals with different subcarrier frequencies and deviations have been developed for use on 525/60 Hz systems and also with lower subcarrier frequencies for reduced bandwidth recorders. The method becomes expensive if decoding from another standard and recording back again is required. However, if SECAM or RGB signals are available, the system is a good one.

FAM. This method of coding was specifically developed by IRT in Munich,² as a low bandwidth system suitable for videotape recording. The system uses a subcarrier of 2.65 MHz which is simultaneously modulated in frequency and amplitude by the R-Y and B-Y signals respectively. The composite signal has a bandwidth of about 3.5 MHz and is developed as shown in Fig. 12.2.

The subcarrier is first frequency-modulated by the R-Y component and the modulator is calibrated for a deviation of ± 500 kHz on 100% amplitude colour bars. The amplitude of the frequency-modulated subcarrier is typically

0.3 volt and with a B-Y signal of 50% amplitude, 100% saturated, the subcarrier is amplitude modulated between 0.07 volts and 0.53 volts, a depth of modulation equal to 0.766. This should not exceed unity as a complete suppression of the carrier would distort the FM signal; a value of 0.766 or 76.6% is satisfactory.

For 100% amplitude bars the depth of modulation would be 1.53 which is of course not possible and the amplitudes of the B-Y and R-Y signals are limited to their 50% values, a limitation which in practice is not too severe. The final chrominance signal therefore has a peak frequency deviation of

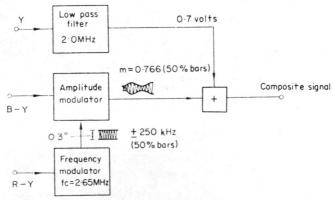

Fig. 12.2. The FAM coder.

 ± 250 kHz (a mod index of 0.25 radians for a 1 MHz R-Y signal) and a peak amplitude deviation of about 75%.

If the R-Y and B-Y signals are bandwidth restricted to about 0.6 MHz, the chrominance signal bandwidth would be 1.7 MHz $\{2(fd + fm)\}$ centred on 2.65 MHz, the upper limit being 3.5 MHz.

The FAM system is also tolerant to time base errors with a 0·15% speed change on 2·65 MHz causing a 4 kHz shift which represents 0·8% of 500 kHz.

The signal however requires a very tight tolerance on the amplitude response of the signal path. Any amplitude distortion including a non-unity gain affects not only the luminance signal causing saturation errors but also the *B-Y* amplitude causing hue errors.

Sequential coding. The time sequential system can operate on either the RGB signals, as shown in Fig. 12.3 or on the Y, R—Y and B—Y signals. The three signals are formed into one signal by sequentially operating three input switches and passing only one of the three signals. This composite signal can then be recorded. The three signals can be obtained simultaneously on playback by means of line delay stores and a commutating switch. The system can be either line sequential or field sequential although the former is preferred because of the smaller delays. The most noticeable distortion is caused by the loss of two-thirds of the original information and on a line sequential system this results in a loss of vertical resolution and disturbing beat patterns

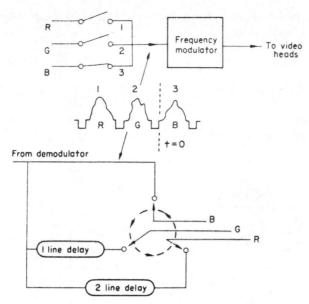

Fig. 12.3. Line sequential coding and decoding.

on vertical movement of the picture. This method of recording is not in common use.

Electronic stabilisation

To understand the various methods used to stabilise the chrominance errors it is first necessary to investigate the effect of time base errors on the decoding of NTSC and PAL colour signals.

The phase of the video chroma represents the hue of the transmitted colour and this is detected by sampling the instantaneous value of the chroma at two points, 90° apart, at which it is equal to the amplitude of the R-Y and B-Y components (see Fig. 12.4).

The chroma phase changes with the relative amplitudes of R-Y and B-Y and the reference subcarrier, normally derived from the colour burst, is regarded as being stable. If the video and hence the chroma is subjected to random timing displacements, this would be mis-interpreted as hue changes in the original scene. The accuracy of phase on playback would have to be within $\pm 10^{\circ}$ or ± 6 nsec for a tolerable impairment.

PAL decoding with a one line delay improves performance in the presence of phase errors although errors better than $\pm 40^{\circ}$ or 24 nsec are still required.

If the errors on the video cannot be reduced the only solution is to reduce their effect on the chrominance signals. One such method is to produce a reference subcarrier that has an identical phase error modulation to the chroma, sometimes called a 'sympathetic reference'. If this is used to sample

the chroma the phase difference between the two signals is due only to the wanted phase modulation.

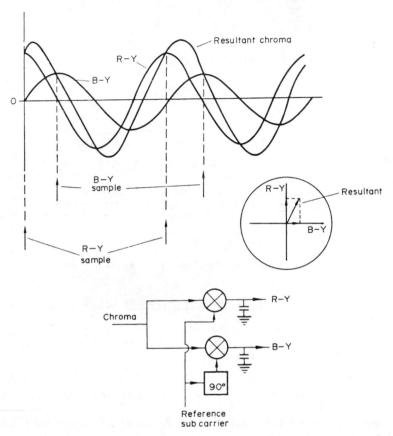

Fig. 12.4. Simple decoding of colour sub-carrier.

Pilot tone

One method of producing a sympathetic reference is to produce a pilot tone

which is added to the FM signal during record.

On playback this can be separated from the RF signal and will contain all the time base variations of the video. It is not possible to make the pilot tone the same frequency as the subcarrier as this would interfere with the FM signal and cause severe moire. The pilot tone frequency must be outside the pass-band of the FM signal and it is convenient to place it somewhere between 500–700 kHz. The pilot frequency is produced during record by dividing the standard subcarrier by a suitable multiple, as shown in Fig. 12.5, with the exact multiple dependent on the video system response and chosen FM standards.

On 625/50 Hz PAL.

 $4.43 \div 6 = 738 \text{ kHz}$ $\div 7 = 634 \text{ kHz}$ $\div 8 = 554 \text{ kHz}$ $\div 9 = 493 \text{ kHz}$

On 525/60 Hz NTSC

 $3.58 \div 5 = 716 \text{ kHz}$ $\div 6 = 596 \text{ kHz}$ $\div 7 = 511 \text{ kHz}$ $\div 8 = 447 \text{ kHz}$

> Stable 4.43 MHz in record Unstable 4.43 MHz in playback

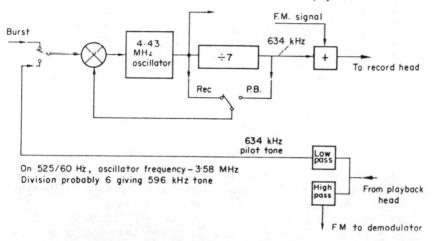

Fig. 12.5. Record and playback of the pilot tone.

On playback the pilot can be separated to lock an a.f.c. oscillator to the correct subcarrier frequency.

In Fig. 12.5 the oscillator is the same as that used during record although this is not always done.

If the time constant of the a.f.c. oscillator is short the subcarrier will have the same timing errors as the chroma and can be used to decode the signal or hetrodyned with it as described later.

Burst locked oscillator

A continuous sympathetic reference can also be derived from an a.f.c. oscillator, with a short time constant, locked to the tape video burst. The only restriction being that the velocity of error is small enough to avoid any significant phase change over a line period. Although this reference does not give a measure of timing as often as the pilot tone, it does have the advantage of not requiring a special record process.

Methods of stabilisation

Decode–encode. The decoding of the chroma signal has already been briefly described. However, if a composite PAL or NTSC signal output is required, re-encoding with a stable local crystal oscillator is necessary. The full corrector is shown in Fig. 12.6. If the decoding of the chroma is on the B-Y and R-Y axis, the two outputs of the decoder would represent the weighted values of the B-Y and R-Y chrominance signal. These two signals are re-coded onto a stable subcarrier and added back to the luminance signal. The output signal

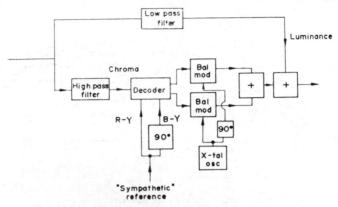

Fig. 12.6. The decode-encode corrector.

of the corrector, therefore, is an unstable video signal with a stable subcarrier frequency. The video would be standard in all respects except for the sync/subcarrier relationship which would not of course be locked.

Two interesting characteristics of the circuit should be noted. First, the decoding need not be on the R-Y and B-Y axis and the nominal phase of the unstable reference is of little consequence. A rotation of the decode axis simply alters the coder axis and rotates the output phase of the coder. If the burst is decoded and coded along with the chroma, the relative phase between burst and chroma is fixed.

The second point, which is an extension of the first, is that the swinging burst and the phase alternation on PAL signals is accommodated by the circuit with no modifications.

This can be seen in Fig. 12.7. It should be noted that both the unstable reference and the crystal oscillator are continuous and are not phase alternated.

Heterodyne. The heterodyne method shown in Fig. 12.8 also requires a sympathetic reference, which follows the tape video instability, and a local stable reference subcarrier. With a combination of heterodyne mixing and filtering a stable chroma signal can be obtained. To facilitate filtering a third frequency, sometimes a multiple of the stable local oscillator, is generated.

This would typically be $(2.5 - 3.5) f_0$ where:

 $f_c = local stable oscillator$

If the other components from Fig. 12.8 are:

f_{ch} - stable video chroma

 $f_{\rm ch}'$ – unstable video chroma on playback $(f_{\rm ch} + \Delta f)$

 $f_{\rm c}'=$ tape sympathetic reference $(f_{\rm c}+\Delta f)$, derived from pilot tone or burst locked oscillator,

the major outputs of each mixer, with the chosen products are as in Table 17.

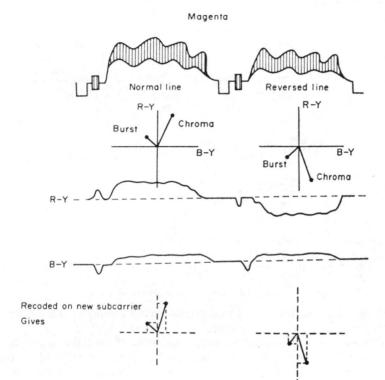

Fig. 12.7. The decode-encode process on PAL signal.

Table 17

	Mixer	Major products	Filter	Product
A	Page 1	$nf_{\circ} - f_{\circ}$ $nf_{\circ} + f_{\circ}$		ar Baker Beer and
В		$nf_{\circ} + f_{\circ}$ $nf_{\circ} - f_{\circ}'$	High pass	$(nf_{\rm o}+f_{\rm c})$
		$nf_{\circ} + f_{\circ}'$	High pass	$(nf_{\circ} + f_{\circ}')$
C		$(nf_c + f_c) - f_{ch}'$	***	66.66.66
D		$(nf_{\rm c} + f_{\rm c}) + f_{\rm ch}'$	High pass	$(nf_{\rm c} + f_{\rm c} + f_{\rm ch}')$
D		$(nf_{\rm o} + f_{\rm o} + f_{\rm oh'}) - (nf_{\rm o} + f_{\rm o'})$ $(nf_{\rm o} + f_{\rm o} + f_{\rm oh'}) + (nf_{\rm o} + f_{\rm o'})$	Low pass	$f_{\rm o} + f_{\rm ch}' - f_{\rm o}'$

The final product is

$$nf_{c} + f_{c} + f_{ch'} - nf_{c} - f_{c'}$$

$$= f_{c} + f_{ch'} - f_{c'}$$
but
$$f_{ch'} = f_{ch} + \Delta f$$
and
$$f_{c'} = f_{c} + \Delta f$$

$$\therefore \text{ Final product } = f_{c} + f_{ch} + \Delta f - f_{c} - \Delta f$$

$$= f_{ch}$$
Luminance

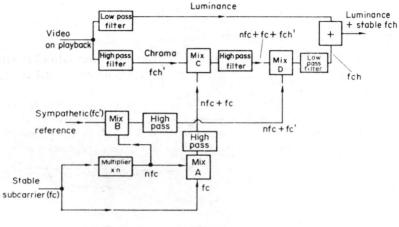

 $fc' = fc + \Delta f$ $fch' = fch + \Delta f$

Fig. 12.8. Heterodyne correction.

If the local oscillator is from a crystal then $f_{\rm ch}$ would not have an exact locked relationship with tape sync.

Two methods of correction and two methods of obtaining a sympathetic reference have been described. They can be combined to produce one of four possible combinations in any recorder,⁵ any one of which is in common use:

Symphathetic Correction method

Burst locked oscillator Heterodyne

Pilot-tone Decode–Encode

Bandwidth reduction

On broadcast NTSC, PAL and SECAM signals the chrominance information is carried on a subcarrier which is positioned in the upper part of the video band. For this reason the recording of these signals necessitates a full bandwidth signal path, an expensive luxury for CCTV applications. It is however quite feasible to re-position the chrominance information on a subcarrier lower down the band prior to recording. A lower frequency subcarrier is obviously subjectively more noticeable although a similar locked relationship between sync and subcarrier to the broadcast standard does help to minimise its subjective effect.

A lower frequency chroma signal can be obtained by beating the higher frequency signal with a stable frequency and taking the difference product. The sync/subcarrier relationship can be preserved by making the stable frequency an exact multiple of horizontal line frequency. The chosen value of the lower subcarrier frequency should be as high as the pass-band of the recorder will permit, allowing for the upper side-band of the chrominance signal.

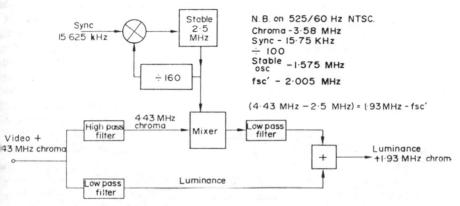

Fig. 12.9. Reduced bandwidth colour signals for 625/50 Hz PAL system.

If the chrominance signal is bandwidth reduced to 0.5 MHz and the composite signal bandwidth is restricted to 2.5 MHz, the new subcarrier frequency (f_{SC}) must be about 2.0 MHz. Figure 12.9 shows a system of producing a new subcarrier at 1.93 MHz from a 625/50 Hz system with a 4.43 MHz subcarrier. A 2.5 MHz stable frequency is produced by multiplying the horizontal line sync by 160.

For 625/50 Hz Broadcast signal

$$f_{\rm s\,c} = (284 - 1/4) f_{\rm h} + 25 \,{\rm Hz} = 4.43 \,{\rm MHz}$$

where $f_{\rm h} =$ horizontal line frequency = 15.625 kHz
 $f_{\rm s\,c}' = (284 - 1/4) f_{\rm h} + 25 \,{\rm Hz} - 160 f_{\rm h}$
= $(124 - 1/4) f_{\rm h} + 25 \,{\rm Hz} = 1.93 \,{\rm MHz}$.

A typical stable beat frequency would be 1.575 MHz (100 $\times f_h$)

$$f_{\rm s\,c} = (228 - 1/2) f_{\rm h} = 3.58 \text{ MHz}$$

 $f_{\rm s\,c}' = (128 - 1/2) f_{\rm h} = 2.005 \text{ MHz}$

On playback the perceptibility of the subcarrier could be further reduced on NTSC signals by adding to the luminance signal the subcarrier from the previous line. On NTSC this would give a complete cancellation. On PAL two lines of delay would be required. A reduction in vertical resolution results although only on high frequency components. The delay lines used should be exactly one horizontal line and one important limitation is the requirement that the playback video line time must be held to within very close limits. This requirement normally necessitates the use of a capstan servo. The method of colour correction can be any of those described.

Pilot chroma carrier

Another technique allowing a reduction of the video bandwidth is to separate the chroma from the luminance and convert the chroma subcarrier to a frequency below the FM passband, say 560 kHz.

Instead of adding this chroma signal with a lower subcarrier back on to the luminance signal it is added to the FM signal and recorded with it.

The distortion on the chroma signal is less than might be expected because the FM signal acts as a bias frequency. The only problem is that a pilot tone for colour correction cannot be used because the space for it has been used up by the chroma pilot carrier.

A very novel method of regenerating the correct 4·43 MHz on playback by heterodyning the lower frequency chroma with a stable 4·43 MHz and a sync locked oscillator can be used with the added advantage of cancelling out timing errors.

A block-diagram for a PAL recorder is shown in Fig. 12.10 and will be described.

Record mode. During record a stable reference subcarrier, derived from the input video burst, is mixed with the output of an oscillator locked to 36 times the horizontal sync frequency.

MIXER A output:

MIXER B output:

4.99 MHz +
$$f_{ch}$$

4.99 MHz - f_{ch} - Low pass - Chroma on a 562.5 kHz carrier (f_{ch} ')

This reduced subcarrier chroma signal is added to (not modulated by) the FM signal prior to recording.

Playback mode. On playback the FM signal and the chrominance signal are easily separated by filtering. The horizontal sync on the demodulated luminance signal and the carrier of the chrominance signal are both phase modulated by the timing instability of the VTR.

RECORD

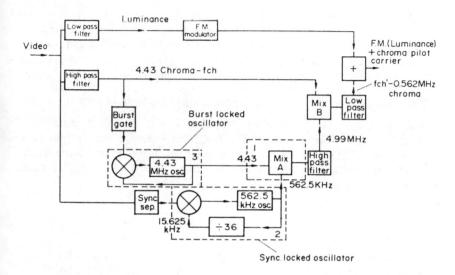

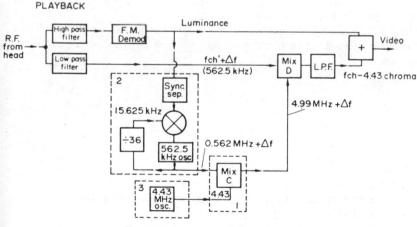

Fig. 12.10. Chroma pilot carrier system.

To remove these errors on the chrominance signal it is processed in the following way. An a.f.c. oscillator with a short time constant is locked to 36 times tape video sync to produce $562.5 \,\mathrm{kHz} + \Delta f$, where Δf is the unwanted modulation. This is mixed with a stable 4.43 MHz to produce a 4.99 MHz also with modulation.

MIXER C output:

$$4.43 \text{ MHz} + (0.562 + \Delta f) \text{ MHz} \rightarrow \text{High pass} - 4.99 \text{ MHz} + \Delta f$$

 $4.43 \text{ MHz} - (0.562 + \Delta f) \text{ MHz}$

The low frequency chrominance information and 4.99 MHz + Δf are now mixed.

MIXER D output:

$$(4.99 + \Delta f) \text{ MHz} + (f_{ch}' + \Delta f) \text{ MHz}$$

 $(4.99 + \Delta f) \text{ MHz} - (f_{ch}' + \Delta f) \text{ MHz} - \text{Low pass} - f_{ch}$

where
$$f_{\rm ch}'$$
 — Low frequency chroma — 0.562 MHz $f_{\rm ch}$ — High frequency chroma — 4.43 MHz

The Δf component is therefore cancelled on the output chroma.

The block diagram looks quite involved, but it should be noted that several elements of the circuit used in record can also be used in playback. For instance Mixer A in record can be used for Mixer C in playback, the sync locked oscillator is also common and the burst locked oscillator can free run on playback to provide a stable 4.43 MHz.

Conclusion

Several techniques that are in common use in CCTV recorders have been described and permutations can be made to provide many combinations.

For systems with RGB signal distribution the choice would be restricted

to using one of the tolerant colour systems.

Most applications however require to record broadcast signals, probably derived from a receiver or tuner, and this is where the number of combinations escalate.

For example:

The system change methods

- 1. NTSC TO SECAM
- 2. PAL TO SECAM
- 3. NTSC TO FAM
- 4. PAL TO FAM
- 5. NTSC TO LINE SEQUENTIAL RGB
- 6. PAL TO LINE SEQUENTIAL RGB

Time base error compensation methods

- 7. Decode-encode with burst locked oscillator
- 8. Decode-encode with pilot tone Full bandwidth
- 9. Heterodyne with burst locked oscillator systems.
- 10. Heterodyne with pilot tone
- 11. Reduced bandwidth systems with reduced subcarrier frequency, colour correction same as 7, 8, 9 or 10.

- 12. Chroma-pilot carrier with heterodyne correction and sync locked oscillator.
- 13. Chroma-pilot carrier with heterodyne correction and burst locked oscillator.
- 14. Chroma-pilot carrier with decode-encode correction and burst locked oscillator.

The wide variety of methods used is, to say the least, confusing and adds to the complexity of deriving a common international standard.

In practice methods 7, 8 and 10 are in common use on one-inch formats while method 12 is very common on $\frac{1}{2}$ in and $\frac{3}{4}$ in formats. Recorders using combinations 1, 2, 3 and 4 have been produced and are still in use although they are becoming less popular, while combinations 5, 6, 9, 13, 14 have, to the author's knowledge, existed only in development laboratories.

References

- COMPAGNIE FRANCAISE DE TELEVISION, Secam colour T.V. system, 19 Rue Ernest-Cognacq, 92 Nevallois-Perret.
- MAYER, N., NOLOCH, G., MOLL, G., FAM, Rundfunktechnislee Mittellungen, Vol. 13 (1969) n. 4. 159–169
- 3. SIMS, H. V., Principles of PAL Colour Television, Butterworth.
- 4. WESSELS, J. H., A simple colour videotape recording system, Phillips Research Laboratory.
- SALTER, M. T. A., Colour TV Recording on Ampex 1 in format Ampex G. B. Ltd., Reading, England.
- BRUCH, DR. W., Selected Papers II P.A.L., Grundlagen-Entwicklung, Hanover, Telefunken A.G.
- BRUCH, DR. W., Neve methoden der Fanbbildanfzeichnung auf einfachen Magnetobandgenoetan (TRIPAL), Telefunken-Zeitung, 40 No. 3, 1967.

13 Cassettes and Cartridges

Audio tape recording started with reel to reel recorders where the tape is rewound on to the feed spool for storage. In the late 60s, it was found that a more convenient method of storing tape was in a cassette with two self contained spools. The minimum of expertise is required to lace-up the tape, a simple plug-in action, and the tape can be left at any point for subsequent playback. Video recorders also started with a reel to reel transport and a similar trend towards cassettes evolved.

However, the broadcaster and the CCTV user have different requirements for the cassette. For CCTV applications ease of use and foolproof operation are the main advantages with the added bonus of tape protection. The broadcaster requires the further facility of playing back several inserts or advertisements without interruption and in any pre-selected order.

Broadcast cassettes

For convenience, the record track format used on broadcast cassettes is same as reel to reel recorders. As the audio and video track spacing are identical, this allows complete interchange between machines.

It is normal, for broadcast requirements, to have two tape transports to enable A–B roll techniques. While transport A is playing back B is searching out the next cassette, lacing up and cueing at the correct start point. At the end of the A sequence, B rolls and A rewinds, changes its cassette and cues up to the correct start point. A typical arrangement can be seen in Fig. 13.1. The cassettes, up to 24, are held in a drum and can be loaded on to either

transport A or B automatically. Associated with each transport are preamplifiers and head switchers which provide the required level of continuous *RF*.

The rest of the electronics for demodulation and time-base correction need not be duplicated because only one transport will be playing back at any instant. A record facility can be added to the system with the addition of one shared *FM* modulator and two sets of record electronics. The arrangement shown also allows dubbing from one transport to the other.

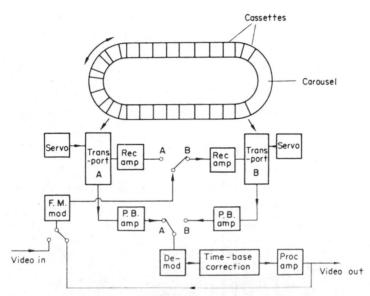

Fig. 13.2. A typical broadcast cassette system.

Tape format. Although the video and audio track dimensions are the same, additional cue track information is required for the cueing of the parking position of the tape and the remote starting of the following sequence at the end of the tape. Unfortunately, international agreement has not yet been reached and slight differences exist among standards in use. Figure 13.2 shows

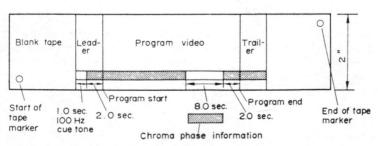

Fig. 13.2. The cassette tape format.

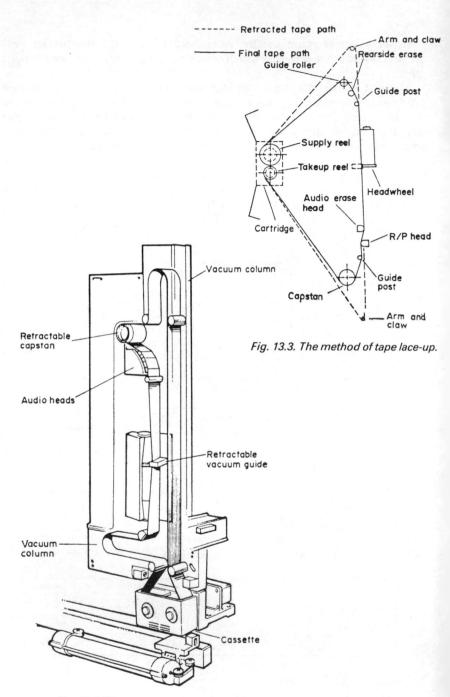

Fig. 13.4. The vacuum column lace-up.

the type of format in common use. The start and stop tones are in the form of bursts of tone on the cue track.

The tones are supplemented by start and end of tape markers, composed of reflective tabs, these can be sensed to avoid complete removal of tape from cassette.

The rest of the cue track is free for digital address codes, programme idents or pre-determined set-up levels for the playback controls. The minimum length of the programme video is two seconds with a maximum cassette capacity of six minutes on the 15 i.p.s. standard. The minimum time for uninterrupted A–B roll sequences is longer than the minimum programme time, as it must be remembered that the duration of a play sequence on A must be greater than the time it takes to stop B tape, rewind, change the cassette, lace the tape, cue up to start point, start and lock-up in sync. This total time depends on the tape transport design, the television line standard and the amount of tape to be rewound on the B transport. A typical timing sequence could be as follows:

Stop and un-lace the tape
*Rewind (60 seconds of tape)
Change cassette
Lace-up
Cue
Start and lock-up in sync
(525/60 Hz)

1.9 seconds
2.5 seconds
1.3 seconds
1.3 seconds
0.2 seconds

Total
9.9 seconds

Tape lace-up. The tape path of a cassette recorder is obviously similar to a reel—reel arrangement, because the audio head to video head spacing and the canoe dimensions must be identical to provide interchange. Two methods are in use to extract the tape from the cassette and position it around the guides and head assemblies. Figure 13.3. shows a method where the tape is pulled from the cassette by means of an arm and claw mechanism and slotted into its correct position. A second approach is shown in Fig. 13.4 where, during lace-up, the capstan and vacuum guide are retracted to a position below the baseplate. The tape is then literally sucked out of the cassette by a vacuum to a position around the edges of the transport and across the heads. The capstan and the video tape guide then revert to their normal play positions.

The BCN multicassette

The BCN format has already produced a cassette version, the BCN5, primarily intended for ENG use. It uses a 20-minute cassette which offers

^{*} An extra one second is required for each additional minute of tape. Very often the rewind can be inhibited to reduce the cycle time by 2.5 seconds; this can be useful although it requires off-line rewind before the cassette can be used again.

greater flexibility of programme operation than the 3 and 6 minute playing times available on quadruplex machines. A system using three play decks can be used to give continuous programme material.

The helical cassette

The helical cassette recorder is similar to its open reel counterparts except that there is no provision for supply and take up spools. These, and two of the tape guide posts, are provided by the cassette.

Current cassettes contain from 5 minutes of tape in some U-matic cassettes intended to survive the rugged conditions of ENG to the 8 hours of domestic VCC.

Two methods of containing the tape are in common use.

1. Co-axial cassettes. This method is used for the VCR and SVR systems where the two spools are mounted on top of each other.

With a tape width of $\frac{1}{2}$ in, the overall dimensions of the cassette are $5\frac{5}{8}$ in $(143.3 \text{ mm}) \times 5$ in $(127 \text{ mm}) \times 1\frac{5}{8}$ in (41.03 mm), see Fig. 13.5. The angle of rise of the tape as it traverses from the lower spool to the upper spool provides the correct rise when wrapped around the drum scanner.

The method of extracting the tape and wrapping it around the drum can be seen in Fig. 13.6. The drum is mounted on a rotating platform. Also on the platform are two guide pins (P) which are positioned behind the tape when the cassette is plugged in. To lace the tape around the drum, the platform rotates clockwise to take-up the position shown in Fig. 13.6(b). The tape has now a wrap in excess of 180° which is sufficient for a two-headed machine.

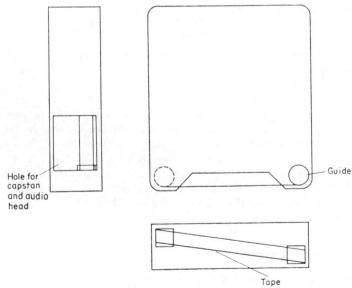

Fig. 13.5. The VCR cassette.

The capstan pinch roller and the audio heads also move into the position shown through the cut out in the cassette cover.

End of tape sensors, are required to avoid the tape being run off the spools. These are provided by a highly reflective adhesive tab which can be sensed with a light source and photo-cell.

2. Co-planar cassettes. This method is used for the U-matic, VHS, Beta and VCC systems where the two spools are mounted side by side. The cassette dimensions vary greatly, but the U-matic is typical.

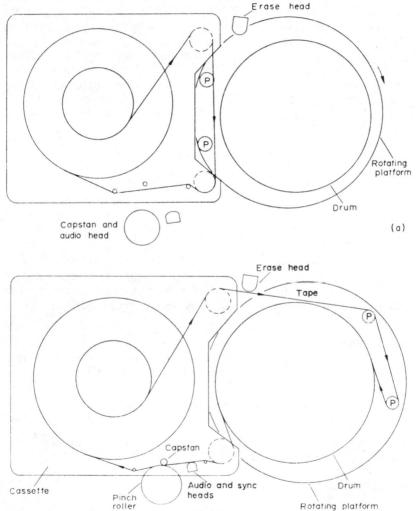

Fig. 13.6. (a) Cassette loaded ready to lace prior to rotation of drum platform. (b) Cassette loaded and tape laced after clockwise rotation of drum platform.

(b)

The head drum is mounted at an angle to provide the necessary helix tape wrap. Movable guides draw the tape out of the cassette and around the scanner. The audio and control track heads are fixed and the tape is made to contact them as it is laced.

Self-lacing cartridges (helical). Most of the advantages of a two reel cassette can be obtained with a self-lacing single reel cartridge. The cartridge is similar to a conventional reel of tape except for the leader which is normally made of a thicker and more rigid piece of p.v.c. or similar material. This facilitates a self lacing action which is provided by rollers at strategic positions around the transport. The advantage of a single reel is that the overall volume of the tape package is reduced. The disadvantage is that the tape must be rewound to remove the cartridge, which can be annoying if it is halfway through a programme which one wishes to continue at a later stage.

One method of overcoming this problem is to provide automatic cueing and search facilities. Methods used vary, but one simple procedure is to record on a cue track a continuous tone, say 1 kHz, during the playback of the tape. This tone then over-records an existing tone. If the tape is stopped, a portion of erased track exists because of the spacing between the erase track and record head. This can be increased by leaving the erase on for a short period in rewind. The gap can be detected when spooling the tape.

When the tape is laced up for a second playing, the tape can be spooled in fast forward until an automatic level detector senses the erased section and stops the tape in the correct position. When play is selected the gap is filled with a 1 kHz tone. Whatever method is used, it is important that all previous cues are removed.

The LVR system reduces the disadvantages of having to rewind before removing the cartridge because the tape returns to the start several times, 14 times on the ¼ in system, during each play. Maximum advantage can then be taken of the reduction in size offered by needing only a single spool.

References

1. FOERSTER, G., Technical aspects of the Phillips VCR System, 7th ITS, Montreux, 1971.

2. JONGELIE, K., Magnetic Recording system, 7th ITS, Montreux, 1971.

3. HEMMINGS, A. J., The philosophy, markets and future of a video cassette system. RTS Journal, March/April 1972.

4. Instavideo Recorder system, Ampex Readout, Vol. 10, No. 3.

- 5. ZACCARIN, P., C. B. B. WOOD., Video player and recorder systems for home use, EBU Tech. 3093-E.
- 6. KIHAR, N., Colour cassette system for the NTSC and Japanese colour-television standards, EBU Technical Review, No. 125, February 1971.

14 Editing

The requirements of editing videotape range from the removal of slight production errors to the complete assembly of a program from individual shots or sequences. The object of this chapter is to detail the technical requirements of recorders and equipment needed to achieve this. Although there is little information, outside the professional sphere, on artistic techniques it is not the intention to cover them in this chapter. Editing has progressed from the physical cutting of the tape to electronic editing (sequenced switching to the record mode), the semi-automatic programming of electronic editing and finally the fully automatic random access editing.

Physical editing

Videotape, like film, can be cut at the end of a chosen scene and spliced on to the start of a new scene. Also like film it is important to cut synchronously. A disturbance in the servo-mechanisms would result if a cut was made from the end of one frame to the centre of another. In film a physical picture and sprocket holes are available to help the editor. On videotape neither of these are present and a system of determining the frame position has been developed. Iron carbonyl powder, with a particle size from 3 to 5 μm , is suspended in a volatile liquid such as Freon TF and is coated on the control track of the tape. The particles tend to cluster around points of maximum magnetisation and the edit pulse becomes visible as the liquid evaporates. This edit pulse can be used as a reference point although its actual position with respect to the TV frame on tape varies with the control track head position.

Quadruplex. The effect of a splice between the guard bands of a quadruplex tape is similar to a straight 'video-cut'. This splice can be made anywhere although subjectively it is preferable to make it during the field blanking. On the 525/60 Hz standard this is in the guard band above the edit pulse while on the 625/50 Hz standard the splice should be made six tracks back (see Fig. 3.4). The edit should be made between the last field of a complete frame on the old scene and the first field of a complete frame of the new scene. If this is not done there will be a disturbance of the picture at the cut and the recorder may mistrack and re-phase during replay.

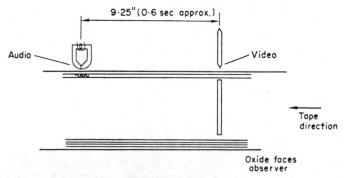

Fig. 14.1. Audio displacement.

The physical position of the video on the lateral tracks is also important if an error in horizontal timing is to be avoided. The tolerance of ± 1.3 mm is in this respect a little wide because it would cause an error of ± 31.6 μ sec (Appendix 3.1.) If good splices are required a station should keep these errors to within ± 0.13 mm (± 3.16 μ sec).

When the edit pulse has been developed on both the ends of the tape to be joined they are mounted in a splicing fixture which facilitates accurate cutting in the required guard band and the physical butt join of the two pieces with a very thin (0.004-0.0045) in pressure sensitive adhesive tape.

The audio on a quadruplex tape is recorded 9.25 in downstream from the video. This distance represents about 0.6 sec and creates problems in deciding where to cut. The problem can be seen in Fig. 14.1. Suppose a cut is required at the instant where, on the new scene, a hammer strikes an object. If the cut is made just prior to the audio occurrence, the video cut is 0.6 sec early. If the cut is made just prior to the video occurrence, the audio is lost.

An L shaped cut is impracticable and under such circumstances the audio must be lifted and edited separately on an audio recorder and re-recorded over the splice.

Helical. It is not possible to splice in the guard band of a helical tape although it is quite feasible to cut at right angles to the tape edge. As for quadruplex, the cut must be synchronous and the development of the control track provides the reference.

The effect of the splice is different from quadruplex and instead of a cut transition the effect is that of a vertical wipe. It can be seen from Fig. 14.2 that the direction of the wipe depends on the relative head to tape direction. For opposing directions the wipe is up and a down wipe is created if the tape and head move in the same direction. The time of wipe depends on the time taken for the splice to travel around the drum scanner. With a drum circumference of 16 in and a tape speed of 10 i.p.s. the wipe would take 1.6 sec. The technique is useful though obviously limited.

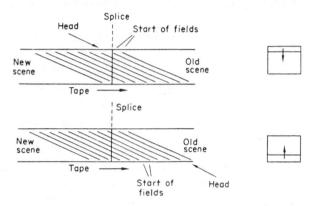

Fig. 14.2. The direction of wipe for a splice on helical format.

General hints. Physical editing requires extreme care and expertise on behalf of the editor and mistakes are normally disastrous. It is expensive because of the time taken in man and machine hours and the fact that it is inadvisable to use the tape again for recording.

The advantages are that the final product is still a first generation recording and that the dubbing time is saved where a long programme needs only a few cuts, as in sports programmes.

The following procedure should be adopted in all cases:

- 1. Handle the tape with care and avoid touching the surface of the tape.
- 2. Keep all equipment clean and demagnetised. Airborne dust particles deposited on the surface of the tape will inevitably cause drop-outs.
- 3. Align the tape accurately to form a butt join without a gap or overlap and ensure that the longitudinal edges are aligned.
 - 4. Apply adequate pressure to the adhesive tape.

Electronic editing

An electronic edit is a controlled switch from the playback of one scene to the record of the next scene in such a manner that synchronism is maintained over the splice point. The new scene can come from other VTRs, telecine or live from the studio. Several functions of the machine need to be controlled during the splice, in particular the capstan servo, erase current, RF drive current and head servo. The servos must be controlled to ensure that a rapid phase change does not occur when the record is initiated and a mode change takes place. The timing of the erase turn on and RF turn on must be controlled and synchronised to ensure the minimum of overlap and the absence of an unrecorded gap between scenes.

Capstan control during editing. In VTRs with a capstan servo the capstan's mode of operation differs between record and playback. During record the capstan provides the nominal tape speed while in playback it controls the tracking phase with respect to the head. During an electronic edit two methods of control can be used—insert and assemble or add-on—each with their own advantages.

Insert mode. In this mode the capstan is kept in the playback condition at all times, where it is controlled from a comparison of control track with head tachometer pulse. It is extremely useful where a synchronous ingoing splice and outgoing splice is required, because the new tracks are recorded in exactly the same position as the old tracks. It is therefore possible to insert a new scene in the place of an old one, hence its name.

The disadvantage of the insert mode is that a control track is required over the entire length of programme to be assembled. If a one hour programme is to be made up, a tape with one hour of continuous recording is required as a

base for the material. This can be time consuming.

Assemble or add-on mode. In this mode the capstan smoothly transits from a phase control of the tape to a velocity control at the time of splice and the control track head is energised to record a new control track at the same instant. If a series of scenes is to be assembled, it is only required to produce an ingoing splice with a slight overlap at the end of a scene for the next splice. Care must be taken not to cause the capstan to accelerate suddenly by the changing phase of the oscillator. Two methods are in common use as shown in Fig. 14.3.

Method (a) allows the oscillator to be controlled up to the splice point when the error control voltage is grounded and the oscillator is allowed to free run to provide the correct nominal tape speed. For the minimum disturbance the error voltage prior to grounding should be zero volts and the oscillator should be adjusted in normal play for this to be so. At the same instant the control track head should switch to record.

Method (b) does not require prior adjustment of the oscillator and is used on most modern servos. The capstan simply reverts to its normal record mode but to allow this certain precautions are taken. At the point of transition the oscillator is liable to change phase by up to 180°. To minimise the absolute timing error the oscillator frequency is made higher in frequency to the head tachometer rate (ft).

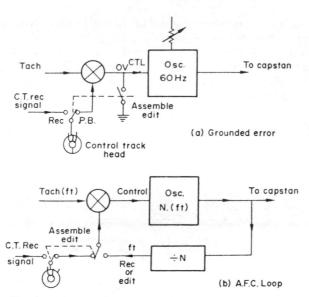

Fig. 14.3. Methods of capstan control in assemble editing.

Figure 8.16 shows that typical oscillator frequency could be 46.08 kHz with N=192 and ft = 240 Hz on the 525/60 Hz standard. The maximum error due to oscillator drift therefore would be half the periodic time of the oscillator frequency.

Error =
$$\frac{1}{2 \times 46.08} \times 10^{-3} = 0.018$$
 msec.

This compares with an error of 8.33 msec if the oscillator frequency were 60 Hz.

Erase and RF turn-on

The problem of synchronising erase and RF drive is created by the physical distance between the erase and video record heads. The problem and solutions are somewhat different on helical and quadruplex and it is worthwhile treating them separately.

Helical editing. An erase head is placed perpendicular to the tape on helical recorders but this is intended to bulk erase the tape when a new recording is being made. To facilitate editing it is necessary to erase one track adjacent to another and because of the shallow helix angle and the length of track this cannot be done by a fixed head.

One solution is to provide an extra flying erase head mounted on the same disc as the video head but preceding it by 120°. The erase frequency, which must be higher than the record signal, and is normally in excess of 15 MHz, is switched on or off a few milliseconds before record drive. The gap width of the erase head encompasses the track and guard band and the

plane of the head is mounted slightly off centre to the video head to allow

for the tape movement over 30° rotation.

If a flying erase head is not fitted it is still possible to edit with a minor but quite acceptable impairment of the picture quality. The method relies on the fact that the FM record signal saturates the tape and almost erases any signal previously recorded.

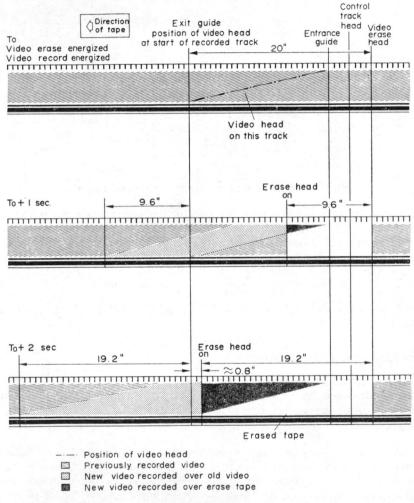

Fig. 14.4. The insert edit.

A short insert (3 seconds) can be made by switching on the RF drive and re-recording over existing tracks. Accurate tracking is required to minimise crosstalk from the old signal on to the new but in general a deterioration of signal/noise ratio better than 3 dB can be expected.

For longer inserts the normal erase head can be used to erase the major portion of the old scene, but an overlap at each splice point is inevitable, as can be seen on examination of Fig. 14.4. The nominal tape speed is 9.6 i.p.s. and the relative head positions are illustrated.

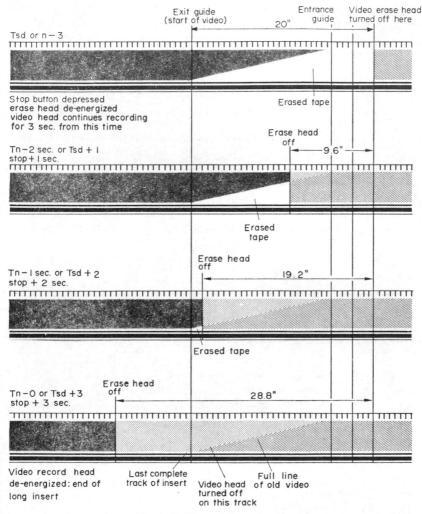

Fig. 14.4. The insert edit (cont.).

At To, the instant the edit is initiated, the RF drive to the video head and the erase current are switched on. The recording however is over non-erased tracks.

At To + 1 second, the tape has moved on 9.6 in and the video head is recording over erased tape on the end of their scans.

At To + 2 seconds, nearly all the video tracks are being recorded on erased tape.

The subjective effect is that of a cut transition to a new scene with a slightly noisy picture which, over a two-second period starting from the bottom,

improves by about 3 dB.

To come out of the splice synchronously the video and the erase cannot simply be turned off because a large erased section would be left. The end of the edit therefore must be pre-meditated by about three seconds and the exit button depressed.

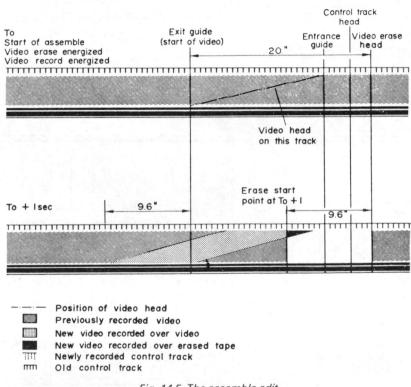

Fig. 14.5. The assemble edit.

If Tn = end of insert

Tsd = Tn - 3 seconds—Exit button depressed.

The outgoing sequence can also be seen in Fig. 14.4.

At Tsd or Tn-3 seconds the erase is switched off but recording continues.

At Tn - 2 seconds the erased portion is being filled with an overlap at the end of the tracks.

At Tn - 1 seconds the erased portion is almost completely filled.

260

At Tn the video head RF drive turns off.

The subjective effect of the outgoing splice is a slight deterioration of signal/noise ratio starting from the bottom of the picture progressing to the top followed by a cut transition.

The assemble edit, shown in Fig. 14.5, is very similar to the insert, with two

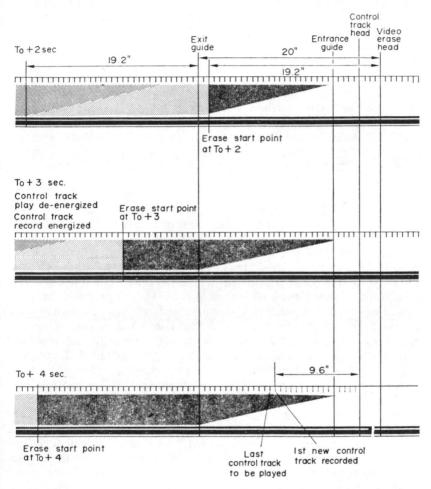

Fig. 14.5. The assemble edit (cont.).

differences. First, we are only concerned with the ingoing splice. Secondly a new control track has to be recorded. It should be noted that this is delayed until To +3 seconds because during the overlap period it is essential to maintain accurate tracking. The only consequence of this delay in recording a new control track is that it must be ensured that at least three seconds of

unwanted recording is left at the end of every scene to enable the following assembly edit.

None of the sequence timings are critical and can be provided by simple

elapsed timing circuitry.

Quadruplex editing. On the quadruplex format it is quite possible to start the erase between the video tracks. The normal video erase head is angled slightly to enable this. The erase head however precedes the video heads by about 8.86 in. (This varies slightly between manufacturers.)

The technique used, to avoid any overlap or gap, is to switch on the erase in a guard band after vertical sync and delay the RF turn on until the erased portion is under the video heads, about 0.58 sec. The time delay could be provided by a simple monostable circuit. However, although the distance between the video and erase heads can be kept to very close limits, the time taken for a point on the tape to move that distance is a function of the tape speed which is dependent on the video standard and field frequency. The track spacing is independent of field frequency (Fig. 3.5) and is only dependent on the relationship between the head and capstan rotational rates.

A more accurate method is to count either frame pulses or tachometer pulses to provide the delay timing. Figure 14.6 shows the relationship in terms of these references. If a frame pulse is being read by the video head the nearest frame pulse upstream to the erase head is 15 frames (150 tach) on 625/50 Hz. or 18 frames (144 tach on 525/60 Hz), from the video head. If a 5 msec delay is subtracted to take-up tolerances it would take a count of 8 tach on 625/50 Hz or 2 tach on 525/60 Hz for the frame pulse to be aligned with the erase head. If the erase is switched on just after this instant it will occur in the guard band after a track with vertical sync. Two more timings are now required which are independent of the line standard. From the initiation of erase the distance to the video head, or RF turn on, is 143 tach and this count can be used to switch the RF to the video heads, energise the control track record in assemble edits and switch on audio record if required. To prepare the video heads for record the head relays must be switched from the play condition to record just after the head has played back its last track, i.e. one revolution prior to record. A count therefore of 142 is also required.

Figure 14.7 shows a simplified logic diagram for an electronic editor. When the start edit switch is closed the first frame pulse read off tape sets a bi-stable and enables gate C. Tach pulses are counted in a series of binary dividers and the required counts, 2, 8, 143 and 142 are derived by matrixing the correct binary outputs. On the count of 2 or 8 the erase is energised via a 5 msec delay to allow for physical tolerances in head spacing. The counter is also re-set. On a count of 142 the video head relays are switched from record after playing back the last track. The head numbering differs between machines but it is assumed that the head position at the time of a tach transition and the reading of a vertical sync is as shown in the diagram with an optional

head numbering in brackets.

At a count of 143 the RF turn on is energised and the counter and flip flop reset. The editor and VTR remain in this state until the 'stop edit' switch is

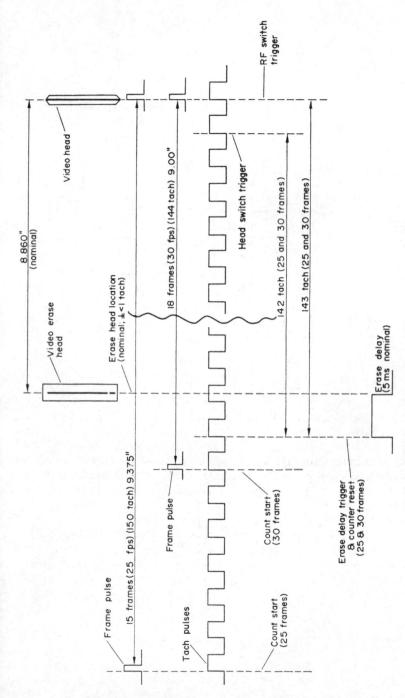

Fig. 14.6. The timing relationship between video and erase head.

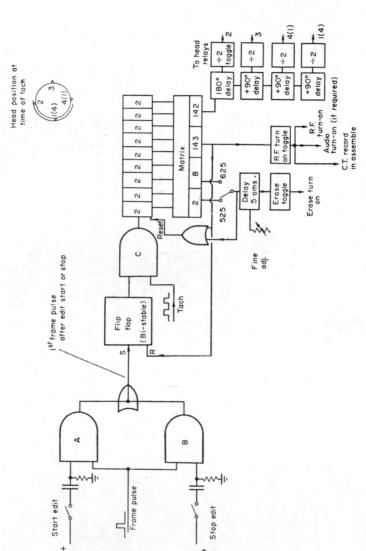

Fig. 14.7. The electronic editor simplified.

closed when the same sequence occurs, switching off the erase head relays and RF drive. One disadvantage of the arrangement shown is that the stop edit sequence cannot be started until the counter is reset, a time of 0.58 of a second after the start edit. If inserts shorter than 0.58 of a second are required a separate counter must be included for the stop function.

Playback and record phase

It is important that the phase of the video on tape does not change significantly over the splice point. To achieve this two conditions must be satisfied:

Playback phase. The playback phase is normally adjusted for synchronism of the video signal with station sync at some point after the output of the VTR.

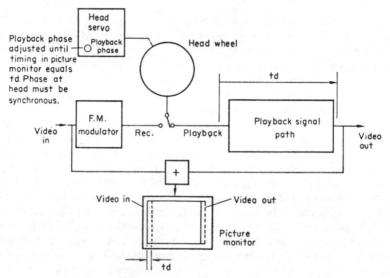

Fig. 14.8. Adjustment of playback phase in edit mode.

Owing to the delay through the signal path this means that the signal is in advance at the video head. For a correctly phased edit the phase of the playback video at the video head itself must be the same as the video to be recorded. One method of achieving this is shown in Fig. 14.8 and is to superimpose the playback and record video pictures and adjust the playback phase for a timing displacement equal to the signal system delay (td). Electronic methods are available which achieve the same object.

Record phase. Some VTRs hold the headwheel comparator in the tach mode, with station sync or video as the external reference, during playback before the edit and record after the edit. With such an arrangement adjustment of playback phase is all that is required.

Other VTRs hold the headwheel on the vertical or horizontal comparator

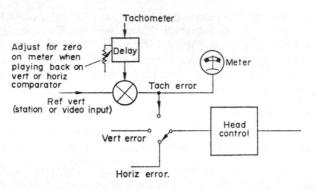

Fig. 14.9. Adjustment of record phase in edit mode.

during playback and switch to the tach comparator during record. With such an arrangement it must be ensured that the head does not change record phase. This can be done by monitoring the tach comparator during playback and adjusting the timing of one of its inputs until its error is zero volts (see Fig. 14.9). At the splice point when the tach comparator is selected the error will be zero, the head wheel undisturbed and the record phase will

be the same as the previous sequence.

Helical VTR adjustment. Helical machines are very much more tolerant of timing errors than quadruplex machines and so accurate phasing is not necessary. However on broadcast machines the replay and record heads are 120° out of phase with each other. It is important that during the pre-edit replay the record head is used so that when the join is made there is no discontinuity in the video phase. On non-broadcast helicals cleaner edits are achieved if the line sync timing before and after the edit does not change, but in general it is sufficient to adjust the tracking to give maximum off tape r.f. Care must be taken, however, because as a result of the shallow track angle adjustments to the tracking will alter the timing of the line syncs. By being off track by 25 per cent a line timing error of up to a line can be caused.

Editing colour sequences

NTSC colour signals have a 4 field sequence and PAL an 8 field sequence, if the subcarrier phase with respect to sync is taken into account. This is

explained in detail in Chapter 15, Figures 15.4 and 15.8.

On NTSC the subcarrier phase for field 1 is 180° different from field 3 and on PAL the same difference appears between field 1 and 5. The VTR, however, only locks up to a 2 field sequence on 525 and 4 field on 625 high band and therefore there is a 50:50 chance of matching a splice or edit with the wrong sequence. Should this occur, the chroma and burst make a 180° phase shift at the splice point which will be sensed by the colour corrector.

Figure 14.10 shows the relationship between reference subcarrier and burst just after an incorrect edit. If no other gross errors are present this

can easily be corrected to a condition shown in Fig. 14.10(b). The sync timing is now out and the subjective effect is for the picture to make a sideways jump equal to half the periodic time of the subcarrier (113 η sec - 625, 140 η sec - 525). This is not noticeable if a scene change occurs but is very noticeable on animation editing. To overcome this problem it is necessary to define the phase of subcarrier with respect to line syncs at all times. Both the SMPTE and EBU have draft proposals but for general use the inherent complication is unnecessary.

If the VTR locks up to the wrong sequence, then prior to the splice, either the chroma on the new scene can be reversed by placing a 180° phase shift in the subcarrier to the encoder or the VTR lock-up can be inhibited and made to skip to the next frame. The problem with the former is that at the 180° transition the encoded signal is upset and it is important therefore that the signal is not being used elsewhere. The problem with the second solution is that the lock up time is extended and editing to a one-frame accuracy is not possible.

A lock-up to 4 fields on NTSC and 8 fields on PAL by using 15 p.p.s. and $6\frac{3}{4}$ p.p.s. edit pulses have been suggested, but apart from the limitation of editing to a frame accuracy, the individual fields are difficult to define, especially when it is appreciated that there is no specification for sync to chroma phasing on either NTSC or PAL.

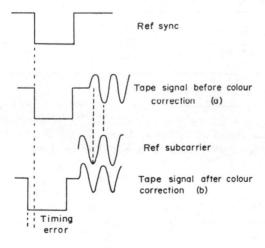

Fig. 14.10. A timing diagram showing the problem of the NTSC 4 field and PAL 8 field sequence in editing.

A final solution is to separate the luminance and chrominance with a comb filter and adjust the phase of a burst and chroma separately to match that of the incoming signal and then recombine it with the luminance. Several problems of vertical resolution and phase response are created by using comb filters and delay networks and an ideal solution has yet to be found.

Electronic editing, general

All electronic editors that do not use a flying erase head have a significant delay either in their stop cycle or both start and stop cycle. For helical it is about 3 sec and on quadruplex about 0.6 sec second on 15 i.p.s. (1.2 sec on 7.5 i.p.s.). This delay neccesitates a pre-meditated action of events which are difficult to synchronise. Not only can an edit be mis-timed on a master tape but the new scene may be late or early with respect to the master. Very often the errors cannot be detected until after the edit has been made.

Cue tone programming of edits

The requirements for rehearsal facilities with the possibility of changing edit points and the assurance of repeatable results led to the development of cueing edit points. Bursts of cue tone which start and stop the edit sequence

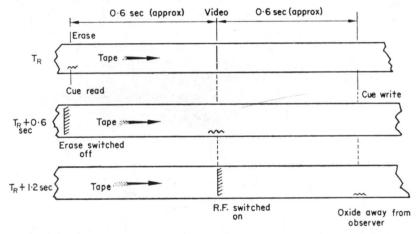

Fig. 14.11. Timing sequence for edit cueing.

are recorded on the cue track. The time delay can be eliminated and indeed made adjustable by reading the cue tone up-stream to where it was recorded.

The cue track record head is positioned 9.75 in downstream from the video head and if a cue read head is positioned near the erase head, say 8.5 in upstream from the video head, a cue can be read 8.5 + 9.75 = 18.25 in or about 1.2 sec in advance. With an editor delay of approximately 0.6 sec the advance cue can be delayed a further 0.6 sec to provide an edit at the instant the cue tone reaches the record head position. The timing sequence can be seen in Fig. 14.11. The procedure for rehearsal is to record a cue at the required point of edit, rewind and playback. During playback the cue is read early, delayed by 0.6 sec and allowed to initiate the edit cycle. The erase and RF turn on however are disabled and instead a switch from the playback signal to the input signal is made on a monitor at the time of edit. The cue delays can then be advanced by up to 0.6 sec or delayed by any amount until

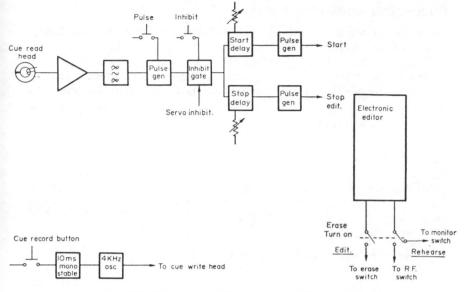

Fig. 14.12. Edit cueing with rehearse facilities simplified.

the correct splice is found. The editor can now be switched to edit and the

sequence repeated, this time making a permanent edit.

Extra precautions are sometimes built in as can be seen in Fig. 14.12 allowing the cues to be inhibited manually if not required or automatically if the servo is not locked. Provision is also made for manual cueing should a tape cue fail to be read. Extra sophistication is sometimes added to the device to allow different frequency tones for remote start of other machines, the physical shifting of cues, selection of individual cues and automatic animation with a pre-selection of the number of frames.

One of the disadvantages with cdit cueing is that although the edit is fixed on the master tape the remote video source may vary slightly. Even if it is started from a fixed cue its start position or run-up time may differ slightly. Finding the edit points on tape is also a time-consuming operation. To overcome these problems time code addressing was developed to allow fully automatic random access editing allowing fast searching of cue points and frame accuracy editing.

Time code addressing

To allow the automatic searching of a particular frame on tape a method of unique addresses for each frame recorded is needed. This can be done by recording a sequential digital code on the cue track with a number unique to that frame. The IEC, SMPTE and EBU have agreed on a code but before going into details it is worthwhile investigating the various digital codes available and their advantages.

Recording codes

Many codes have been devised, each with its own application and limitations. The most common ones have been listed in Fig. 14.13.

Obviously the cue track requires a sequential series of binary digits, this can be achieved by storing the composite number in a shift register and reading out the information at clock or bit rate. In the example chosen a 17 bit binary number 0110100010101111 is used to compare the various codes.

R-Z return to zero. This is the most obvious method of recording a series of 1's and 0's. Each pulse width is one half a bit time and a one is signified by a positive pulse and a zero by a negative pulse. The current falling to zero between pulses. The system is poor as each transition is only half the full possible swing from positive to negative. Also a resolution of twice the number of bits per inch (b.p.i.) is required to resolve the pulses. Thirdly, a redundancy of information exists because two transitions are used to describe each bit.

R—B return to bias. In this system the tape is biased to saturation either with a preceding head or with a d.c. current through the record head. Each pulse saturates the tape in the opposite direction and thus uses the full transition range of the medium. A one is signified by a pulse while a zero is signified by the absence of a pulse. The system is more efficient than RZ but still requires a high resolution. It also requires a reference of the bit rate because if a long series of 0's are being played back the number of missing pulses must be determined. On most multi-track computer decks a clock track is recorded on a separate track which gives the bit rate for all other tracks.

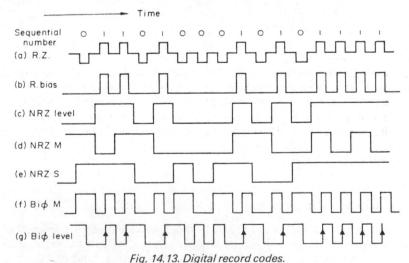

N-Z-R non-return to zero (level). This system is even more efficient, using full transitions with no redundant information. With this arrangement a high means one and a low means zero. In terms of transitions a positive

transition denotes a change from 0 to 1 and negative from 1 to 0, no transition denotes the same value as the previous bit. One transition per bit is the maximum rate, which is obtained with a recording 101010 etc., a resolution equal to the b.p.i. is therefore required. The system still requires a clock track and also has two major disadvantages:

- 1. A series of 0's or 1's could result in no transitions giving the signal a very low frequency component. The response of the system must therefore be from d.c. to bit rate. In practice a known phase reversal can be inserted every n bits to remove the d.c. component.
- 2. The most serious fault with this system is that if a transition is missed, not only the following bit is read wrongly but all bits until the next transition. In other words for a series 011110, if the first transition from 0 to 1 is missed, all ones will be read wrongly as 0.

N-R-Z mark. This system overcomes objection 2 in the N-R-Z level system. In this method a transition is made for every 1 to the opposite state. No transition is made for a 0. The polarity of the signal is immaterial as either a positive or a negative transition represents a 1, an error in reading a transition affects one bit only. The problem of clock rate and DC component still exists.

N-R-Z space. This system is the complement of N-R-Z mark and it is worthwhile comparing the waveforms of the two systems. In the N-R-Z space waveform, a transition indicates a zero and comparison with the N-R-Z mark waveforms shows that a transition occurs on the former waveform for the spaces on the latter. One method of producing a clock rate pulse is instead of recording a clock track, to record the complement on a second track. This way a clock rate can be produced with the advantage of a check or parity information. The N-R-Z Mark or N-R-Z Space are most commonly used systems in multitrack computer systems.

Bi-phase mark or Manchester 1. This system was devised where it is not possible to record a separate clock track and a transition occurs at the start of every bit. An extra transition occurs if the digit is one and no transition for zero. The direction of a transition is immaterial; therefore the phase or polarity of the signal is not important. The decoding of the signal is more complex because the clock edges and the bit information edges have to be separated. Once this is done the signal can be decoded at any speed, which offers many advantages in search processes on audio and video tape recorders.

The complement to this system is the bi-phase space or Manchester $I+180^{\circ}$, where the extra transition represents a 0 instead of a 1. This code is not shown.

At first sight it may seem that the system requires a resolution of twice the bit density, which is true, but it is not quite as bad as it seems when it is realised that the signal is very similar to an FM signal with two discrete frequencies and no low frequency component. Band filtering gives this system excellent noise immunity with the possibility of recovering low level high frequency components.

Bi-phase level or Manchester $II + 180^{\circ}$. This is another self clocking code in which a negative transition is made for zero and a positive transition for one. A transition is only made at clock time if it is required to give the correct phase transition for the following bit. In other words a series of '10101010 etc.' would not require an intermediate transition while a series of 1's or 0's would. It can be seen that a clock component is still present whatever the number and the signal is very similar to Manchester I but with the transitions meaning different things.

SMPTE address code

The code adopted as a standard is the Manchester I or Bi-phase mark. This offers the following advantages over other codes:

- 1. It is self clocking which allows decoding over a wide range of speeds.
- 2. Inversion of the signal is immaterial, which is useful for transmission on telephone lines.
 - 3. There is no DC component.

Manchester I Coder. The basis of a Manchester coder is illustrated in Fig. 14.14. A transition is required every clock time and an extra transition if the bit value is 1. Clock pulses (C2) are gated with the sequential binary number (A1) to provide the extra transition. $C_1 + C_2A_1$ triggers a divide by 2 circuit to provide the Manchester code.

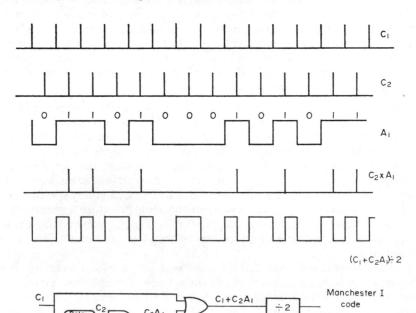

Fig. 14.14. Manchester I coder.

Manchester I Decoder. The problem of decoding is to separate the information pulses from the clock pulses and to be able to do this over a range of playback speeds from 1.5 i.p.s. to 150 i.p.s., a range of 1:100. To do this the code is amplified, phase split and differentiated, as shown in Fig. 14.15, to produce a positive pulse for every transition of the code, the equivalent to $C_1 + C_2 A_1$ in the coder. The pulse chain is then masked to separate the clock pulses from the information pulses.

To understand the masking action it must first be accepted that the clock pulses are separated. The clock pulses are used to reset a ramp generator

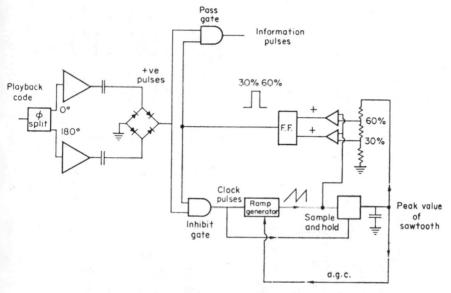

Fig. 14.15. Manchester I decoder.

which consists of a constant current source charging a capacitor. The mask reference is formed by sampling the peak value of the sawtooth and holding the voltage on a store capacitor. The masking pulse is developed by taking two proportions of the held voltage, 60% and 30%, and comparing this with the following ramp in two differential amplifiers. An output from each amplifier is formed when the ramp exceeds the 30% and 60% of the held voltage. These outputs are used to trigger a flip-flop, the output of which is used to open a pass gate, for the information pulse and inhibit the clock gate. The complete timing diagram can be seen in Fig. 14.16. The circuit can work at any speed as the gate pulse is always generated between clock pulses. At very high tape speed however the ramps become very small and an a.g.c. circuit with a long time constant is used to increase the amplitude of the ramps should they become low. The only time the circuit becomes inaccurate is during rapid acceleration or deceleration. The circuit can initially lock-up incorrectly but as shown in Fig. 14.16 these incorrect sequences pull into step in the presence of a modulated signal.

Format of SMPTE/EBU code

The code is sequenced in real time as this is familiar to the operators and addresses a frame with the time of a twenty four hour day in hours, minutes, seconds and frames. It is also coded as a binary coded decimal (b.c.d.) to make maintenance and fault finding easier. The maximum number of bits required for each decimal is as follows:

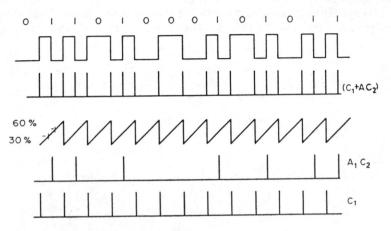

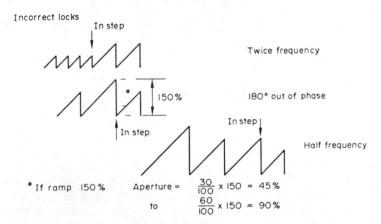

Fig. 14.16. Manchester I decoding.

Maximu	ım Nos:						
Hours Tens	Units	Minutes Tens	Units	Seconds Tens	Units	Frames Tens	Units
2	9	5	9	5	9	2	9
XX10	1001	X101	1001	X101	1001	XX10	1001

XX10 274

1001

If four bits were required for each decimal the total would be 32 bits, however a saving of six bits can be made dure to the fact that the tens of hours and frames column never exceeds five. These six bits are reserved for other functions which will be explained later.

The longitudinal space available for the code is equal to the length of one frame, which is 0.5 in on the 525/60 Hz standard. Packing densities of 800 bits per inch are quite common but on a track with uncertain head to tape contact like the cue track it was decided to restrict it to 160 b.p.i. This allows 80 bits per frame which are split up as follows:

28 bits—Time address code.

6 bits—Assigned for definite information or fixed 0.

32 bits—Spare for user option (binary groups).

16 bits—Sync word.

Total 80

The bits are assigned as shown in Fig. 12.17 and described as follows

- 0-3 Units of frames
- 4-7 First binary group
- 8-9 Tens of frames
- 10 Drop frame (1) (NTSC only)
- 11 Fixed zero
- 12-15 Second binary group
- 16-19 Units of seconds
- 20–23 Third binary group
- 24–26 Tens of seconds
- 27 Unassigned address bit (0 until assigned by the IEC)
- 28-31 Fourth binary group
- 32–35 Units of minutes
- 36-39 Fifth binary group
- 40-42 Tens of minutes
- 43 Unassigned address bit (0 until assigned by the IEC)
- 44–47 Sixth binary group
- 48–51 Units of hours
- 52–55 Seventh binary group
- 56-57 Tens of hours
- 58 Unassigned address bit (0 until assigned by IEC)
- 59 Fixed zero
- 60-63 Eighth binary group
- 64-79 Synchronising word
 - 64–65 Fixed zero 66–77 Fixed one
 - 78 Fixed one
 - 79 Fixed one

There is no restriction on the use of the 32 user bits and they can be filled with any binary number. They will most probably be used for tape identity, programme and scene idents, VTR control settings or other production information.

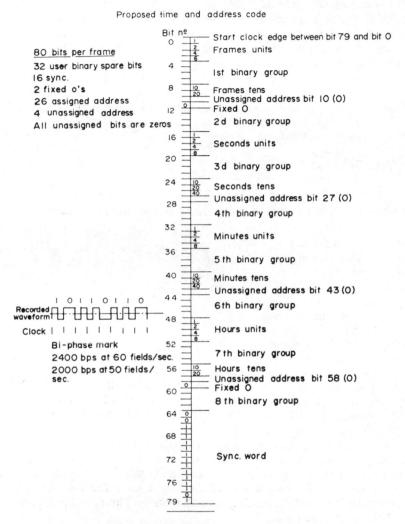

Fig. 14.17. Proposed time and address code.

The address bits are arranged as follows:

Units frames			
Bits 0-3	4 bit BCD arranged 1-2-4-8	Count 0-9	
Tens frames			
Bits 8–9	2 bit BCD arranged 1-2	Count 0–2	
276			

Units seconds		
Bits 16-19	4 bit BCD arranged 1-2-4-8	Count 0-9
Tens seconds		
Bits 24-26	3 bit BCD arranged 1-2-4	Count 0–5
Units minutes		
Bits 32-35	4 bit BCD arranged 1-2-4-3	Count 0-9
Tens minutes		
Bits 40-42	3 bit BCD arranged 1-2-4	Count 0–5
Units hours		
Bits 48-51	4 bit BCD arranged 1-2-4-8	Count 0-9
Tens hours		
Bits 56-57	2 bit BCD arranged 1-2	Count 0–2

Functions of sync word

The sync word has two main functions:

- 1. To indicate the start of the frame address
- 2. To indicate the direction of tape travel, as it is required to read the code in Fast forward and Rewind where the order of information is reversed.

For condition 1 it must be unique and should not be formed in the time code. The sync word contains 12 ones which should not occur elsewhere. The advantage of splitting up the code in groups of four now becomes apparent as assuming the worst case of all the user bits filled with ones the maximum number of sequential ones is 9, between bits 24 to 35 when the seconds tens indicate 5 and the minutes units 7. i.e.:

24 .												35
1011						1						1110
5												7

Similarly, nine sequential ones can occur between bits 40 and 51.

For condition 2 the sync word starts and ends with two identity bits to indicate direction. Once the sync word is detected, 12 consecutive ones, a zero is detected and the state of the following bit indicates the direction of the tape, 1 for forward, 0 for reverse.

The sync is detected by a $\div 10$ circuit which is reset every time a 0 occurs, the output only going to a high state when at least 10 consecutive ones occur.

The first zero after at least 10 ones sets a flip flop which opens two gates. If the following bit is one a second flip flop is set indicating forward, and if it is zero it is reset indicating reverse motion. The first flip flop is reset until the next sync pulse.

Bit number 10 (the "drop frame flag")

The field rate of a 525/60 Hz colour signal is more precisely 59.94 fields per second or 0.1% lower in frequency than the nominal 60 Hz. Therefore the straight forward counting of frames at 60 fields per second will yield a 0.1% error to real time.

Over one hour, 3600 seconds, this would accumulate to 3.6 seconds. To keep in step with real time a frame can be skipped every 100 frames. To skip a frame may be confusing at a later stage if an address which does not exist is selected for an edit point. To allow the time code to be different to real time is also confusing, requiring added complexity in computing the programme length.

It is left to the user which method is used and the SMPTE have defined

the following uses of bit number 10:

Mode zero. In this mode no numbers are omitted from the chain of addresses and when used, bit number 10 is assigned a 'zero'.

Mode 1. In this mode the first two frame numbers (1 and 2) at the start of each minute, exept minutes 0, 10, 20, 30, 40, 50, are omitted from the count. When this mode is used bit No. 10 is assigned a 'one'.

In mode zero the 3.6 seconds of error over one hour equals 108 frames. In mode one, two frames per minute amounts to:

60 × 2 = 120 frames per hour minus 6 exceptions 6 × 2 = 12 frames Total omissions = 108 frames.

In mode one therefore the code matches real time to within two frames.

Bit number 11 (standard binary groups)

There is no restriction on the way the binary groups are used but at some time in the future the SMPTE and the IEC will standardise on their particular use. When used in this anticipated manner, bit number 11 will be assigned a 'one'.

Bit numbers 27, 43, 58, 59

The uses of these bits are yet to be decided and until a definite decision is made

they are assigned a zero.

One possible use is to identify the tape recording standard. Another use might be to identify the PAL four frames or NTSC 2 frame sequence, although this is not absolutely necessary, and would only be required for check purposes, as the information could be contained in the address number itself. If it is arranged that frame 1 of the day is made frame 1 of the TV signal (however it is specified), on a 525/60 Hz NTSC signal, all addresses with an odd number of frames is frame one and an even number of frames indicates frame 2. On 625/50 HzPAL signals it is more complex as the seconds and the frame number must be added and divided by four. A remainder of 1 denotes frame 1, remainder of 2 denotes frame 2 . . . etc. and no remainder frame 4. This could be detected either by simple logic or by mental arithmetic from the address number only.

Time code controlled editing

If time code has been added to the tape on one of the existing audio tracks, on its own dedicated track or during the vertical interval, it can be used to log the edit points prior to the edit session. These pre-edit decisions need not be made using a broadcast machine and it is usual to use a cheaper industrial or domestic VCR. The tape can be prepared by making a parallel copy when the original recording is made or by subsequently dubbing to the VCR. If the former method is used the producer can note the sequences required by the time of day. This can be especially useful for sport or news when it is often impossible even to review the material let alone dub it before editing. The disadvantage is that the time code may well be discontinuous and some complication is introduced into the subsequent edit session.

Once the pre-edit decision list has been made it is then possible to reduce the time needed for the final edit or a further rough cut can be made.

Off line editing.

There are two forms of off line editing but both use the cheap helical, usually U-matic, in conjunction with an edit controller to produce a rough cut of the final programme. The term 'off line' is used to describe a system that allows the editor to spend longer preparing for the final 'on line' edit

using the master tapes on high quality machines.

The first form of off line editing uses the time code merely to identify the splice points. There are many different edit controllers with a range of sophistication to meet all needs. In their simplest form they enable the editor to rehearse each edit a number of times before the actual splice is made, but since the edit timing is referred to control track pulses, which are impossible to read at low tape speeds, their accuracy and repeatability are in the order of a few frames. The final cut is made using time code cues manually noted during the rough cut session.

More complex edit controllers use the time code to control the movement of two or more VTRs, or telecines, and the actions of a vision and audio mixer. Long and involved edit transitions can then be rehearsed, in slow motion if required, until the frame accurate final version is achieved. The cues and machine operations can then be stored in a computer system

and the master material used to produce the programme.

The second form of off line editing aims to offer all the facilities of the most complex broadcast editing suite but at a fraction of the running or capital cost. The user can then spend longer preparing the programme and can forget the technical aspects of editing since these are taken care of by the built-in microprocessor. Once the programme has been prepared the output, in the form of punched tape or audio cassette, can be given to a studio with the broadcast machines and the master tapes cut to match the frame.

Automatic editing

Once a time address has been placed on tape, the control of tape transports is a matter of arithmetic computation. Several edit modes can be used but the two most common methods are:

1. The assembly of a programme on machine B fitted with an electronic editor from a master tape of random scenes on machine A.

2. The assembly of a programme on machine C from two playback machines A and B. The latter can be quicker and allows mixing, keying and wiping between scenes where the former is restricted to the cut transition.

The calculations required for both systems are very similar as two machines must search for their cue points, stop, start together and lock in synchronism. Then at an appropriate time an edit or cut or mix must be made. Figure 14.18 shows a typical arrangement where it is required that two machines are locked together for a cut to be made.

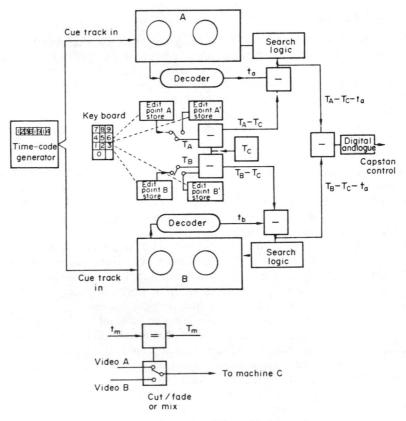

Fig. 14.18. Automatic editing with time codes.

If

ta = dynamic code read from transport A.

tb = dynamic code read from transport B.

TA = time code of required transition on tape A (manually set on keyboard).

TB = time code of required transition on tape B.

Tc = The cue point advance for lock-up of machines.

Step 1. Each transport cues up to correct position by spooling until for transport A:

$$TA - Tc - ta = 0$$

For transport B:

$$TB - Tc - tb = 0$$

Step 2. Start both machines. To maintain synchronism (TA - Tc - ta) - (TB - Tc - tb) should be kept at zero and the capstan servo of one transport is adjusted for this to be so. For instance if the sum is negative, transport B must be slowed down. Once locked the normal capstan servo on each machine should keep sequence. At a time when TA = ta the cut or mix can be made.

If electronic editing is used the cycle time of the editor must be taken into account.

References

- 1. Video-Tape splicing, 3M's Video-talk, Vol. II, No. 3, 1969.
- BOUNSALL, N., Electronic editing of magnetic television tape recording, JSMPTE, 71 95-99, Feb. 1962.
- ROIZEN, J., Electronic marking and control for rapid location of vertical blanking area, JSMPTE, 67, 732-733 Nov. 1958.
- MACHEIN, K. R., Factors affecting the splicing of video tape, JSMPTE, 67, 730-731, Nov. 1958.
- BUSBY, E. s., Frame numbering of Television tape recordings, JSMPTE, 79, March 1970.
- BUXTON, A. J., AND HEATHER, J., Automatic Tape Editing, 104th Conference SMPTE, Jan. 1969.
- ANDERSON, C., The problems of splicing and editing colour video magnetic tape IEEE Transactions, Vol. BC—15 No. 3, 1969.

15 Slow Motion Techniques

The quadruplex machines first used for broadcast video recordings were not suitable for slow motion replay because they divided the picture into segments (see Chapter 3). Once the helical machine had reached maturity it was possible to use the same machine for both normal and slow motion replay as described in Chapter 4. The first successful slow motion device used for videotape was the video disc. The storage disc used is one where the recording medium is nickel cobalt which is coated with rhodium to provide a hard protective surface. Figure 15.1 shows a typical disc which is 16 in in diameter, weighs about 5½ lb and has a useful recording area on both sides of the disc $4\frac{1}{2}$ in wide from the outer rim.

The number of tracks that can be accommodated on one disc surface depends on the track and guard band width. With a track width of 0.0075 in and a guard band of 0.0025 in the centre-to-centre track spacing is 0.01 in allowing 450 tracks within the 4.5 in of recording area. One field is recorded per track which means that the total disc capacity, using both surfaces is 900 fields. On 625/60 Hz:

total time per disc =
$$\frac{900}{50}$$
 = 18 seconds.

On 525/60 Hz

total time per disc =
$$\frac{900}{60}$$
 = 15 seconds.

Most practical systems use one or two discs.

The tracks, unlike an audio record, are concentric rings and the heads are stepped in when the other head or heads are recording or playing back. The disc rotates once per TV field which gives the following head to disc speeds: On 625/50 Hz

Rotational rate of disc = 50 r.p.s.
Speed(s) =
$$\pi D50$$

where D = diameter of track.

For outer track:

$$S = 50 \times 16 \times \pi = 2514 \text{ i.p.s.}$$

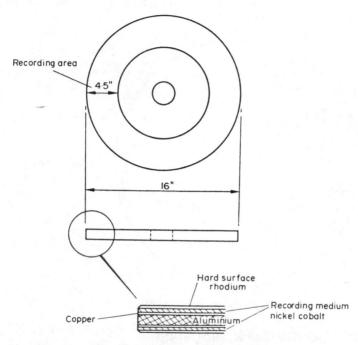

Fig. 15.1. The video magnetic disc.

For inner track

$$S = 50(16 - 9) \pi = 1100 \text{ i.p.s}$$

On 525/60 Hz

Rotational rate = 60 r.p.s.

For outer track

$$S = 60 \times 16 \times \pi = 3016 \text{ i.p.s}$$

For inner track

$$S = 60 \times 7 \times \pi = 1320 \text{ i.p.s}$$

The tracks can be recorded from the outer edge to the inner limit sequentially, recording odd fields on one surface and even fields on the other, moving the head during the field it is not recording.² Such an arrangement however requires a rapid flyback when the heads reach the centre with an obvious gap in the recording.

For sporting events where the action is unpredictable it is desirable always to have the discs full with the last η seconds, when η is the capacity of the store. This can be done as shown in Fig. 15.2. On the inward journey the video head records a track and moves in two tracks to record again. When it reaches the centre it has recorded on 225 tracks missing every alternate track. On its outward journey it records on the vacant spaces interlacing the tracks. When the video head reaches the edge the first track is erased and rerecorded over. With such an arrangement each disc surface will always have the last 450 recorded fields of information.

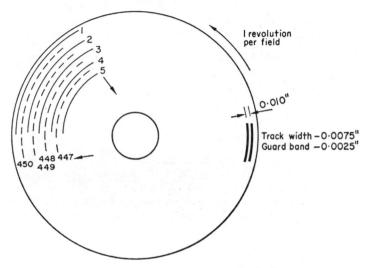

Fig. 15.2. The disc record format (typical).

Record and playback sequence

If a storage capacity greater than 15 or 18 seconds is required, at least two discs must be used, which adds some complexity to the record and playback sequence.³

Assuming the video heads on the four disc surfaces are labelled A, B, C and D a typical record sequence would be as shown in Table 18.

		Table 18		
HEAD	FIELD	FIELD	FIELD	FIELD
(or	1, 5, 9,	2, 6, 10,	3, 7, 11,	4, 8, 12,
channel)	13, etc.	14, etc.	15, etc.	16, etc.
A	Record _	Step	Step	Erase
В	Erase	Record _	Step	Step
C	Step	Erase	Record	Step
D	Step	Step	Erase	Record
	-			

Note that field 1 is recorded on A, 2 on B, 3 on C, 4 on D etc., and after recording a field the head steps in twice, one step being one track, and erases

the existing track the revolution prior to recording.

The erase can be performed either by a separate head preceding the video head or by the video head itself on the revolution before recording. The former is preferable as the width of the erase can include the guard band to avoid interference from stray signals during mis-tracking.

A forward playback sequence at normal speed is very similar to record with the erase inhibited and the video head replaying instead of recording

as shown in Table 19.

Table 19

FIELD	FIELD	FIELD	FIELD
1, 5, 9,	2, 6, 10,	3, 7, 11,	4, 8, 12,
etc.	etc.	etc.	etc.
Reproduce	Step	Step	
48 1	Reproduce .	Step	Step
Step	•		Step
	Step		Reproduce
	1, 5, 9, etc. Reproduce Step	Reproduce Step Reproduce Step	Reproduce Step Step Step Step Reproduce Step Reproduce Reproduce Step Reproduce Step Reproduce Step Reproduce

Reverse motion at normal speed can be obtained by reversing the stepping direction of the heads and by reversing the order of selection of the heads. This can be done simply by exchanging the A and C commands and reversing the stepping direction as follows:

This gives the result shown in Table 20.

Table 20

etc.	2, 6, 10, etc.	3, 7, 11, etc.	4, 8, 12, etc.
Step		Reproduce	Step
^ _	Reproduce /		Step
Reproduce	Step		X 7
Step	Step	•	Reproduce
	Reproduce	Reproduce Reproduce Step	Reproduce Step Step

Stop-motion

A still frame or stop motion can be obtained by stopping the heads and repeating a playback frame. This could be done by playing back any sequential odd and even fields from two tracks. The disadvantage of this is that the

frozen action shows an integration of movement over 1/25 sec on 625 or 1/30 sec on 525 signals. A better system is to play back one track or field which will give an integration of only 1/50 or 1/60 sec, ignoring lag in the camera tube.

The only problem now is that the field selected is either an odd or an even field and the playback video should consist of a sequential series of odd and even fields. One method of overcoming this problem is to convert an even field to an odd or vice-versa. Figure 15.3 shows the start and end of two sequential fields and a correct signal should progress from A to B to B' to A.

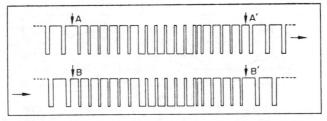

Fig. 15.3. The horizontal sync relationship between fields.

Assume that one track has recorded on it the upper field from A through to B. The following recorded track will of course record from B onwards. If the recorder were just playing back track A, it would be correct for one field up to point B. However it now repeats itself, which is satisfactory up to A' as A to A' is the same as B to B'. At this point the video from track A is incorrect and a half-line delay is required to convert the phase of an odd field to an even and vice-versa. Vertical resolution is impaired but movement rendition is improved compared with the two field playback.

For monochrome signals the insertion of a half-line delay is all that is required to correct the field sequence. For colour, an additional correction is required to maintain chroma phasing. The requirements of chroma correction are different for PAL and NTSC and it is worth treating them separately.

NTSC chroma correction

NTSC colour sub-carrier is chosen to be an odd multiple of half-line frequency in order to minimise the dot pattern and interleave the chrominance and luminance spectra. The effect of this is to cause the subcarrier phase to be 180° different in phase to the subcarrier in the same position on the previous line. Because the system has an odd number of lines over two fields, line one of field 3 is different from line one of field 1. For this reason the 525/60 Hz NTSC signal is sometimes said to have a four-field sequence. This can be seen in Fig. 15.4 where the subcarrier alternates 180° for each line and line one frame is 180° different from line one frame 2. In order to maintain the correct chroma continuity any playback field must be able to be converted to look like any one of the four fields. This can be done by inverting the chroma

including burst on certain fields. Table 21 below illustrates the complete correction sequence. The $\frac{1}{2}$ line delay converts dissimilar fields. The chroma invertor is used to convert the chroma of a similar field to a dissimilar frame and also when the $\frac{1}{2}$ line delay is used on a similar frame. This can be seen by referring to Fig. 15.4. *If line 1 (odd field) of frame 2 is converted to line 264 (even field) of frame 2 then a $\frac{1}{2}$ line delay and chroma invertor are required.

Half line delay logic (HL)

It can be arranged that disc surfaces A and C always contain odd fields. This being so the logic required can be easily determined as the $\frac{1}{2}$ line delay is

Table 21

Required P.B field Recorded field Frame Frame 2 Even (disc) Odd Even Odd 1/2 L.D. Odd 16 L.D. C.I. CI. Frame I 1/2 L.D. Even 1/2 L.D. C. I. C.I. (B) 1/2 L.D.* Odd 1/2 L.D. C.I. (C) C.I. Frame 2 1/2 L.D. Even C.I. 1/2 L.D. (D) C. I. Where 1/2 L.D. insertion of 1/2 line delay And C.I. chroma signal inverted

not required when the reference sync is odd and playback is either from A or C OR reference is not odd and playback is not from A + C.

In Boolean

$$\overline{HL} = Ro (A + C) + \overline{Ro} (\overline{A} + \overline{C})$$

$$HL = \overline{Ro} (A + C) \cdot \overline{Ro} (\overline{A} + \overline{C})$$

or

where Ro =Reference odd.

A + C = Playback from disc surface A + C.

HL = Half line delay logic.

Chroma invert logic. The chroma invertor logic can be understood by analysing the correction table. It should be noticed that the CI changes state

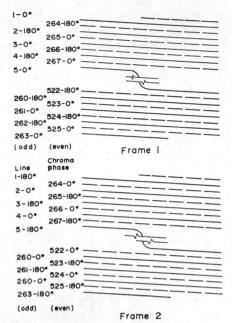

Fig. 15.4. NTSC subcarrier phase, showing a 4 field (2 frame) sequence.

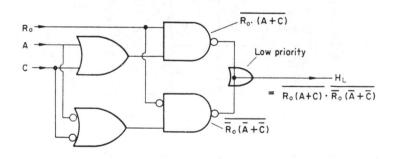

R₀ Reference 30Hz—high for odd field
A High when playing back on disc A
C High when playing back on disc C
H_L High when 1/2 line delay is required
C.I. High when chroma inverter is required

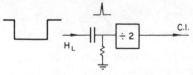

Fig. 15.5. Half line delay and chroma invertor logic for NTSC.

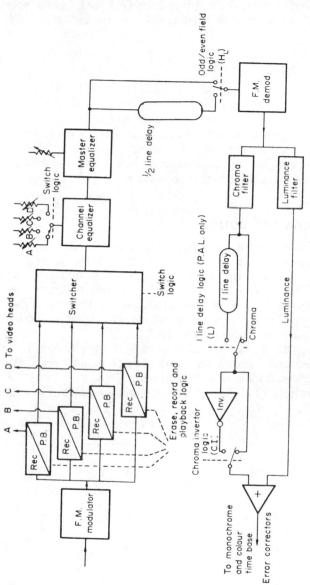

Fig. 15.6. The video disc signal system.

(either removed or inserted) every time the half-line delay is inserted. This can be achieved by using the half-line delay (HL) to trigger a binary switch as in Fig. 15.5 every time the half-line delay is inserted.

Video disc signal path

A block diagram of the complete signal path can be seen in Fig. 15.6. It is very similar to a VTR using frequency modulation with similar deviation frequencies. The differences are that the RF to the video heads is gated to record the correct fields and an additional erase function may also be required.

In the playback path, the output of the signal system is passed to the halfline delay and chroma invertor correctors before the conventional monochrome and colour time base error correctors.

PAL chroma correction

PAL colour subcarrier has a quarter-line offset which causes the colour subcarrier to phase shift by 90° on successive lines. Because 625 is divisible by four with a remainder one, line one of field 1 is 90° different from line 1 of field 3, 180° different from line 1 of field 5, 270° different from line 1 of field 7, an eight field sequence. A further complication is that on every second line of the PAL signal the V component of the chroma signal is reversed giving a four field sequence as shown in Fig. 15.7.

Note that on any line of an odd or even field, say 309 or 621, the *V* component is reversed two fields later. If the complete sequence is plotted over eight fields it would look something like Fig. 15.8.

To convert field 1 to field 3, a half-line delay would not be required but

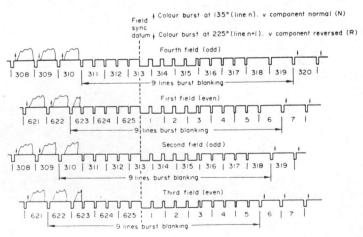

Fig. 15.7. The PAL signal showing the 4 field sequence due to the alternating phase of the V component.

Frame-1 Frame-2

		Chroma	
		phase	Component
	-Field I	0 1	* N
reld 2 N 0 314 — Field 4	- Field 2 _	270 314	*R
N 180 2	F16.0 2	90 2	R
R 90 315		180 315	N
			N
N 180 316 —		90 316	N N R R
N 0 4		270 4	R
R 270 317		180 317	N
5 to 309 8 318 to 622 318 to 622	5 to 309 8 318 to 622		
N 0 310		270 310	R
R 270 623 —		180 623	N
R 90 311		0 311	N
N 0 624		270 624	R
N 180 312		90 312	R
R 90 625		0 625	N
R 270 313		180 313	N
R 90 625 — — R 270 313		0 625	N

Frame-3					Frame-4			
Subcarrie	er			Supcorr	er			
V Component	Chro			V Component	Chrom	0		
2 K K Z Z K K Z	180 90 270 180 0 270 90	314 2 315 3 3:6 4 317	Field 8	R 2 2 R R 2 2 R	270 180 0 270 90 0 180 90	314 2 315 3 316 4 317	Field 7	
222222	90 0 180 90 270 180	310 623 311 624 312 625 313	318 to 622	2662266	180 90 270 180 0 270 90	310 623 311 624 312 625 313	319 to 622	

Fig. 15.8. PAL subcarrier phase and V component position showing an 8 field (4 frame) sequence.

note that the V component is wrong. This can be corrected by delaying the chroma one whole line making line $1 \dots$ to line 2 etc., The chroma phase is now also wrong by 180° which can be corrected with a chroma invertor. Therefore to convert field 1 to field 3 a one-line delay and chroma inversion is required. If the same analysis is carried out for all fields the following chart can be compiled.

Half-line delay logic. The half line delay logic for PAL is very similar to the NTSC although as shown in the correction the odd fields are now recorded on B and D requiring an inversion of Ro, giving:

$$\overline{H} = Ro(A + C) + Ro(\overline{A} + C)$$

One-line delay logic. Looking at the Table 20, the requirement for the one-line delay is repeated in each quadrant of the table. The logic therefore can be simplified to produce the diagram in Fig. 15.9. Simple Boolean logic is now required to decide when the 1 line delay is required.

Chroma invertor. Examination of the correction chart shows that the chroma invertor changes condition every time either the one line delay or the half-line

	red yback eld								
Recorded field (disc)		FramelI		Frame 2		Frame 3		Frame 4	
		Even	Odd 2	Even 3	Odd 4	Even , 5 (1)	Odd 6(2)	Even 7(3)	0dd 8(4)
Frame I	I Even		1/2 L.D. 1 L.D.	IL.D. C.I.	1/2L.D.	C. I.	1/2 L.D. 1 L.D. C. I.	IL.D.	1/2 L.D.
Frame 1	2 Odd	1/2 L.D.		1/2 L.D. 1 L.D	IL.D	1/2 L.D.		1/2 L.D 1 L.D.	I L.D.
	(B)	C.I.			C.I.		C.I.	C.I.	
			1/2L.D.		1/2 L.D.		1/2 L.D.		1/2L.D.
	3 Even (C)	I L.D.			IL.D.	IL.D.			I L.D.
Frame 2			C. I.	-		C. I.	-	C.I.	C.I.
1101110 2		1/2 L.D.		1/2 L.D.		1/2 L.D.	-	1/2 L.D.	
	4 Odd	IL.D.	IL.D.		1	IL.D.	IL.D.		
	(D)	C.I.		C.I.			C.I.		C.I.
			1/2L.D.		1/2L.D.		1/2 L.D.		1/2L.D
	5 (1')Even		IL.D.	I L.D.	1		IL.D.	IL.D.	
	(A)	C. I.	C.I.		C. I.			C. I.	
Frame 3	6(2')Odd	1/2 L.D.		1/2 L.D. 1 L.D.	IL.D.	1/2L.D.		1/2 L.D. 1 L.D.	I L.D.
	(B)		C.I.	C. I.	1754	C.I.			C. I.
	7 7 70 7		1/2 L.D.		1/2L.D.		1/2 L.D.		1/2 L.D
	7(3') Even	I L.D.			I L.D.	IL.D.			I L.D.
	(C)	C. I.	5.9	C.I.	C.I.		C. I.		
Frame 4		1/2 L.D.		1/2 L.D.		1/2 L.D.		1/2 L.D.	
	8(4')0dd	I L.D.	IL.D.		-	IL.D.	I L.D.	-	/
	(D)		C.I.		C.I.	C.I.		C. I	

delay are removed. This can be provided by the simple circuit shown in Fig. 15.10.

Slow and fast motion

Slow motion can be obtained by playing back each field more than once. By playing back each field twice the effect of half speed is created, repeating each field three times gives one-third speed. Odd fractions, say two-fifths speed, can be created by repeating one field twice, the next three times, an average of $2\frac{1}{2}$ times.

The required correction sequence can be derived from the correction charts

by moving across for every station field and down every time a switch to the next disc surface is made. For reverse motion one would move up the chart.

Fast motion is normally created by recording every second or third field and then playing back at the correct speed or thereabouts. The chart can still be used by blanking off the unrecorded fields. If only the odd fields were recorded, a playback at normal speed would require the insertion of a half-line delay on every second field.

Helical slow motion

The two basic forms of helical machine produce their still frames in fundamentally different ways (see Chapter 4). The segmented system has

Ref. field				
Disc surface	. 1	2	3	4
А	2 4 Y	×	×	
В		300 N	×	X
С	×	do		X
D	×	×		

L = A(2+3) + B(3+4) + C(1+4) + D(1+2)

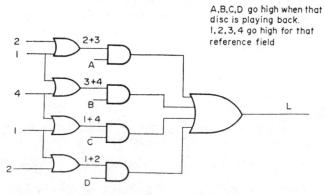

Fig. 15.9. 1 line delay logic (PAL only).

to provide a frame, or at least a field, store but with the advent of digital memories this has become quite feasible and has the further advantage of being able to modify the picture by redistributing the data in the store.

The nonsegmented systems are able to reproduce a still frame without the need to store the picture elements but can only do so with the aid of a wide range time base corrector. The facilities available are limited to

> If either half line delay or one line delay is removed, CI changes state

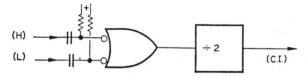

Fig. 15.10. The chroma invertor logic for PAL.

simple speed and direction changes but these are sufficient for many videotape operations, especially sport.

The method of reproducing the correct field sequence is based on the heterodyne section of the TBC, see Chapter 12.

Conclusion

The video disc was the only means of obtaining still and slow pictures for many years. It was not portable and therefore required both a send and return signal path when used in conjunction with an outside broadcast unless it was used without rehearsal. During post production use extra staff and space were required, often for quite short sequences. The possibility of using each frame for a single picture is very attractive, for example, when close ups of candidates at a general election are needed. However a separate tape or film has to be kept so that the disc can be used for other operations between the preparation and use of the shots.

It would seem inevitable that the new HVTRs will take over all slow and still frame operations in the future, especially since the machines are so much more portable.

References

- BOICE, C., A new approach to colour slow motion, Video Recording, Visual Electronics, Sunnyvale, California.
- FIX, H., FUNK, H. AND VOLLENWEIDER, E., Slow motion device for monochrome and color television using magnetic disk store. EBU Review, Part A No. 112, December 1968.
- 3. STRATTON, L., Reviewing slow motion disc principles. Broadcast Engineering, February 1969
- 4. MACLEOD, Magnetic discs for video recording, JSMPTE, Vol. 80, April 1971, 295-297.

16 Mobile Video Recording

The main requirements of a mobile recorder in addition to those of a static one are:

- 1 Light weight
- 2 Battery operation3 Stability
- 4 Weather proofing
- 5 Compatibility with static machines

Quadruplex machines are too heavy and bulky and cannot operate easily from battery sources. This has restricted their use to large outside broadcasts where they can be operated from permanent installations in vans. Until battery powered portable cameras were available this was not a great disadvantage except in terms of staff and vehicle size. Highly mobile current affairs and news operators had to use film, as did those wishing to shoot outdoor drama or light entertainment sequences. The need to process film before it could be viewed made it necessary to shoot extra material in case there were technical or dramatic errors. There was no means for on-site review to help with continuity and the different characteristics of film made subsequent colour matching with studio electronic shots difficult. An electronic recording system would remove these difficulties.

Industrial and educational users were the first to use videotape for location shooting since they could accept a lower picture quality and the re-use of tape made this method more economic than film. The generally accepted recorder was the U-matic and the manufacturers soon provided all the peripheral equipment required to perform the most complex postproduction work. Once cameras with a broadcast performance and equal in weight to a 16 mm film camera were available it was possible to replace existing news crews with entirely electronic ones. Electronic News Gathering (ENG) and Electronic Field Production, (EFP) for drama, have now become commonplace despite the high capital cost of the equipment.

Electronic News Gathering

Many news stories are predictable, for example the arrival of a visiting head of state, but very few occur during programme times. For this reason some means of recording the pictures, with either film or videotape, is required.

Videotape has the advantage that it can be replayed without further processing and so can be checked at once for both technical and editorial quality. This can mean the difference between having a story or not, because the people involved may be out of reach by the time the film is available and so a retake is impossible. It is also possible to replay the tape down a land line or over a radio link and so save the journey to the

processing plant.

All the members of a reporting team have to be highly mobile and so their equipment must be as light as possible. This is not just for their convenience but also to reduce the freight charges when the equipment has to be flown overseas. The present cameras weigh around 7 kg and the recorder has to be comparable. It must also be battery powered, weather-proof and immune to mechanical shocks. The machines used at the base station may be less strictly specified but must be compatible with the

portable ones and capable of complex audio and video edits.

The U-matic format which uses 3/4 inch tape in cassettes is capable of producing pictures equal in quality to 16 mm film on the 525/60 Hz system and has been universally adopted for ENG on this standard. The 625/50 Hz system has a lower head to tape speed, 8.54 m/s versus 10.26 m/s, and so an improved version was developed using higher frequencies for the luminance FM and the colour under sub-carrier. The slower rotational speed of the 625/50 Hz machines means that there is a larger guard band than on the 525/60 Hz machines. This has been used to provide wider video tracks, 125μ against 85μ , while returning the guard band to 40μ . The head gap has also been reduced to less than 1 \mu which improves the high frequency response. A final change is that a pilot burst is included in each of the separate parts of the signal, luminance and chrominance, as they pass through the recorder. The two bursts are placed in parts of the signal not used and enable much more accurate frequency conversion and level setting (see Fig. 16.2). A separate track for time code addresses is provided on the tape format. It runs across the part of the video track used for the vertical interval pulses and so does not affect the picture. It can only be recorded at the time of the first recording and cannot be edited.

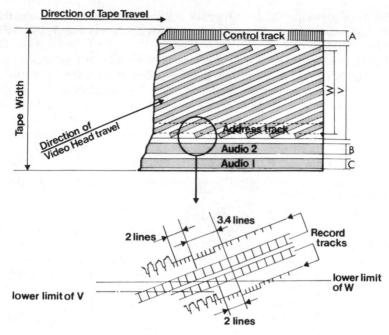

Fig. 16.1 Tape format.

The portable recorder

The lightest portable recorder weighs approximately 7 kg and runs for just over 1½ hours on a single battery charge. There is no provision for replay, other than a confidence check, since the machine will generally only be used in circumstances where replay is not feasible, for instance recording in crowds.

Larger machines, weighing up to 15 kg, are in use and provide colour replay either for local viewing or onward transmission. The recording format is the same for both machines which are limited to the smaller of the two cassette sizes. These hold 20 minutes of tape although a thin based tape lasting 30 minutes and a robust one lasting 5 minutes are available.

A 20 minute tape is usually more than enough for a single story, with the possible exception of a sports match or similar event, and anything longer becomes unwieldy during the editing stage because of the slow speed of the fast forward and rewind. Although it is good practice to put a line up signal, for example colour bars, on the front of the tape, there is usually neither the time or the facility for doing so. The camera can often provide such a signal and if it can be used two advantages result. The first is that the editor can set the correct levels during the dub and the second is that the first part of the tape is not used for the story. Where tape is loaded into the cassette some mechanical handling is inevitable as the leader is attached. This results in a significant increase in the noise during the first and last two

minutes of any tape. There are also surface marks and creases resulting from the extra thickness of the splice which can affect the quality of the

replay.

The drum diameter of a U-matic is 110 mm (4.3 in) and it has considerable inertia. This causes two problems, first it takes some time for the drum to reach the required speed from rest, this time depending to a large extent on the power of the drum motor. Once the correct speed has been achieved the sustaining power is quite small and so portable recorders tend to have slower run-ups than base machines. The second problem becomes apparent when the recorder is subject to acceleration such as when it is being carried. Provided care is taken the recorder can be used while it is in motion. Fig. 16.3. shows how rotation about the axis of the head drum and motor should be avoided.

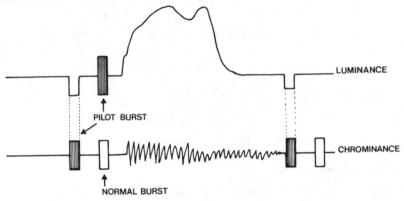

Fig. 16.2 Pilot burst.

The variation in drum speed caused by motion, often referred to as gyro errors, was only corrected once for each rotation but later machines provide eight tach pulses per revolution and so better speed control at the

expense of reduced battery life is possible.

The slow start is embarrassing because no pictures can be recorded before the drum servo locks up. News pictures often appear without warning and whereas with film only one or two frames are lost at start up, with tape the politician may well have crossed the pavement and driven off before the recorder is ready. To overcome this the recorder has a standby mode which leaves the tape wrapped around the scanner which in turn is kept rotating at about half speed. In order to provide a final recording with a continuous control track, essential for editing, the recorder makes assemble edits each time it is caused to record. At the end of each section the transport rolls the tape back two or three seconds and parks it. When the next section is started the recorder runs forward in play until the end of the previous section is reached. It then begins to record having phased the record head and capstan to the old recording. This compromise still means that the video recorder is at a disadvantage compared with film, but the editing is greatly eased.

Editing

Except when the story is a single statement the tape will need to be edited before transmission. The edit machine is compatible with the portable but has an extra pair of heads on the scanner (Fig. 16.4). These are to erase the unwanted tracks during an edit.

Fig. 16.3 Tape recorder movements.

In order to join the two sections of tape the play and record machines have to be started together from a known point so that as the previous shot is ending on the record machine the start of the new section is arriving on the play machine. This is usually achieved by counting control track pulses. To perform a good edit the outgoing and incoming video have to have the same line timing. If there is an error the picture will twitch as the edit goes through during replay. Fine adjustment of the off tape timing with respect to reference syncs can be made by the tracking control. The shallow angle of the video tracks means that as the tracking is adjusted the off tape video timing alters (see Chapter 4). For this reason it is better to adjust for correct timing rather than maximum r.f. on replay. The effect of line timing errors at the edit can be seen in Fig. 16.5, but in general the time base corrector will remove any timing errors.

While finding the edit points the tape is moved vigorously up and down. This can cause the tape to stretch and introduce velocity errors. The more robust tape was thought to be useful here but machine tape handling is improving so that the problem has become less important.

The replay machine will require several seconds, up to 7, before it has locked up. If the start of the section is not to be lost during the editing the

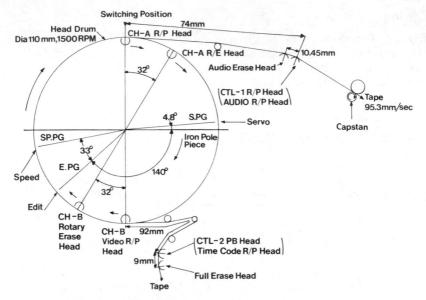

Fig. 16.4 Scanner with erase head.

recorder will have to be started at least 10 seconds before the chosen point. As suggested above, this can be overcome by recording a continuous control track on the original tape.

Each time the tape is parked ready to run up to the edit point the guides mark the surface. This can be seen as a small horizontal displacement of the picture which runs up the picture one or two seconds after an edit point.

Remote replay

There are often land lines between studio centres which can be used to transmit the recorded pictures for inclusion in a later programme. If the output is to be rerecorded there is no problem of synchronism since the recorder will lock to video in. If it is to be included in a live studio's output then the output must be correctly phased with respect to the main network. There is usually only one line between the studio and the recorder and so a local reference has to be provided. A crystal as good as one part in 10^8 will drift by one line every 22 minutes. Provided that the TBC used can cope with the error, i.e. it is less than five lines, this system will allow the VTR reference to be phased just before the VTR is on the air. It will then hold its lock long enough for the story to be transmitted (Fig. 16.6.).

Time base correction

The output of a U-matic has stable chrominance sub-carrier and unstable luminance (see Chapter 12). This is the result of correction circuits de-

Fig. 16.5 Effect of timing error at edit on picture.

signed to make the signal suitable for display on a colour monitor. The sync to sub-carrier phase relationship is destroyed by this process and has to be restored for broadcast use. If it is necessary to mix the output with another source the timing errors have to be removed first and this can be done in a number of ways.

One approach is shown in Fig. 16.7. The timing errors of the luminance are re-applied to the chrominance by mixing the sub-carrier with a local oscillator whose frequency is varied according to the sync edge timing. This is the reverse of the replay function of the recorder. The new signal now has the sync to sub-carrier phase relationship restored and can be converted to digital form and time base corrected in the usual manner.

An alternative approach is to decode the off tape signal to either U and V or I and Q and then to recode before time base correction. This can lead to phase problems and so it is better to perform the time base correction first and the decode recode second.

A major function of the TBC is to cope with the very large errors that result from the recorder being moved while recording. These can extend to several lines in either direction over a short period.

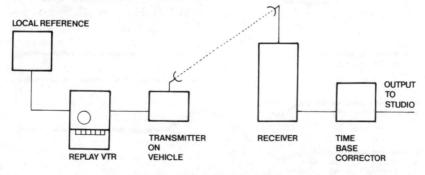

Fig. 16.6 ENG replay chain.

One technique is to provide a suitably large number of lines of delay, e.g. 16, so that the TBC is able to cope with the largest errors, but this can be expensive in both financial and circuit terms. An alternative is to cause the window of the TBC to follow the average of the input signal. This enables a window of two or three lines to cope with any amount of error, possibly at the expense of a certain amount of picture movement.

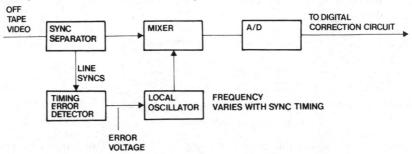

Fig. 16.7 Heterodyne section of time base corrector.

On later U-matics the off tape r.f. signal is available at a socket on the machine before it has been processed and translated into a normal signal. This is designed to reduce the signal processing when a dubbed copy is made as in editing. A purpose-built time base corrector can take advantage of this and can apply the necessary correction without having to dismantle the signal a second time.

The reduced band width of the U-matic system can to some extent be compensated for by artificially sharpening the lunimance edges. However this should not be done during the edit process as the second recording only keeps the low frequency component of the correction signal which results in a 'ring' or shadow following any vertical edges in the picture, (see Fig. 16.8.). This crispening feature is available on several time base correctors,

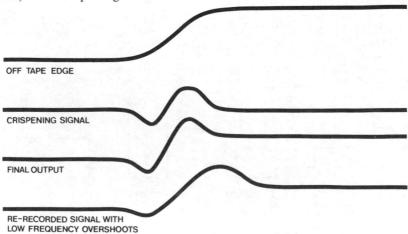

Fig. 16.8 Sharpening luminance edges on U-matic system.

Electronic field production

For both broadcaster and industrial user it is often cheaper and quicker to use real scenery than to build it in the studio. The need for high mobility is less important than for ENG and so the recorders can be vehicle or trolly mounted. If necessary the portable versions of both the B and C format machines can be carried to the site or, with a certain degree of care, while recording.

Independence from the mains, or compressed air, as required by the quadruplex system, makes any temporary installation in a boat, plane or

car relatively simple.

By recording on site it is possible to use a mixer to combine the output of two or more cameras and so perform some of the editing process during shooting as in the studio. A lightweight production unit can then be used for drama and for sports coverage if a second recorder is included.

The main advantage to drama is the possibility of checking the effect of lighting and acting before the crew leaves the site or an expensive set is dismantled. The final pictures are also more likely to match those shot in the studio when the outside sequences are intercut with them. This can be particularly disturbing if the action moves in and out rapidly when the colour match and the character of the pictures can be seen to change frequently. Some attempt to blend film into electronic pictures can be made but since this can only really be done by adjusting the electronic material it becomes necessary to shoot the film sequences first which places an unnecessary restriction on the programme maker. Even if a perfect colour match is possible the different look of film with its unsteadiness and dirt against the reduced contrast and sharpness of electronic pictures make the change clearly visible.

Conclusion

The increasing sophistication of electronic equipment will in time enable all television material to be produced by electronic means although for the small user the capital cost is likely to be too high. The trend towards ENG is well established and it is now often easier to transmit a story via a satelite link than to return the film or have it locally processed. EFP offers the chance to make complex programmes without the need for large studio centres and so releases more capital for the actual programme which suggests that large television centres will no longer be required except for post-production.

Table 23
Position and location of recorded tracks for U-matic format

		625 Standard	625 High
		and 525	Band
A	Control track width	0.60 mm	0.60 mm
В	Audio 2	0.80 mm	0·80 mm
C	Audio 1	0.80 mm	0·80 mm
	Address track	0.50 mm	0.50 mm
	Video track width	0.085 mm	0·125 mm
	Video track angle	4.968°	4.968°
V	Video width	15·5 mm	15.5 mm
W	Effective width (V-video overlap)	14·8 mm	14·8 mm
	Tape width	$19.03 \text{ mm}_{-0.06}^{+0} \text{ mm}$	$19.03 \text{ mm}^{+0}_{-0.06} \text{ mm}$
	Tape speed	95·3 mm/sec 3·75 i.p.s.	95·3 mm/sec 3·75 i.p.s.
	Luminance f.m.		
	Sync tip	3.8 MHz	4·8 MHz
	Peak white	5·4 MHz	6·4 MHz
	Chrominance a.m.	$685 \mathrm{kHz} \pm 500 \mathrm{kHz}$	$924 \mathrm{kHz} \pm 500 \mathrm{kHz}$

17 Digital Video Recording

As an analogue signal passes along a signal chain it suffers degradation at each step. This is not true of a properly designed digital system which can be transparent to the signal. The recording process is the last one to be converted to the digital process and so holds the key to an entirely transparent studio chain.

In order to persuade broadcasters to convert to a new system it is essential that the capital costs should be no greater than those of existing equipment and that the operating costs should be less. The one-inch video formats have already made savings when compared to the quadruplex system and so they are the standard against which any digital system will be

judged.

Until the video signal is generated and distributed in digital form it will be necessary to pass it through several analogue to digital and digital to analogue coders and decoders (codecs). That this is feasible has been clearly shown by the common use of digital effects generators and time base correctors (see Chapter 11) in existing systems. All that remains is the provision of an internationally accepted means of recording the digitised

signal on tape and subsequently recovering it.

Broadcast video signals require a high bit rate, current codecs used in time base correctors operate between 100 M bits/sec and 150 M bits/sec. The digital signal occupies a bandwidth approximately four times that of the original analogue signal and so in order to maintain tape consumption at present levels a four-fold increase in packing density is required. This will result in a reduction of the signal to noise ratio which on current analogue machines has to be in excess of 40 dB. The greater immunity of digital signals to interference by noise allows the use of equipment with a signal to noise ratio of around 20 dB. The packing density can be increased by either reducing the recorded wavelength or the video track width.

305

If the recorded wavelength is reduced it is necessary to reduce the head gap which results in reduced penetration of the oxide by the signal flux. The volume of oxide influencing the replay head is reduced in proportion to the square of the head gap reduction and so the noise power changes in proportion to the gap length. If the contributions from head amplifiers is ignored we find that the signal to noise ratio is proportional to bit length.

When the track width is reduced the volume of oxide influencing the head is reduced proportionally since flux penetration is not affected. Both the signal and noise power reduce in proportion and so the signal to noise

voltage ratio varies with the square root of the track width.

These two facts suggest that an ideal system would have very narrow tracks, perhaps $2 \mu m$, and the longest possible bit spacing. In practice edge effects, coating thickness, tracking accuracy and amplifier noise affect the results. Adequate results have been obtained from relatively broad, $60 \mu m$, tracks and a high bit density. The implication is that considerable

improvement may be expected.

Although systems with 200-300 M bits/sec capability have been produced, significant bandwidth saving can be made by suitable modification to the linear coding system and by restricting the amount of the signal coded to the essential data. This allows for error and drop out protection to be incorporated in the coded signal. It is also desirable to reduce the bit rate to a level that enables the signals to be transmitted via land lines, such as the European digital multiplex network which has a bit rate of 34 M bits/sec.

There is no need to record the blanking period provided the timing of synchronising pulse edges is preserved. This offers a 24% saving of bits. Until the whole system is operating digitally some bits will need to be transmitted to provide a reference to reconstruct the blanking at the

receiving end and the bit saving will be around 22%.

A second method of reducing the bit rate is differential pulse code modulation (DPCM). In the eight bit linear pulse code modulation system commonly used for video there are 256 equally spaced quantising levels. At three times subcarrier sampling rate on the 625/50 Hz system this results in a bit rate of 106 M bit/sec. If it can be assumed that each sample will have a value close to its predecessor, that is the picture content does not alter rapidly, then it is only necessary to transmit the change. In the DPCM system, the difference between a prediction of the sample value and the real value is transmitted. To gain maximum bit saving a non linear quantiser is used and only small differences are transmitted with full accuracy. Larger differences are sent with progressively less accuracy but since these rapid large changes occur in picture areas of high detail they are not readily visible to the eye. The loss in transparency due to these errors is traded for bit saving. Some of the loss can be regained by adding a contribution from the preceding sample with chrominance predictions from several preceding lines.

A third economy can be made by sampling below the usual three times sub-carrier frequency. Paradoxically this results from the trend towards the use of four times sub-carrier sampling rates which gives rise to a sample pattern which repeats every other field and, provided that the phase of the 4 f_{SC} sampling is defined, suitable filtering and a halving of the bit rate produce a signal which is nearly transparent. The errors are most visible as a loss of diagonal luminance resolution or a $12\frac{1}{2}$ Hz flicker at the boundary between two saturated colours but since this is an unusual signal condition the subjective impairment is less than a grade on the CCIR scale. Unfortunately the errors introduced by coding cannot be corrected or compensated for later.

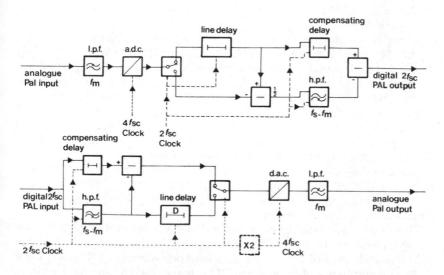

Fig. 17.1 Sub-Nyquist sampling codec with 4f_{SC} interfaces.

This system, known as sub-Nyquist sampling, is shown in block diagram form in Fig. 16.1. Both the coding and decoding stages require a one line delay which reduces the vertical resolution. The filtering is restricted to the upper video frequencies which are most affected by interference resulting from the halving of the sampling rate. NTSC signals require two lines of delay in order to produce the correct chrominance and hence the vertical resolution losses are twice those obtained for PAL.

On stationary pictures the PAL chrominance condition is the same after both 1 and 625 lines. This fact can be used to improve the vertical resolution, by using a frame delay, but at the expense of temporal losses which are seen as blur on moving pictures. In this case the NTSC system gains and using a field delay improves the vertical resolution by a factor of four with only half the blur of a PAL signal.

So far we have only considered coding the composite colour signal. An alternative is to treat the luminance and colour components separately, allocating a higher sampling rate to the higher bandwidth luminance.

Experiments have been made using 12 MHz sampling for luminance and 4 MHz sampling for the U and V colour components but other proportions (12, 6, 6, 14, 7, 7) are being considered. The bit rate is the product of the word length, 8 bits, and the sum of the samples.

e.g.
$$8 \times (12+4+4) = 160 \text{ M} \text{ bits/sec.}$$

Although the bit rate is high it is more usefully employed since the colour

component requires less bandwidth than the luminance.

Whatever coding system is used it is likely that some pictures will produce a DC or very low frequency signal. Many of the links in the signal chain are AC coupled, especially video recorders, so the code will have to be modified. At the same time it is possible to include some form of error checking although in general this will increase the final bit rate.

The DC can be removed by any of the coding systems used for recording timecode (see Chapter 14). However these tend to increase the bit rate and offer no error protection other than parity. Several coding systems, e.g. Miller² and block, have been devised which offer both error protection and

reduced bandwidth without excessively increasing the bit rate.

Although Miller² coding reduces the high frequency content of the signal it uses phase sensitive binary detection. This requires half cell discrimination but a one and a half cell period for each transition.

Block coding uses a ten bit word for each sample but only those codes with a equal number of 1s and 0s are valid. There are only 252 of these, and so special arrangements are made for the remaining 4 levels given by an 8

bit analogue to digital converter.

This system has built in error detection since the non-valid codes are easily recognised. In theory 75% of errors will be detected since there are 252 valid codes out of 1032. All errors with odd numbers of bits and some with even numbers will be detected. If both a one and a zero are in error in a single word this method will not rectify it and separate provision must be made.

Conclusion

The need for a digital recorder for archive use, programme delay in large continental countries and as a link in an otherwise digital chain is apparent.

The possibility of the necessary packing densities, in the region of 300 M bits/sec, has been shown by a prototype system using the U-matic format. It only remains to find a suitable means of recording the audio and providing the variable speed and editing facilities currently offered by broadcast machines.

The audio could be recorded as longitudinal analogue tracks as at present, making editing easy, or included in the video signal. In the latter case it would be necessary to decode, store, modify and rerecord the whole signal if any part were to be edited.

Overall it seems likely that it will be the late 1980s before digital

recorders are in widespread use.

References

- BALDWIN, J. Digital Television Recording with low tape consumption, IBC 1978 conference publication No. 166 and SMPTE Journal, July 1979.
- CONNOR, D. Digital Television at reduced bit rates, SMPTE Digital Video 1977 and SMPTE Journal Nov. 1977.
- 3. RAINGER, P. AND RATCLIFF, P. A. Low bit rate system for digital coding, SMPTE Journal August 1979 and SMPTE Digital Video 2.

Appendix

1. Example to show how a back gap in a record head stabilises the reluctance

Mean circumference -l

The toroid shown, forms the basis of a magnetic head. Its reluctance (S) can be formulated as:

$$S = \frac{l}{a \times \mu_{\rm o} \mu_{\rm r}}$$

where l = mean length of magnetic path.

a = cross sectional area of path.

 $\mu_{\rm o} = {\rm Absolute\ permeability\ } (4\pi\times 10^{-7}).$

 μ_r = Relative permeability.

typically l = 0.8 cm

 $a = 0.05 \text{ cm}^2$

and $\mu_r = 380$.

$$S = \frac{0.8 \times 10^{-2}}{380 \times 4\pi \times 10^{-7} \times 5 \times 10^{-6}} = 3.33 \times 10^{6} \text{ At/Wb}.$$

The permeability can also be expressed in terms of MMF and Flux.

$$S = \frac{I \times N}{\Phi}$$

 $\hat{\Phi} = \text{Flux in Wb}$

N = Number of turns in winding

I =Current in winding.

If N = 400 and $\Phi = 4\mu Wb$.

$$I = 33mA$$

If a small gap is cut in the ring 0.004 cm long then reluctance of the air path.

$$=\frac{l}{\mu_0 \times a} = 6.04 \times 10^6 \,\text{At/Wb}$$

:. Total reluctance

$$= 3.33 + 6.04 = 9.37 \text{ At/Wb} \times 10^{6}$$

New current for 4µWb

$$I = \frac{9.37 \times 10 \times 4 \times 10^{-6}}{400}$$
$$= 94 \text{mA}$$

With gap included the record drive increases by a factor of 3. However with a large proportion of the reluctance being air the flux for a given current is more stable i.e.: 50% change in μr with no gap gives a 50% change in Φ . With gap, only about 17% change in flux occurs. A similar reduction in flux change occurs for head wear.

2. Loss due to gap effect

From chapter 1 (5).

$$e = K_2 I \omega \cos \frac{2\pi x}{\lambda}$$

As Byae

$$By = KI\omega \cos \frac{2\pi x}{\lambda}$$

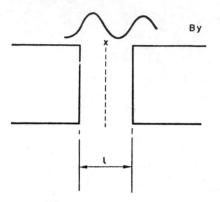

If the head has a finite gap length (1) then the average By is the integral of all the flux from x - l/2 to x + l/2 divided by l.

Average
$$By = \frac{1}{l} \int_{x-l/2}^{x+l/2} By \, dx$$

$$= \frac{1}{l} \int_{x-l/2}^{x+l/2} KI\omega \cos \frac{2\pi x}{\lambda} \, dx$$

$$= KI\omega \cdot \frac{1}{l} \cdot \frac{\lambda}{2\pi} \left[\sin \frac{2\pi (x+l/2)}{\lambda} - \sin \frac{2\pi (x-l/2)}{\lambda} \right]$$

From

$$\sin (A + B) = \sin A \cos B + \cos A \sin B$$

$$\sin (A - B) = \sin A \cos B - \cos A \sin B$$

2

Average
$$By = KI\omega \cdot \frac{1}{l} \cdot \frac{\lambda}{2\pi} \cdot 2\cos\frac{2\pi x}{\lambda}\sin\frac{\pi l}{\lambda}$$
.

$$= KI\omega\cos\frac{2\pi x}{\lambda}\left(\frac{\sin\pi l/\lambda}{\pi l/\lambda}\right)$$

This is the same as By modified by a $\frac{\sin \alpha}{\alpha}$ term where $\alpha = \frac{\pi l}{\lambda}$.

Output falls to zero when

$$\sin \pi l/\lambda = 0$$

i.e. when $l = \lambda$ or 2λ or 3λ , etc.

when gap length equals wavelength on tape.

312

3. Loss due to incorrect azimuth

From Fig. 1.24.

$$a = z \tan \theta$$

where θ = Angle of Azimuth.

z = track width.

If θ is small

$$a = z\theta$$

Ignoring gap effect the average induction By can be determined by integrating

between $x - \frac{z\theta}{2}$ and $x + \frac{z\theta}{2}$ and dividing by a.

Average
$$By = KzI\omega \cdot \frac{1}{a} \int_{x-z\theta/2}^{x+z\theta/2} \frac{2\pi x}{\lambda} dx$$

with same trig identities as Appendix 2.

Average
$$By = KI\omega \cdot \frac{1}{z\theta} \cdot \frac{\lambda}{2\pi} \left[\sin \left(\frac{2\pi x}{\lambda} - \frac{\pi z\theta}{\lambda} - \sin \left(\frac{2\pi x}{\lambda} + \frac{\pi z\theta}{\lambda} \right) \right] \right]$$

$$By = KI\omega \cdot \frac{1}{z\theta} \cdot \frac{\lambda}{2\pi} \cdot 2\cos \left(\frac{2\pi x}{\lambda} \right) \sin \frac{\pi z\theta}{\lambda}$$

$$= KI\omega \cos \omega t \left(\frac{\sin \pi z\theta/\lambda}{\pi z\theta/\lambda} \right)$$

The modifying term is now $\frac{\sin \beta}{\beta}$ where $\beta = \frac{\pi z \theta}{\lambda}$.

Output falls to zero when

$$\sin \pi \frac{z\theta}{\lambda} = 0$$

i.e. when $z\theta = \lambda$ or 2λ or 3λ , etc.

If
$$z\theta = \lambda$$

and
$$\lambda = \frac{s}{f}$$

$$fext = \frac{S}{z\theta}$$

4. Alignment of field sync

From Table 3, $F = 29.2 \pm 1.3 \text{ mm}$

If tach output gives pulse when the head recording the vert sync is in the centre of tape then alignment of tach must be on 3rd serration.*

* Head No 4—Ampex Head No 1—R.C.A. Centre of tape is 25.4 mm (1.00 in) from bottom of tape. Start of field sync precedes this by

$$29.2 - 25.4 = 3.8 \text{ mm}$$
. (E.B.U Spec. Fig. 3.4)

Head to tape speed = 1620 in/sec = 4120 cm/sec

Time to travel 3.8 mm
$$= \frac{3.8}{4120} = 92.4 \,\mu\text{sec.}$$

This time from start of field sync corresponds to the 3rd serration.

Tolerance.

$$\pm$$
 1·3 mm corresponds to $\frac{92\cdot4}{3\cdot8}$ × 1·3 = \pm 31·6 μ sec. $\Rightarrow_{\frac{1}{2}}$ line.

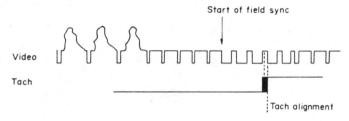

Calculation of position of frame pulse due to control track head displacement

Frame pulse is normally generated at first serration of vertical sync, when head is approximately in centre of track.

Control track head position is 45.5 tracks downstream. As one track plus guard bard = 15.625×10^{-3} , the distance between video head and control track head = $45.5 \times 15.6.5 \times 10^{-3} = 0.712$ in. The nearest field on tape can be calculated as follows:

On 525/60 Hz

Control track pulse is 3 fields -2.5 tracks from the track with field sync.

On 625/50 Hz

$$2 \text{ fields} = 40 \text{ tracks}$$

Control track pulse is 3 fields + 5.5 tracks from the track with field sync. 314

6. Format dimensions of helical recordings

The following calculations for the format dimensions of helical recordings are made for the four most common formats in use. No standardisation has yet been reached internationally although the $\frac{1}{2}$ in format promulgated by the Electronic Industries Association of Japan (EIAJ) is finding some common use for 60 Hz standards and the Phillips V.C.R. is becoming very popular in Europe on the 50 Hz standards.

Most of the variables in a helical format depend on each other and modify the final conditions. To initially break into the circle two basic requirements

are specified:

1. Head speed. This forms the major portion of the head to tape speed, the tape speed adding or subtracting about 1% to the final value. The required head speed is mainly determined by the resolution of the tape and the maximum record frequency:

where $S = \lambda f$.

S = Head/tape speed

 λ = Minimum wavelength resolved

f = Maximum record frequency.

For $\gamma \text{Fe}_2\text{O}_3$ the minimum wavelength is about 0.075 mil (About 2 μ m). If the maximum record frequency = 13.3 MHz, the

Head/tape speed = $0.075 \cdot 13.3 \cdot 10^{-3} \cdot 10^{6}$ = 1000 i.p.s.

For high energy tape, the minimum wavelength is about 0.0375 mil (1.0 μ m). This permits a head/tape speed of half that required for $\gamma \mathrm{Fe_2O_3}$, to obtain the same frequency response.

If the upper response is lowered to 8.7 MHz,

$$S = 0.0375 \cdot 8.7 \text{ MHz} = 325 \text{ i.p.s.} (8.25 \text{ m/s})$$

2. Tape speed. The initial required tape speed is a balance between length of playing time and the video signal/noise ratio. A faster tape speed permits a wider video track which in turn gives a higher signal/noise ratio. The second consideration for the tape speed is to maintain horizontal sync line up. The longitudinal movement during one field period should be directly related to the TV line length which in turn is determined by the head to tape speed. In the following calculations the approximate head and tape speed are used as a starting point and subsequently modified.

Ampex 1 in single-headed omega wrap

60 Hz standard (initial requirements)

Required head speed—1000 i.p.s.

Required longitudinal speed—9 in i.p.s. (provisional)

Drum diameter

For a single headed machine operating at 60 fields per second. 1 revolution takes 1/60 second.

Drum circumference (C) =
$$\frac{1000}{60}$$
 = 16.67 in

Drum diameter = $\frac{16.67}{\pi}$ = 5.3 in

Track angle

Space allowed for video tracks = 0.905 in

The tape rise must be 0.905 in over the circumference of the drum (16.67 in).

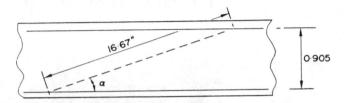

If the tape is stationary then the track angle (α') can be calculated as follows:

$$\sin \alpha' = \frac{0.905}{16.67}$$

$$\alpha' = 3^{\circ} 7'$$

The track angle is modified by the movement of the tape and if the tape moves 9 in in one second then during one field:

tape movement
$$=\frac{9}{60}=0.15$$
 in

The effect of this movement depends upon the relative movement between the head and tape. If the tape moves in the opposite direction to the head then the angle is reduced.

The track length would be increased by:

$$\cos 3^{\circ} 7' \cdot 0.15 \text{ in } \simeq 0.15 \text{ in}$$

True track length:

$$= 16.67 \text{ in} + 0.15 \text{ in} = 16.83 \text{ in}$$

If α = Angle of track when head and tape move

$$\sin \alpha = \frac{0.905}{16.67 + 0.15}$$

$$\alpha = 3° 6'$$

Tape movement

For sync line-up the video track movement must be an integral number of lines plus half a line to allow for line sync phase at the start of a new field. If track length = 16.83 in

1 TV line length on track =
$$\frac{16.83 \text{ in}}{262.5}$$
 = 0.0641 in

Track movement on consecutive tracks must be:

line length
$$(n + \frac{1}{2})$$

where n = 1, 2, 3 . . ., etc.

Tape longitudinal movement during 1 field time:

$$=\frac{(n+\frac{1}{2})\cdot 0.0641}{\cos\alpha}$$

For n = 2*

longitudinal movement = 0.1589 in

The exact tape speed $= 60 \cdot 0.1589$ in = 9.6238 i.p.s.

The corrected head/tape speed = 1009 i.p.s.

The centre-centre track spacing:

=
$$\sin \alpha$$
. 0.1589 in = 0.0087 in (6 thou track, 2.7 thou guard band)

50 Hz operation

If the same assembly is used on 50 Hz systems, the following changes occur due to the new head rotational speed of 50 r.p.s.:

New head speed = 16.67.50 833 i.p.s.

TV line length on track =
$$\frac{16.83}{312.5}$$
 = 0.0539.

* n = 1 too slow n = 3 too fast

$$= \frac{50 (n + \frac{1}{2}) \cdot 0.0539}{\cos \alpha}$$

If n=3

longitudinal movement = 0.189 in

tape speed = 9.44731 i.p.s.

Head/tape speed = 842.4 i.p.s.

track centre-centre spacing = $\sin \alpha \ 0.189 = 0.0102$ in (6 thou track width, 4.2 thou guard band)

IVC 1 in single headed alpha wrap

60 Hz standard (initial requirements)

Required head speed = 717 i.p.s.

Required tape speed = 7 i.p.s.

Drum diameter

1 revolution takes 1/60 second.

Drum circumference (C) = $\frac{717}{60}$ = 11.94 in

Drum diameter $=\frac{11.94}{\pi} = 3.8 \text{ in}$

Track angle

Space allowed for video tracks = 1 in

... The tape rise must be 1 in over 11.92 in

Stationary tape

$$\sin \alpha' = \frac{1}{11.92} = 0.0836$$

$$\alpha' = 4^{\circ} 47'$$

Extra tape movement

 $=\frac{7}{60}=0.116$ inches per field

True track length (one field).

$$= 11.94 + 0.116 = 12.056$$
 in

$$\sin \alpha = \frac{1}{12.056}$$
 = 0.0828
 $\alpha = 4^{\circ} 45'$

 α = angle of video track when head and tape move in opposite directions.

Tape movement

1 TV line length on track =
$$\frac{12.056}{262.5}$$
 = 0.046 in

longitudinal movement for 1 field =
$$\frac{(n + \frac{1}{2}) \cdot 0 \cdot 0.046}{\cos \alpha}$$

for
$$n = 2.0$$
 = 0.115 inches/field.

Exact longitudinal speed
$$= 60 \cdot 0.115 = 6.91 i.p.s.$$

Exact head to tape speed
$$= 723.9 \text{ i.p.s.}$$

Centre-centre track spacing

=
$$\sin 4^{\circ} 45'$$
. $0.115 = 0.0095$ in (6.5 mil track width + 3 mil guard band)

EIAJ Type 1 two headed, ½ in tape

60 Hz standard only

Drum diameter

For two headed machine, 1 revolution takes $\frac{1}{30}$ of a second.

Drum circumference (C) =
$$\frac{10.9}{30}$$
 = 36.35 cm
Drum diameter = $\frac{36.35}{\pi}$ = 115.82 mm (4.54 in)

Track Angle

Space allowed for video tracks (excluding overlap) = 10·10 mm

The tape rise therefore must be 10·10 mm over half the circumference of the drum.

Stationary tape:

$$\sin \alpha' = \frac{10.10 \times 2}{363.5} = 0.0556$$

$$\alpha' = 3^{\circ} 11'$$

Extra tape movement:

$$=\frac{200}{60}=3.33 \text{ mm}$$

True track length (1 field) = 181.75 + 3.33 = 185.1 mm

$$\sin\alpha \frac{10\cdot 10}{185\cdot 1} = 0.0546$$

 α = angle of video track when head and tape move in opposite directions.

Tape movement

1 T.V. line length or track =
$$\frac{185 \cdot 1}{262 \cdot 5}$$
 = 0.705 mm.

For sync line-up:

longitudinal movement for 1 field =
$$\frac{(n + \frac{1}{2}) \cdot 0.705}{\cos \alpha}$$

For
$$n = 4.0$$
. = 3.175 mm/field .

Exact longitudinal speed = $60 \cdot 3.175 = 190 \text{ mm/sec}$ (7.5 i.p.s.) Exact head to tape speed = 11.09 m/sec.

Centre-centre track spacing.

$$= \sin 3^{\circ} 7' 43'' . 3.175 = 0.173 \text{ mm } (0.0067 \text{ in})$$

(0·13 mm track width + 0·043 mm guard band)

Phillips VCR Cassette two headed ½ in wide tape

50 Hz Standard (initial requirements)

Required Head speed = 8.25 m/sec. Required longitudinal speed = 15 cm/sec.

Drum diameter

1 revolution takes $\frac{1}{25}$ of a second.

Drum circumference = 330 mm
Drum diameter = 105 mm

Track angle

Space allowed for video tracks = 10.6 mm (excluding overlap) Tape rise must be 10.6 mm over half the circumference of the drum.

Stationary tape:

$$\sin \alpha' = \frac{10.6 \times 2}{330} = 0.0642$$

 $\alpha' = 3^{\circ} 41'$

Extra tape movement:

$$= \frac{150}{50} = 3 \text{ mm per field.}$$

True track length (1 field)

$$= 165 - 3 = 162 \text{ mm}$$

(Note: Head and tape movement in the same direction)

Tape movement

1 T.V. line on track =
$$\frac{162}{312.5}$$
 = 0.514 mm

For sync line-up

longitudinal movement for 1 field =
$$\frac{(n + \frac{1}{2}) \cdot 0.514}{\cos \alpha}$$
 For $n = 5.0$ = 2.835 mm/field

Exact longitudinal speed =
$$50 \cdot 2.835 = 14.29$$
 cm/sec
Exact head to tape speed = $8.25 - 0.14 = 8.11$ m/sec

Centre-centre spacing:

$$\sin 3^{\circ} 45' \cdot 2.835 = 0.187 \text{ mm}$$

(0.130 mm track width + 0.057 mm guard band)

IVC/Rank-Cintel 9000 Series

This format is slightly different to other helical wraps. It uses 2 in wide tape and with a two headed drum rotating at 150 r.p.s. it records one sixth of a field per track on the 625/50 field standard. On the 525/60 field standard it rotates at the same rate but records one fifth of a field per track.

The IVC 2 in Format

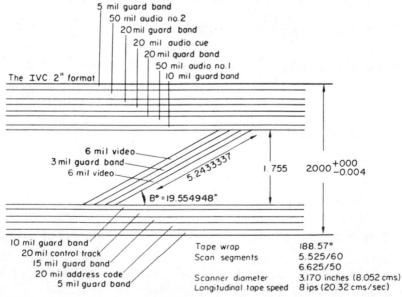

If drum diameter = 3.17 in

Circumference $= \pi \times 3.17 = 9.96 \text{ in}$ Head speed $= 9.96 \times 150 = 1494 \text{ i.p.s.}$ Tape rise $= 1.755 \text{ in over } 188.57^{\circ}$

If the tape is stationary then the track length = $9.96 \cdot \frac{188.57}{360} = 5.218$ in

$$\sin\alpha' = \frac{1.755}{5.218}$$

$$\alpha' = 19^{\circ} 42' (19.70^{\circ})$$

Longitudinal tape movement = 8 i.p.s.

For one scan movement $=\frac{8}{6.0.50} = 0.0267$ in

Increase in track length $= \cos 19^{\circ} 42'$. 0.0267 in = 0.025 in

Track length = 5.218 + 0.025 = 5.243 in

 $\sin\alpha = \frac{1.755}{5.243}$

 $\alpha = 19.555^{\circ}$

Track angle with tape

movement

Head to tape speed

= $1494 \div \cos 19.555^{\circ}$. 8 = 1501.5 i.p.s.

Centre-centre track spacing = Sin 19.555°. 0.0267 = 0.009 in (6 thou track, 3 thou guard band)

T.V. lines length = $\frac{1501.5}{625.25}$ = 0.0906 in

T.V. lines per 180° scan $\frac{625}{2.6} = 52.125$ lines

It can be seen from above that the sync line-up formula must be modified to

Longitudinal movement during one scan = $\frac{(n + \frac{1}{8}) \times 0.0906}{\cos \alpha}$

As n = 0 produces too slow a tape speed and n = 1 too fast a tape speed, this format does not have horizontal sync line-up.

It also is not possible to have still frame or slow-motion.

7. Track angle change resulting from a conical wrap

If the required space for the longitudinal tracks (d) is 0.100 in and the maximum drum angle of overlap is limited to 65° , then for drum dimensions calculated in Appendix 6 the length of overlap (l) is:

$$l = \frac{16.65 \times 65}{360} \doteqdot 3 \text{ in}$$

If β equals the angle of the sides of the drum from the perpendicular then the overlap is as shown.

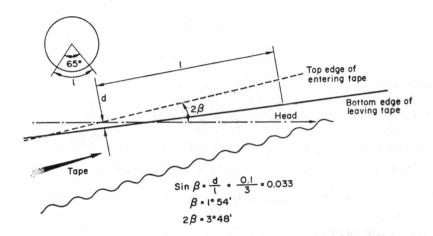

The angle of the track is modified by the change in angle of the tape. In this example it is 3° 48' less on the bottom edge than the top edge.

If the narrowest angle is 3° 6', as calculated in Appendix 6 then the angle

must increase to 6° 54'.

8. Modulation index of FM wave

To show that the modulation index of an FM wave is $\frac{f_a}{f_m}$ and is equal to the peak phase modulation of the signal.

$$\omega = \omega_c + \omega_d \cos \omega_m t$$

$$\omega = \frac{d\phi}{dt}$$

$$\phi = \int \omega dt$$

$$= \int (\omega_c + \omega_d \cos \omega_m t) dt$$

$$= \omega_c t + \frac{\omega_d}{\omega_m} \sin \omega_m t$$

 $\omega_c t$ is an angle increasing with time

 $\frac{\omega_d}{\omega_m} \sin \omega_m t$ is a sinusoidal modulation of $\omega_c t$ reaching a maximum of $\pm \frac{\omega_d}{\omega_m}$ when $\sin \omega_m t = \pm 1$.

$$\therefore \ \theta = \frac{\omega_a}{\omega_m} = \frac{f_a}{f_m}$$

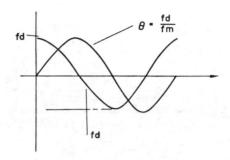

9. Spectrum of sinusoidally frequency modulated signal

$$e = E \sin \phi t$$

$$\phi = \omega_c t + \frac{\omega_d}{\omega_m} \sin \omega_m t$$

$$\frac{\omega_d}{\omega_m} = \theta$$

$$\therefore e = E \sin (\omega_c t + \theta \sin \omega_m t)$$

$$e = E[\sin \omega_c t \cos (\theta \sin \omega_m t) + \cos \omega_c t \sin (\theta \sin \omega_m t)]$$

Now

$$\sin (\theta \sin \omega_m t) = 2J_1(\theta) \sin \omega_m t + 2J_3(\theta) \sin 3\omega_m t + 2J_5(\theta) \sin \omega_m t + \dots$$

$$2J_{2n+1}(\theta) \sin (2n+1)\omega_m t$$

and

$$\cos (\theta \sin \omega_m t) = J_0 \theta + 2J_2(\theta) \cos 2\omega_m t + 2J_4(\theta) \cos 4\omega_m t + \dots$$

$$2J_{2n}(\theta) \cos 2n\omega_m t$$

$$\therefore e = E \left[J_0 \theta \sin \omega_c t + 2J_1(\theta) \cos \omega_c t \sin \omega_m t + 2J_2(\theta) \sin \omega_c t \cos 2\omega_m t \right]$$

+
$$2J_3(\theta) \cos \omega_c t \sin 3\omega_m t$$

+ . . .
+ $2J_{2n}(\theta) \sin \omega_c t \sin 2n\omega_m t$
+ $2J_{2n+1}(\theta) \cos \omega_c t \sin (2n+1)\omega_m t$].

The first term represents the centre frequency, while each of the following terms represents a pair of 'side-bands' symmetrical about the centre frequency and spaced by:

$$\omega_m$$
, $2\omega_m$... $2n\omega_m$... $(2n+1)\omega_m$

This can be seen by expanding:

$$\begin{split} e &= E[J_0(\theta) \sin \omega_c t] \\ &+ J_1(\theta)[\sin (\omega_c + \omega_m)t - \sin (\omega_c - \omega_m)t] \\ &+ J_2(\theta)[\sin (\omega_c + 2\omega_m)t + \sin (\omega_c - 2\omega_m)t] \\ &+ J_{2n}(\theta)[\sin (\omega_c + 2_n\omega_m)t + \sin (\omega_c - 2_n\omega_m)t] \\ &\text{etc.} \end{split}$$

Calculation of amplitudes of wanted sidebands and unwanted components in a VTR frequency modulated signal, when modulated by colour sub-carrier

625/50 Hz High Band

For 100% amplitude, 100% saturated colour bars.

$$\theta = 0.54$$
 (chapter 5)

From Bessel functions* wanted 1st order SB = 0.260 w.r.t. peak signal.

* Eleven and fifteen place tables of Bessel functions-Enzo Cambi.

For 3rd harmonic:

$$\theta_3 = 1.62$$

From Bessel functions unwanted 3rd lower SB = 0.075 w.r.t. 3rd harmonic. For folded SB—3rd lower sideband of the fundamental:

From Bessel functions = 0.0032 w.r.t. peak signal.

Amplitude of wanted SBs = 0.26

Amplitude of unwanted SB due to 10% 3rd harmonic = 0.0075

(-51 dB)

Amplitude of unwanted folded SB = 0.0032 (-58 dB)

525/60 Hz High Band

For 100% Amplitude, 100% saturated colour bars.

$$\theta = 0.935.$$

From Bessel functions wanted 1st order SB = 0.418 w.r.t. peak signal For 3rd harmonic:

$$\theta_3 = 2.8$$
.

From Bessel functions unwanted 4th lower SB = 0.107 w.r.t. 3rd harmonic. For folded SB—4th lower sideband of the fundamental:

From Bessel functions = 0.0019 w.r.t. peak signal Amplitude of wanted SBs = 0.418 Amplitude of unwanted SB due to 10% 3rd harmonic = 0.0107 (-52 dB) Amplitude of unwanted folded SB = 0.0019 (-67 dB)

11. Record equivalent circuit of a video head

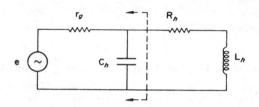

 r_g = drive source resistance

 C_h = head inter-winding capacity

 R_h = head losses. Winding resistance, eddy current, hysteresis.

 L_h = head winding inductance.

Thevenin equivalent

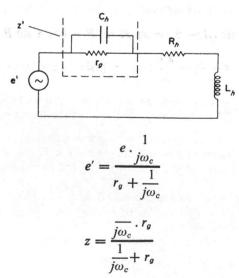

If
$$r_a \ll \frac{1}{j\omega_c}$$

$$e' = e$$

$$z = r_a$$

12. The Cosine equaliser

From Fig. 7.12

$$V_{\rm in} = V \sin \omega t$$

$$V_D = V \sin(\omega t - \theta)$$

$$V_{\rm Ref} = \frac{V}{2} \sin \left(\omega t - 2\theta \right)$$

$$V_0 = V_D - K(V \text{in} + V_{\text{Ref}}) = V \sin(\omega t - \theta) - \frac{K}{2} (V \sin \omega t - V \sin(\omega t - 2\phi))$$

$$(\omega t - 2\phi)$$

$$\phi = \frac{2\pi td}{tp}$$

$$td = Delay line time$$
 $tp = periodic time of input frequency = $\frac{1}{f}$$

This shows that when K=0, $V_0=V\sin{(\omega t-\theta)}$, i.e.: equal to V_D in amplitude and phase for all frequencies.

$$\sin (A - B) = \sin A \cos B - \cos A \sin B.$$

$$V_0 = V \sin (\omega t - \theta) - \frac{KV}{2} (\sin \omega t + \sin \omega t \cos 2\theta - \sin 2\theta \cos \omega t)$$

If
$$\theta = 0$$
, i.e.: Delay = 0° then $\frac{td}{tp} = 0$

$$V_0 = V \sin \omega t - \frac{KV}{2} (\sin \omega t + \sin \omega t \times 1 - 0 \times \cos \omega t).$$

$$V_0 = (V - KV) \sin \omega t$$
.

 V_0 is less than V, decreases with increase of K, same phase as V_D , adjustment of K causes no phase change.

If
$$\theta = \frac{\pi}{4}$$
, i.e.: Delay = 45° then $\frac{td}{tp} = \frac{1}{8}$

$$V_0 = V \sin\left(\omega t - \frac{\pi}{4}\right) - \frac{KV}{2} (\sin\omega t + \sin\omega t \times 0 - 1\cos\omega t)$$

$$= V \sin\left(\omega t - \frac{\pi}{4}\right) - KV (\sin\omega t - \cos\omega t).$$

$$= \left(V - \frac{\sqrt{2}KV}{2}\right) \sin\left(\omega t - \frac{\pi}{4}\right).$$

 V_0 is less than V, decreases with increase of K, same phase as V_D , adjustment of K causes no phase change.

If
$$\theta = \frac{2\pi}{4}$$
, i.e.: Delay = 90° or $\frac{td}{tp} = \frac{1}{4}$.

$$V_0 = V \sin\left(wt - \frac{\pi}{2}\right) - \frac{KV}{2} (\sin \omega t + \sin \omega t \cos \pi - \sin \pi \cos \omega t)$$

$$V_0 = V \sin\left(wt - \frac{\pi}{2}\right) - \frac{KV}{2} (\sin \omega t + \sin \omega t \times -1 - 0\cos \omega t)$$

$$= V \sin\left(wt - \frac{\pi}{2}\right) - 0.$$

At Frequency where delay = $90^{\circ} V_0 = V_D$.

Amplitude and phase unaffected by K. This frequency called the 'turnover frequency'

$$\theta = \frac{3\pi}{4}, \text{ i.e.: Delay } 135^{\circ} \text{ or } \frac{td}{tp} = \frac{3}{8}.$$

$$V_{0} = V \sin\left(wt - \frac{3\pi}{4}\right) - \frac{KV}{2}\left(\sin\omega t + \sin\omega t \cos\frac{3\pi}{2} - \sin\frac{3\pi}{2}\cos\omega t\right)$$

$$= V \sin\left(wt - \frac{3\pi}{4}\right) - \frac{KV}{2}\left(\sin\omega t + \cos\omega t\right)$$

$$V_{0} = V \sin\left(\omega t - \frac{3\pi}{4}\right) + \frac{\sqrt{2}KV}{2}\sin\left(\omega t + \frac{3\pi}{4}\right)$$

$$= \left(V + \frac{\sqrt{2}KV}{2}\right)\sin\left(\omega t - \frac{3\pi}{4}\right)$$

i.e.: greater than V, increases with increase in K, same phase as V_D , adjustment of K causes no phase change.

If
$$\theta = \pi$$
, i.e: Delay = 180° or $\frac{td}{tp} = \frac{1}{2}$ 328

$$V_0 = V \sin(\omega t - \pi) - \frac{KV}{2} (\sin \omega t + \sin \omega t \cos 2\pi - \sin \cos \omega t)$$

$$= V \sin(\omega t - \pi) - KV \sin \omega t$$

$$= (V + KV) \sin(\omega t - \pi).$$

i.e.: greater than V, increases with increase in K, same phase as V_D , adjustment of K causes no phase change. More generally

$$V_D = V_{\text{in}} \sqrt{\omega t}$$

$$V_{\text{REF}} = \frac{V_{\text{in}}}{2} \sqrt{2\omega t}$$

$$V' = K \left(\frac{V_{\text{in}}}{2} + V_{\text{REF}} \right) = \frac{KV_{\text{in}}}{2} \left(1 + \sqrt{2\omega t} \right)$$

Cosine Rule

$$A^2 = B^2 + C^2 + 2BC\cos\phi$$

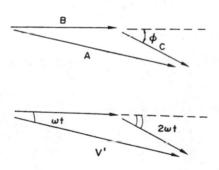

$$\therefore (V^{1})^{2} = (1 + 1 + 2\cos 2\omega t) \sqrt{\omega t} \cdot \left(\frac{KV_{\text{in}}}{2}\right)^{2}$$

$$(V^{1})^{2} = (2 + 2\cos 2\omega t) \sqrt{\omega t} \cdot \left(\frac{KV_{\text{in}}}{2}\right)^{2}$$

$$(V^{1}) = \sqrt{2} (1 + \cos 2\omega t)^{\frac{1}{2}} \sqrt{\omega t} \cdot \frac{KV_{\text{in}}}{2}$$

$$1$$

But $\cos^2 \omega t = \frac{1}{2}(1 + \cos 2 \omega t)$

$$\therefore \cos \omega t = \frac{1}{\sqrt{2}} (1 + \cos \omega t)^{\frac{1}{2}}$$

Sub 2 into 1

$$V' = 2\cos\omega t \sqrt{\omega t} \cdot \frac{KV_{\rm in}}{2} = KV_{\rm in}\cos\omega t \sqrt{\omega t}$$

$$V_0 = V_D - V' = V_{\rm in} \sqrt{\omega t} - KV_{\rm in}\cos\omega t \sqrt{\omega t}$$

$$\therefore V_0 = V_{\rm in} (1 - K\cos\omega t) \sqrt{\omega t} \text{ (as shown in Fig. 6.12c)}$$

13. Analysis of an A-stable multivibrator modulator

Equivalent circuit of discharge path of coupling capacitor for Fig. 7.4

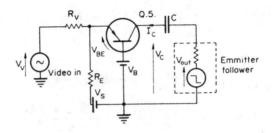

Where

$$R_E = 2R_1 + \frac{R_2}{2}$$

$$R_V = \frac{R_3}{2}$$

Typical values:

$$V_B = 6.2 \text{ volts}$$

$$V_S = 12 \text{ volts}$$

$$V_{BE} = 0.4 \text{ volts}$$

$$V_{out} = 4.0 \text{ volts}$$

$$\therefore R_E = 1.05 K\Omega$$

$$R_V = 3.5 K\Omega$$

$$h_{fe} = 0.98$$

$$C = 50 pf$$

$$R_1 = 400 \Omega$$

$$R_2 = 500 \Omega$$

$$R_3 = 7000 \Omega$$

When V_c discharges to 0 volts circuit 7.4 (b) will commutate.

Frequency of oscillation =
$$\frac{1}{2t}$$

Where $t_1 = t_2$ and is the time for V_c to discharge from V_{OUT} to 0 volts.

$$I_{E} = \frac{V_{S} - (V_{B} + V_{BE})}{R_{E}} + \frac{V_{V} - (V_{B} + V_{BE})}{R_{V}}$$

Charge on a capacitor Q = CV

$$I_c \times t = CV_{\text{out}}$$

$$t = \frac{CV_{\text{out}}}{I_c}$$

From (1)

$$f = \frac{1}{2t} = \frac{I_c}{2CV_0} = \frac{h_{fe}I_e}{2CV_{\text{out}}}$$
 3

NOTE frequency ∝I_e

For example given. If $V_v = O$ volt

$$I_e = \frac{12 - (6.2 + 0.4)}{1.05 \cdot 10^{-3}} + \frac{0 - (6.2 + 0.4)}{3.5 \times 10^{-3}}$$
$$= 5.15 \, mA - 1.9 \, mA$$
$$= 3.25 \, mA$$

From (3)

$$f = \frac{0.98 \cdot 3.25 \cdot 10^{-3}}{2.50 \cdot 4 \cdot 10^{-12}} \approx 8 MHz$$

If $V_v = 1.35$ volts

$$I_e = 5.15mA - \frac{6.6 - 1.35}{3.5 \times 10^{-3}}$$

= 3.65mA.
 $f \approx 9 MHz$

A deviation of 1 MHz.

14. Calculation of timing error due to guide displacement x

Triangles ABC and A'B'C' are similar

Angle ABC = Angle A'B'C' = θ

where θ = Angle of head to centre of Tape.

$$\sin\theta = \frac{A'C'}{B'A'} = \frac{dx}{x}$$

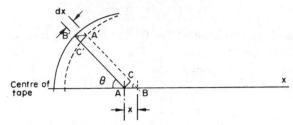

displacement (d_x) :.

$$d_x = x \sin \theta$$

If x = 0.001 in and the nominal Head/Tape speed = 1570 in/sec

$$td_x = \frac{x \sin \theta \times 10^6}{1.570} \, \mu \text{secs.}$$

The maximum angle θ will occur for a head playing back 16 lines 8 above the centre line and 8 below

$$\theta = \pm 45^{\circ} = 90^{\circ} = 1 \text{ mS} = 15.625 \text{ lines}$$

 $16 \text{ lines} = 90 \times \frac{16}{15.625} = 92^{\circ} 8' = \pm 46^{\circ} 4'$

The peak-peak error for a 0.001 in × axis movement

$$td_{x}p-p = \pm \frac{0.001 \sin 46^{\circ} 4'}{1570} \times 10^{6} = \pm 0.459 = 0.916 \,\mu\text{sec}$$

Calculation of timing error due to guide displacement y

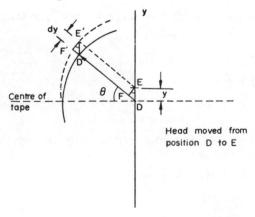

DEF = D'E'F'

Angle DEF = D'E'F' =
$$\theta$$
 cos θ = $\frac{E'F'}{E'D'}$ = $\frac{dy}{y}$
 $EF = E'F' = dy = y \cos \theta$

The error reaches a maximum at $\theta=0$ and a minimum at maximum values of θ . The peak-peak error

$$tdy \ p\text{-}p = \frac{0.001 \times 10^6}{1570} (1 - \cos 46^\circ 4') \ \mu\text{sec}$$
$$= 0.194 \ \mu\text{sec}$$

Unlike tdx the error is symmetrical about the centre in both sign and amplitude.

16. Calculations of timing error due to guide radius change

Pole tip velocity

$$v = 2\pi r Nh$$
.

r = guide radius

Nh = Head rotational speed in r.p.s.

If radius is increased to r' then new velocity

$$v'=2\pi r' Nh$$

The difference

$$v - v' = 2\pi Nh (r - r')$$

displacement error over 90° rotation = 1 m S

$$d = v - v' \times 10^{-3}$$
 (distance = velocity × time)

Timing error

$$td = \frac{d}{\text{velocity}} = \frac{v - v' \times 10^{-3}}{v}$$
From (a) = $\frac{2\pi Nh (r - r') \times 10^{-3}}{2\pi r Nh} = \frac{(r - r') \times 10^{-3}}{r}$

For a nominal radius = 1 in and a difference $r - r' = 500 \mu$ in.

$$td = \frac{500 \times 10^{-6} \times 10^{-3}}{1} = 500 \ \eta \text{secs.}$$

17. The effect of friction between the head drum scanner and the tape on tape tension

The formula for the tension ratio for a wrap on a cylindrical surface

$$\frac{To}{Ti}=e^{\mu\theta}$$

e = 2.7183

 μ = coefficient of friction

To = Tension on tape outgoing

Ti = Tension on tape ingoing

 θ = Angle of wrap in radians

 $\mu = 0.02$ to 0.1 for well designed drum.

For $\mu = 0.02$, 360° wrap

$$\frac{To}{Ti} = e^{.0.02 \times 2\pi} = 1.13$$

If Ti = 5 oz To = 5.65 oz

For $\mu = 0.1$ 360° wrap

$$\frac{To}{Ti} = 1.88$$

If Ti = 5 oz To = 9.4 oz $\mu = 0.2$ 360° wrap

$$\frac{To}{Ti} = 3.5$$

If Ti = 5 oz To = 17.5 oz $\mu = 0.2$ 180° wrap

$$\frac{To}{Ti} = 1.88$$

$$Ti = 5 \text{ oz } To = 9.4 \text{ oz}$$

The results show the importance of low coefficient of friction and the singular advantage of 180° wrap in terms of tape tension.

The reduction of velocity errors using interpolation

The development of an interpolation between error samples to provide velocity compensation can be achieved in several ways. Straight line interpolation is normally used and this obviously is an approximation leaving a residual error when used to correct a sinusoidal component due to guide displacement. See Appendices 14 and 15.

The following equations describe the residual error for the various options.

Error without correction

For a 0.001 in error in the x direction the error for any angle:

$$dx = \sin \theta \cdot 10^{-3}$$

For a 0.001 in error in the y direction the error for any angle:

$$dy = \cos\theta \cdot 10^{-3}$$

The timing error can be found by dividing by the head to tape speed Nominally:

Error after line by line correction

The error is corrected at the start of every line i.e.: every 5.76° rotation of the head on 625/50 Hz or every 5.49° rotation of the head on 525/60 Hz.

For direction x (625/50 Hz):

$$dx^{I} = (\sin \theta - \sin \cdot n \cdot 5.76^{\circ}) \cdot 10^{-3}$$

For direction y:

$$dy^{I} = (\cos \theta - \cos . n . 5.76^{\circ}) . 10^{-3}$$

where n = the number of whole lines from point where $\theta = 0^{\circ}$.

Error with straight line interpolation between end points

Slope =
$$\frac{f(n+1) \cdot 5.76 - f(n) \cdot 5.76}{5.76}$$

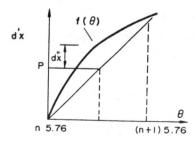

Residual error:

Value at
$$p = \frac{\theta - n \cdot 5.76}{5.76} (f(n+1) \cdot 5.76 - f(n) \cdot 5.76)$$

:. Residual error:

$$dx^{II} = \sin \theta - \sin \cdot n \cdot 5.76^{\circ} - \frac{\theta - n \cdot 5.76^{\circ}}{5.76^{\circ}} \left(\sin \left[n + 1 \right] 5.76^{\circ} - \sin \cdot n \cdot 5.76^{\circ} \right)$$

$$dy^{II} = \cos \theta - \cos \cdot n \cdot 5.76^{\circ} - \frac{\theta - n \cdot 5.76^{\circ}}{5.76^{\circ}} \left(\cos \left[n + 1 \right] 5.76^{\circ} - \cos \cdot n \cdot 5.76^{\circ} \right)$$

Error with straight line interpolation between the last two previous sample points, as on the last line of any head sweep using the error store technique.

$$dx^{\text{III}} = \sin \theta - \sin \cdot n \cdot 5.76^{\circ} - \frac{\theta - n \cdot 5.76^{\circ}}{5.76^{\circ}} (\sin \cdot n \cdot 5.76^{\circ} - \sin [n - 1] 5.76^{\circ})$$
$$dy^{\text{III}} = \cos \theta - \cos \cdot n \cdot 5.76^{\circ} - \frac{\theta - n \cdot 5.76^{\circ}}{5.76^{\circ}} (\cos \cdot n \cdot 5.76^{\circ} - \cos [n - 1] 5.76^{\circ})$$

If a memory is used to store the line error for every line on one complete revolution then the interpolation is not quite the same as case 3. On one revolution 62.5 lines are recorded. Therefore line 1 of head 1 is $\frac{1}{2}$ a line displaced in head angular position to the same line one revolution later. The error stored is the average over several revolutions making:

$$dx^{\text{IV}} = \sin \theta - \sin \cdot n \cdot 5.76 - \frac{\theta - n \cdot 5.76^{\circ}}{5.76^{\circ}} \left(\sin[n+1] \cdot 5.76 - \sin \cdot n \cdot 5.76 + \sin[n+\frac{1}{2}] \cdot 5.76^{\circ} - \sin[n-1] \cdot 5.76^{\circ} \right) \frac{1}{2}$$

$$dy^{\text{IV}} = \cos \theta - \cos \cdot n \cdot 5.76^{\circ} - \frac{\theta - n \cdot 5.76}{5.76^{\circ}} \left(\cos[n+1] \cdot 5.76^{\circ} - \cos \cdot n \cdot 5.76 + \cos[n+\frac{1}{2}] \cdot 5.76^{\circ} - \cos[n-1] \cdot 5.76^{\circ} \right) \frac{1}{2}.$$

The above equations can be used to calculate the maximum errors for any line (1-8) from = 0° to 52° , for a 0.001 in error in the x or y movement of the guide.

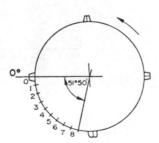

Maximum Timing Error (Angle) Line Number: n	$t^{I} dx$ $\eta \sec$	t ^I dy η sec	$t^{II} dx$ $\eta \sec$	$t^{\text{II}} dy$ ηsec	$t^{\text{III}} dx$ $\eta \sec$	t ^m dy η sec	$t^{IV} dx$ $\eta \sec$	t ^{IV} dy η sec
0	63·8*	3·2	0·04	0·8*	0·04	6·41*	0·04	1·60*
	(5° 45')	(5° 45′)	(3° 20′)	(2° 52)	(5° 20')	(5° 45')	(5° 45')	(5° 45)
1	63·2	9·6	0·12	0·79	0·64	6·39	0·20	1·60
	(11° 31′)	(11° 31′)	(8° 48')	(8° 38)	11° 31′	(11° 31′)	(11° 31′)	(11° 31′)
2	61·8	15·9	0·20	0·78	1·28	6·27	0·36	1·56
	(17° 16′)	(17° 16′)	(14° 29′)	(14° 23)	(17° 16′)	(17° 16′)	(17° 16')	(17° 16′)
3	60·0	22·0	0·28	0·75	1·90	6·13	0·51	1·52
	(23° 2′)	(23° 2′)	(20° 13′)	(20° 10′)	(23° 2′)	(23° 2′)	(23° 2′)	(23° 2′)
4	57·4	27·9	0·35	0·72	2·50	5·89	0·66	1·45
	(28° 47′)	(28° 47′)	(25° 58′)	(25° 54′)	(28° 47′)	(28° 47′)	(28° 47′)	(28° 47′)
5	54·3	33·5	0·42	0·68	3·09	5·62	0·80	1·38
	(34° 33′)	(34° 33′)	(31° 44′)	(31° 39′)	(34° 33′)	(34° 33′)	(34° 33′)	(34° 33′)
6	50·7	38·9	0·49	0·64	3·64	5·29	0·94	1·30
	(40° 19′)	(40° 19′)	(37° 29′)	(37° 25′)	(40° 19′)	(40° 19′)	(40° 19′)	(40° 19′)
7	46·5	43·7	0·55	0·59	4·14	4·88	1·06	1·19
	(46° 4′)	(46° 4′)	(43° 14′)	(43° 10′)	(46° 4′)	(46° 4′)	(46° 4′)	(46° 4′)
8	41·9	48·2*	0·61*	0·53	4·62*	4·45	1·18*	1·08
	(51° 50′)	(51° 50′)	(49° 0')	(48° 57′)	(51° 50′)	(51° 50′)	(51° 50′)	(51° 50′)

* Maximum error per head sweep.

NOTE: Method II provides the best velocity correction giving a reduction of 100:1 over line-byline correction. This method, however, requires a 1 line delay for the video. Method IV is most common giving a 50:1 reduction although Method III is used on the last line which may only have a 15.1 reduction.

19. Standards organisations

ANSI:

American National Standards Institute, 1430 Broadway, NY USA (formerly USA Standards Institute, USASI, formerly American Standards Association, Inc., ASA). ANSI does not originate standards itself, but rather provides procedures for establishing national standards called "American National Standards" based on a consensus of those substantially concerned with the scope of the corresponding standards. ANSI has approved a number of audio standards sponsored by EIA, IEEE, and SMPTE. Most foreign and international standards are distributed in the USA by the ANSI. Write ANSI for the current free catalog of ISO, IEC, and American National Standards.

ARD:

Arbeitsgemeinschaft der Rundfunkanstalten der Bundesrepublik Deutschland (Association for Radio Stations of the German Federal Republic). The standards are published for ARD by the Institut für Rundfunktechnik, 2000 Hamburg,

Mittelweg 113, West Germany.

BS: Standards published by British Standards Institution (BSI), British Standards House, 2 Park Street, London W.1, England. BSI Sales Branch, Newton House, 101 Pentonville Rd., London N.1, England. These standards are available in the USA through ANSI. Write BSI for the following Sectional Lists: SL 10, Acoustics; SL 1, Cinematography; SL 26, Electrical Engineering; and SL 29, Nomenclature.

CCIR: International Radio Consultative Committee, International Telecommunication Union, Place des Nations, Geneva, Switzerland. The texts of CCIR recommendations and reports are published in the documents of the Plenary Assemblies of the International Radio Consultative Committee, every three years. The volume on Broadcasting and Television (Study Group X and others) sells to non-members of CCIR for approximately \$6 including packing and postage, and may be ordered

mately \$6 including packing and postage, and may be ordered directly from the ITU at Geneva. (Not available from ANSI). Standards published by Deutscher Normenausschus (DNA) (German Standards Committee). This organisation formulates

the Deutsche Industrie Normen (German Industrial Standards, DIN) which are widely used in Europe. Although the titles will be given here in English, the original standards are, of course, all in German. Some of the Standards are also available in English translations, sometimes very literal, indicated by "E/DIN." These standards are sold by Beuth-Vertrieb GmbH, 1 Berlin 30, Burggrafenstrasse 4-7, West Germany. Standards in German, and the "E/DIN" translation, are available in the USA from ANSI. Some of the standards are available in unofficial translations in flnished form, indicated "E/U-f," and some in very rough draft form, "E/U-d," from J. G. McKnight, Ampex Corp., Mail Stop 26-01, 401 Broadway, Redwood City, Calif., 94063, USA. Write Beuth-Vertrieb GmbH for the "DIN Normen-verzeichnis für die heimstudio-, rundfunk-, magnetton-, verstärker-, und phono-Technik, einschliesslich elektroakustischer Wandler und Messtechnik" ("DIN Standards List for

graph engineering, including electroacoustic transducers and measurement techniques") (in German).

Electronic Industries Association, Engineering Department, 2001 Eye Street, N.W., Washington, D.C. 20006, USA. Some EIA standards have been approved as ANSI standards. Write

'high fidelity', radio, magnetic recording, amplifier, and phono-

EIA for the current free catalogue of standards.

EIAJ Electronic Industries Association of Japan, 3–14, Maruouchi, Chiyoda-Kin Tokyo, Japan.

IBTO: International Broadcasting and Television Organization (OIRT

DIN:

EIA:

in French), Liebknechtova 15, Prague, 5 Czechoslovakia. An international organisation of several East European, Asian and African nations and Cuba.

IEC: International Electrotechnical Commission, 1, rue de Varembé, Geneva, Switzerland. Standards listed in the ANSI catalogue and available in the USA through ANSI.

EBU: European Broadcasting Union, Technical Centre, Avenue Albert Lancaster 32, B-1180 Bruxelles.

IEEE: Institute of Electrical and Electronics Engineers, Inc., 345
East 47th St., New York, NY 10017, USA (formerly AIEE and IRE). These standards are available from the IEEE order department. Write IEEE for the current free catalog. Some IEEE standards have been approved as ANSI standards.

ISO: International Organisation for Standardisation, 1, rue de Varembé, Geneva, Switzerland. Standards listed in the ANSI catalog and available in the USA through ANSI.

JIS: Standards published by the Japanese Standards Association (JSA), 1–24 Akasaka 4, Minato-Ku, Tokyo, Japan. The standards are available in the USA through ANSI.

MRIA: Magnetic Recording Industries Association. Merged with EIA in 1965; no standards issued.

NAB: National Association of Broadcasters (also called NARTB at one time), Engineering Department, 1771 N. Street, N.W., Washington, D.C. 20036, USA. Standards for use by the USA broadcasting industry. No catalogue.

PPI: Philips Phonographic Industries, Baarn, The Netherlands. PPI publishes a widely used company standard on cassette recording.

RIAA: Record Industry Association of America, Inc., One East 57th St., New York, N.Y. 10022, USA. Tape and disc record standards. No catalogue.

SMPTE: Society of Motion Picture and Television Engineers, 9 East 41st St., New York, NY 10017, USA. These standards are published in the Journal of the SMPTE in their draft and finally approved forms. The approved standards are available from ANSI only. Write SMPTE for the current free index to SMPTE standards.

USA FED.: United States of America, Federal Specifications. Procurement standar d for Federal agencies. Bureau of Ships, Department of the Navy standards can be ordered from Naval Ship Engineering Center, Code 6665.2M, Washington, D.C. 20360, USA. General Services Administration standards can be ordered from the General Services Administration's regional offices in Boston, New York, Washington (D.C.), Atlanta, Chicago, Kansas City (Mo.), Dallas, Denver, San Francisco and Auburn (Wash.), USA.

UTE: Union Technique de l'Electricite, 20, rue Hamelin, Paris (16°), France. Available in the USA through ANSI in French only.

20. Standards

Arrangement is by the subject of the standard:

1. General standards (where one document includes several of the subjects)

2. Glossaries, symbols, etc.

- 3. Recording and reproducing equipment specifications
- 4. Measuring and adjusting recording and reproducing equipment (including test tapes)

5. Tape

- 5.1 Specifications
- 5.2 Testing methods
- 6. Containers for tape
 - 6.1 Reels
 - 6.2 Cartridges
- 7. Tape records
- 8. Miscellaneous
- 9. Video Recording

Within a subject, entries are alphabetical by the standardising organization. EIA standards which are also ANSI standards are, nevertheless, listed under EIA.

1. GENERAL STANDARDS

(Including glossaries, recording and reproducing equipment, measurements, tape, containers and tape records in one standard.)

The following two standards are for recording and reproducing equipment and records for professional program exchange.

IEC Publication 94

Magnetic Tape Recording and Reproducing 24 Systems: Dimensions and Characteristics. Third edition, 1968.

Amendment 1

(Changes which replace the "surface induction" specification of recording characteristics with a "recorded tape flux characteristic") (in preparation.)

Addition 1

Tape cassettes for domestic use: twin-hub, four-track, mono-stereo compatible (in preparation). For the time being, see Philips Phonographic Industries, "Tape Cassette, Twin-Hub Four-Track Mono/Stereo Compatible for Domestic Use" (4th Revision, Oct. 1968). GPG 670. 4/4. (Published in *J. AES* 16, 430–435, Oct. 1968).

BS 1568: 1960 + Amendment

PD 5962, Dec. 1966

Magnetic Tape Sound Recording and Reproduction (Dimensional Features).

The following two standards are for recording and reproducing equipment and records for use by the USA broadcasting industry.

NAB Standard

Magnetic Tape Recording and Reproducing (Reel-to-Reel) (April 1965).

NAB Standard

Cartridge Tape Recording and Reproducing (Oct. 1964).

2. GLOSSARIES, SYMBOLS, ETC.

(See also Sec. 1, General Standards)

ANSI S1.1-1960*

Acoustical Terminology (Sec. 8: Recording and Reproducing).

ANSI Y32.2-1967

Graphic Symbols for Electrical and Electronics Diagrams

DIN 40 700: Part 7

Graphical Symbols for Magnetic Heads (Sept. 1957). E/U-f

DIN 45 510

Magnetic sound recording: Terminology; 6. German, English, French (Draft, Feb. 1969)

IEC Publication: 50 (08)

International Electrotechnical Vocabulary: Electroacoustics. (Sec. 08-25: Recording and Reproduction).

* Standards known to be under revision are shown by an asterisk.

3. RECORDING AND REPRODUCING EQUIPMENT SPECIFICATIONS

(See also Sec. 1, General Standards)

DIN 45 500

Part 4

"High Fidelity" Home Equipment: Magnetic tape recording and reproducing systems (Oct. 1967)

DIN 45 511:

Tape Recorders:

Part 1

Tape recorder for recording on magnetic tape with 6.3 mm (0.25 in) width, mechanical and electrical specifications (Draft, March 1969) E/U-f and E/DIN of March 1966 issue.

Part 2

Tape recorder for 3- or 4-track recording on magnetic tape with 12.5 mm (0.5 in) width, mechanical and electrical specifications (Draft, March 1969)

Part 3

Tape recorder for 4-track recording on magnetic tape with 25·4 mm (1 in) width, mechanical and electrical specifications (Draft, March 1969)

EIA RS-288 (1963)

Audio Magnetic Playback Characteristics at 7.5 in/s.

JIS C5550-1967

Magnetic Tape Recording and Reproducing Equipment (in English).

USA Fed. Specs. W-R-00168a (GSA-FSS)

Recorder-Reproducer, Sound (Magnetic Tape Type) (March 1968)

USA Fed. Specs. W-R-170a

Recorder-Reproducer, Sound (Portable, Battery Operated) (May 1966).

W-R-170a Interim Amendment—2 (GSA-FSS)

Interim Amendment (March 1968).

USA Fed. Specs. W-R-0001404 (GSA-FSS)

Recorder-Reproducer, Sound (Portable. Battery Operated, Cassette Type) (August 1968)

4. MEASURING AND ADJUSTING RECORDING AND REPRODUCING EQUIPMENT (Including Test Tapes)

(See also Sec. 1, General Standards)

ARD

Basic Specifications for Magnetic Sound Recording Equipment, and General Directions for their Adjustment (June 1965). German only.

DIN 45 513

DIN Test Tapes

Part 1

76 cm/s (30 in/s), 6·3 mm (0·25 in) tape width (Apr. 1968). E/DIN.

Part 2

38 cm/s (15 in/s), 6·3 mm (0·25 in) tape width (Oct. 1967). E/DIN.

Part 3

19 cm/s (7·5 in/s), 6·3 mm (0·25 in) tape width (Oct. 1966). E/DIN, E/U-f. **Part 4**

9.5 cm/s (3.75 in/s), 6.3 mm (0.25 in) tape width (Jan. 1968). E/DIN Part 5

4.75 cm/s (1.88 in/s), 6.3 mm (0.25 in) tape width (Mar. 1966). E/DIN—for 1963 issue only.

Part 6

4.75 cm/s (1.88 in/s), 3.8 mm (150 mil) tape width (draft, Mar. 1967).

DIN 45 520*

Magnetic Tape Equipment: Method for Measuring the Absolute Magnitude and the Frequency Response of the Remanent Magnetic Flux of Magnetic Recording Tape (Sept. 1957) E/U-f.

DIN 45 521

Magnetic Tape Equipment: Measuring the Crosstalk Ratio of Multitrack Equipment (Oct. 1963).

DIN 45 524

Evaluation of the tape speed of magnetic tape transports (draft, March 1969).

EIA . . .

EIA Reproducer Test Tape (Open-reel) for tape speeds of 7.5 in/s (19 cm/s) and 3.75 in/s (9.5 cm/s) (in preparation; now Standards Proposal 1030)

IBTO Recommendation . .

OIRT Reference Tapes for the International Programme Exchange.

JIS C5551-1966

Testing Methods for Magnetic Tape Equipment (in English).

UTE C97-110

Electroacoustics: Magnetic Tape Recorders for Semi-Professional or General Public usage: Characteristics and Methods of Measurement (July 1966).

5. TAPE

(See also Sec. 1, General Standards)

5.1 Specifications

DIN 45 500

Part 9

"High Fidelity" Home Equipment: Magnetic tapes (draft, Sept. 1966).

DIN 45 512

Part 1

Magnetic Tapes: Mechanical properties (Aug. 1968)

EIA RS-355 (1968) (ANSI C83.45-1969)

Standard Dimensions for Unrecorded Magnetic Sound Recording Tape

USA Fed. Spec. W-T-0070/1

Tape, Audio Type, Cellulose Acetate Base (Apr. 1963)

USA Fed. Spec. W-T-0070/2

Tape, Audio Type, Polyester Base (Apr. No charge 1963)

5.2 Testing Methods

DIN 45 512

Part 2

Magnetic tapes: Recording performance characteristics (Draft, Feb. 1969) (Aug. 1968)

DIN 45 519

Measuring Methods for Tapes:

Part 1

Print-through (Oct. 1955). E/U-d

Part 2

Signal to DC-Noise Ratio (Oct. 1955). E/U-d

DIN 45 522

Test Methods for Magnetic Tapes:

Part 1

Measurement of the coefficient of friction (Dec. 1968)

Part 2

Measurement of flexibility (Aug. 1968)

Part 3

Measurement of nominal strength (Aug. 1968)

Part 4

Measurement of longitudinal curvature

EIA RS-339 (1967) (ANSI C83.35-1968)

Recommended Test Method—Layer-to-layer Adhesion of Magnetic Tape

EIA RS-342 (1967) (ANSI C83.36-1968)

Recommended Test Method—Magnetic Tape Electrical Resistance Coating

EIA RS-362 (1969) (ANSI C83.56-1970)

Recommended Test Method—Tensile Property of Magnetic Tape

USA Fed. Spec. W-T-0070

Tapes, Recording, Sound and Instrumentation, Magnetic Oxide Coated, General Specifications for (Apr. 1963)

6. CONTAINERS FOR TAPE

(See also Sec. 1, General Standards)

6.1 Reels

DIN 45 514

Magnetic Tape Equipment: Reels, Cine-Type (Mar. 1961). E/DIN, E/U-f DIN 45 515

Magnetic Tape Equipment: Hub (Mar. 1955). E/DIN

DIN 45 517

Magnetic Tape Equipment: "Disassembleable" Reel (Identical to EIA and NAB "Type A" reel.)

Part 1

Hub, flange, screw and nut (Oct. 1963).

Part 2

Adaptors (Oct. 1963).

EIA RS-346 (1968) (ANSI C83.38-1968)

Type A Hubs and Reels for Magnetic Tape

EIA RS-347 (1968) (ANSI C83.40-1968)

1/2 Inch Type B Plastic Reel for Magnetic Tape

EIA RS-351 (1968) (ANSI C83.39-1968)

Type B Plastic Reel for Magnetic Tape

USA Fed. Spec. W-R-175b

Reels and Hubs for Magnetic Recording Tape, General Specification for (May 1967).

USA Fed. Spec. W-R-175/1b

Reels, standard, plastic, and fibreglass, 5/16-inch center hole (May 1967)

6.2 Cartridges

EIA RS-264 (1962)

Magnetic Recording Tape Cartridge Dimensions

EIA RS-332 (1967) (ANSI C83.45-1969)

Dimensional Standards—Endless Loop Magnetic Tape Cartridges, Types 1, 2 and 3.

EIA . . .

Magnetic Tape Cartridge—Co-Planar Type CP-2 (Compact Cassette), Dimensional Standards (in preparation; now Standards Proposal 1055)

7. TAPE RECORDS

(See also Sec. 1, General Standards)

CCIR Recommendation 261-1

Standards of Sound Recording for the International Exchange of Programs, Single Track Recording on Magnetic Tape (1966). Vol. 5, p. 13-15.

CCIR Recommendation 408-1

Standards of Sound Recording for the International Exchange of Programs, Two-Track Stereophonic Recording on Magnetic Tape (1966). Vol. 5, p. 23-24.

EIA . . .

Endless-loop cartridges with eight-track stereophonic records at 3.75 in/s (in preparation; now Standards Proposal 1065)

EIA . . .

Endless-loop cartridges with four-track stereophonic records at 3.75 in/s (in preparation; now Standards Proposal 1066)

EIA...

Compact cassettes with four-track mono/stereo compatible records at 1.88 in/s (in ration: now Standards Proposal 1067)

EIA...

Open-reel four-track stereophonic records at 3.75- and 7.5 in/s (in preparation; now Standards Proposal 1068)

EIA RS-224 (1959)

Magnetic Recording Tapes (Rev. of REC 138 and REC 132)

IBTO Recommendation 24

Magnetic Tape Recording for the International Programme Exchange

RIAA Bulletin E-5

Standards for Magnetic Tape Records (Feb. 1969).

RIAA . . .

Standards for Multitrack Magnetic Tape Duplicating Masters (preliminary draft, May 1967).

8. MISCELLANEOUS

DIN 45 523

Remote Control by Signals from Magnetic Tape Recorders (July 1968).

DJN 45 525

Evaluation of the Time Period During Which Batteries May be Used in Magnetic Tape Recorders (draft, May 1968).

EIA REC-133 (1949)

Magnetic Recorder Combined with Home Radio Receivers (reprinted June 1954).

EBU

TECH 3084 E Standards for television tape-recordings TECH 3093-E

Video player and recorder systems for home use.

21. The EIA Standard RS-170

The EIA standard RS - 170 specifies in section 2.6 for a monochrome television signal that: "It shall be standard that the the rate of change of the frequency of recurrence of the leading edges of the horizontal sync pulses be not greater than 0.15 per cent per second."

It is more convenient to consider the instability in terms of the peak timing error and the rate of change of the timing error. The rate of change of error is normally assumed to be sinusoidal.

Therefore:

$$t_e = T_e \sin 2\pi f_a t \tag{1}$$

where:

 t_e = instantaneous value of the timing error.

 T_e = peak value of the timing error.

 f_d = frequency of the change in timing error.

If the periodic time of the sync pulse waveform is t_o , then the angular error θ_e in radians is:

$$\phi_e = \frac{2\pi t_e}{t_0} = \frac{2\pi T_e}{t_0} \sin 2\pi f_d t$$
 2

The rate of change of error is:

$$\omega_e = \frac{d\phi_e}{dt}$$

or

$$f_e = \frac{d\phi_e}{dt} \cdot \frac{1}{2\pi}$$

From (2)

$$f_e = 2\pi f_d \frac{T_e}{t_0} \cos 2\pi f_d t$$

The rate of change of frequency error

$$\delta f_e = \frac{df_e}{dt}$$

From (3)

$$\delta f_e = (2\pi f_d)^2 \frac{T_e}{t_0} \sin 2\pi f_d t$$

Substituting $f_0 = \frac{1}{t_0}$

where f_0 = frequency of recurrence of horizontal sync pulses

$$\delta f_e = (2\pi f_d)^2 T_e f_o \sin 2\pi f_d t$$

taking peak values

$$\left|\frac{\delta f_e}{f_0}\right| = (2\pi f_d)^2 T_e$$

For R.S. 170:

$$\left| \frac{\delta f_e}{f_0} \right| \leqslant 0.0015$$

$$\therefore T_e = \frac{0.0015}{4 \cdot \pi^2 f_d^2} = \frac{38}{f_d^2} \mu \text{ seconds}$$

If this is plotted the following graph is produced.

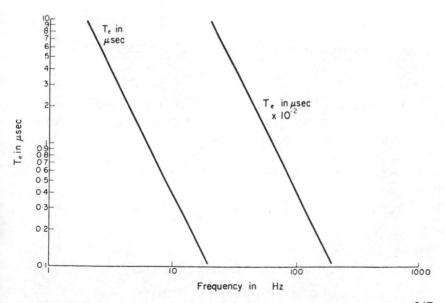

22. Logic symbols

Throughout this book logic symbols to the USA MIL-STD-806B have been used. The basic gates and their functions are illustrated below.

The following table of combinations illustrates the functions of two variables and their equivalents as well as the truth table. H in the truth table illustrates a positive or high potential and L represents a low or negative potential.

*		Table of combinations
And	Or	A t/f B t/f X t/f
A X	АX	H † H † H † H † L f L f L f H † L f L f L f L f
A — X	A	H f H t L f H f L f L f L t H t H t L t L f L f
АX	A>	H + H f L f H + L + H + L f H f L f L f L + L f
A	А	H f H f L f H f L t L f L t H f L f L t L t H t
A	A	H f H f H f H f L f H f L f H f H f L f L f L f
А > х	А — Э	H t H f H f H t L t L t L f H f H f L f L t H f
A — □ □ □ □ — X	А	H f H t H f H f L f H f L t H t L t L t L f H f
А	А———— X	H

23. The signal to noise ratio of a video signal with the same peak-peak random noise as a quantised monochrome signal

If the steps were being considered as random noise then an assessment of the signal to noise ratio could be obtained from the formula:

$$S/N \, dB = 20 \log_{10} \frac{V_S}{V_N} + 18 \, dB$$

where

 V_s = Video amplitude (peak-peak)

 V_N = Noise amplitude (peak-peak)

Note: The 18 dB is a factor used to convert the peak noise to an RMS value.

If
$$V_N = \frac{V_S}{2^n}$$
 then:

$$S/N dB = 20 \log_{10} 2^n + 18 dB$$

= $6n + 18 dB$

This represents the noise for the same amplitude of random noise.

24. The RMS value of quantised noise

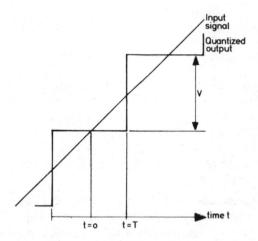

The instantaneous value of the deviation between the input signal and the quantised output:

$$v = \frac{V_t}{2T}$$

(RMS is the square root of the mean of the sum of the squares)

$$v^{2} = \frac{V^{2}t^{2}}{4T^{2}} \quad \text{(square)}$$

$$\int v^{2} dt = \frac{V^{2}}{4T^{2}} \int_{0}^{T} t^{2} dt \quad \text{(sum of squares)}$$

$$= \frac{V^{2}}{4T^{2}} \left[\frac{T^{3}}{3} \right]_{0}^{T} = \frac{V^{2}T}{12}$$

: mean of the sum of the squares is

$$\frac{V^2T}{12T} = \frac{V^2}{12}$$

.. square root of mean of sum of squares is

$$V_{\rm RMS} = \sqrt{\frac{V^2}{12}} = \frac{V}{3.46}$$

$$20\log_{10}\frac{V}{V_{\rm RMS}} = 20\log_{10} 3.46 = 10.79 \text{ dB}.$$

The true value of peak-peak signal to RMS noise for a monochrome signal which has been coded from black level to peak white is therefore:

$$S/N dB = 20 \log_{10}. 2^n + 10.79 dB$$

= $6n + 10.79 dB$

25. Signal to noise ratio when 100% colour bar signal is encoded

When a colour bar signal is encoded each individual quantised step must be larger in order to encompass the larger amplitude signal. The reference signal level for noise measurements is 0.7 volt, the excursion from black level to peak white.

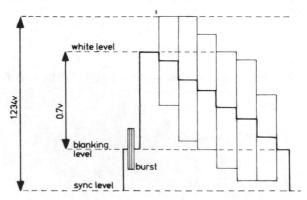

The colour bar signal is larger by:

$$20 \log_{10} \frac{1.234}{0.7} = 4.92 \, \mathrm{dB}$$

Formula 4 in Appendix 24 is therefore modified to:

$$S/N dB = 6n + 10.79 - 4.92$$

= 6n + 5.87 dB 5

Equation 2 reduces to

$$E' = \frac{1}{3} \left[\left(\frac{3E\sqrt{3}}{2} + 2\beta_2 q - \beta_1 q - \beta_3 q \right)^2 + 3 \left(\beta_3 q - \beta_1 q - \frac{\sqrt{3}}{2} E \right)^2 \right]^{1/2}$$

which is of the form

$$E' = \frac{1}{3} [(A + f_1(\beta))^2 + (B + f_2(\beta))^2]^{1/2}$$

Considering equation 3 as the addition of two vectors, $\overrightarrow{A} + \overrightarrow{B}$ corresponding to the ideal subcarrier output, and $\overrightarrow{f_1(\beta)} + \overrightarrow{f_2(\beta)}$ corresponding to the error wave we have

$$\Delta E = \frac{1}{3} [f_1^2(\beta) + f_2^2(\beta)]^{1/2}$$

$$= \frac{q}{3} [(2\beta_2 - \beta_1 - \beta_3)^2 + 3(\beta_3 - \beta_1)^2]^{1/2}$$

$$= \frac{2q}{3} [\beta_1^2 + \beta_2^2 + \beta_3^2 - \beta_1\beta_3 - \beta_1\beta_2 - \beta_2\beta_3]^{1/2}$$

 ΔE is a maximum when $\beta=\pm\frac{1}{2}$ for one sample and $\mp\frac{1}{2}$ for the other two samples so that

$$\Delta E_{\rm max} = \frac{2q}{3}$$

The maximum phase and gain errors measured relative to the ideal subcarrier output can be found by considering the vector sum $\overrightarrow{E} + \overrightarrow{2q/3}$. For a full scale codec input V_{FS} and n bits per sample the phase and gain errors are respectively

Phase error
$$\leqslant \pm \sin^{-1} \left(\frac{2V_c}{3 \cdot 2^n E} \right) \deg$$

Gain error $\leqslant \pm \left(\frac{200}{3 \cdot 2^n} \right) \frac{V_c}{E} \%$

These relations are summarised for E = 70 mV/100 mV/175 mV and $V_c = 1.234 \text{ V}$ (corresponding to 100/0/100/0 colour bars) in Chapter 10 Tables 12 and 14 for 5, 6, 7 and 8 bit systems.

26. Errors in measured LF linearity of a step staircase video signal after a digital encode—decode process

If an 8-bit system is used to encode 100% saturated colour bars (1.234 V p-p) then each quantised step would correspond to:

$$\frac{1.234}{2^n} = \frac{1.234}{256} = 4.82 \,\mathrm{mV}$$

As a % of the luminance signal (0.7 V p-p):

$$\frac{4.82 \times 10}{0.7} \times 100 = 0.689\%$$

With a 5-step staircase test waveform this would correspond to:

$$5 \times 0.689 = 3.45\%$$
 of one step.

If it is assumed that the maximum error of the level of one step is $\pm \frac{1}{2}$ of the least significant bit (lsb) level then the error between 2 steps could be ± 1 lsb.

If the differentiating pulse method of measuring linearity is used then the difference between the lowest and the highest pulse *could* be:

$$2 \times 3.45\% = 6.9\%$$
 of correct step level

More generally:

LF linearity =
$$\frac{2V_c \times S}{2^n \times V_L} \times 100\%^*$$

where

 V_c = peak-peak amplitude of the composite colour signal (1.234 V).

 V_L = peak-peak amplitude of the luminance signal (0.7 V).

n = number of bits.

S = number of steps in the test signal.

* This expresses error as a percentage of the correct level. CCIR Rec 451 recommends expressing the difference between the largest and the smallest as a percentage of the largest. The formulae is therefore modified to

% error =
$$\frac{2s \times V_c}{(V \times 2^n) + (S \times V_c)} \times 100\%$$

27. Subcarrier phase and gain errors arising from quantisation

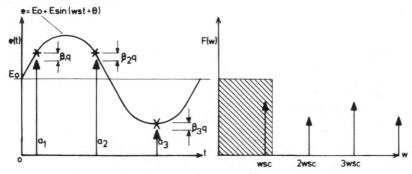

Sampled and quantised subcarrier, time and frequency domain.

Let a_1 , a_2 , a_3 be the quantised impulse samples from a codec and $\beta_1 q$, $\beta_2 q$, $\beta_3 q$ be the corresponding quantising errors $(-\frac{1}{2} \leqslant \beta \leqslant +\frac{1}{2})$. Using an interpolation filter of cut-off frequency $\frac{3}{2}\omega_{sc}$ we can write the filtered codec output as

$$\sum_{k=1}^{\infty} ak \, Sa(3\omega_{sc}(t-kt_{s}/2)) = \Delta E_{0} + \Delta E \cos(\omega_{sc}t+\phi) + e(t)$$

where

 ΔE_0 = spurious dc component

 ΔE = the peak of an error wave

e(t) is the ideal output.

The error wave and ΔE_0 both arise from folded subcarrier harmonics generated by quantising and sampling. Since equation 1 represents a sum of orthogonal sampling functions then the peaks of a_k lie on the output subcarrier (which is comprised of the wanted signal and the error wave). Hence, it can be shown that the subcarrier amplitude is

$$E' = \frac{1}{3} [(2a_2 - a_1 - a_3)^2 + 3(a_3 - a_1)^2]^{1/2}$$

where

$$a_1 = E_0 + E \sin(\omega t + \phi) + \beta_1 q$$

$$a_2 = E_0 + E \sin(\omega t + \phi + \frac{2\pi}{3}) + \beta_2 q$$

$$a_3 = E_0 + E \sin(\omega t + \phi + \frac{4\pi}{3}) + \beta_3 q$$

Reference

GRAHAM WADE, Plymouth Polytechnic Research Report, 1977.

Glossary

The terms used in the book comply where possible with those recomended by the Nomenclature Subcommittee of the SMPTE Magnetic Video Tape Recording Engineering Committee. The following glossary denotes terms used in this book in capitals and other frequently used terms in small type.

* Indicates SMPTE specified terms.

Add-on Edit see ASSEMBLE EDIT.

Amtec A manufacturer's term for a monochrome time base corrector using sync as a reference.

ASSEMBLE EDIT An electronic edit where a new scene or sequence is recorded on the end of an existing recording. A new control track is recorded and only the ingoing splice is synchronous.

a.t.c. A manufacturer's term for a monochrome time base error corrector using sync as a reference.

Audio No 1 Track, see PROGRAMME AUDIO TRACK.

Audio No 2 Track, see CUE TRACK.

Auto-Chroma, see CHROMA AMPLITUDE CORRECTOR.

AUTOMATIC LOCK A VTR playback condition where the playback video is in full synchronism with the station sync.

BANDING* A visible difference in the reproduced characteristics in that portion of a picture associated with one head channel, when compared with adjacent areas associated with other head channels. In quadruplex recorders, these differences occur in horizontal bands of 16 or 17 scanning lines when reproducing a 525/60 Hz signal:

HUE: Banding in which the visible difference is in the hue
NOISE: Banding in which the visible difference is in the noise
SATURATION: Banding in which the visible difference is in the saturation.

BASE FILM* The substrate of tape that supports the magnetic coating

BEARDING An overload condition producing FM sidebands outside the pass-band, the loss of which causes black areas to overflow irregularly into white areas after sharp transitions.

BINDER* The material used to bond the magnetic particles to each other and to the base film.

BLACK LEVEL FREQUENCY The frequency of the FM signal corresponding to the blanking level of the video signal.

Bleeding whites, see BEARDING.

BLOCKING* The tendency of the adjacent layers of tape in a roll to stick together.

CANOE The curved section of tape between the input and output tape guides.

Cartridge, see CASSETTE.

CASSETTE An enclosed tape package containing one or two spools that allows automatic lacing of the tape path when loaded into a cassette player.

CAPSTAN* The driven spindle in a tape machine, sometimes the motor shaft itself, which rotates in contact with the tape and meters the tape across the transport.

Cavec A manufacturer's term for a chroma amplitude and velocity error corrector.

CHROMA AMPLITUDE CORRECTOR A device that automatically adjusts the play-back equalisation by referring to the colour burst amplitude.

Colour a.t.c. A manufacturer's term for a colour time base error corrector using colour burst as a reference.

Colortec A manufacturer's term for a colour time base error corrector using colour burst as a reference.

CONTROL TRACK* The area on the tape containing a recording used by a servo mechanism primarily to control the longitudinal motion of the tape during playback in a quadruplex system (see SMPTE RP 16).

CUE TRACK* The area reserved on the tape for audio information relating to production requirements, electronic editing information, or a second programme signal.

DE-EMPHASIS A reduction in the amplitude of the high frequency components of the video signal (equal on opposite to the pre-emphasis) after demodulation.

DOWNSTREAM* The adverb pertaining to locations on the tape longitudinally displaced from a given reference in the direction of a tape motion.

DROP-OUT A drop in playback RF level that causes a noticable impairment on the playback video.

Drum, see DRUM-SCANNER—helical; HEAD WHEEL—quadruplex

DRUM-SCANNER The rotational head and cylindrical guiding assembly of a helical VTR.

DUB*

- 1. To make a copy of a recording by re-recording.
- 2. A copy.

E-E Electronics to electronics, the signal routing of the RF signal from the modulator to the demodulator.

Edit pulse, see FRAME PULSE.

Female guide, see VACUUM GUIDE.

FRAME PULSE A pulse superimposed on the control track signal to identify the longitudinal position of a video track containing a vertical sync pulse. Used as an aid to editing and in the synchronisation of some recorders (see SMPTE RP5 and RP 16 and EBU Tech 3084-E).

Freeze frame, see STILL FRAME

GEOMETRY ERRORS Time base and velocity errors caused by changes in guide, head or tape dimensions or position between record and playback.

GUARD BAND The unrecorded section of tape between record tracks.

HEAD CHANNEL* The signal path unique to each magnetic head. In a quadruplex system, the outputs of four channels are combined to provide a continuous RF signal.

HEAD CLOGGING* The accumulation of debris on the head, the usual result of which is a loss of signal during playback, degradation, or failure to record in the record mode.

HEAD POSITION PULSE A unique tachometer pulse signifying the position of a rotating head.

HEAD-TO-TAPE-SPEED* The relative speed between tape and head during normal recording or replay.

HEAD WHEEL* A rotating wheel with magnetic heads mounted on its rim.

HIGH BAND*

1. Pertaining to those frequencies specified in SMPTE RP6 Practice HB (and EBU).

2. Pertaining to those recordings made in accordance with Practice HB of RP6, or equipment capable of making those recordings.

3. The carrier frequencies which appear on tape made in accordance with such practices. HIGH ENERGY TAPE A tape with a higher coercivity and retentivity than ferric oxide. Typically cobalt doped ferric oxide or chromium dioxide.

HORIZONTAL LOCK A VTR playback condition where the horizontal syncs of the video is in synchronism with station horizontal sync.

INSERT EDIT An electronic edit where a new scene or sequence is recorded between two existing scenes. An existing control track is required which is not erased or over recorded. Both the ingoing splice and outgoing splice is synchronous.

Jitter, see TIME-BASE ERROR

Line-lock, see HORIZONTAL LOCK

LONGITUDINAL* Pertaining to dimensions or motions parallel to the tape travel. LOW-BAND*

1. Pertaining to those frequencies specified in SMPTE RP6, Practice LBM or LBC (and EBU).

2. Pertaining to those recordings made in accordance with Practice LBM or LBC of RP6 or equipment capable of making those recordings.

3. The carrier frequencies which appear on a tape made in accordance with such practices.

MOIRE A coherent beat pattern normally produced by the harmonic distortion of the FM signal. It is most noticeable in large areas of large amplitude high frequencies, i.e. colour sub-carrier.

Pix-lock, see AUTOMATIC LOCK

POLE TIPS* Those parts of the video head which protrude radially beyond the rim of the head wheel and form the magnetic path to and from the tape.

PRE-EMPHASIS An increase in amplitude of the high frequency components of the video signal prior to frequency modulation.

PRESSURE DEMAGNITIZATION Partial reduction of the recorded flux as a result of impact or high pressure from guide posts.

PRINT THROUGH* The unintentional transfer of a recorded signal from one layer of magnetic tape on to adjacent layers.

PROGRAMME AUDIO TRACK* The area reserved on the tape for the main audio signal, usually associated with the accompanying video recording.

QUADRUPLEX* An adjective describing a standardised method of video magnetic tape recording which uses four magnetic heads mounted around the rim of a head wheel. The head wheel rotates in a plane perpendicular to the direction of the tape motion.

RECORD* The magnetic pattern on the tape corresponding to a signal.

RECORD CURRENT OPTIMIZER (RCO) A device that facilitates the optimum setting of the video head current by using the following head to play back a preceding recorded track.

REFERENCE EDGE* On a videotape containing quadruplex recorded information, that longitudinal tape edge nearest the control track.

RF The modulated video signal.

RF DUB*

1. To dub by rerecording the RF signal recovered from a tape being copied.

2. A copy made by this process.

Scanner, see DRUM SCANNER

 $SERVO\ CAPSTAN\ A$ servomechanism which controls the rotational velocity and phase of a capstan.

SERVO* HEAD WHEEL* A servomechanism which controls the rotational velocity and phase of the head wheel.

Shoe, see VACUUM GUIDE

Shuttle, see SPOOLING

SPLICE (mechanical)* A butt-joint between two pieces of tape held together by means of a strip of adhesive foil.

SPLICING TAPE The adhesive foil used to secure the butt join mechanical splice.

SPOOLING The movement of tape from one reel to the other without being in record or playback.

SUPPLY REEL* A reel from which the tape is unwound during record, reproduce or fast-forward modes.

Switch-lock, see VERTICAL LOCK

STILL FRAME The repetitive playback of one picture.

SYNC TIP FREQUENCY The frequency of the FM signal corresponding to the bottom of sync level of the video signal.

TACHOMETER LOCK A VTR record or playback condition where the head wheel is in phase and frequency lock with a station reference (i.e. mains, station vertical sync or input video vertical sync) from a comparison of the reference with the head position pulse.

TACH PULSE A pulse derived optically, magnetically or mechanically from the rotation of a controlled motor.

TAKE-UP REEL* A reel on to which the tape is wound during the forward movement of the tape.

TAPE* Magnetic A tape consisting of a flexible base material usually coated on one side with a thin magnetisable layer.

TAPE GUIDES Rollers or posts to position the tape correctly along its path on the tape transport.

TAPE INPUT GUIDE* The last guiding element encountered by the tape before the vacuum guide.

TAPE LEADER* (magnetic) The section of tape, usually recorded ahead of the programme material, which contains engineering alignment signals and production information.

TAPE NEUTRAL PLANE* A plane located and defined by the tape input guide and tape output guide in which the tape would lie if it were undeflected by the vacuum guide.

TAPE OUTPUT GUIDE* The first guiding element encountered by the tape after the vacuum guide.

TAPE SPEED* The linear rate of travel of the undeformed recording medium past any stationary portion of a transport.

TIME BASE ERROR* A timing error between an off-tape video signal and a stable station source.

Tone-wheel pulse, see TACH PULSE

Tracking control signal, see CONTROL TRACK SIGNAL

Tip engagement, see TIP PENETRATION

Tip height, see TIP PROJECTION

TIP PENETRATION* The momentary radial deflection of the tape in the vacuum guide caused by the passage of a video head pole tip.

TIP PROJECTION* The measured radial difference between the pole tip and the head wheel rim.

Tip protrusion, see TIP PROJECTION

Television magnetic recording, see VIDEOTAPE RECORDING.

TENSION SERVO A servomechanism controlling the longitudinal tension of the tape either keeping it constant or by maintaining minimum time base error.

TRACK* An area on the tape containing a record.

TRACK-CURVATURE* The deviation from straightness of a single video track record TRACKING Adjustment of the tape playback position to phase the video tracks to the rotating head.

TRAILING EDGE, VIDEO TRACK* The upstream edge of the video track.

TRANSVERSE* Pertaining to dimensions or motions perpendicular to the tape travel. Transverse recording, see QUADRUPLEX RECORDING.

UPSTREAM* Pertaining to locations on the tape longitudinally displaced from a given reference point, in a direction opposite to tape travel.

VACUUM GUIDE* The part of the video head assembly used to maintain the tape in the correct position relative to the head wheel by means of a suction system.

VELOCITY ERROR The rate of change of time base error, often expressed in time base error change per TV line.

Velocity Error Compensator (VEC) A device that reduces the time base error changes during the line period.

VERTICAL LOCK A VTR playback condition where the vertical sync of the playback video is in synchronism with station vertical sync.

VIDEO DUB*

- 1. To dub by rerecording the video signal recovered from the tape being copied.
- 2. A copy made by this process.

Video Head Optimiser (VHO) see RECORD CURRENT OPTIMISER

VIDEO TAPE* Magnetic recording tape intended for recording and playback of television signals.

VIDEOTAPE RECORDING A term normally refering to all forms of magnetic tape recording of video signals sometimes abbreviated to VTR.

WHITELEVEL FREQUENCY The frequency of the FM signal corresponding to the peak white level of the video signal.

Index

A.C.:	Beta max, 94	C-format, 71
bias, 38	BFO, 115	Channel amplifiers, 123
supply control, 148	B-format, 67	Chroma:
A.D.C., 218	data, 70	auto correction, 354
A.F.C., 118	Bias - a.c., 38	correction, 200
Analogue:	d.c., 37	NISC, 286
delay, 190	Binary delay line, 192	PAL, 290
time base correction, 189	error detection, 198	pilot, 110
to digital conversion	Binder, 43	Clamping, 133
(A.D.C.), 213, 218, 220	Bi-phase level, 272	Cleaning, 49
Arm compliance, 63, 64	Bi-phase mark, 271	Closed circuit TV, 80
Assemble edit, 354	Bit rate reduction, 230, 306	
AST, 76	bit rate, 305	Co-axial cassette, 250 Codec, 305
A-stable modulator, 117, 330	bit saving, 230, 306	Codes:
A.T.C., 354	Blanking switcher, 127	
Audio:	Block coding, 308	address, 269
equalisation, 39, 42	Blocking, 355	bi-phase level, 272
heads, 24	Broadcast formats:	bi-phase mark, 271
playback, 28	cassettes, 246	EBU, 274
record, 23	helical, 67	editing, 269
tracks, 58, 76, 354	quad, 55	Manchester I, 271
Auto:		Manchester II, 272
chroma, 354	Burst locked oscillator, 237	NRZ, 271
editing, 280	Burst (pilot), 296, 298	recording, 308
	C A C 255	SMPTE, 274
equalisation, 135	C.A.C., 355	timecode, 269
frequency control, 118	Care:	Coercivity, 20,22
optimisation, 120	of tape, 48	Colour:
scan tracking, 76	of electronics, 51	correction, 200
servo mode, 158	Canoe, 355	error, 175
tension, 184	Capstan motor servo, 147	under recording, 88
tracking, 161	Cartridge, 252	Comparator head wheel, 160
Axial displacement, 168	Cassette:	Compatibility, 178
Azimuth adjustment, 35	B-format, 249	Compliance arm, 63, 64
D 1 22 24 242	broadcast, 246	Control track:
Back gap, 23, 26, 310	co-axial, 250	B, 69
Banding, 49, 354	co-planar, 251	C, 75
Bandwidth reduction, 240	helical, 249	quadruplex, 60
Base material, 42	multi, 249	Conversion:
BCN multicassette, 249	quadruplex, 246	A-D, 218
Bearding, 354	self lacing, 252	A.D.C., 218
Beat frequency oscillator	CCTV, 80	D-A, 221
(BFO), 115	Centre frequency, 108	Convertor single stage, 221

Co-planar cassettes, 251	Distortion:	quadrature, 168
Correction:	frequency modulation, 103	quantising, 349
analogue delay, 190	harmonic, 107	typical, 175
binary delay, 192	quantisation, 215	velocity, 172, 334, 358
coarse, 224	tape, 36	EAM 222
colour, 200	Double limiter frequency	FAM, 233
digital, 213	modulation, 92	Fast motion, 292
monochrome, 189	DP, 217	Feedback clamping, 133
NTSC chroma, 286	Driver, record, 119	Ferrite heads, 33
PAL chroma, 290	Drop-out compensation,	Field sync:
time base, 188	44, 49, 134	alignment, 313
velocity error, 205, 229	Dumping, 204	position, 61
vernier, 222	Dynamic tracking (DT), 76	waveform, 286
Cosine equaliser, 124	E44	Fluctuating error, 189
Counter:	Eddy current:	Flying erase, 257
forward–backward, 143	brake, 139	Formats:
ring, 147	loss, 33	Ampex 1 in, 315
Crispening, 302	Edition	B, 67
Cue track:	Editing:	Betamax, 94 C, 71
address codes, 269	assemble, 256	
edits, 268	automatic, 280	EIAJ ½ in, 319 IVC 1 in, 283
general, 58 tones, 268	colour, 266	IVC/RANK 2 in, 321
tolles, 208	cue tone, 268	LVR, 92
	electronic, 255	Phillips VCR, 320
D-A conversion, 221	erase turn on, 257 helical, 254	Quadruplex, 59
Decode-encode, 238	insert, 256	u-matic, 95
De-emphasis, 39, 111	off line, 279	VHS, 94
Degaussing, 51	physical, 253	Fourth power law, 195
Delay line:	playback phase, 265	Forward/backward counter, 1
analogue, 190	quadruplex, 254, 262	Frame pulse, 151
binary, 193	record phase, 265	still, 76, 87
quantised, 192, 198	time code, 269, 279	Frequency:
quartz, 192	E.J., 88, 296	automatic control, 118
Delta modulation, 230	Electronic:	B-format, 70
Demagnetisation, 33, 51	address codes, 269	centre, 108
Demodulation, 131	field production, 303	C-format, 79
Detection, error, 198	journalism, 88, 296	deviation, 102
Deviation, 102	news gathering, 88, 296	distortion, 103
DG, 216	stabilisation, 235	double limiter f.m., 92
Differential:	Equalisation:	doublers, 132
gain (DG), 216	audio, 39	f.m. theory, 96
phase (DP), 217	parameters, 42	high band u-matic, 296
Digital:	playback, 52	losses, 31,
analogue conversion, 221	Equaliser cosine, 124	modulators, 114
bandwidth, 305	Erase, 24	moiré, 106
bit rate, 305	flying, 257	quad I, 55
block coding, 308	head, 25	quad II, 66
codec, 305	process, 24	standards, 95, 101
miller coding, 308	turn on, 257	super high band, 66, 101
sample rate, 214	Error:	sync tip, 101, 357
time base correction, 213	correction, 188	Front porch switch, 130
video recording, 305	detection, 198	
Diode, varactor, 116, 190	dumping, 204	Gain, differential, 216
Disc, 282	fluctuating, 189	Gap:
Discrimination, 143	geometrical, 166	effect, 31, 311
Discriminator, 143	positional, 169	head, 23

Gate, quantised, 198 Insert edit, 258, 356 frequency, 145 Instability, 165 Geometrical errors, 166 pulse width, 148 adjustment helical, 176 Integrator, pulse, 144 Multicassette, 249 Interchange, 177 environment, 181 Neutral plane, 356 guide position, 169 head position, 168, 176 Law, fourth power, 195 Noise: Level, bi-phase code, 272 modulation, 44, 105 interchange, 177 quadrature, 168 LF linearity, 216 quantising, 349 tension, 175 Linear video recording random, 105 velocity, 172 NRZ, 271 (LVR), 92 Line lock, 321 Guide error: NTSC colour correction, 286 calculations, 170 Line-up, sync, 74, 86, 316 Line shift register, 225 positional, 169 PAL, chroma correction, 290 Patterning, 106 Lock: radius, 172, 333 automatic, 321 Penetration, 358 vacuum, 358 horizontal, 158 Permeability, 23, 310 sync/subcarrier, 204 Phase comparator: vertical, 155 logic, 160 Half line delay (HL), 287 Locked oscillator, burst, 237 types, 140 Harmonic distortion, 107 Longitudinal track: Physical editing, 253 Head: helical, 69, 74 Pilot: alignment losses, 34 quadruplex, 58 burst, 296, 298 video recording, 92 audio, 24 chroma, 242 drum, 55 tone, 110, 236 Losses: erase, 25, 257 eddy current, 33 Pinch wheel, 63 ferrite, 33 frequency, 31 Playback, 122 gap, 23 head, 34 modes, 163 response, 32 spacing, 32 phase, 265 servo, 47, 157 thickness, 33 Pole tips, 356 wheel, 55, 265 Position: wrap, 80 Magnetophone, 16 field sync, 61 Head wheel: Manchester code, 271, 272 head, 176 dimensions, 55 Mark, bi-phase, 271 Positional errors, 169 logic, 160 Memory: Portable machines, 297 modes, 163 random access (RAM), 226 Pre-emphasis, 112 servo, 157 store, 207 Print, 356 Helical: Mobile video recording, 295 Processor, video, 48 adjustments, 176 field production (EFP) Projection, tips, 51, 55, 358 alpha wrap, 84 (LPU), 303Pulse: cassette, 249 field sync, 61 news gathering (ENG) conical wrap, 85 (EJ), 296 frame, 157 editing, 257 line up, 74, 86, 316 portable recorder, 70, 79, formats see formats Pulse width motor control, 148 297 interchange, 177 Modulation: omega wrap, 67, 83 Off line editing, 279 index, 102 slow motion, 76, 293 One-headed wraps, 82 noise, 105 stop motion, 87, 285 Optimisation, 52, 120, 121 Modulator (FM) 114 Heterodyne, 238 Oscillator, burst locked, 237 astable, 117, 330 High band, 101 Overlap, 58, 69, 74 delta, 230 super, 66, 101 Oxide, 22, 43 double limiter, 92 u-matic, 296 reactance, 115

Moiré, 356

calculation, 108

Motion, slow, 76, 87

Motor control, 145

causes, 106

d.c., 149

Horizontal:

Humidity, 175

Hysteresis, 19

sheared, 22

comparator, 158

sync line up, 74, 86, 317

Quad I, 55 Ouad II, 65 Quadrature displacement, 168 Quadruplex: deck, 64 format data, 61

general, 55	Shelf working, 110	penetration, 358
velocity error correction,	Shoe, 357	projection, 51, 358
189, 205	Shuttle, 357	Tone:
Quantised:	Slow:	pilot, 205
errors, 349	disc, 292	wheel, 358
gate, 198	helical, 293	Track:
noise, 349	motion, 76, 282	curvature, 358
Quartz delay line, 192	Spacing loss, 32	longitudinal, 58, 69, 74
	Splice, 357	spacing, 317
Radius, guide, 172, 333	Splicing tape, 357	width quad, 56, 59
Random access memory	Stop motion, 87, 285	helical, 69, 73
(RAM), 226	chroma correction NTSC.	Tracking:
Record:	286 PAL, 290	auto, 52, 161
codes, 308	Switcher, 126	control, 153
current optimiser, 357	Switch suppression, 133	dynamic, 76
driver, 119		Trailing edge, 358
electronics, 114	Sync:	Transverse recording, 358
head, 25	feedback, 202, 227	Transverse recording, 550
mode, 166	line up, 74, 86	u matic 05
phase, 265	sub-carrier lock, 204	u-matic, 95 Under, colour recording, 89
	tip frequency, 101, 357	
process, 25 Recorded wavelength, 27		Upstream, 358
	Tach:	Manua
Recorder, elements, 45	lock, 357	Vacuum:
Reduction, bit rate, 230, 306	pulse, 357	chambers, 63
Reference:	Tape:	guide, 64, 358
edge, 357	care, 48	Varactor diode, 116, 190
stable, 196	characteristics, 41	VCC, 91
Register, line shift, 225	checking, 49	VCR, 250, 320
Reluctance, 20, 23	deck, 63	Velocity control, 138
Remanence, 20, 23	guide, 357	Velocity error, 172
Replay:	leader, 357	calculation, 334
process, 28	neutral plane, 357	cause, 172
remote, 300	tension, 184	compensation, 358
Response:	thickness, 41	correction, 205, 229
final audio, 36	transport, 47, 63	typical, 175
video requirements, 111	Temperature coefficient,	VERA, 17
Retentivity, 20, 23	175, 181	Vertical:
R.F.:	Tension:	lock, 358
dub, 322	auto, 186	mode, 157
turn on, 322	servo, 185	synchronism, 161
Ring counter, 147	Thickness loss, 33	VHO, 358
	Time base correction,	VHS, 94
Scanner, 67, 71	47, 188	Video:
Segmentation, 56, 67	analogue, 190, 194	disc, 282
Sequential coding, 234	colour, 200	dub, 358
Servo:	digital, 213, 222	head, 51, 291
capstan, 147	monochrome, 189, 197	Video head optimiser, 358
elements, 139	velocity, 189, 205, 210	Video home system, 94
head wheel, 157	Time code, 269, 276	
modes, 152	editing, 279	Wavelength, recorded, 27
phase comparator, 140	Timing errors, 181	White level frequency, 358
practical (quad), 150	Tip:	
(helical), 162	engagement, 358	Zero guard band, 89
Sheared hysteresis 22	height 358	

Particular de la companya del companya de la companya del companya de la companya del companya de la companya de la companya de la companya del companya de la companya della companya de la companya della companya della companya del